AnOtherMan

FREE
SPIRIT

...SHAW: REBEL STAR OF STAGE AND SCREEN

AnOtherMan

CASEY
AFFLECK:
HOLLYWOOD'S
MOST
ANTICIPATED
BREAKOUT
STAR

EX
TREME STY
LES

AnOtherMan

Emile Hirsch - A
MAVERICK Star
in the MAKING

New BO
HEMIA
A MANIFESTO for change

Another
Man

W
H
I
T
E
J
A
C
K

Force of Nature

Issue 11
Autumn/Winter
2010
Mens Fashion

Keith Richards
photographed by
Mario Sorrenti

Another
Man

KEITH

RICHARDS

A-L-T-E-R-E-D S-T-A-T-E-S
James Franco, Aphex Twin
Antony Hegarty, Ryan Trecartin
Tutankhamun

Another
Man

Issue 12
Spring/Summer
2011
Mens Fashion

Tom Ford
photographed by
Jeff Burton

TOM FORD

L-I-G-H-T-S, C-A-M-E-R-A... A-C-T-I-O-N !
Starring a cast of iconic gentlemen: John Waters,
Sam Riley, Joe Dallesandro and The Duke of Windsor
Plus: Pin-ups by Hedi Slimane, Centrefold
by Richard Phillips, Sci-fi by China Miéville and
Striptease by Betty Page

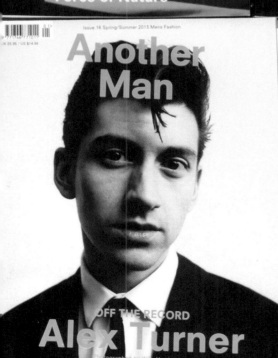

Issue 16 Spring/Summer 2013 Mens Fashion

Another
Man

OFF THE RECORD
Alex Turner

Bobby Gillespie, Richard Hell, Nick Cave, Jake Bugg, Sky Ferreira

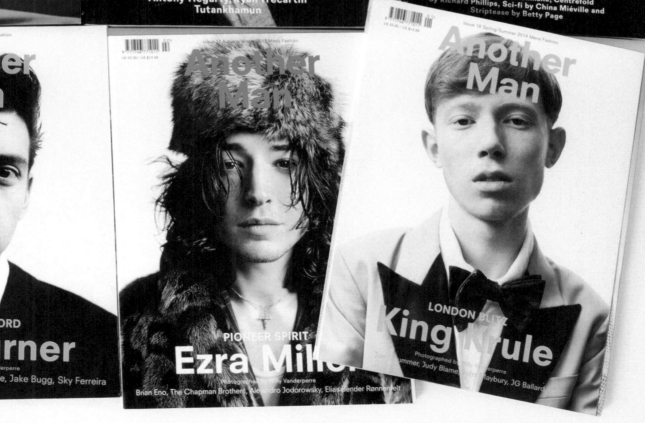

Another
Man

PIONEER SPIRIT
Ezra Miller

Brian Eno, The Chapman Brothers, Alejandro Jodorowsky, Elias Bender Rønnenfelt

Another
Man

LONDON BLITZ
King Krule

Judy Blame, JG Ballard

ANOTHER MAN

Men's Style Stories

RIZZOLI
NEW YORK

New York Paris London Milan

First published in the United States in 2014 by
Rizzoli International Publications, Inc.
300 Park Avenue South
New York, NY 10010
www.rizzoliusa.com

Publisher: Charles Miers
Managing Editor: Anthony Petrillose
Production: Maria Pia Gramaglia
Text Editor: Caitlin Leffel
Design Coordinator: Kayleigh Jankowski

ISBN: 978-0-8478-4327-5
Library of Congress Number: 2014936165

2014 2015 2016 2017
10 9 8 7 6 5 4 3 2 1

Printed in China

"Skip Spence's Jeans" from *Distrust that Particular Flavor* by William Gibson.
© 2003, by *Ugly Things Magazine*.

"style" from *Mockingbird Wish Me Luck*. Copyright © 1972 by Charles Bukowski. Reprinted by permission
of HarperCollins Publishers. The additional lines of this extended version of the poem (© Charles Bukowski)
are reprinted by permission of Linda Lee Bukowski.

"Nocturnal Inquisition (with apologies to Padgett Powell)" by Jarvis Cocker. © 2014, by Jarvis Cocker.

Trade:
Front cover (clockwise from top left)
Alex Turner, photography by Willy Vanderperre, *Another Man* issue 16, 2013
Photography by Alasdair McLellan, styling by Alister Mackie, *Another Man* issue 13, 2011
Photography by Mark Segal, styling by Alister Mackie, *Another Man* issue 2, 2006

Back cover
Kate Moss, photography by Willy Vanderperre, styling by Alister Mackie, *Another Man* issue 1, 2005
Alex Turner, photography by Willy Vanderperre, styling by Alister Mackie, *Another Man* issue 16, 2013 (main underlay)
Photography by Terry Richardson, styling by Alister Mackie, *Another Man* issue 1, 2005 (top left underlay)

Special Edition:
Front cover (clockwise from top left)
Ezra Miller, photography by Willy Vanderperre, styling by Alister Mackie, *Another Man* issue 17, 2013
King Krule, photography by Willy Vanderperre, styling by Alister Mackie, *Another Man* issue 18, 2014
Alex Turner, photography by Willy Vanderperre, styling by Alister Mackie, *Another Man* issue 16, 2013

Back cover
Ezra Miller, photography Willy Vanderperre, styling by Alister Mackie, *Another Man*n issue 17, 2013 (underlay)
Philip K at Tomorrow Is Another Day, photography by Alasdair McLellan, styling by Alister Mackie, *Another Man*
issue 15, 2012 (overlay)

ANOTHER MAN

Men's Style Stories

Compiled by

ALISTER MACKIE

Editors: Ben Cobb and Jefferson Hack

This book is dedicated to Bryan McMahon and Louise Wilson

FOREWORD
by
ALISTER MACKIE

"Memory... is the diary we all carry about with us." — *Oscar Wilde*

This book is designed as a scrapbook filled with all the heroes and anti-heroes, icons and pin-ups that have fuelled *Another Man*, and my imagination, over the years. It is a stream of consciousness in fanzine form, chronicling the magazine's reoccurring obsessions, characters, places and themes. Creating this visual diary has been an analogue process, laying out tear sheets by hand in an anti-digital remix of the *Another Man* archive. These finished pages are also a collective vision, a shared romantic point of view created by the *Another Man* family of contributors. I would like to personally thank the photographers, stylists, designers and artists who have accompanied me on this journey.

INTRODUCTION
by
JEFFERSON HACK

Joaquin Phoenix is photographed smoking, seductive, a Hollywood outlaw, manly in his imperfect beauty.

He was the first cover star of *Another Man* and set the stage for a decade of anti-hero covers, which have come to define the existential exploration of men's style and characters unique to our pages. Actors as outlaws, rock stars as rebel icons, the anti-hero is the outsider, the fighter, the one who never fitted the mould, who broke the mould, for whom new moulds have to be cast. It's the romantic allure of a pursuit of freedom beyond the shackles of convention that sets him apart.

Joris-Karl Huysmans birthed the modern decadent in his 1884 novel *À rebours*. The ancestral lineage of this aesthetically charged, amoral character can be traced from the Romantics through to contemporary pop culture: from Wilde's Dorian Gray and Rimbaud's derangement of the senses to Huxley's 'Doors of Perception', through which Jim Morrison stepped, leading the way for Lou Reed's and Robert Mapplethorpe's walks on the Wild Side, and on and on...

If this archetype is really the modern freedom fighter of the psyche, the one we can live vicariously through, then the mantra for these men has been that the more impossible to define they are, the better they look! Subconsciously he represents the failure of society and ideals, the dark side of modern angst; he is a purer, truer, more soulful opposite of our culture of self-obsession, greed, rage and despair than the heroic, Homeric version. It's the

unpredictability and promise of new possibilities that makes us hold out so much hope for him.

As creative director of *Another Man*, Alister Mackie has tirelessly championed this rebel spirit. Mackie's unique take on men's style has defined the codes of the magazine, inspiring a new incarnation of that complex beast, the modern gentleman. We have explored this idea in every issue of *Another Man* and come to realise that true elegance lies in behaviour more than credentials; a gesture, posture, sartorial stance, poise or performance can be so slight but so precise that it communicates more about a man than an entire wardrobe. What it means to be a man is more about the subtleties of manners, the precision of language, the mindfulness of others, all examples of how style and action can transform a man from a savage to an aesthete.

'Style is the answer to everything,' wrote Charles Bukowski in his erudite poem reprinted in full in this book. This gruff-talking, broken-nosed, barely sober man of letters caught a line between men that distinguishes the savage from the nobleman: 'I've met more men in jail with style than men out of jail,' he continues. 'Style is the difference, a way of doing, a way of being done.' He describes style not in the vestiges of privilege, wealth and prominence, but in worlds and behaviours beyond the cultural confines of Bond Street. Style is something that cannot be bought, but it can be learnt and taught, and to have true style—a genuine personal style—it must, like any art, be practised.

Paul Simonon and Bobby Gillespie trace their style influences back to Johnny Rotten and the Afro-Caribbean immigrants that came to London in the 1960s and promptly reinvented British music. The Clash and Primal Scream—twin engines of UK music and style revolutions, sonic brothers-in-arms defining the times from Punk to Acid House—are brought together for this book, in conversation for the first time.

These music icons—joined in these pages by the inimitable Jarvis Cocker—played in our hometowns, appeared in our magazines and performed on our TVs; they were accessible and vital, vagabond men who upheld a kindred gang spirit. The collective sense of release at gigs in those pre-smartphone-waving days was palpable, life changing, epic. The revolutions in language, design, dress and attitude kick-started by these bands felt truly explosive. Remembering now the obsession, the personalisation and the perfectionism of street style—in 'getting it right', in wearing the right jackets in the right colour and having the right haircut—it seems almost surreal to think of a time when there was an underground, when you could really stand for something by the way you stood out.

This rebellion via identification spawned a tribe of teenagers all defining themselves, their values, beliefs, dreams and desires through street and club culture, the avant-garde and the underground was the rite of passage that most men in England of our generation took. Mackie may have left Scotland to run away and join the *Dazed & Confused* circus in the early '90s, but he could never leave behind the Jesus and Mary Chain and Glasgow School of Art. His needle-sharp point of view inspires a scrapbook of characters that are juxtaposed from page to page —the anti-hero is at the core of this manifesto, but there is a lot more.

For each issue of the magazine, Mackie produces an entire cut-and-paste book of references; it's a remarkable study of character and influences. Full of paintings, film stills, historical photography and illustrations, scans from old books counterpoised with cutting-edge artworks, the latest in typographic or industrial design, these visual tomes are usually crammed with anything and everything but fashion. So assured that fashion must fit into the style of the moment and that style needs to be reflected by the intrinsic mood of our culture, it's as if Mackie is divining his vision and craft in a forward and fluid motion, like an architect might imagine a new shape for a building, or an auteur filmmaker plan his or her next production. In these pages he teaches men how to dress for now and for themselves, not as products of a fashion and advertising system, but by using dress as a statement of defiance, a mode of action, a principle of personality or, simply, as a guilty pleasure, wilfully enveloped in wanton trophies of desire.

Tim Blanks, the existentialist chronicler of Mackie's visions, has written the key essays for each issue of *Another Man*, joining the dots between fashion and art, subculture and artifice. His witty, insightful and often foretelling essays have brought a new lexicon to men's fashion, a sparring parry and riposte to Mackie's visual throwdowns. In conversation with Mackie about the making of this book, he describes Mackie's mindset as one beset by 'Factory Syndrome'—the secret wish harboured by us children of Warhol that we too could have hung out at the Factory—and it is this idea that Blanks believes is the root of Mackie's self-expression. Intertwined with 'this weird sense of recreating experiences you never had', Blanks would have us believe a Mackie shoot is a constant metaphysical party —an endless re-enactment or recreation of a subculture moment now forever lost in an increasingly conservative and clichéd pop landscape, a dance through multiple déjà vus.

Mackie's post-Warholian remix of the *Another Man* world in this beautifully art-directed book seems to take its cue from Richard Prince's appropriations more than Warhol's popism. As image selector and remixer, Mackie invites new meanings and possibilities through juxtaposition, collage, layering, subversion and re-assembling of the imagery. There is a deep understanding of subcultural and queer history, a fascination with celebrity, the fan perspective on music and movie icons, a love of the avant-garde and an eye for outsider culture, bikers, gangs, the banned and the culturally damned.

When Mackie looks to the future it's often through a post-apocalyptic lens. This is when we see machismo enter his frame, the ultra-male trait of survival. Fur-clad warriors and techno pagans morph into modern lab rats; men as pre-flight astronauts undergoing experiments on second skins, bodies ripped and ready to don new hybrid fabrics as lyrical, prophetic extensions of mood and feeling.

Elsewhere, Mackie's creative cohort makes her appearance. Kate Moss and Mackie began an artistic love affair almost fifteen years ago, one that's still blooming. It's never been formally acknowledged by the press, but we all know that their mutual admiration has resulted in some incredible revisions of the female archetype for magazines, film and video, and beyond. Like Derek Jarman and Tilda Swinton a generation before them, Moss has been Mackie's muse remade for photographs as grunge boy, mythic goddess and gothic bride, always an unexpected burst of the feminine among the pages of *Another Man*. She is the magazine's poster girl, so versatile a model and so collaborative a creator, she artfully reappears from issue to issue as a counterpoint to this 'other' man, a creature of defiant, plural sexuality that can hang with the boys or step up to outperform them on stage or screen.

If there's one final fantasy or style trope that hasn't yet been discussed, it's the mood of escape. Physical and psychic escapades are imagined as bursts of hedonist flight to far-flung climes; the West Coast dream light of LA, the intense bright colours of Africa. These are some of Mackie's favourite destinations, where spiritual discovery is beset by a journey for the eyes and where new landscapes and surreal vistas are carved from ancient and not so ancient cultures. It's what happens when you channel the spirit of '60s psychedelia into the cosmic atmosphere of the desert. It's what happens when you begin to place yourself in the footsteps of Livingstone or Rimbaud or other great explorers of Africa's interior: strong inner-primal forces are ignited and beautiful magical transformations occur.

As much as the anti-hero cover star is a manifesto of discontent, the future for Mackie is far from a dark dystopia. As this book shows, there is more than a silver lining to our pages where experimentation bursts with optimism. Through the reflection in the silver balloons in Mackie's imaginary Factory set, we can see the twinkling eyes of a true seeker, within whom the spirit of defiance is carried through with wit and humour. It's an approach to magazine image-making that is becoming rarer and rarer, where clothes act as ambassadors of ideas, and personal storytelling through styling is as much a gesture, a provocation and performance as a liberation to be enjoyed not by the privileged few insiders, but by anyone who wants to, aspires to, cares to or dares to be other.

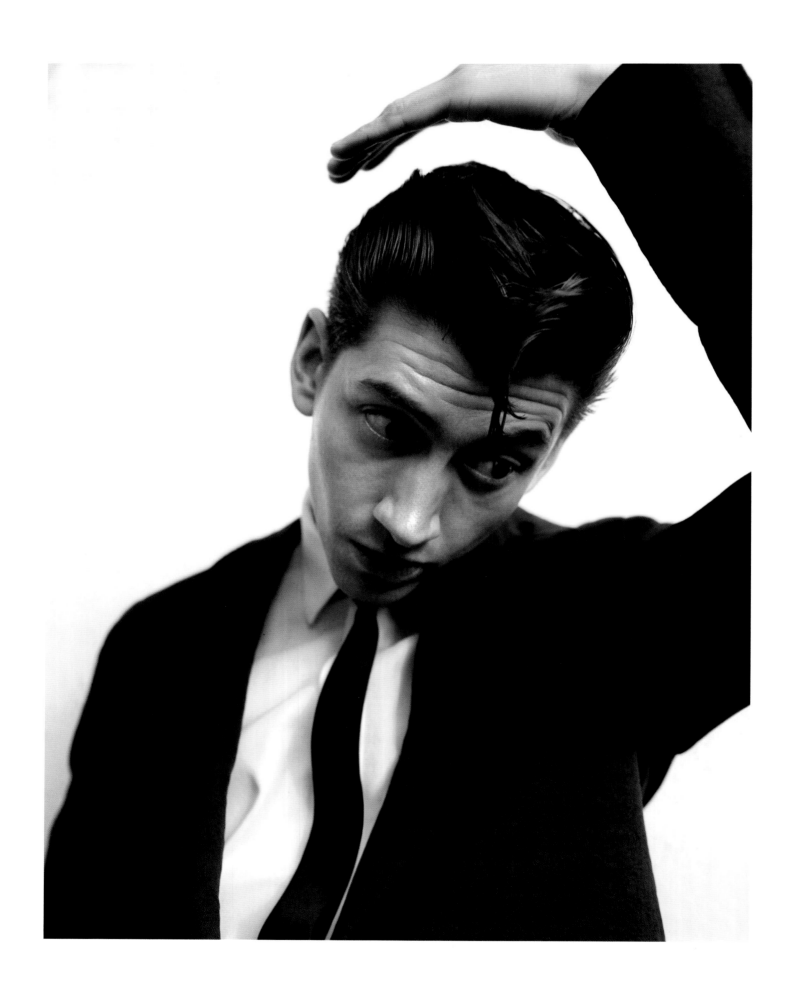

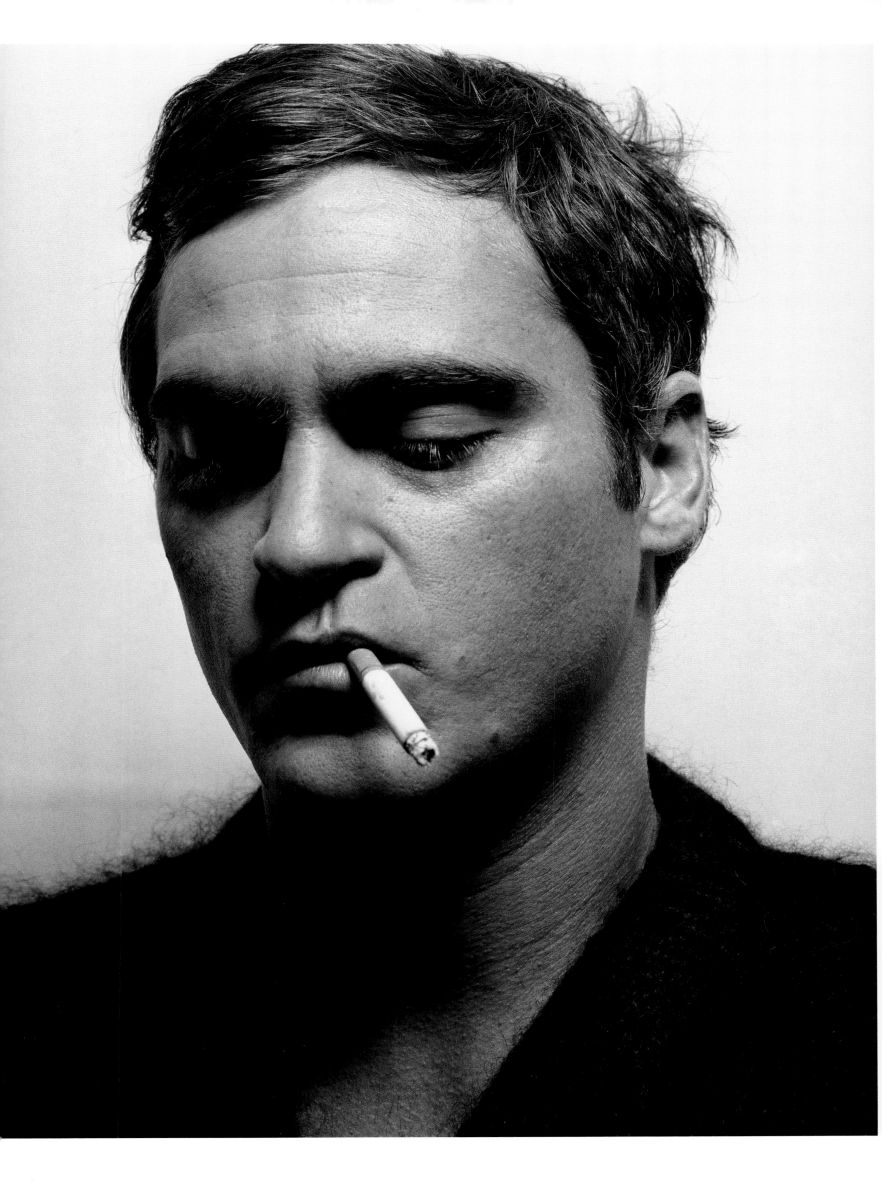

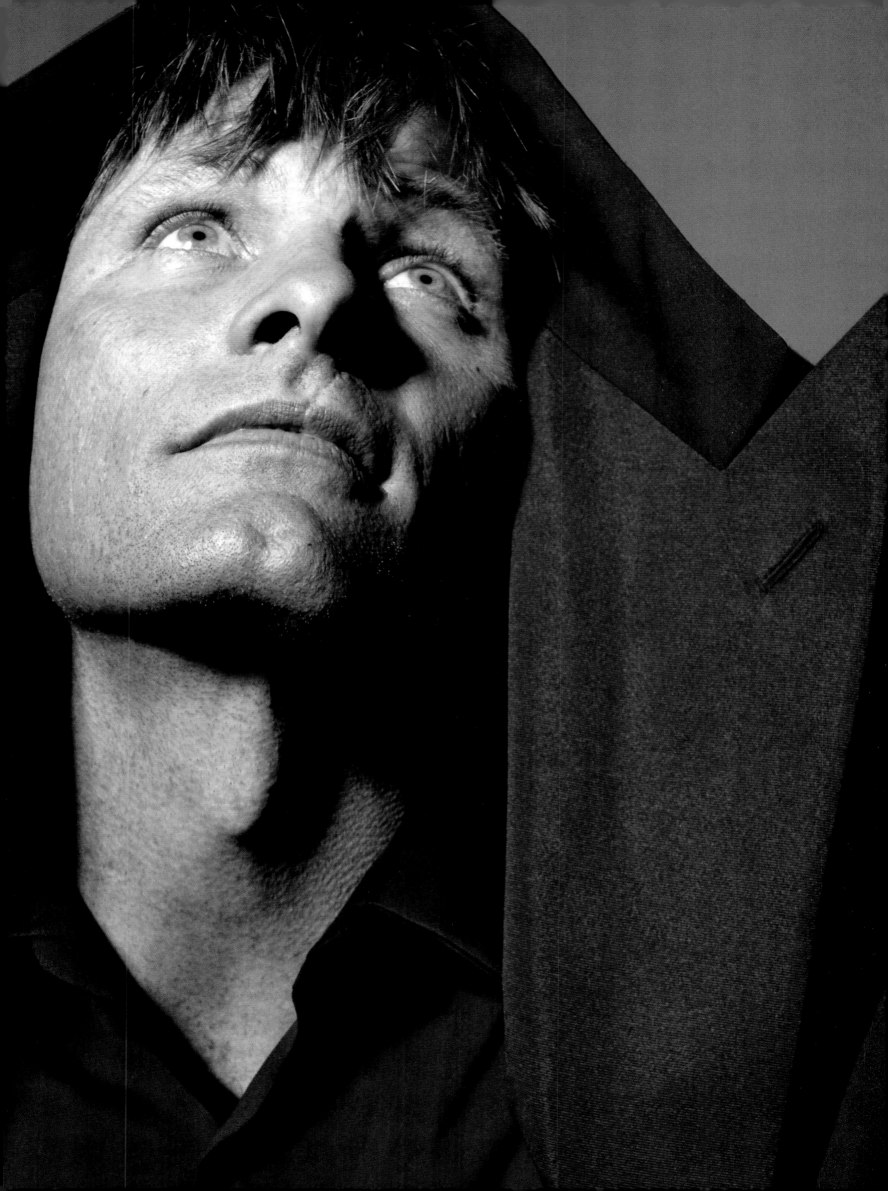

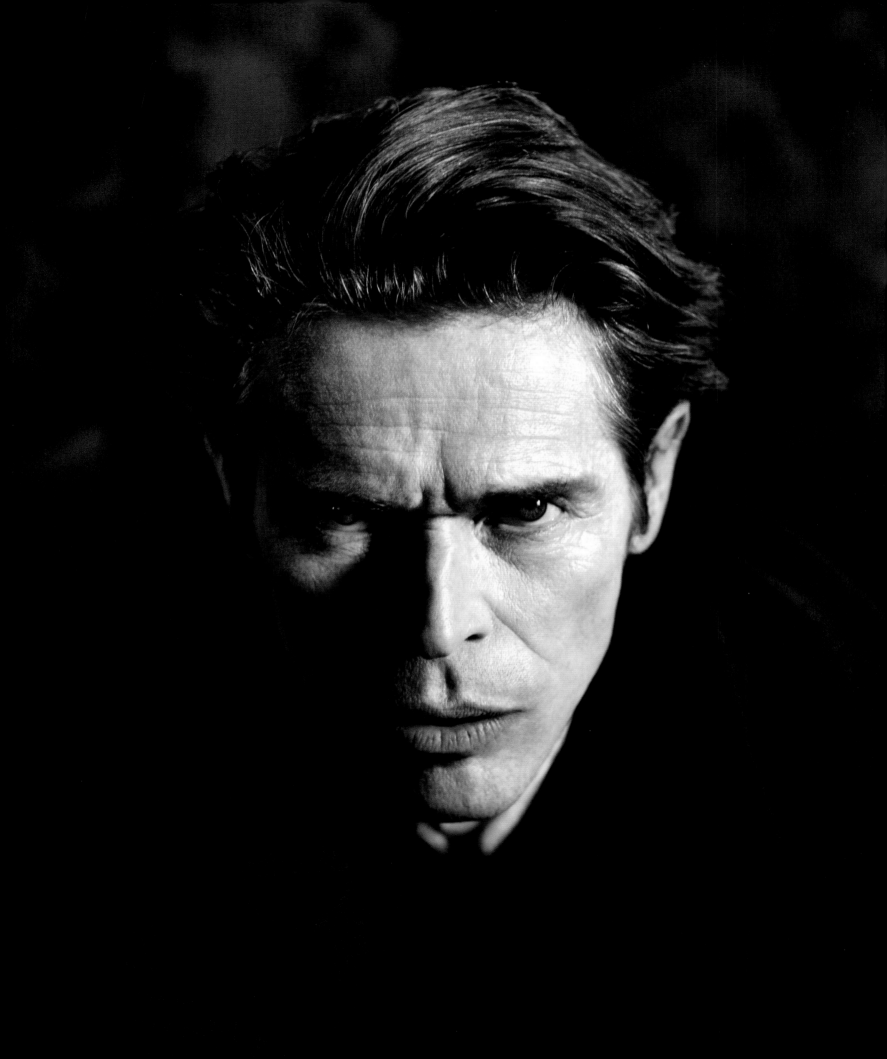

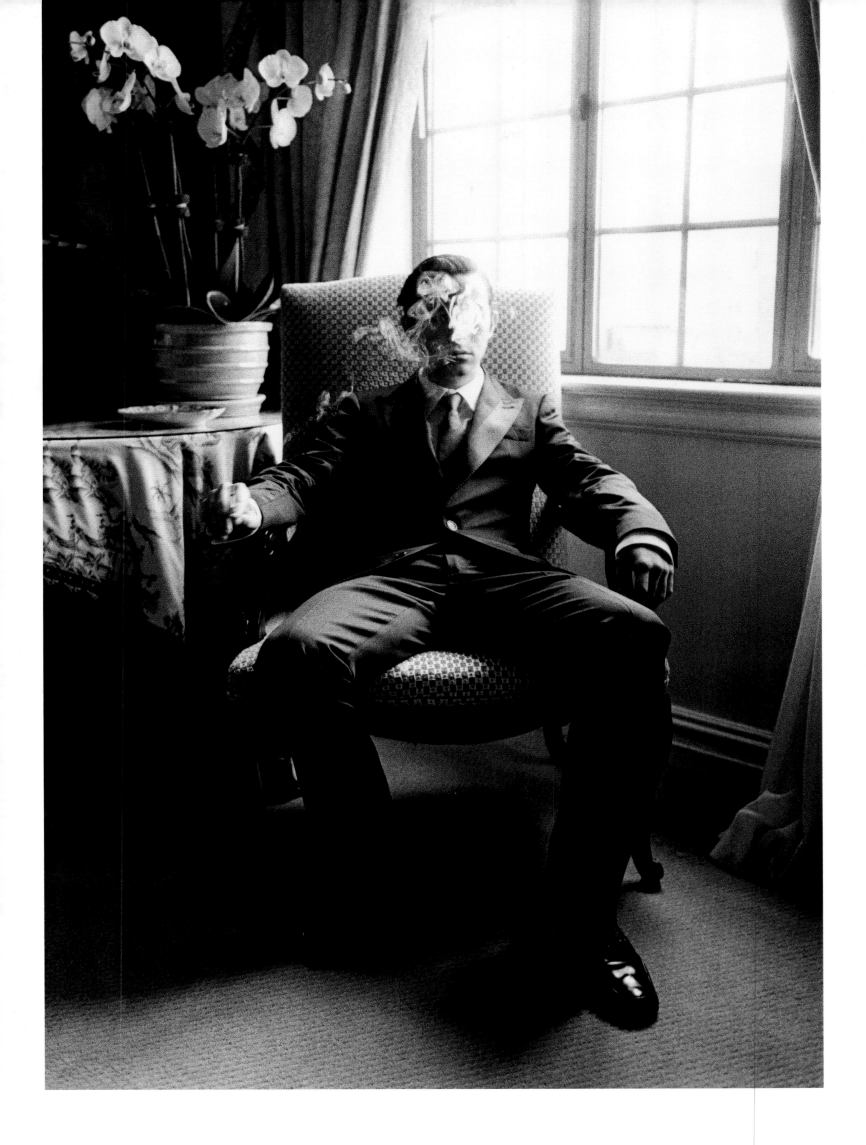

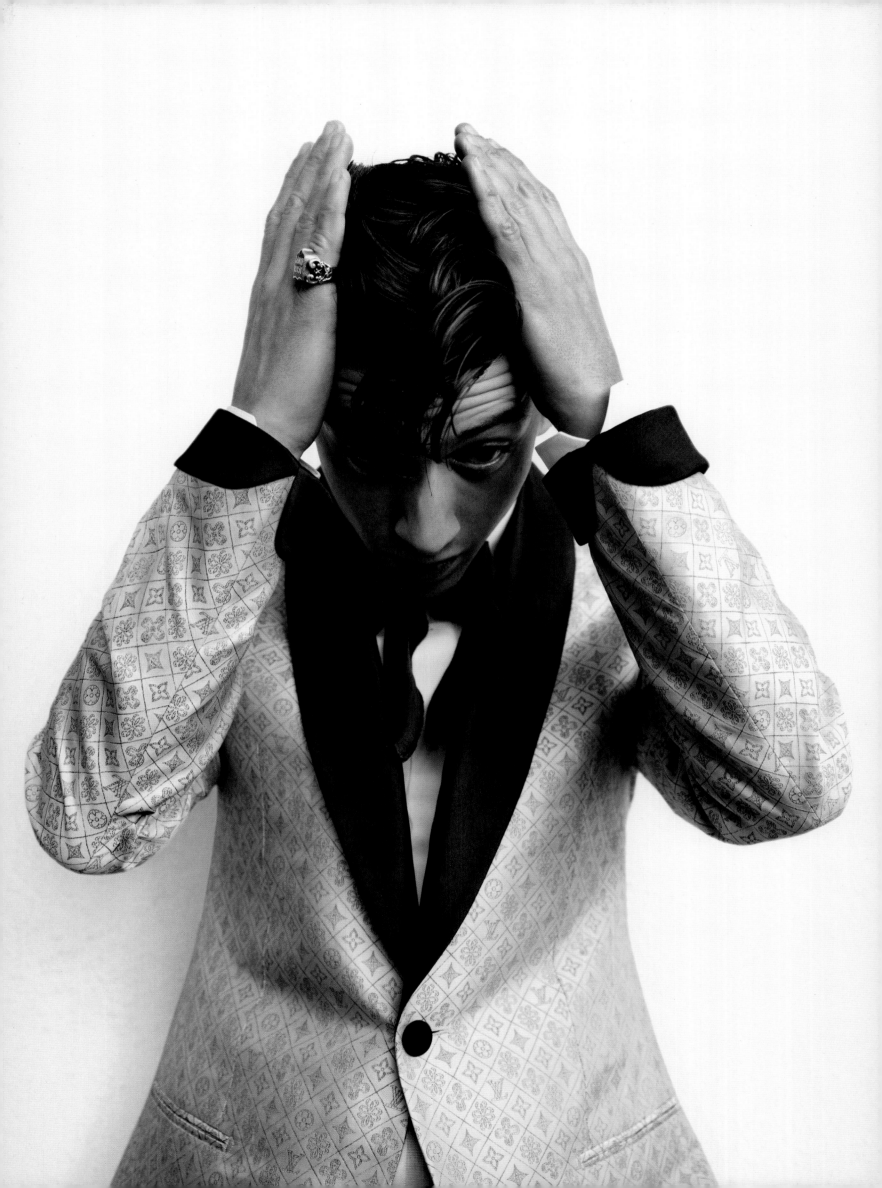

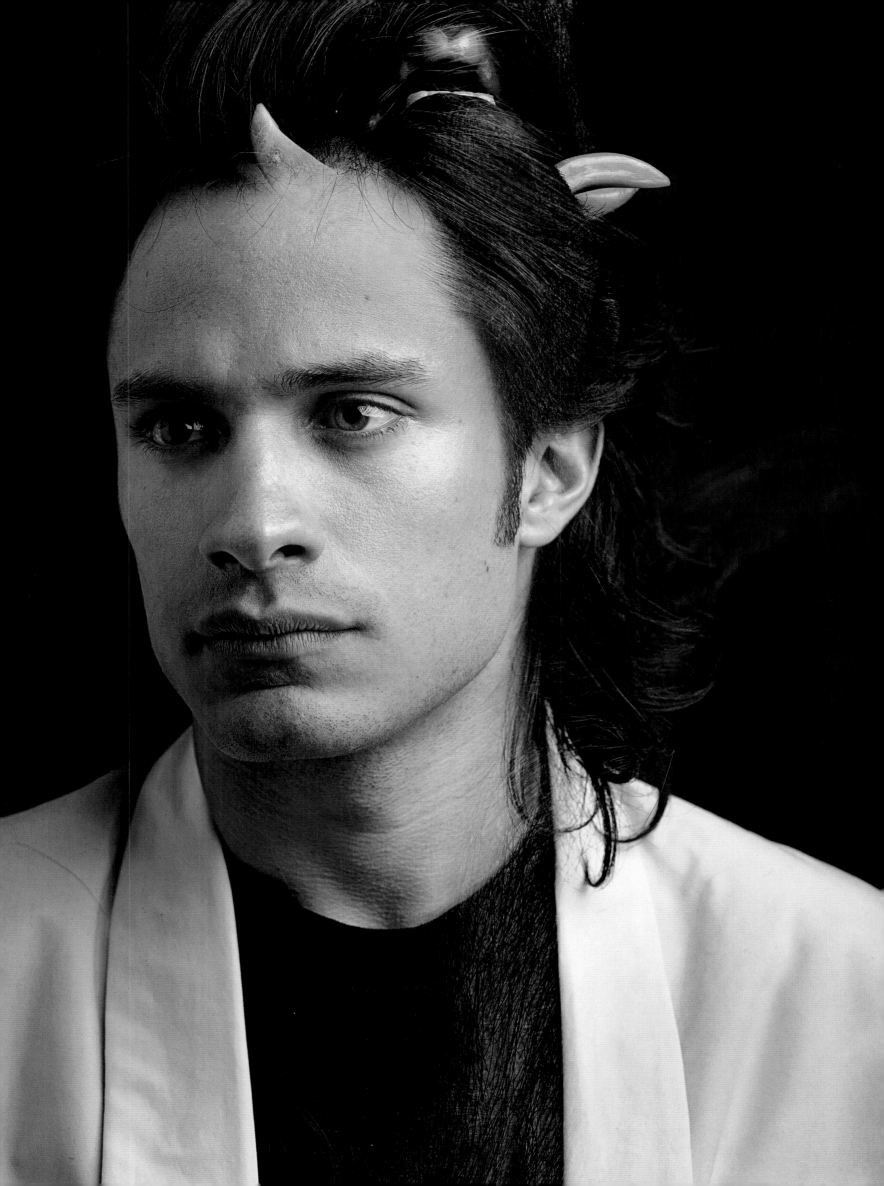

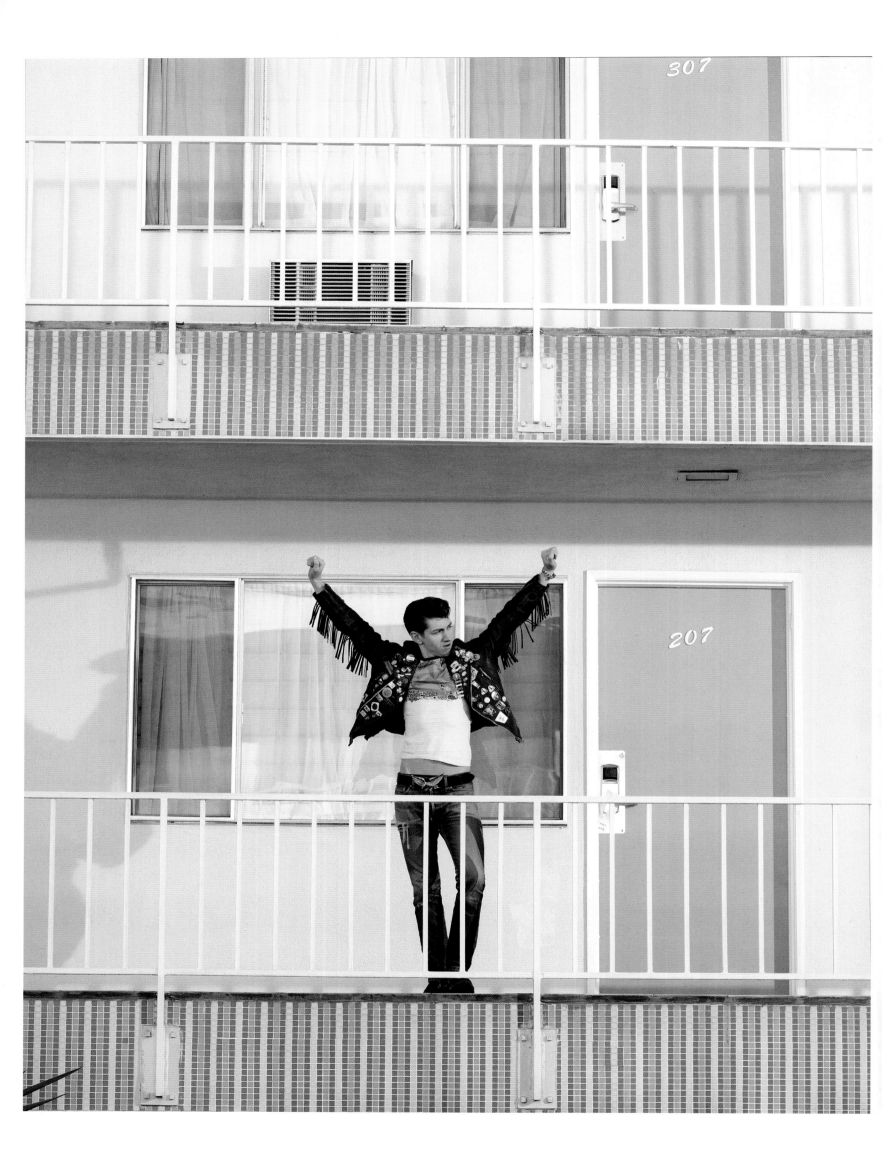

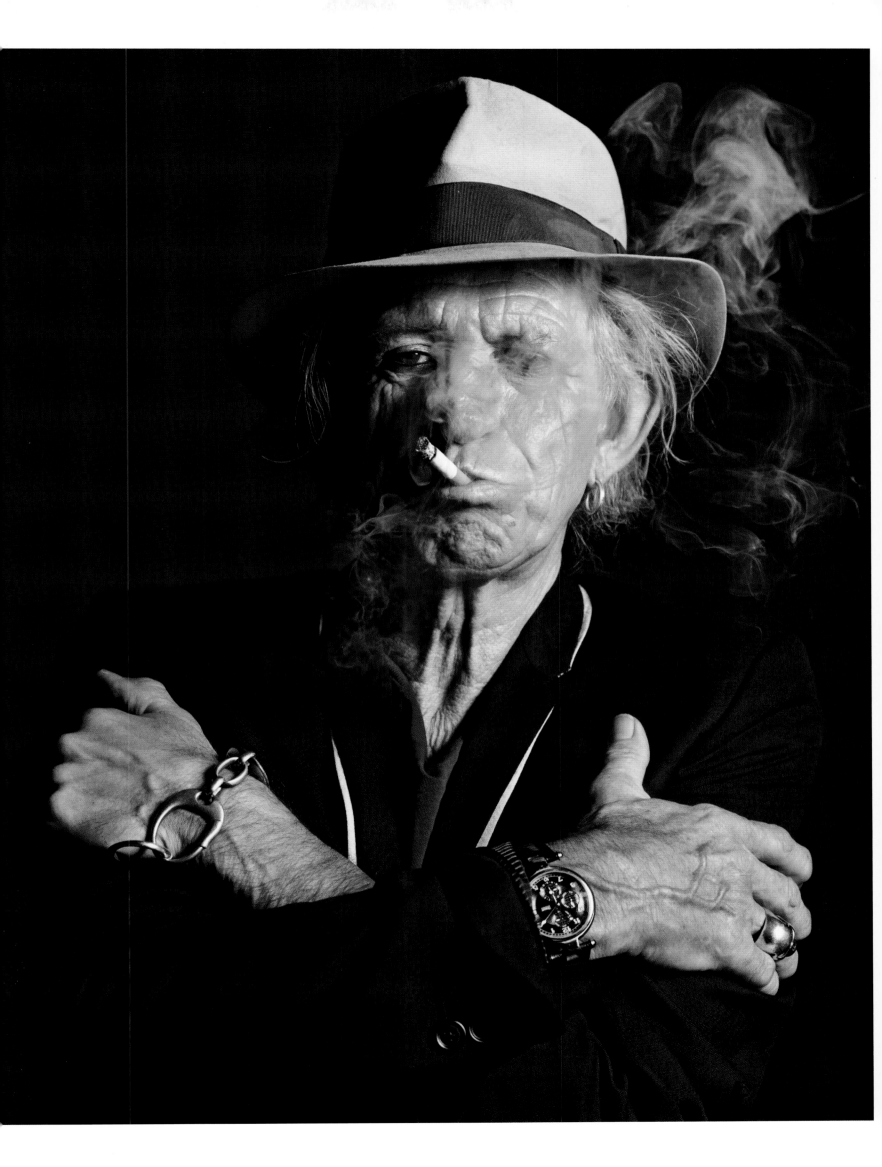

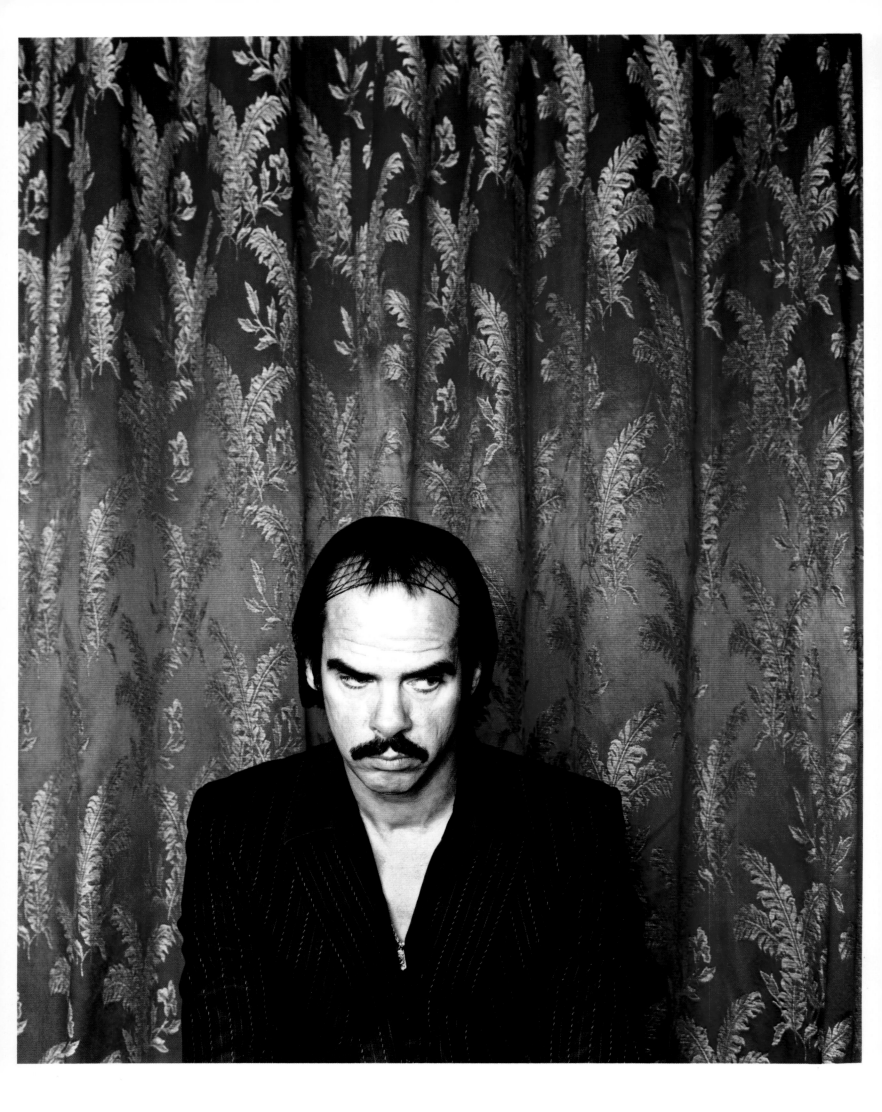

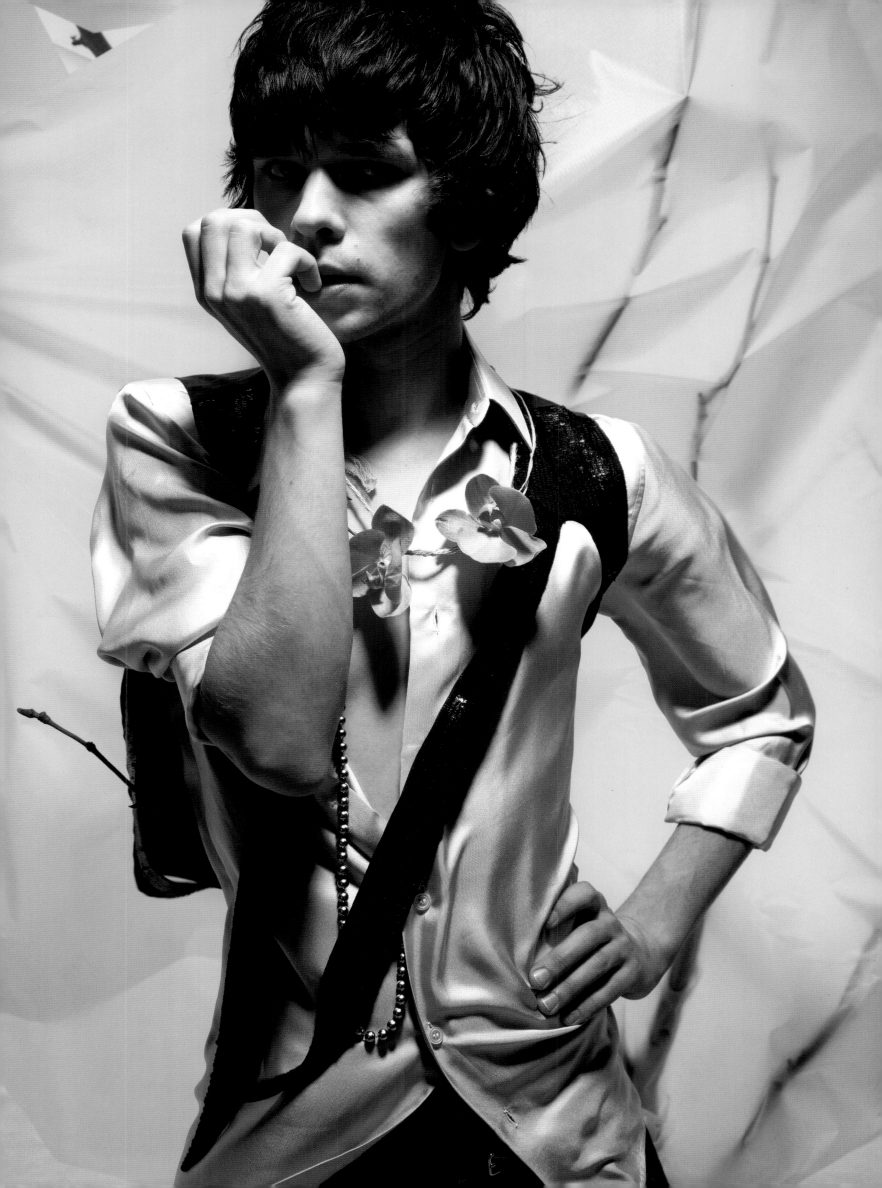

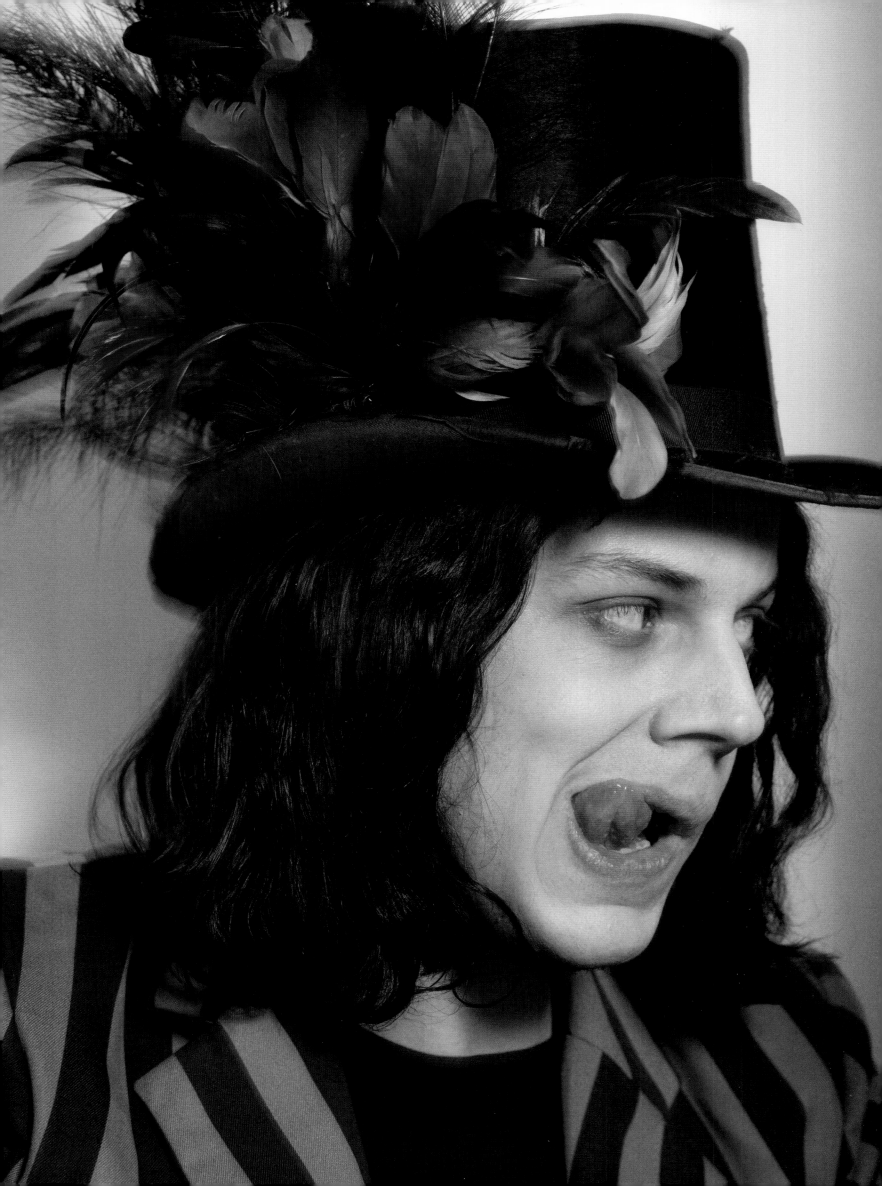

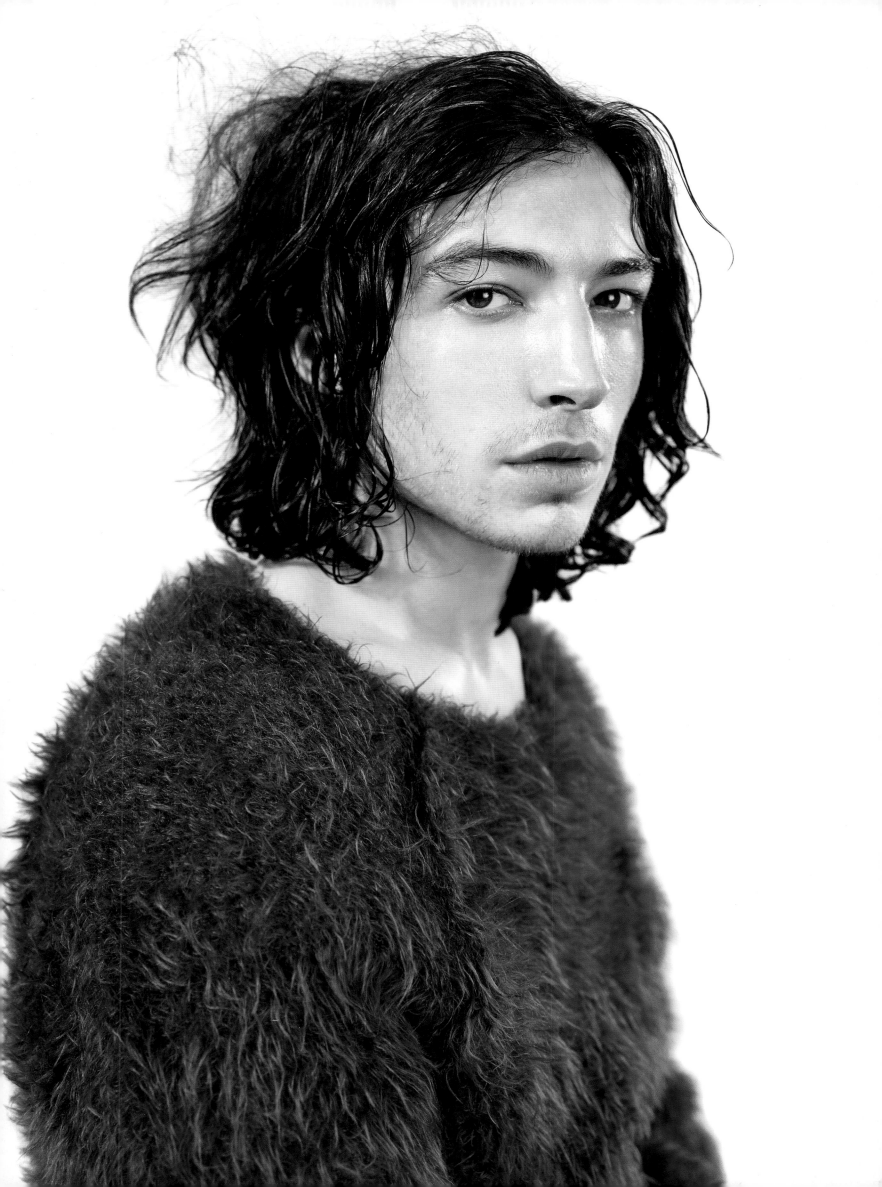

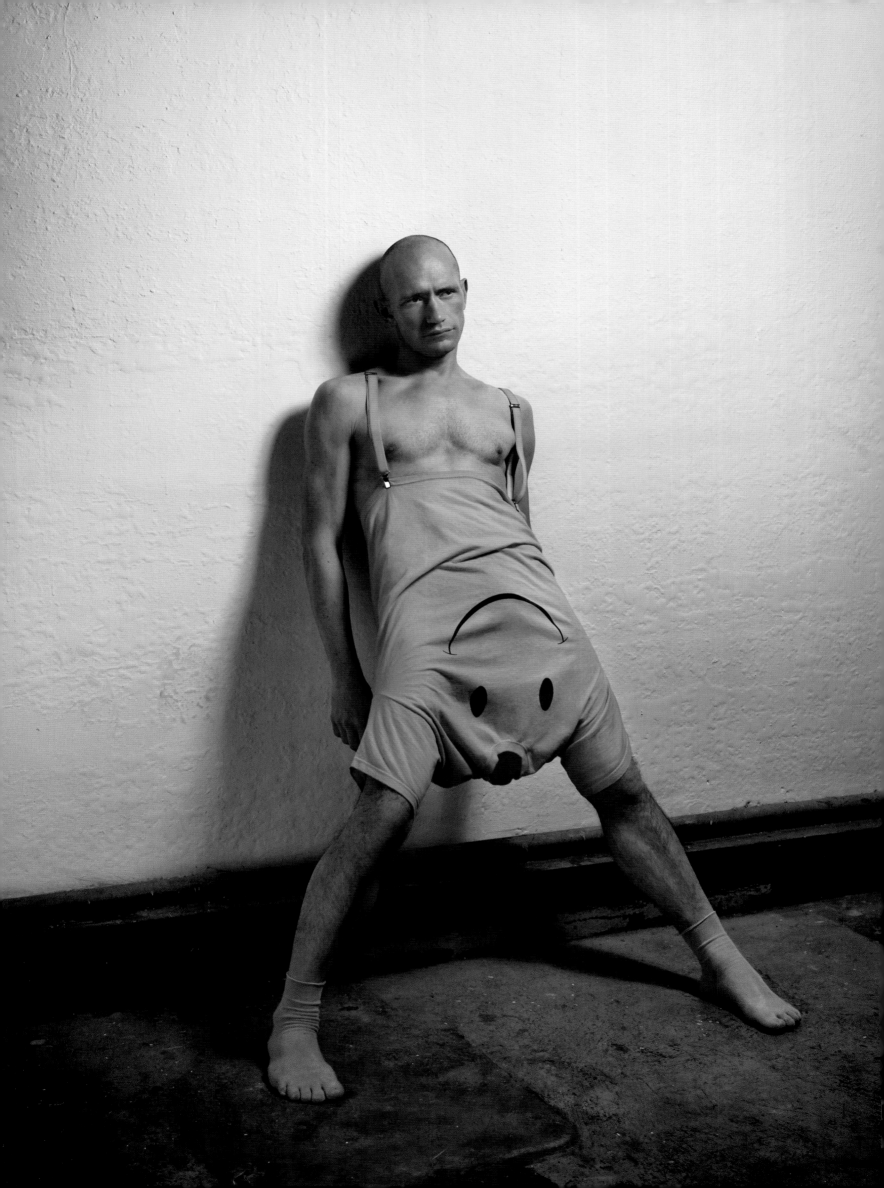

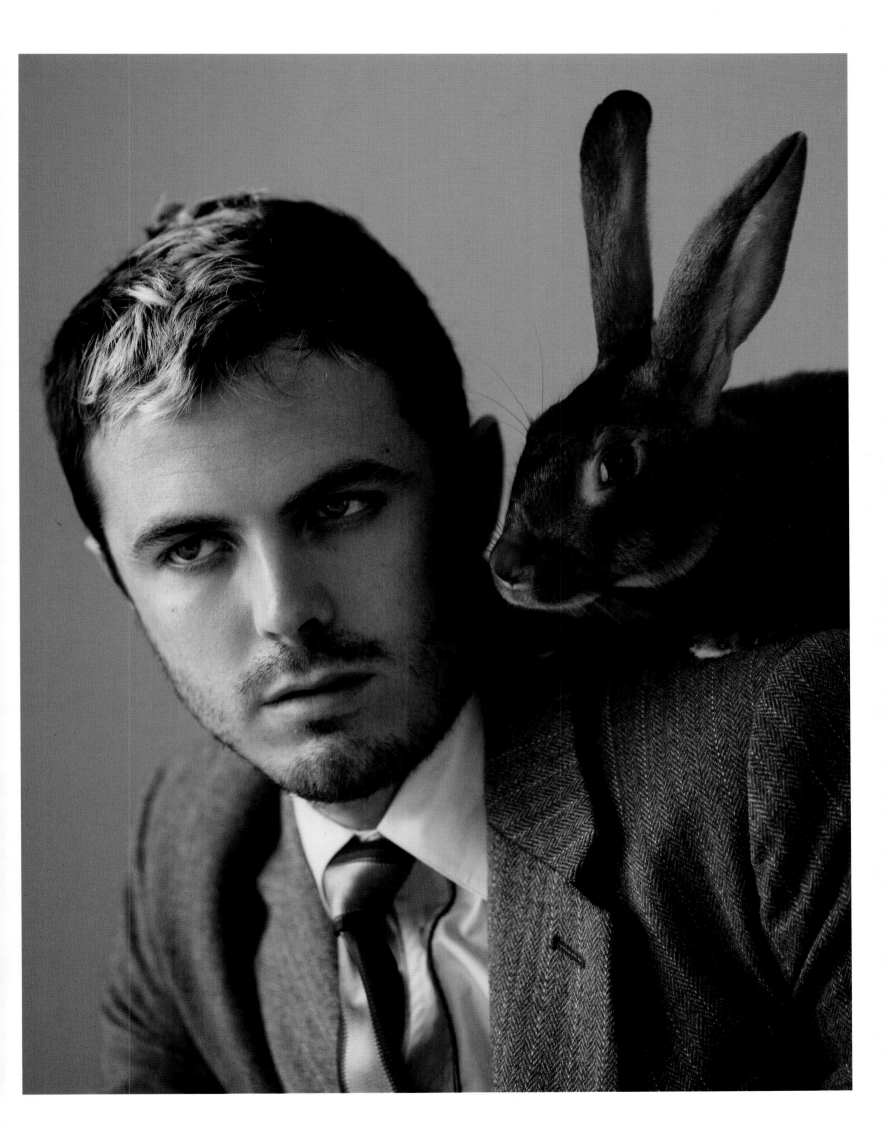

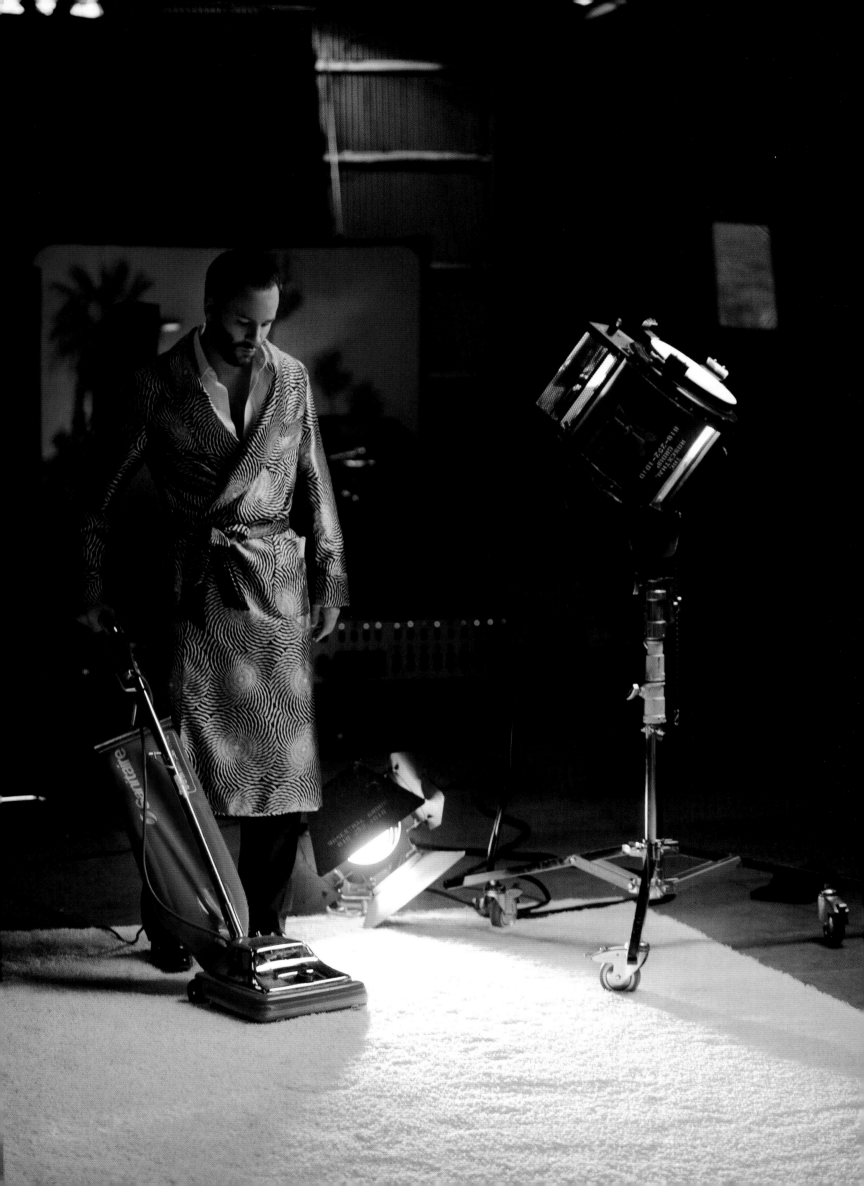

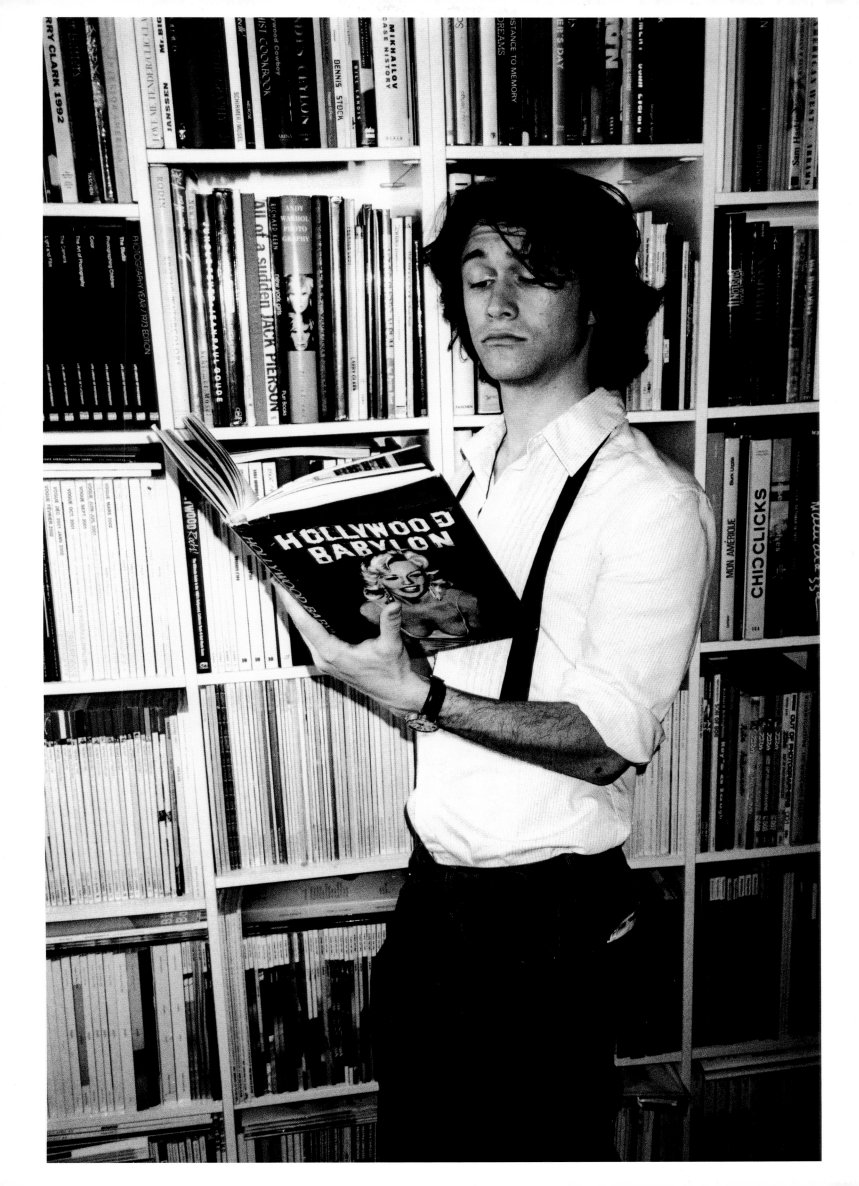

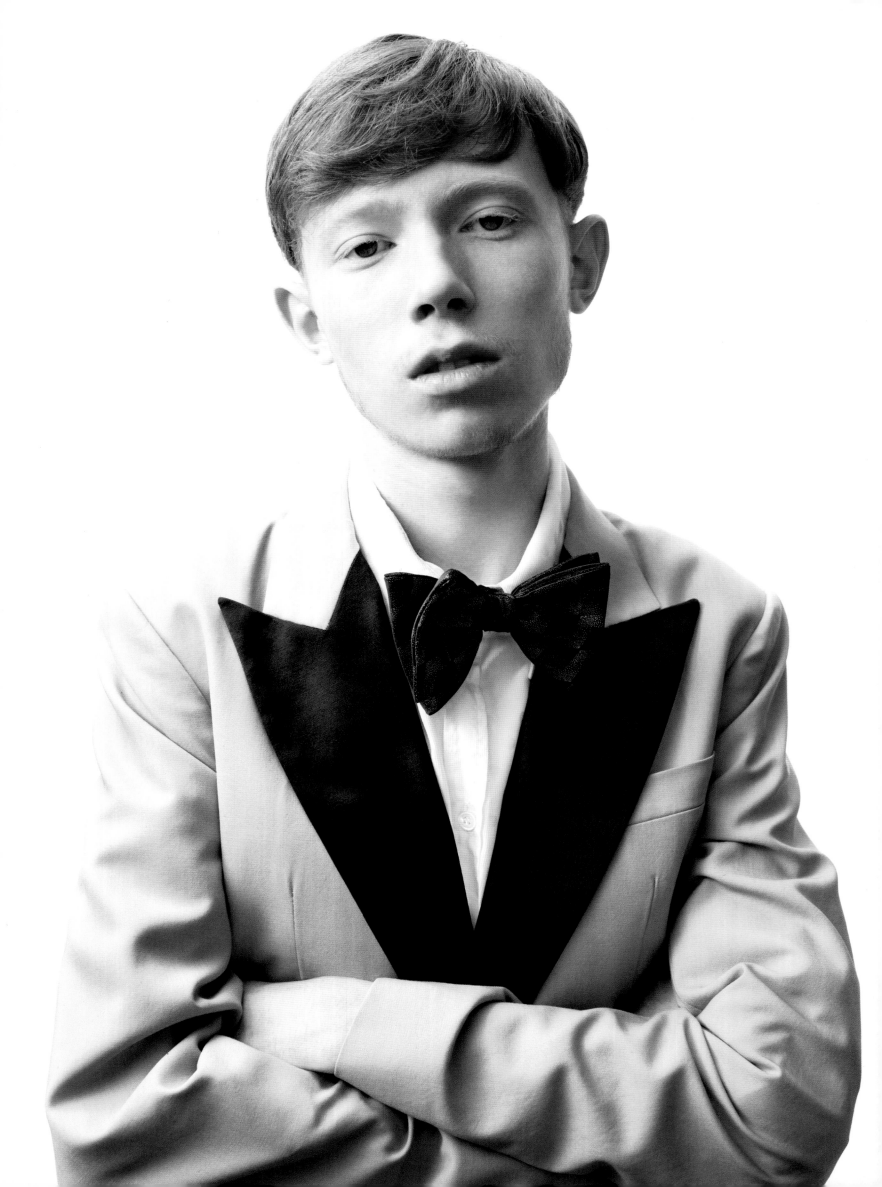

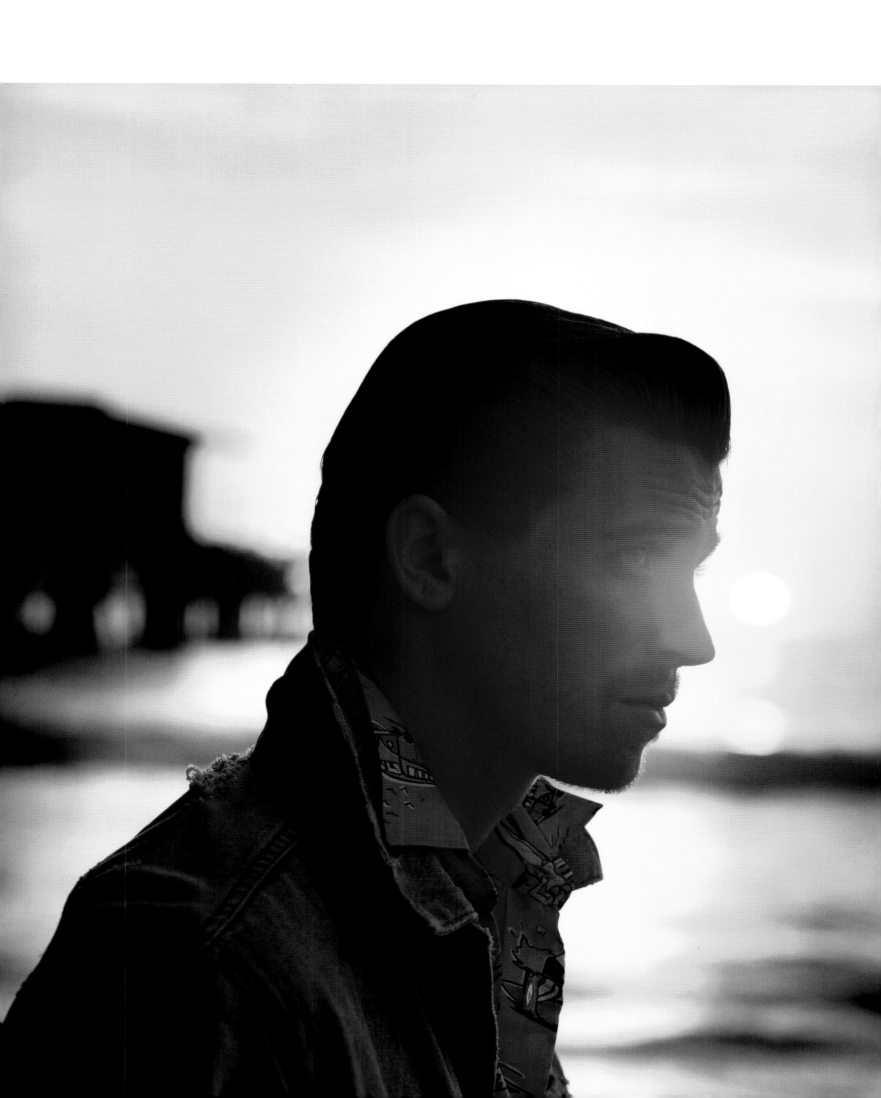

GENTLEMEN'S CLUB

"The only people for me are the mad ones, the ones who are mad to live, mad to talk, mad to be saved, desirous of everything at the same time."
—*Jack Kerouac*

STYLE
by
CHARLES BUKOWSKI

style is the answer to everything—
a fresh way to approach a dull
or a dangerous thing.
to do a dull thing with style is preferable
to doing a dangerous thing without it

to do a dangerous thing with style
is what I call Art.

bullfighting can be an Art
boxing can be an Art
loving can be an Art
opening a can of sardines can be an Art

not many have style
not many can keep style

I have seen dogs with more style than men
although not many dogs have style.
cats have it, with abundance.

when Hemingway put his brains to the wall
with a shotgun
that was style.

or sometimes people give you style:
Joan of Arc had style
John the Baptist
Christ
Socrates
Caesar,
García Lorca.

I've met men in jail with style
I've met more men in jail with style
than men out of jail.

Style is the difference,
a way of doing, a way of being done.

6 herons standing quietly in a pool of water,
or you walking out of the bathroom naked
without seeing me.

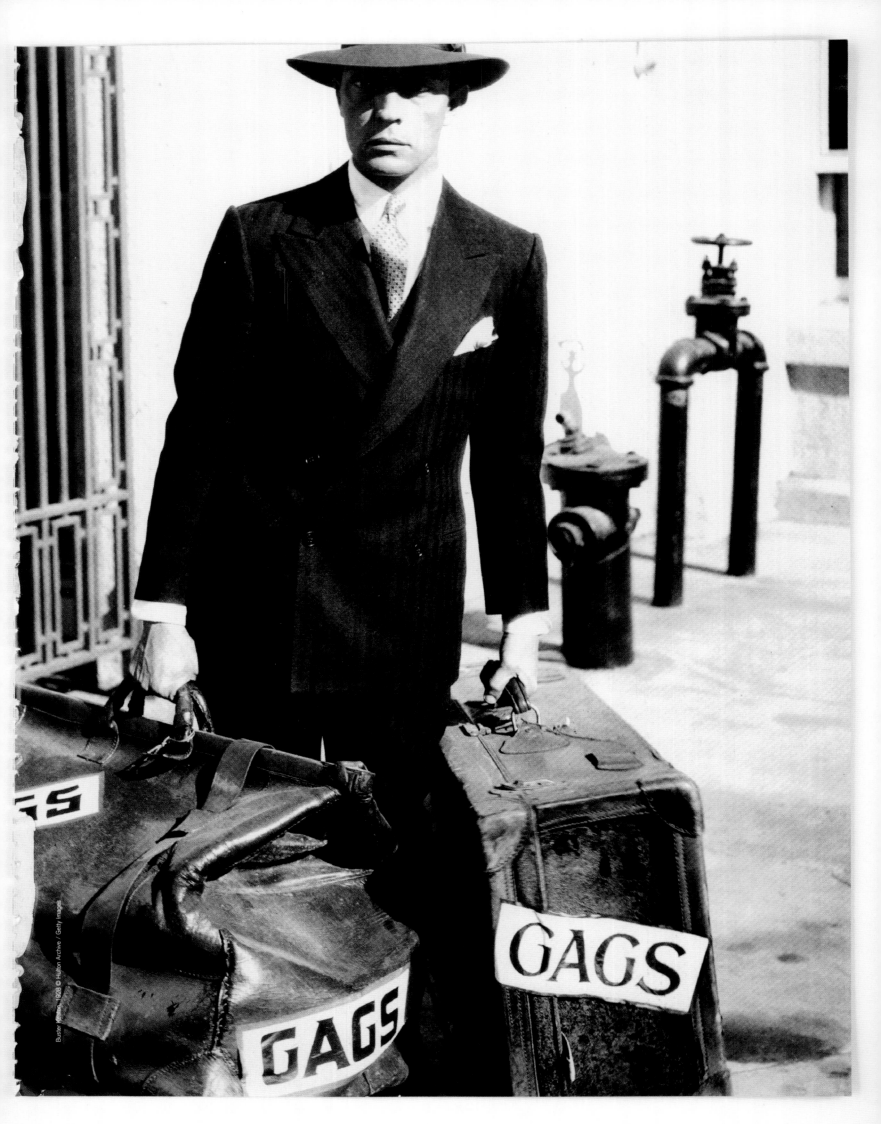

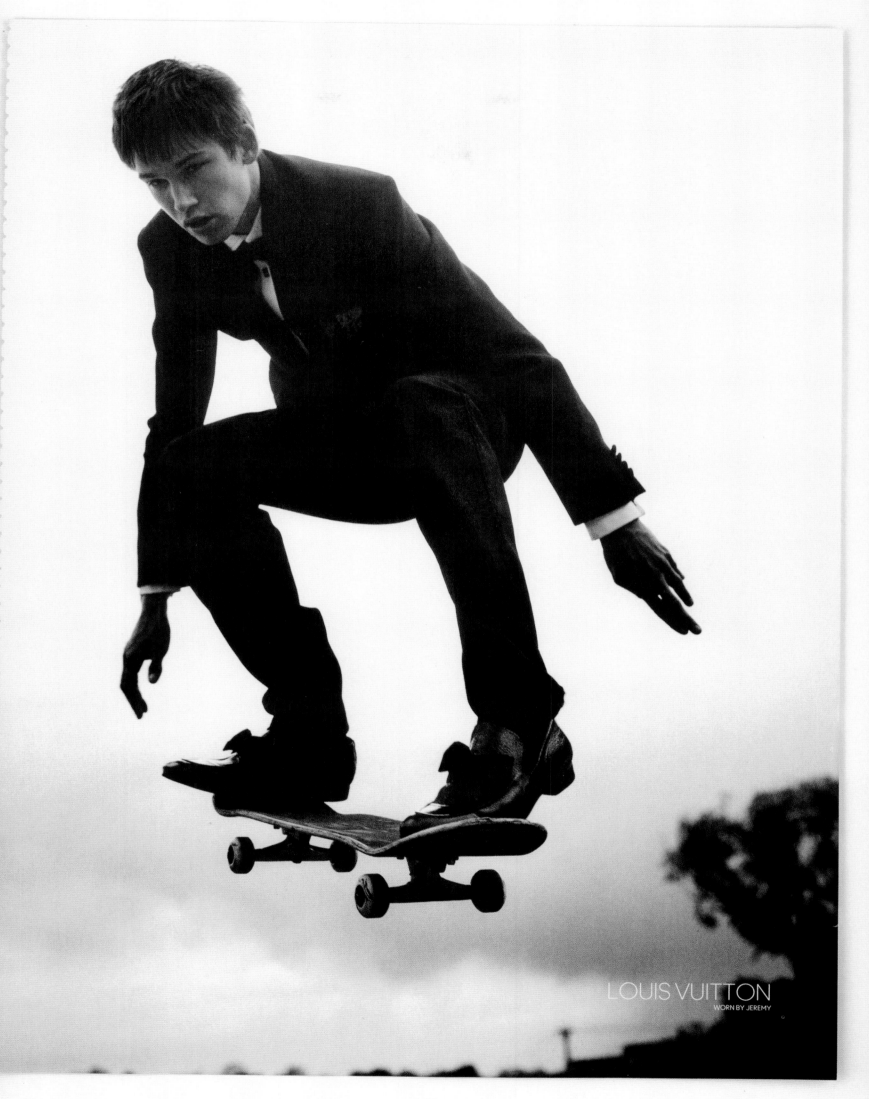

LOUIS VUITTON
WORN BY JEREMY

VIVIENNE WESTWOOD MAN
WORN BY ALESSANDRO, BRUNO AND ANTONIO
VIVIENNE WESTWOOD GOLD LABEL
WORN BY CHIARA AND ALLEGRA

38

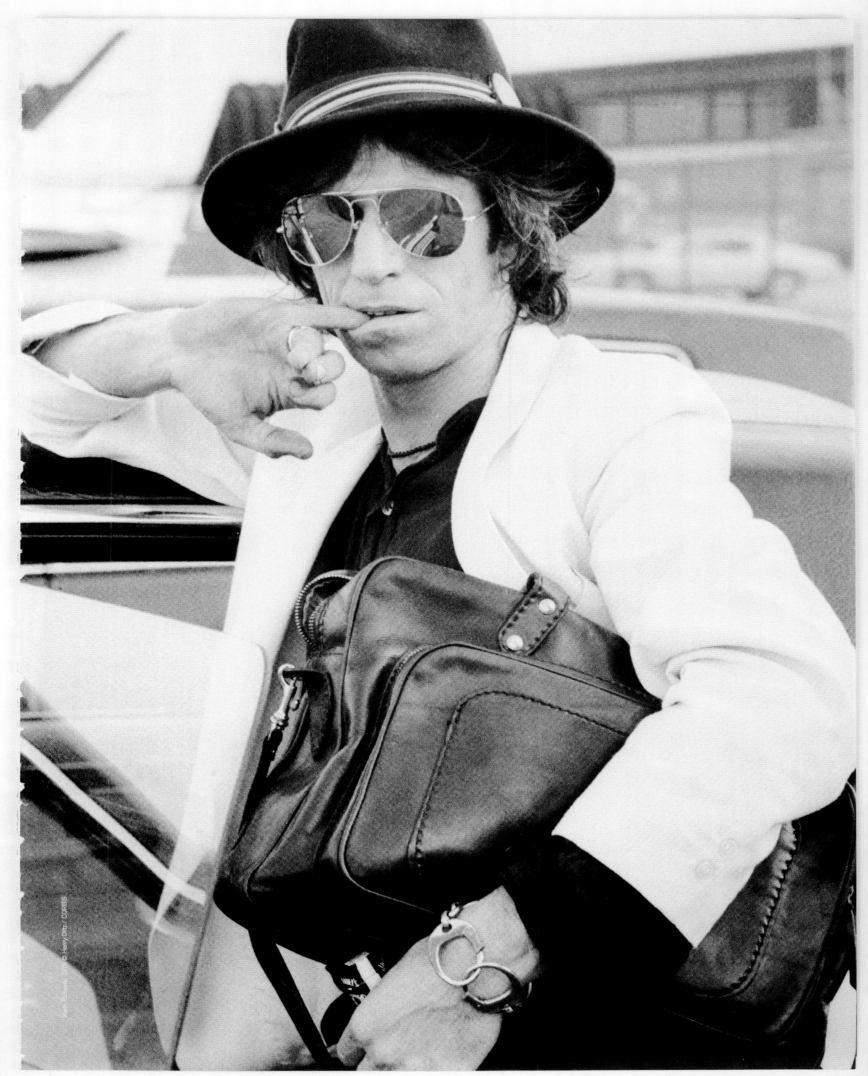

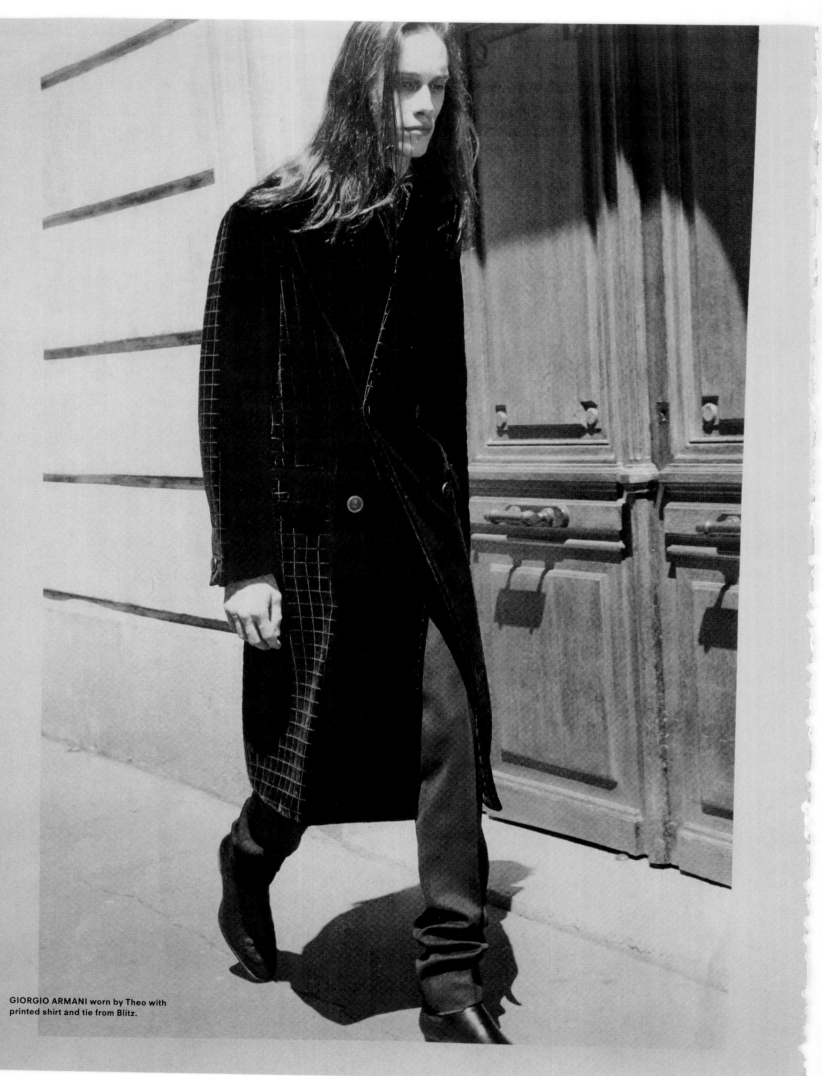

GIORGIO ARMANI worn by Theo with
printed shirt and tie from Blitz.

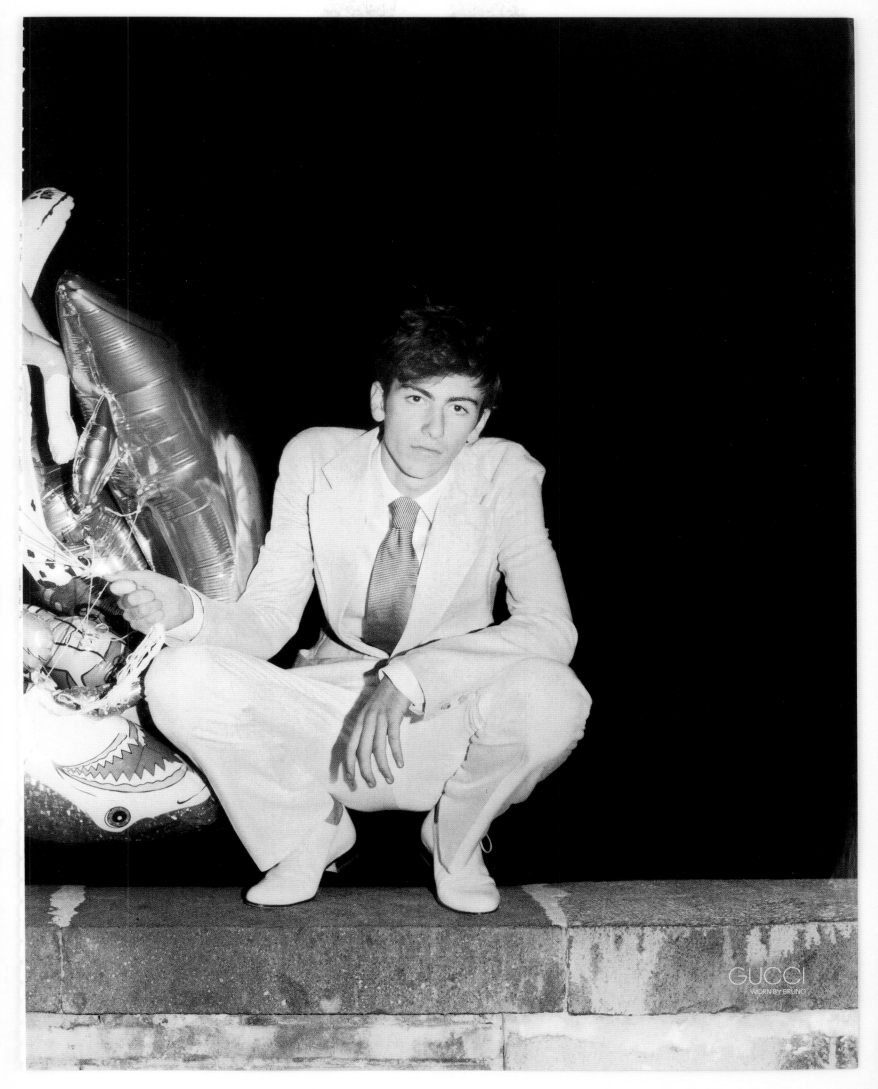

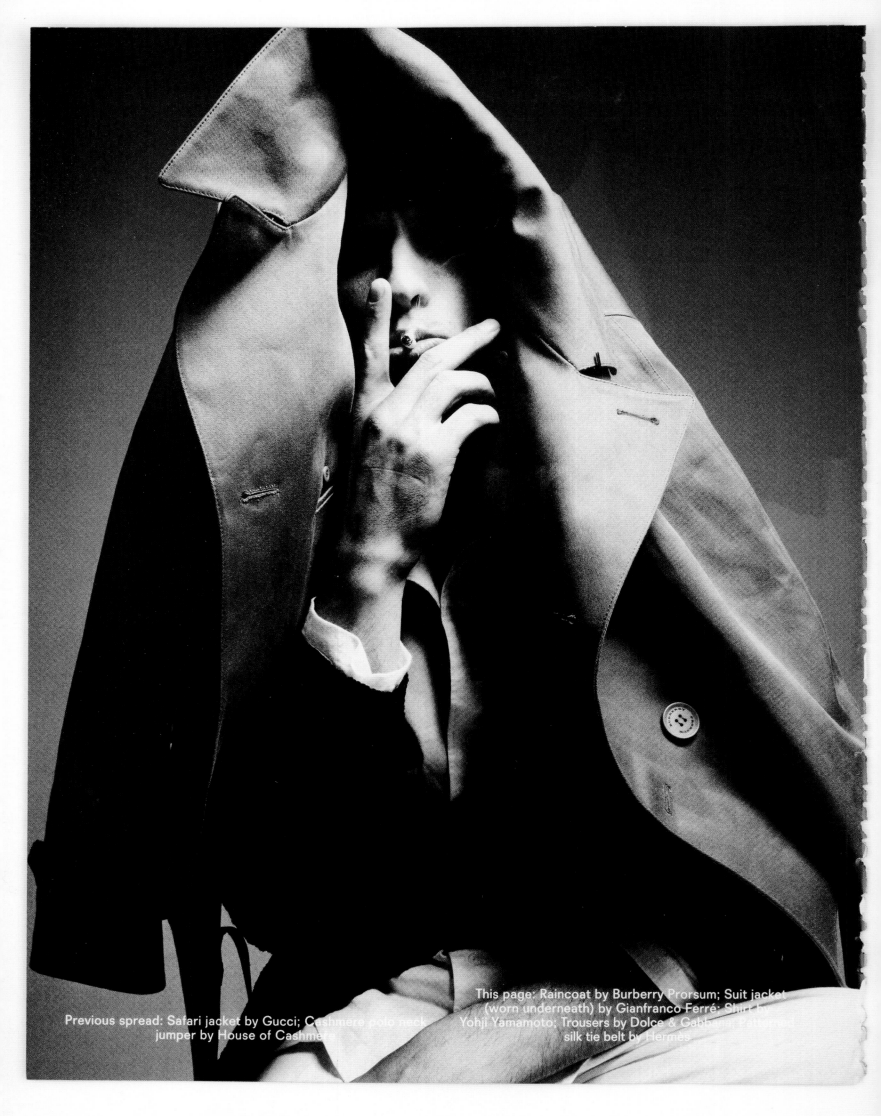

This page: Raincoat by Burberry Prorsum; Suit jacket (worn underneath) by Gianfranco Ferré; Shirt by Yohji Yamamoto; Trousers by Dolce & Gabbana; Patterned silk tie belt by Hermès

Previous spread: Safari jacket by Gucci; Cashmere polo neck jumper by House of Cashmere

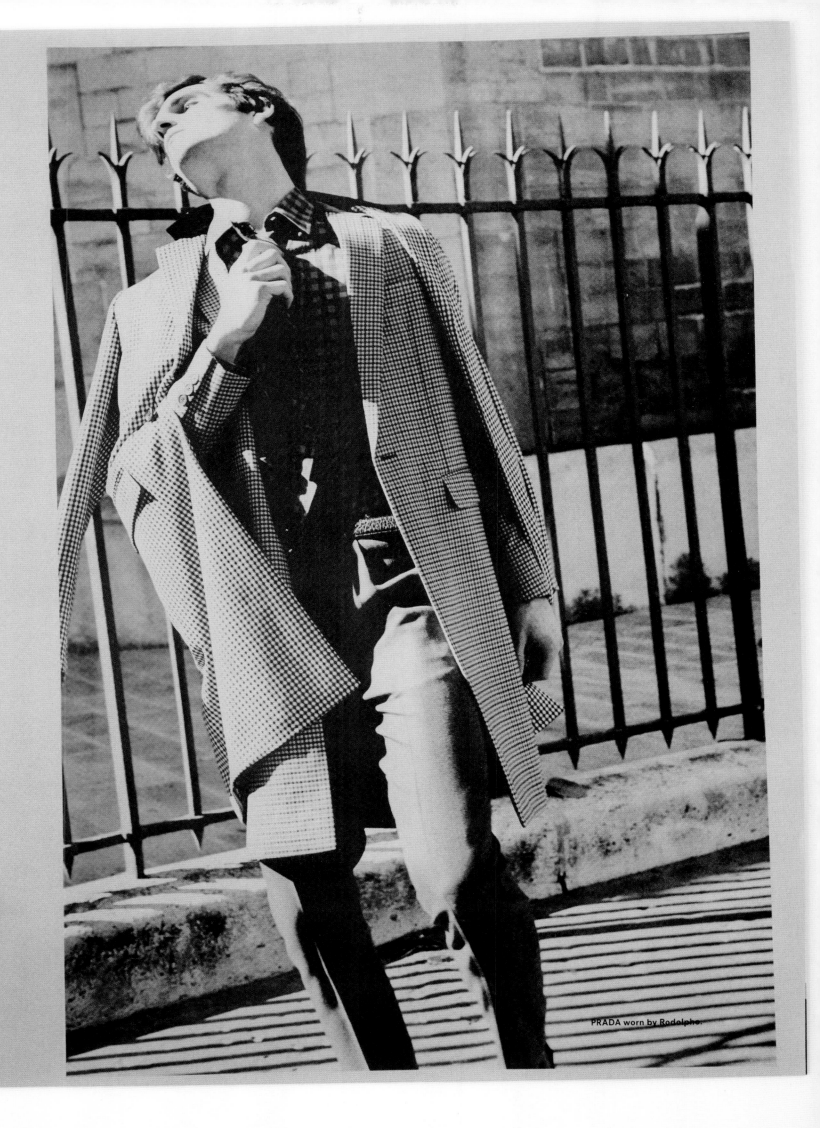

PRADA worn by Rodolpho.

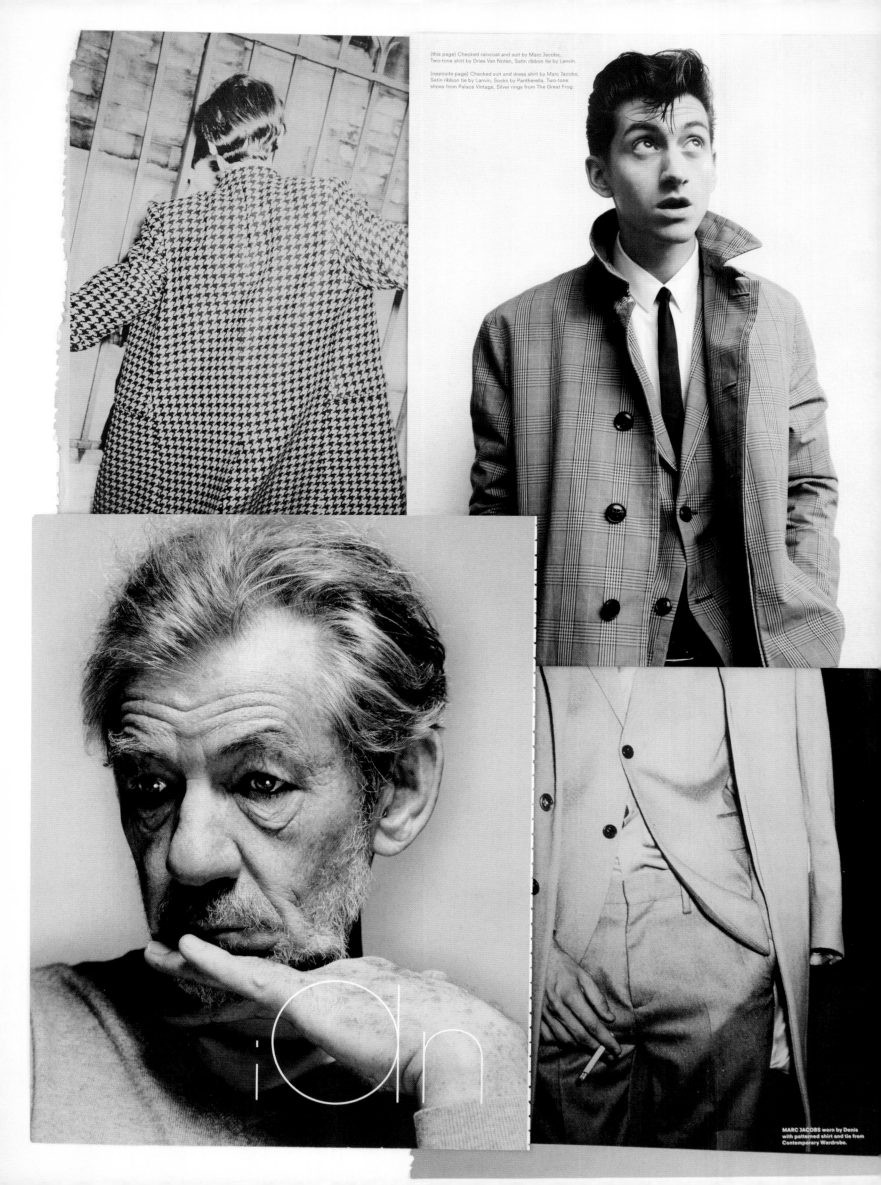

(this page) Checked raincoat and suit by Marc Jacobs, Two-tone shirt by Dries Van Noten, Satin ribbon tie by Lanvin.

(opposite page) Checked suit and dress shirt by Marc Jacobs, Satin ribbon tie by Lanvin, Socks by Pantherella, Two-tone shoes from Palace Vintage, Silver rings from The Great Frog.

MARC JACOBS worn by Denis with patterned shirt and tie from Contemporary Wardrobe.

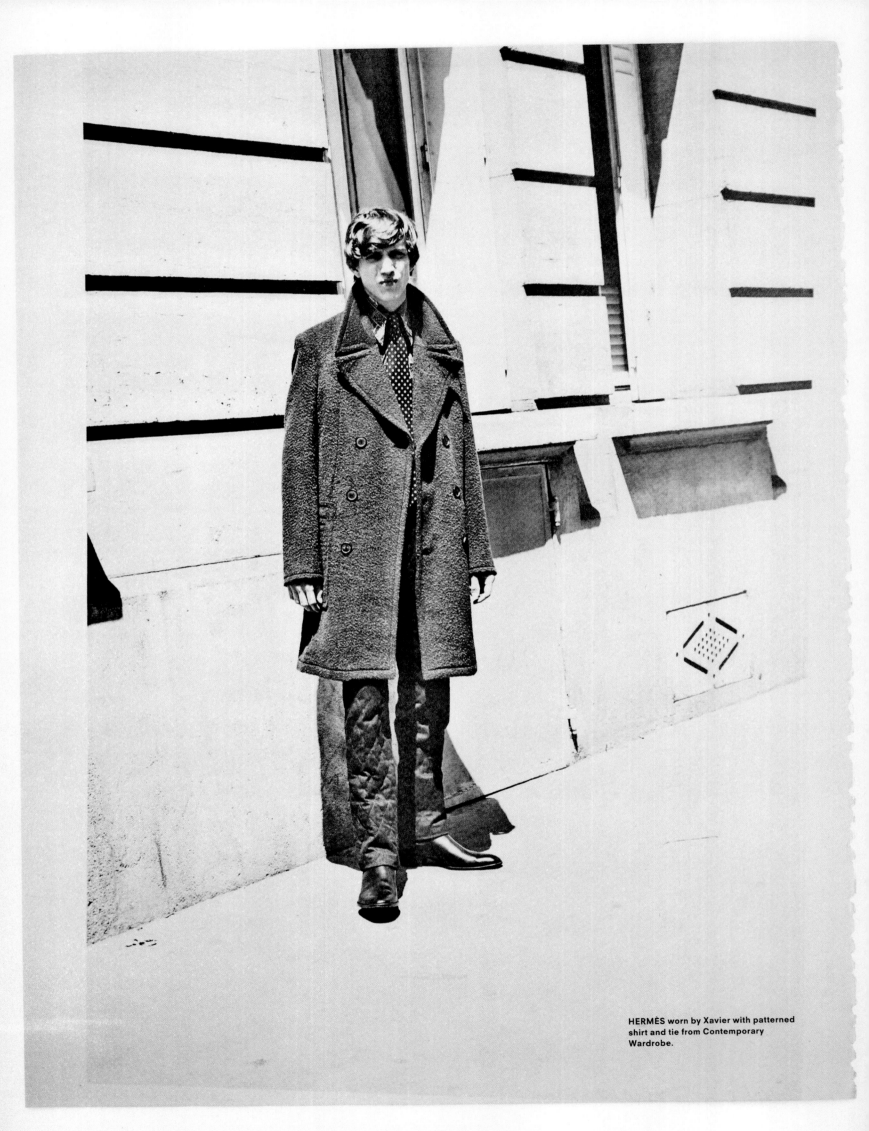

HERMÈS worn by Xavier with patterned shirt and tie from Contemporary Wardrobe.

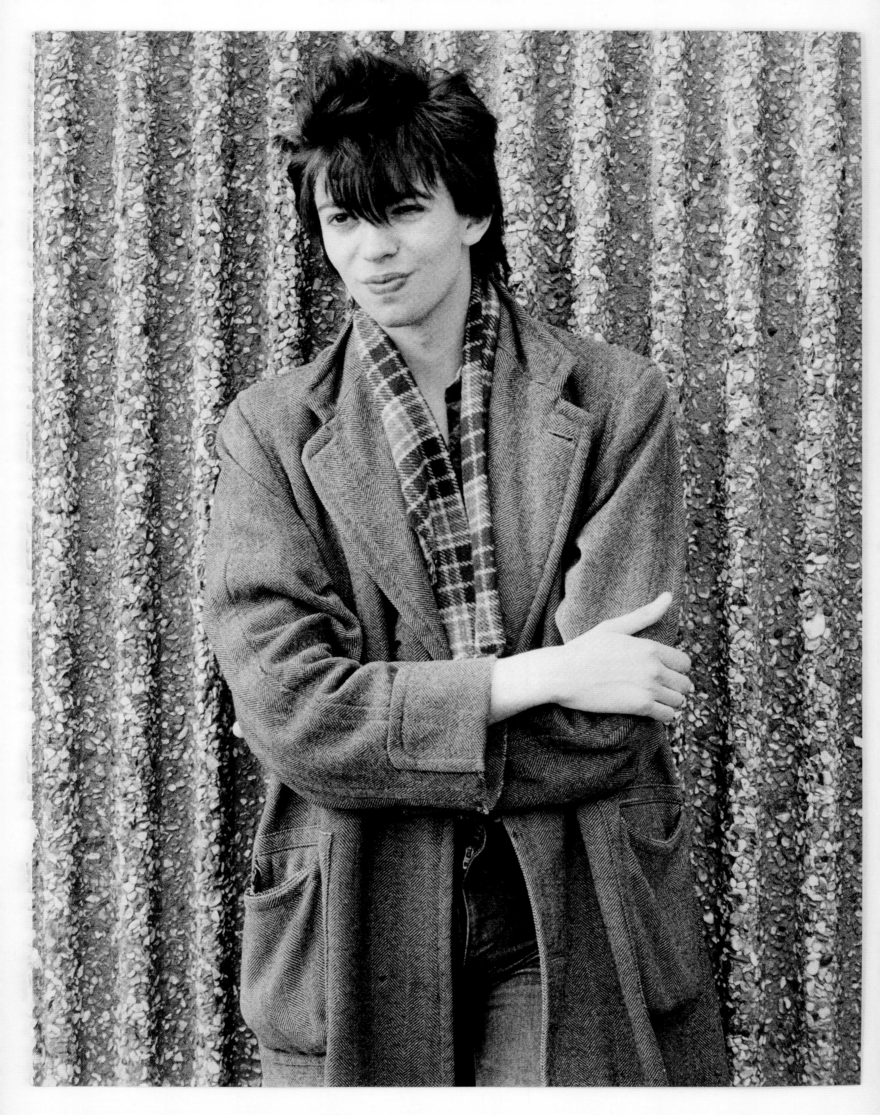

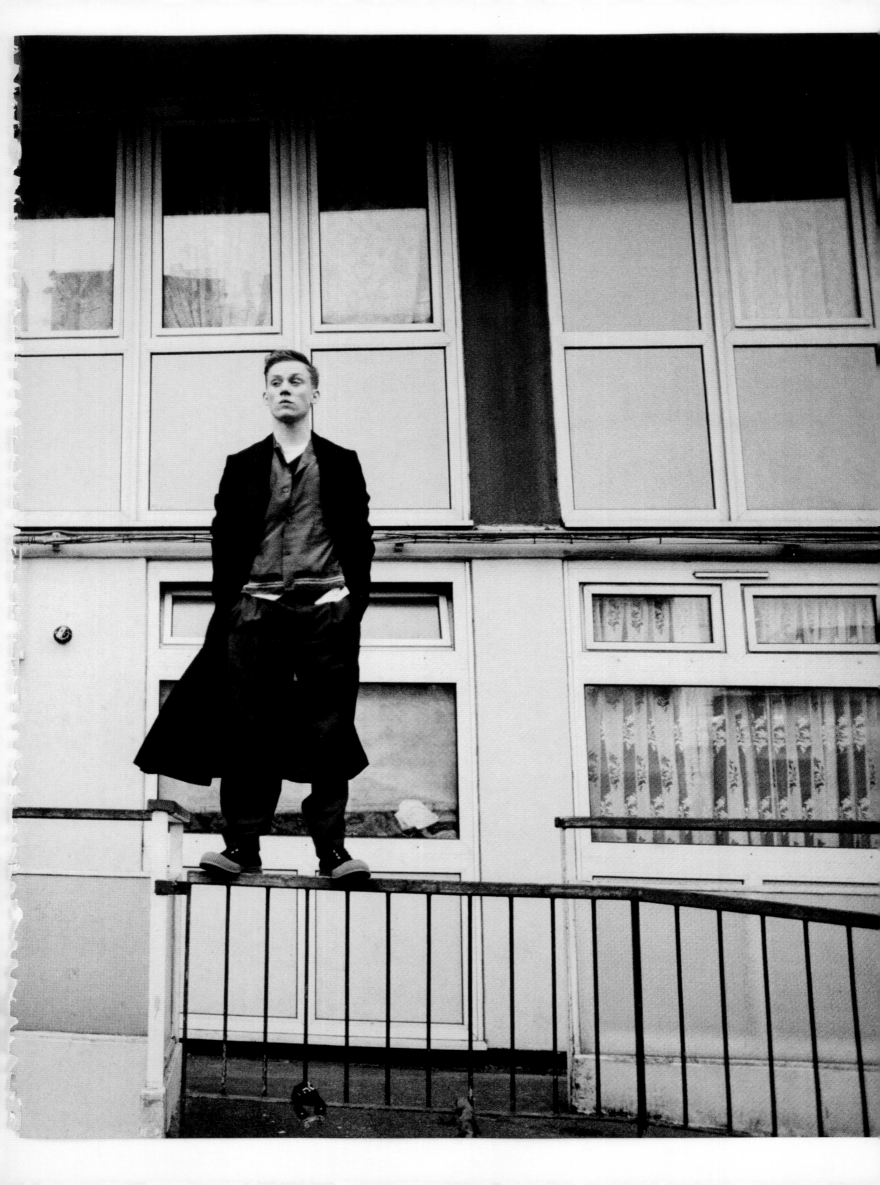

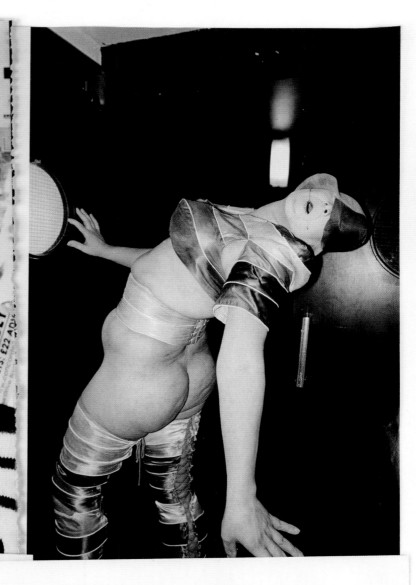

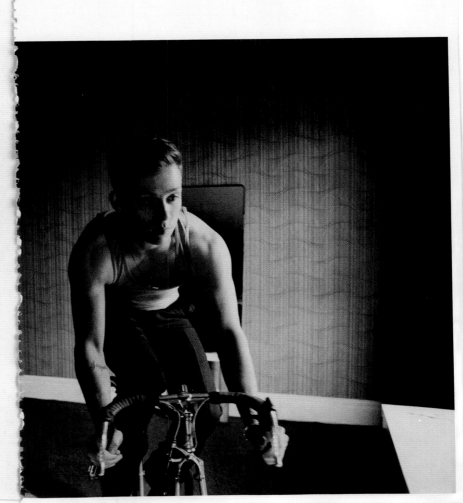

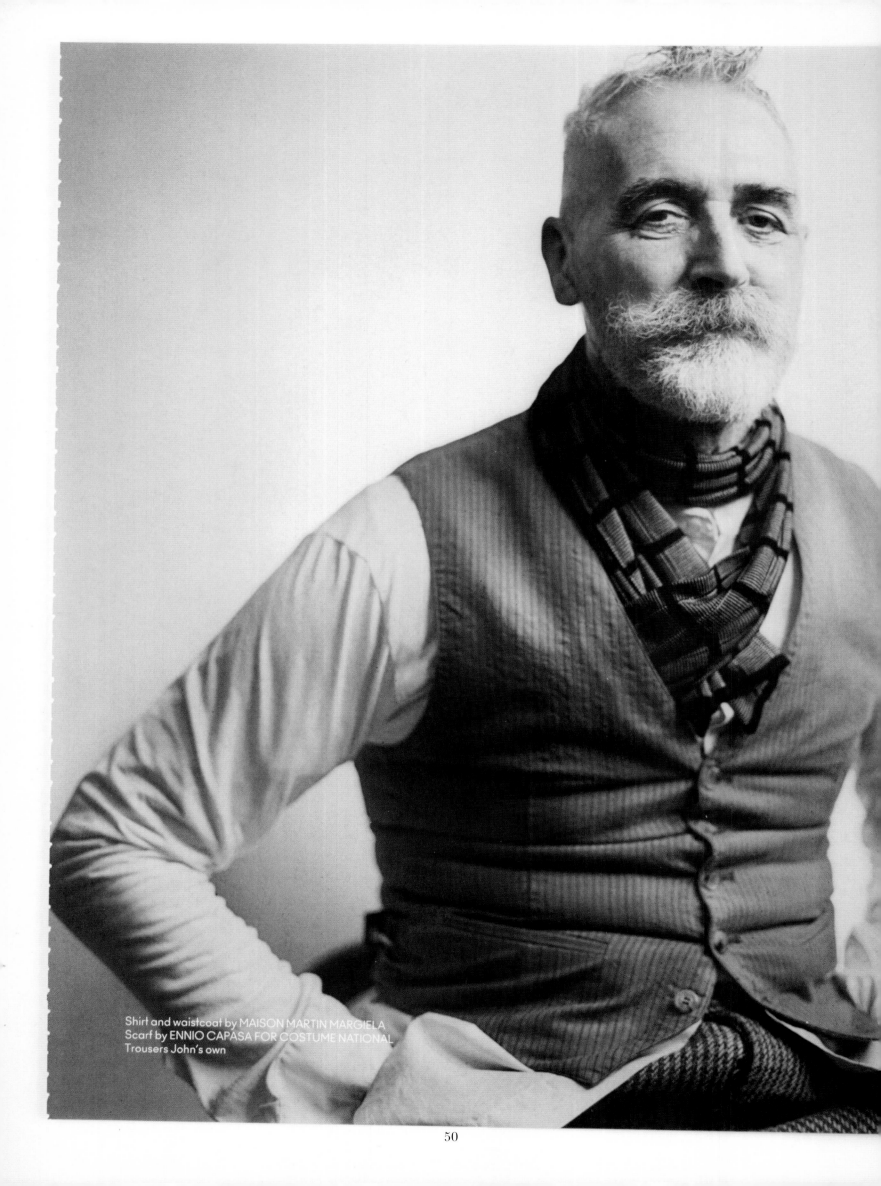

Shirt and waistcoat by MAISON MARTIN MARGIELA
Scarf by ENNIO CAPASA FOR COSTUME NATIONAL
Trousers John's own

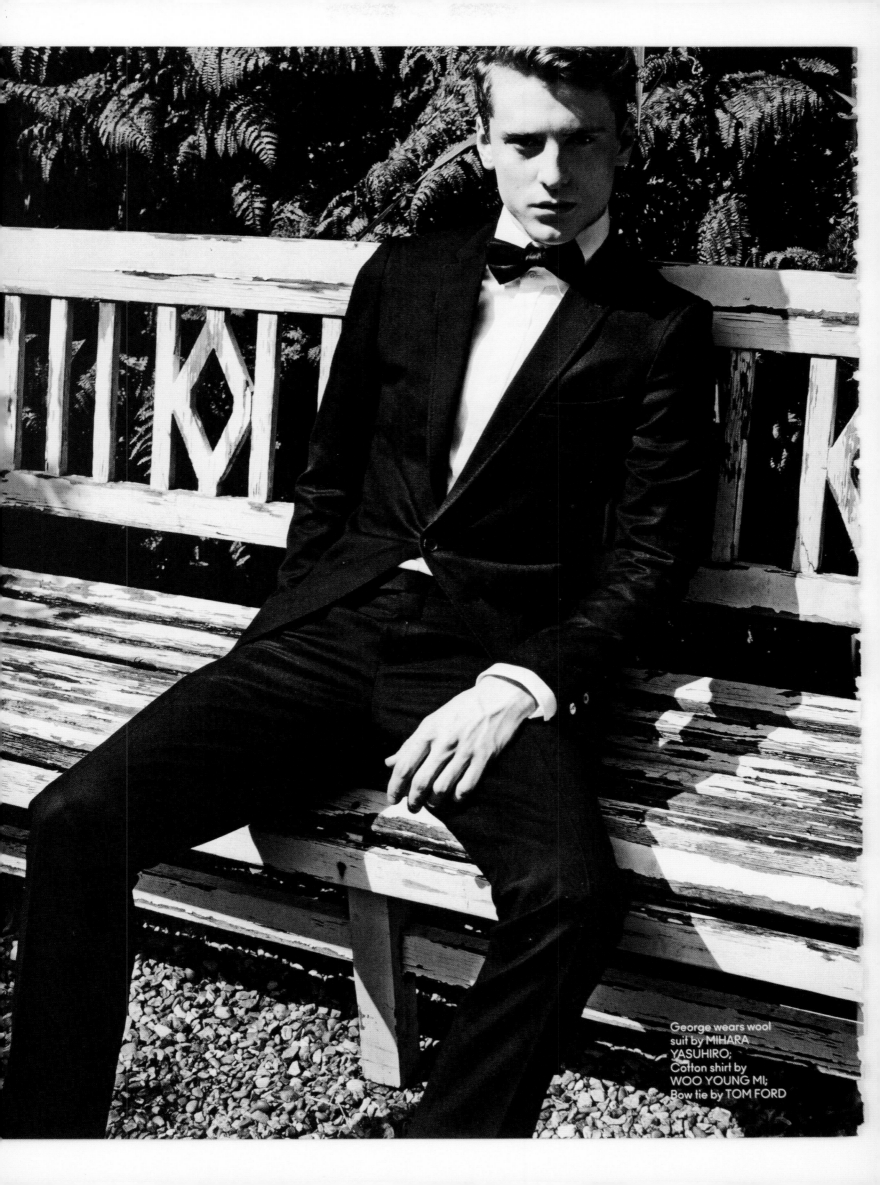

George wears wool
suit by MIHARA
YASUHIRO;
Cotton shirt by
WOO YOUNG MI;
Bow tie by TOM FORD

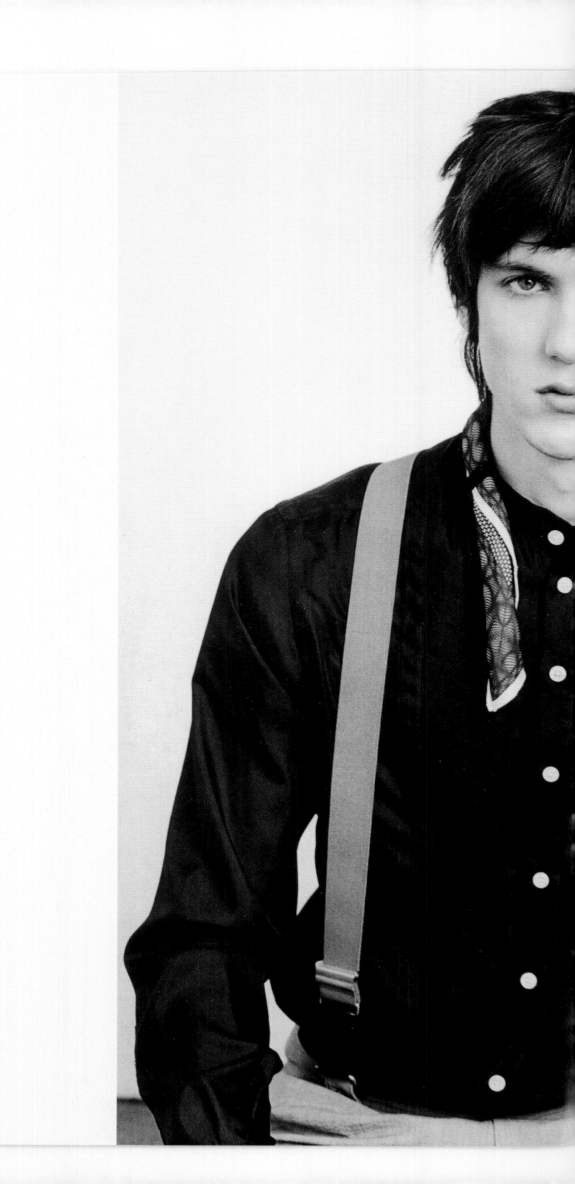

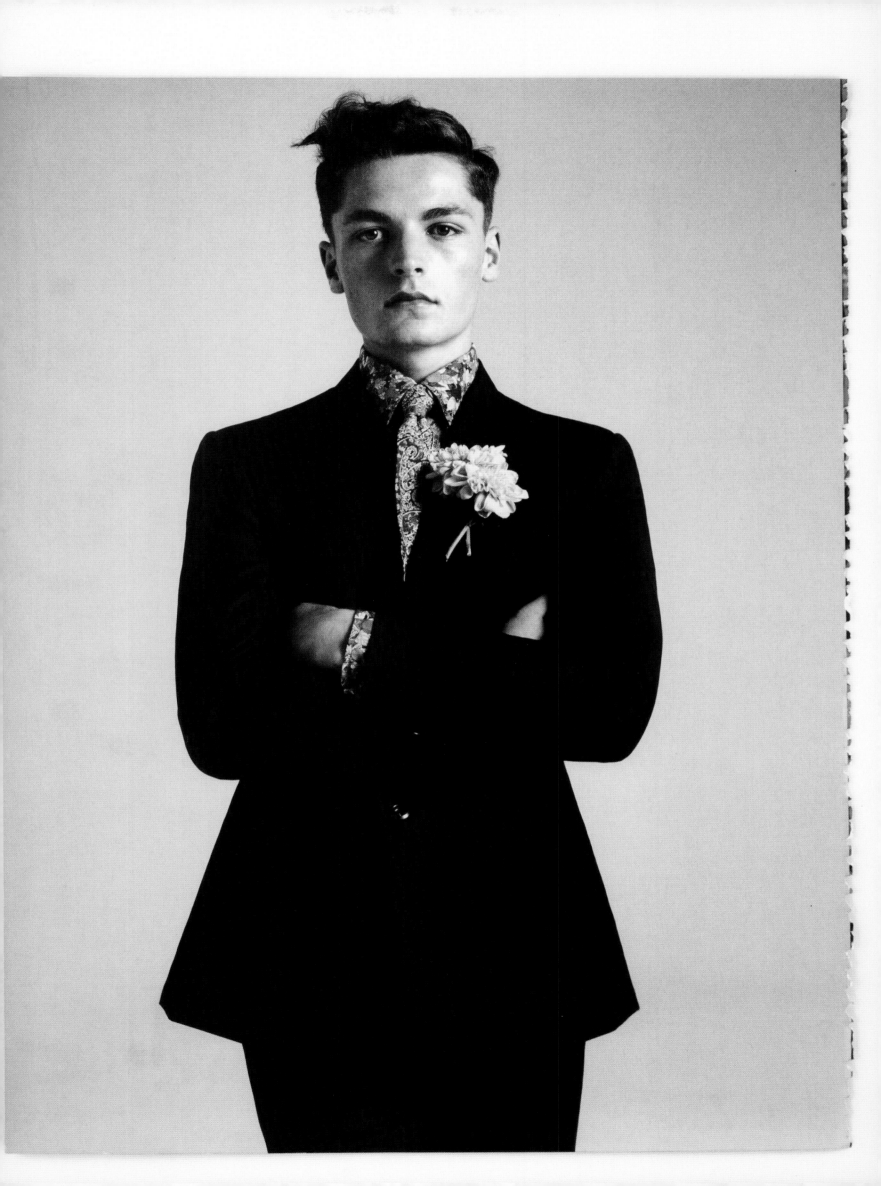

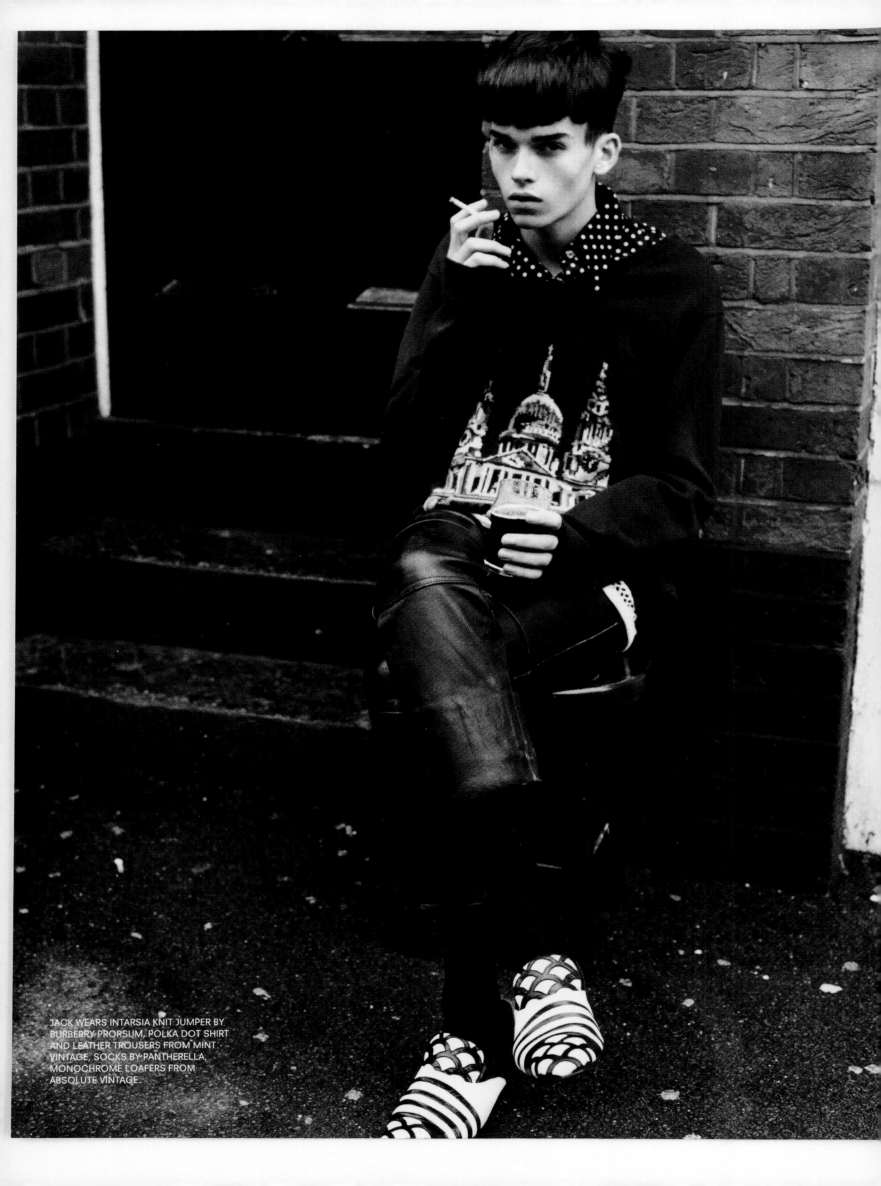

JACK WEARS INTARSIA KNIT JUMPER BY
BURBERRY PRORSUM, POLKA DOT SHIRT
AND LEATHER TROUSERS FROM MINT
VINTAGE, SOCKS BY PANTHERELLA,
MONOCHROME LOAFERS FROM
ABSOLUTE VINTAGE.

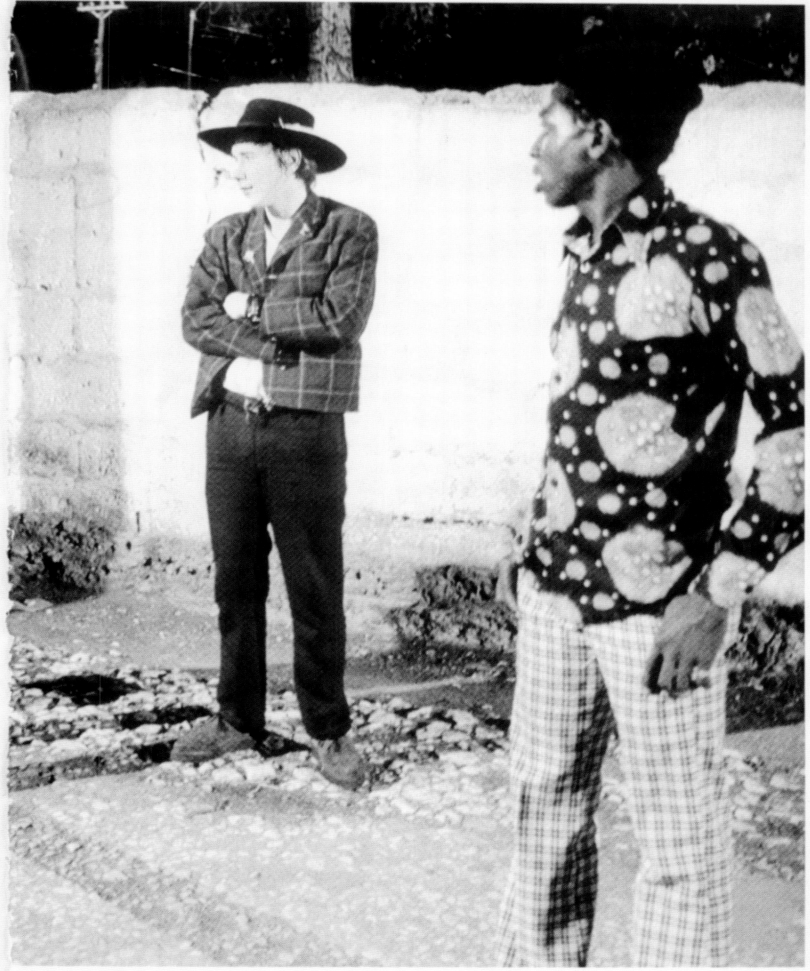

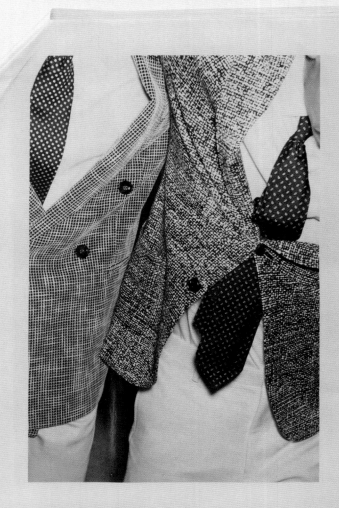

(left to right) Deconstructed double-breasted jacket and cotton shirt by Giorgio Armani, Silk polka dot tie by Canali, Deconstructed patterned jersey jacket by Giorgio Armani, Cotton shirt by Givenchy by Riccardo Tisci, Patterned silk tie by Polo Ralph Lauren.

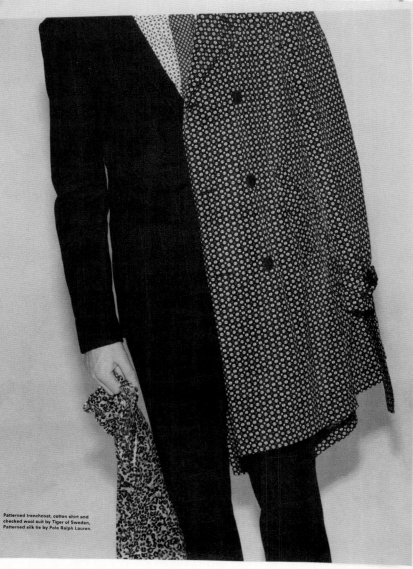

Patterned trenchcoat, cotton shirt and checked wool suit by Tiger of Sweden, Patterned silk tie by Polo Ralph Lauren.

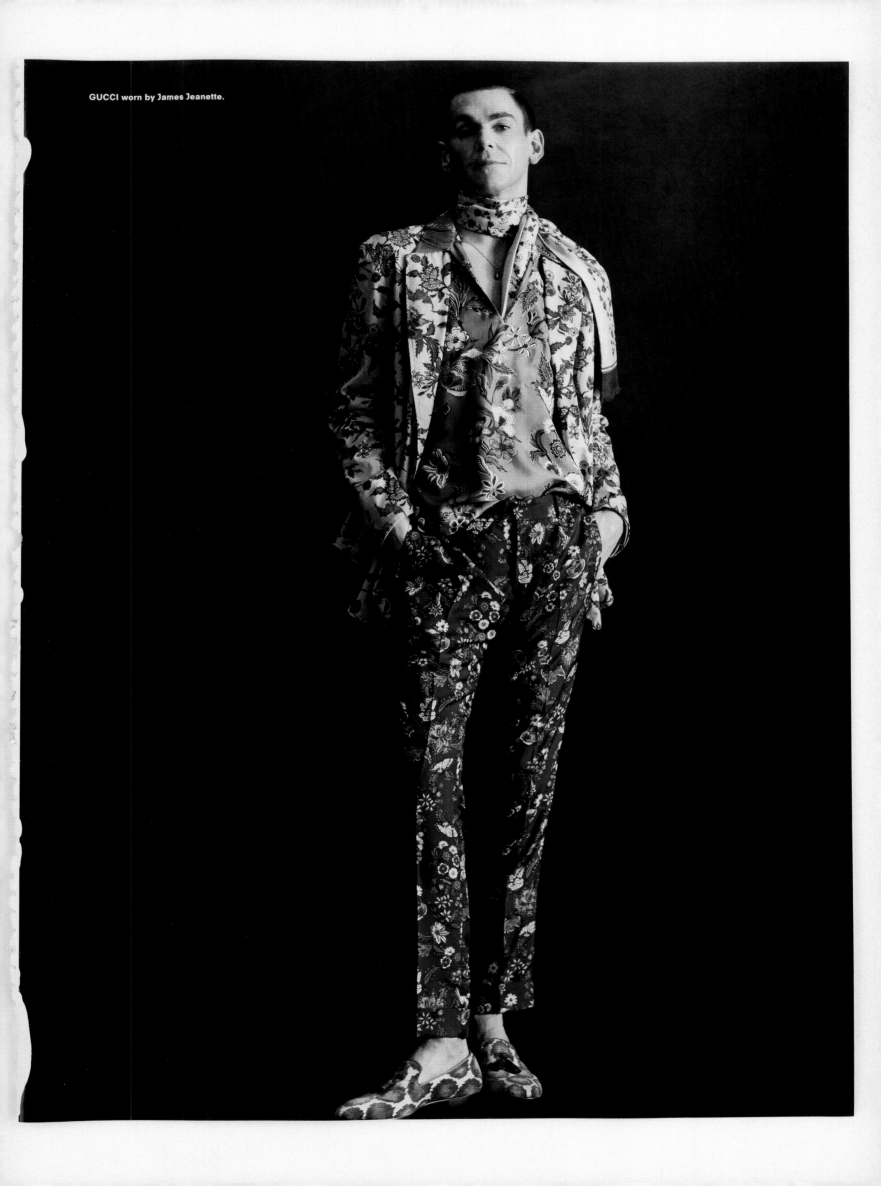

GUCCI worn by James Jeanette.

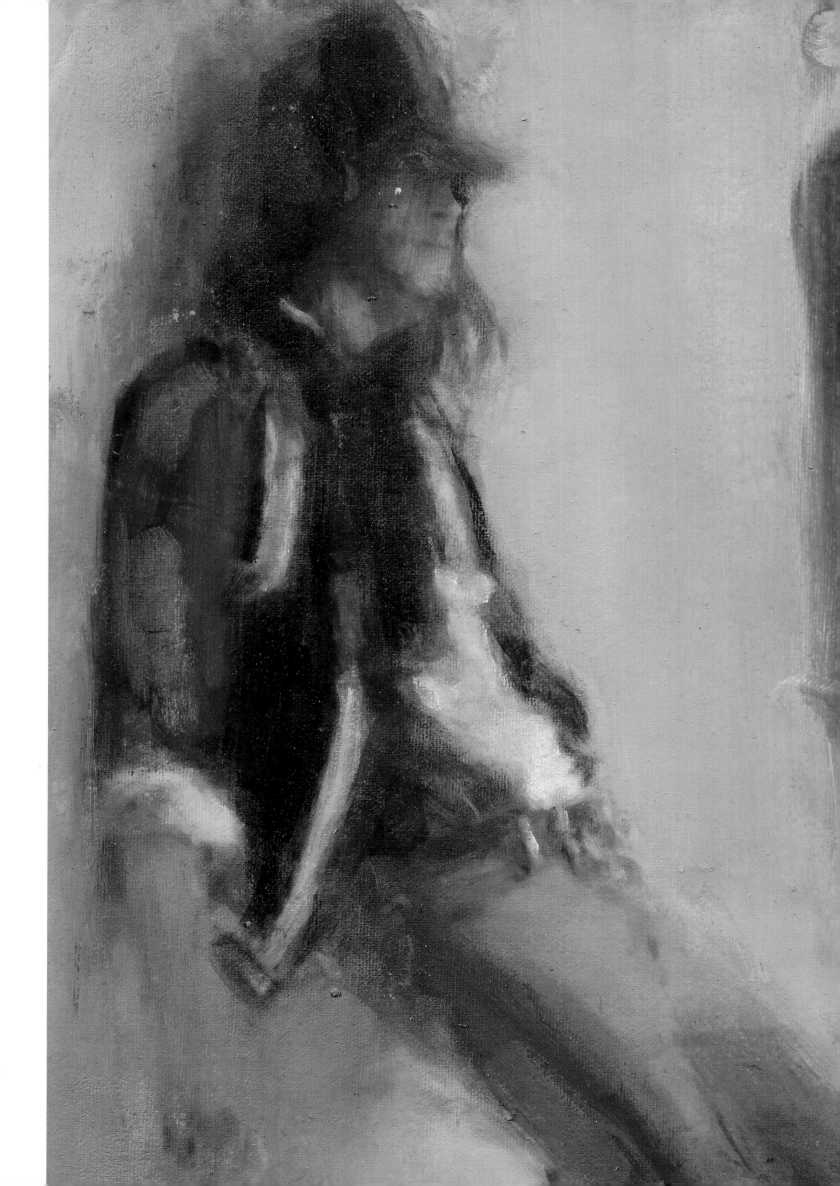

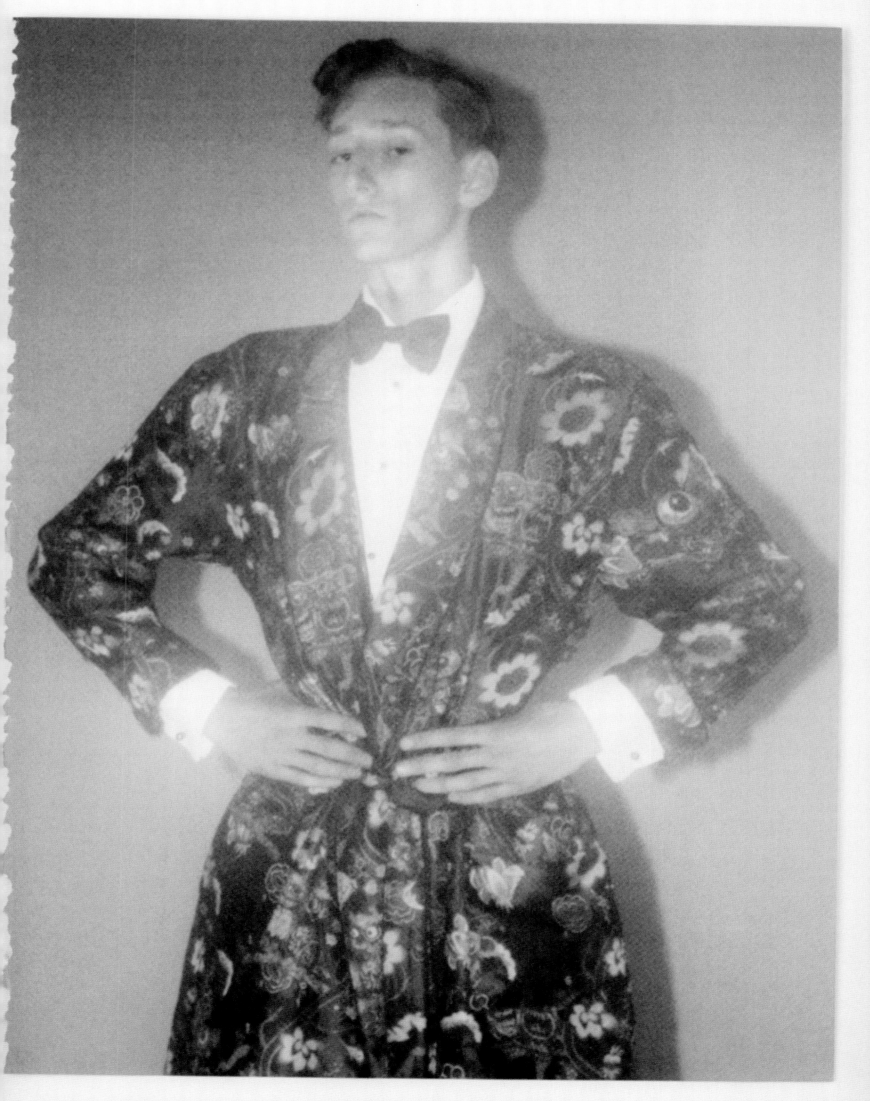

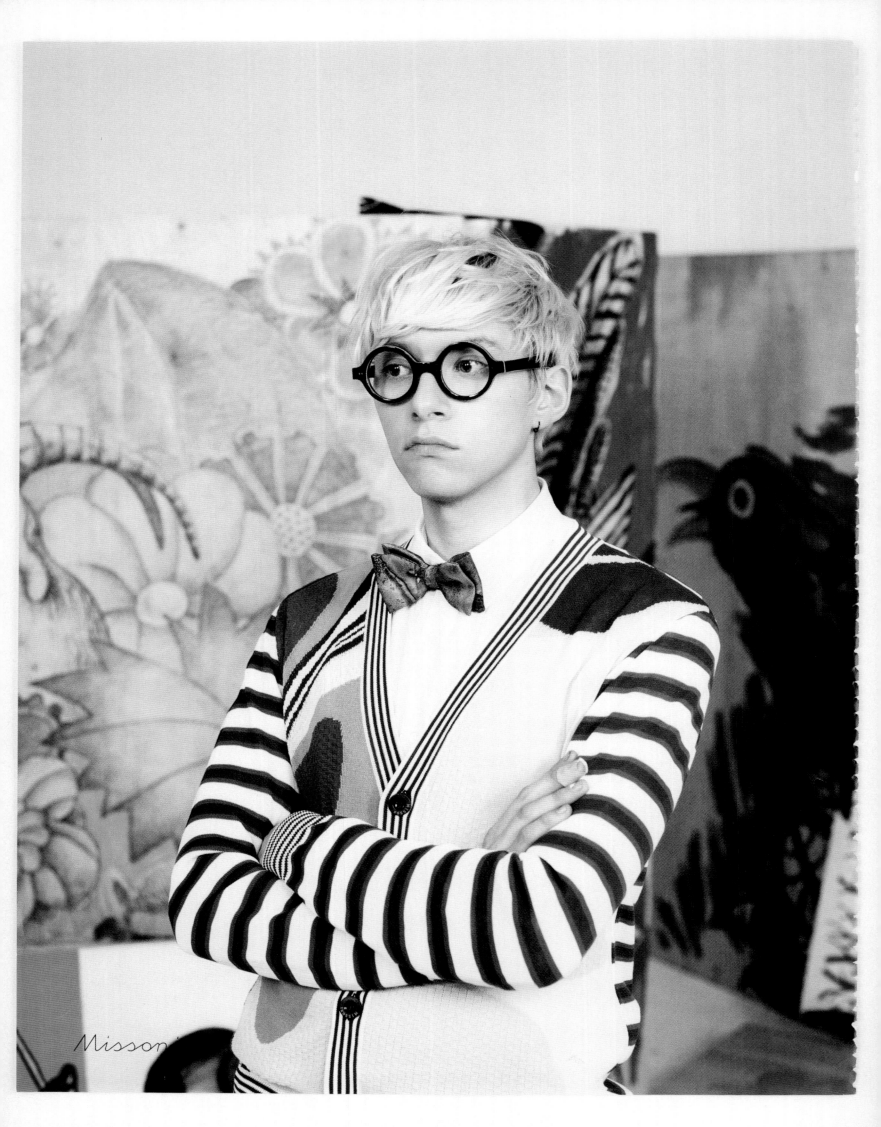

Missoni

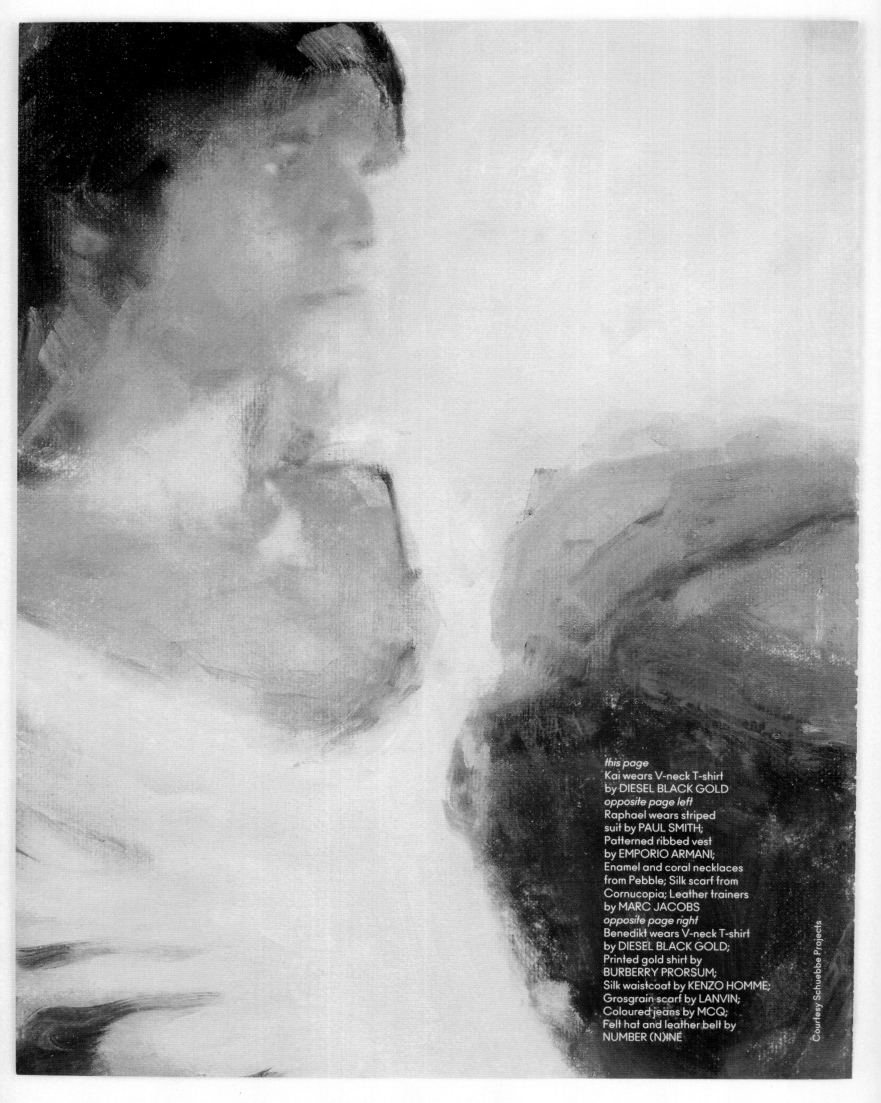

this page
Kai wears V-neck T-shirt
by DIESEL BLACK GOLD
opposite page left
Raphael wears striped
suit by PAUL SMITH;
Patterned ribbed vest
by EMPORIO ARMANI;
Enamel and coral necklaces
from Pebble; Silk scarf from
Cornucopia; Leather trainers
by MARC JACOBS
opposite page right
Benedikt wears V-neck T-shirt
by DIESEL BLACK GOLD;
Printed gold shirt by
BURBERRY PRORSUM;
Silk waistcoat by KENZO HOMME;
Grosgrain scarf by LANVIN;
Coloured jeans by MCQ;
Felt hat and leather belt by
NUMBER (N)INE

Courtesy Schuebbe Projects

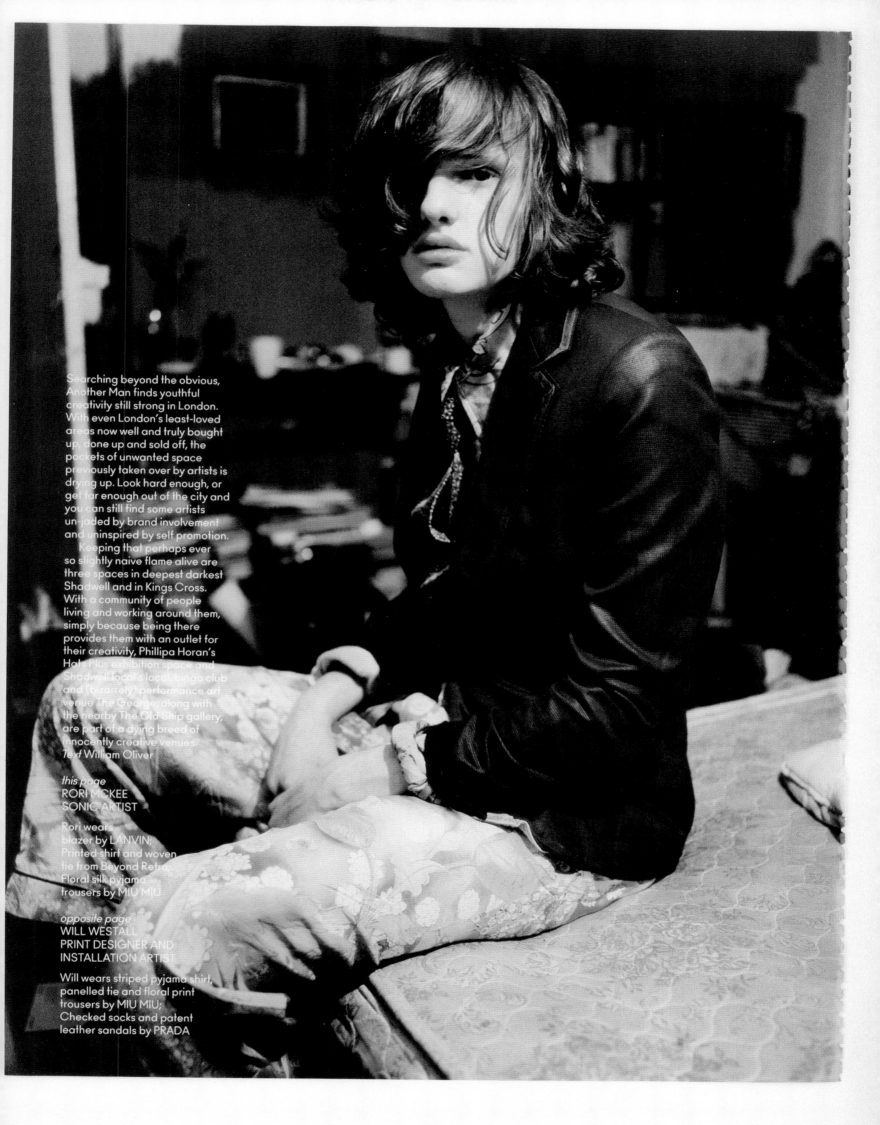

Searching beyond the obvious, Another Man finds youthful creativity still strong in London. With even London's least-loved areas now well and truly bought up, done up and sold off, the pockets of unwanted space previously taken over by artists is drying up. Look hard enough, or get far enough out of the city and you can still find some artists un-jaded by brand involvement and uninspired by self promotion.

Keeping that perhaps ever so slightly naive flame alive are three spaces in deepest darkest Shadwell and in Kings Cross. With a community of people living and working around them, simply because being there provides them with an outlet for their creativity, Phillipa Horan's Hats Plus exhibition space and Shadwell local's local, bingo club and (bizarrely) performance art venue The George, along with the nearby The Old Ship gallery, are part of a dying breed of innocently creative venues.
Text William Oliver

this page
RORI MCKEE
SONIC ARTIST

Rori wears
blazer by LANVIN;
Printed shirt and woven
tie from Beyond Retro;
Floral silk pyjama
trousers by MIU MIU

opposite page
WILL WESTALL
PRINT DESIGNER AND
INSTALLATION ARTIST

Will wears striped pyjama shirt,
panelled tie and floral print
trousers by MIU MIU;
Checked socks and patent
leather sandals by PRADA

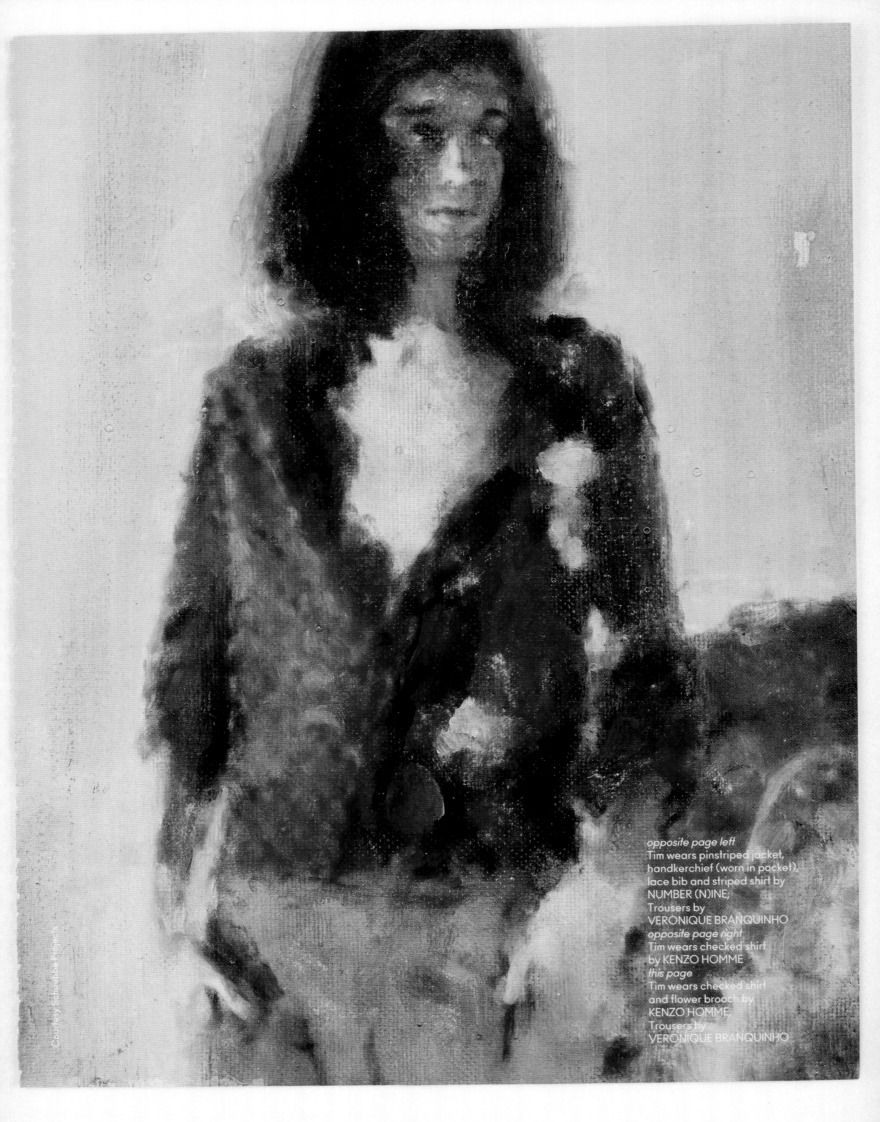

opposite page left
Tim wears pinstriped jacket,
handkerchief (worn in pocket),
lace bib and striped shirt by
NUMBER (N)INE;
Trousers by
VERONIQUE BRANQUINHO
opposite page right
Tim wears checked shirt
by KENZO HOMME
this page
Tim wears checked shirt
and flower brooch by
KENZO HOMME
Trousers by
VERONIQUE BRANQUINHO

64

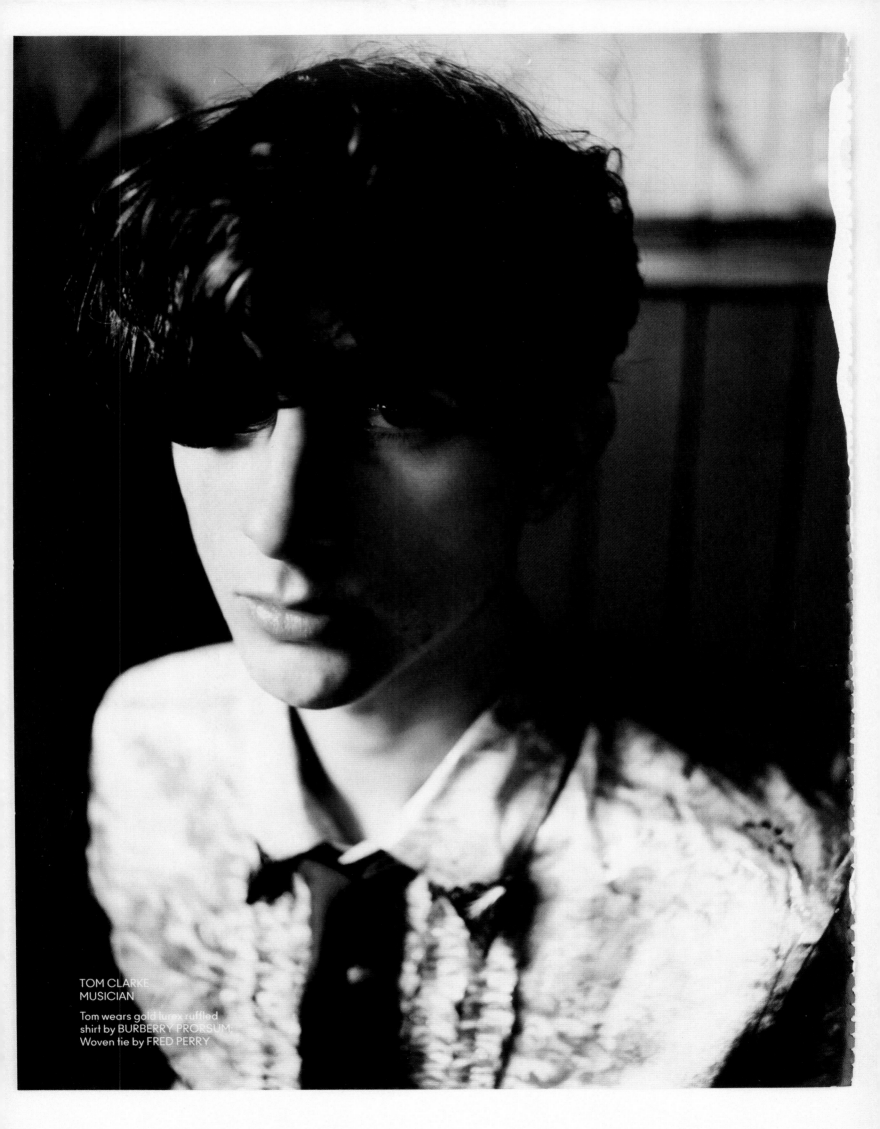

TOM CLARKE
MUSICIAN

Tom wears gold lurex ruffled
shirt by BURBERRY PRORSUM.
Woven tie by FRED PERRY

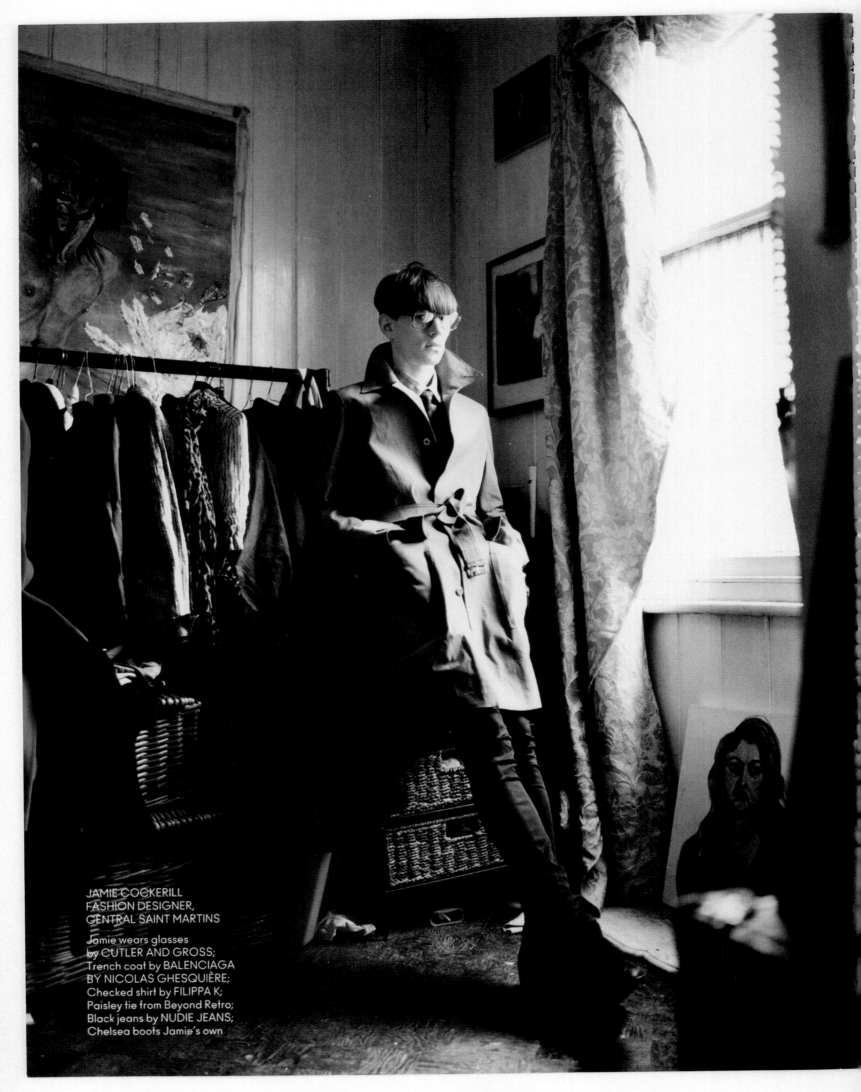

JAMIE COCKERILL
FASHION DESIGNER,
CENTRAL SAINT MARTINS

Jamie wears glasses
by CUTLER AND GROSS;
Trench coat by BALENCIAGA
BY NICOLAS GHESQUIÈRE;
Checked shirt by FILIPPA K;
Paisley tie from Beyond Retro;
Black jeans by NUDIE JEANS;
Chelsea boots Jamie's own

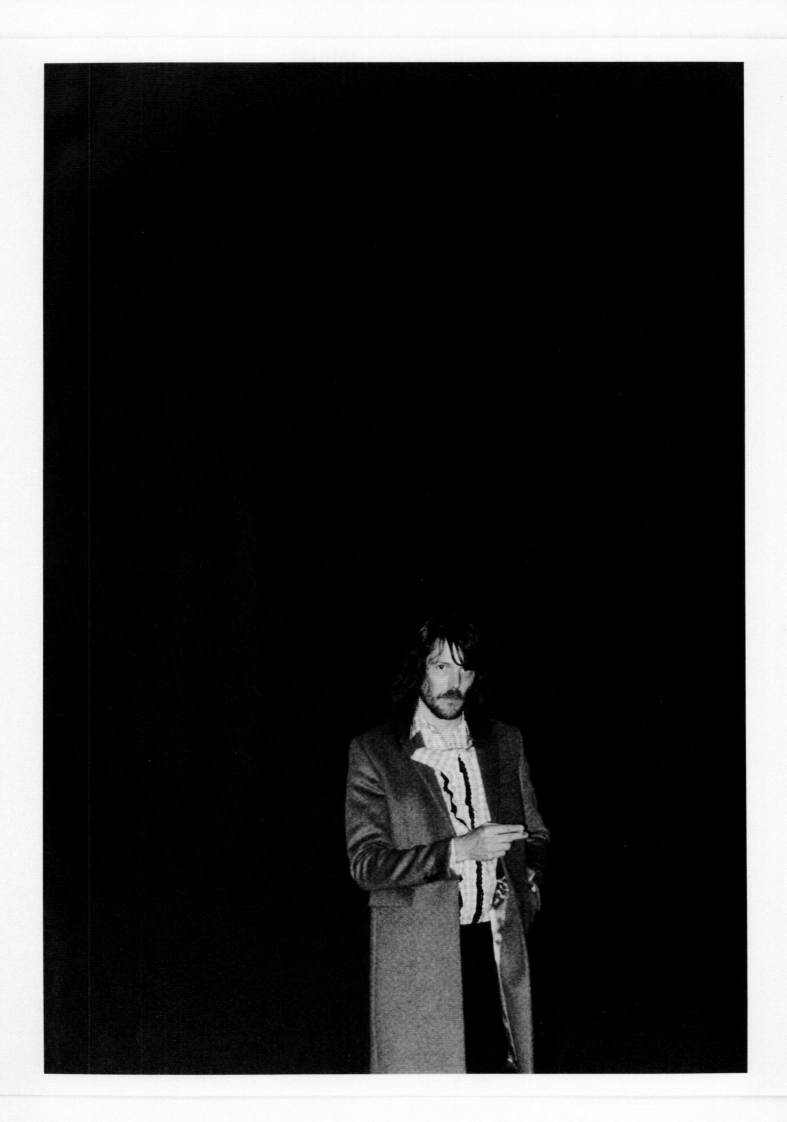

HEROES

*"We admire them, we envy them, for great qualities
we ourselves lack… If everybody was satisfied with
himself, there would be no heroes."*
—*Mark Twain*

SKIP SPENCE'S JEANS
by
WILLIAM GIBSON

After Altamont, and the Manson murders, with the hot fat of the Sixties congealing in a suddenly cold pan, I flew out to San Jose to visit a couple of acquaintances from D.C. They'd gone there intending to start a band. The one who did start a band was Little John, the original drummer for what became the Doobie Brothers.

I had no idea what San Jose might be like—otherwise I wouldn't have gone there. After an initial horrific foray into what was left of the Haight (I'd missed its heyday, whenever that might have been), I quickly retreated to San Jose. The Haight was a Burroughsian cartoon, a few skeletal speed-driven life forms scuttling back and forth across streets that had been nuked by the Methedrine Bomb. San Jose, on the other hand, was the fullest blue-collar bohemia imaginable, an utterly style-free zone in which the local bikers displayed the nearest thing to panache. The pot came sprayed with PCP, the wrong kind of excitement. It was dull as ditchwater, aside from being vaguely dangerous; so dull that I began to fear I'd get depressed enough to stay there.

One evening, though, just at dusk, I went out for a stroll with Little John and two other denizens of what would later, after my departure, become Chez Doobie. A block or so from the house, an astonishing figure appeared. Tall, very handsome, and quite magically elegant, this apparition was introduced to me as Skip Spence, formerly of Moby Grape.

His outfit was the single most perfect expression of Country Music Hip I'd ever seen, and I've seen nothing to match it since. Nothing Nudie about it, nothing Flying Burrito, but rather, classic-with-a-twist, rooted in the kind of hardcore rodeo esoterica I'd glimpsed a little of during my school years in Tucson. His jacket may have been Filson, the Seattle outfitter, something in a riding twill, but a western business cut, not casual. Under this, he wore a white pinpoint oxford Supima (these are always Supima) cotton western business shirt, buttoned at the collar, no tie. His hat, well, I knew enough about cowboy hats to know that I knew nothing about them, but I guessed that this one was on par with the rest of his outfit. (He removed it while he spoke with us, holding it carefully and rather formally.) His boots, I guessed, were not Tony Lama but by someone whose clients could only smile patiently at the mention of Tony Lama. But between jacket and jeans stretched a long-legged vertical of dark indigo denim, and this is what made the strongest and most lasting impression. Skip Spence's jeans were perfect. As I stared at them, while he and the ur-Doobies chatted gravely about studios and managers, I understood: They were a pair of Levi's, likely several sizes too large to begin with, which had been deconstructed, a seam at a time, then meticulously tailored, each seam perfectly resewn with the correct iodine-tint thread. But not only did they fit him exquisitely, as perfectly as garment has ever fit man —they had been reconstructed, recontextualised,

jacked out of blue denim mundania entirely, into some unknown realm of Hispano-American, deeply Catholic romanticism.

They fell over his boots without a break, by virtue of the fronts having been slit, the edges perfectly hemmed, and, down front and back, creases had been sewn in. They would have to be dry-cleaned, I decided, itself a novel concept, then, when it came to jeans.

He had all the style of someone from another and better planet, in that working-class northern California residential street, but I knew that I was experiencing star quality, and that he would've gone as easily off the scale on the Kings Road.

And then he said goodbye, and we walked on, and someone allowed, quietly, that Skip had a problem with heroin, and that there were problems with his label. But, they all agreed, he was a good guy, a very good guy indeed, and that he had promised to help them. And I imagine that he did.

I never forgot him, and the gift of his brave elegance, and it was only a year or so ago that I heard *Oar* for the first time.

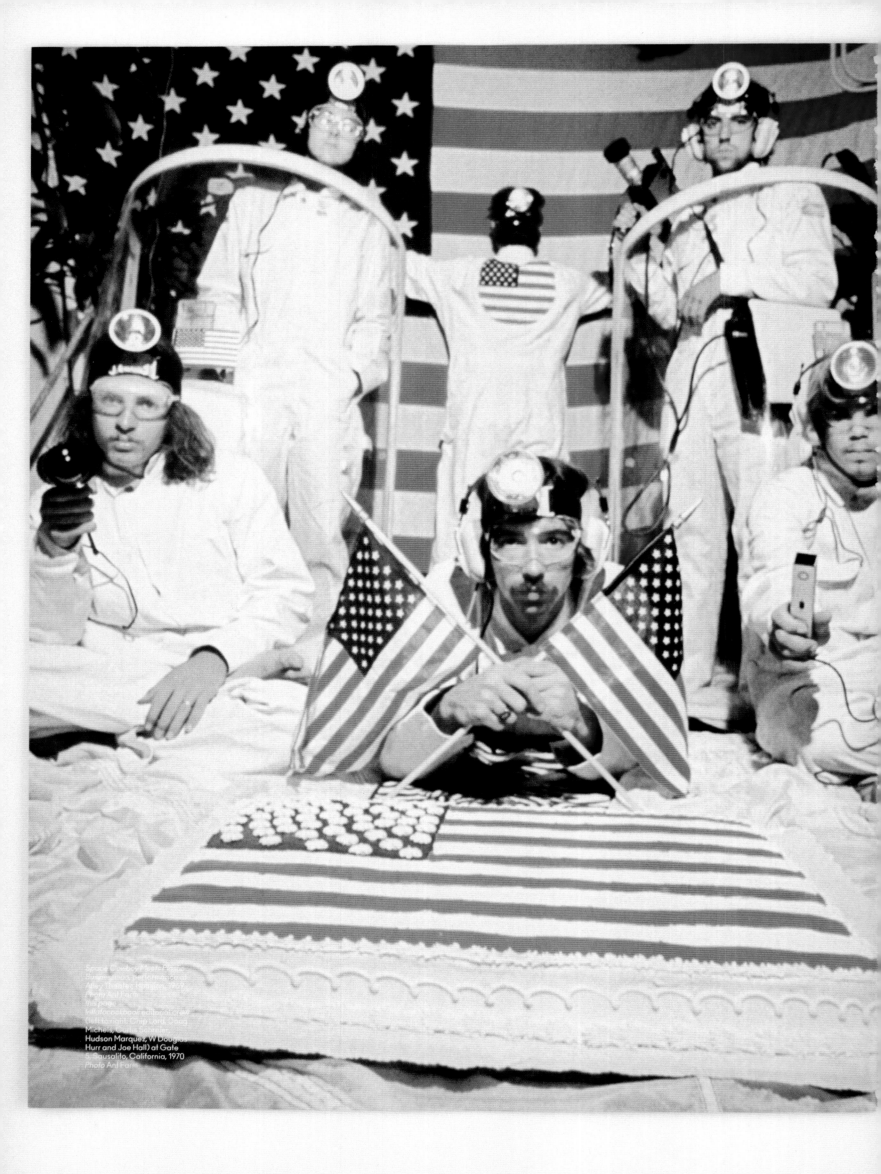

Space Cowboy (Ant Farm,
Superman's performance,
Alley Theater, Houston, 1970
Photo Ant Farm
this page:
Inflatocookbook editorial crew
(left to right: Chip Lord, Doug
Michels, Curtis Schreier,
Hudson Marquez, W Douglas
Hurr and Joe Hall) at Gate
5, Sausalito, California, 1970
Photo Ant Farm

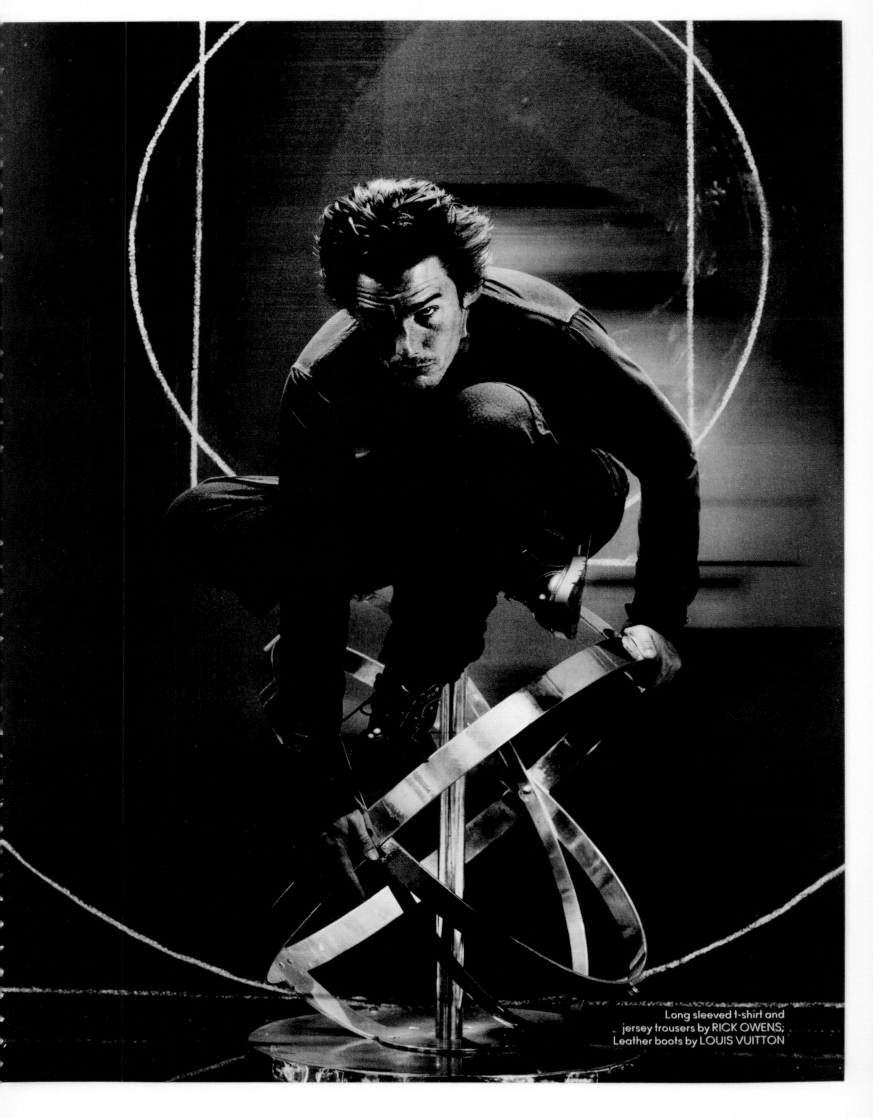

Long sleeved t-shirt and
jersey trousers by RICK OWENS;
Leather boots by LOUIS VUITTON

73

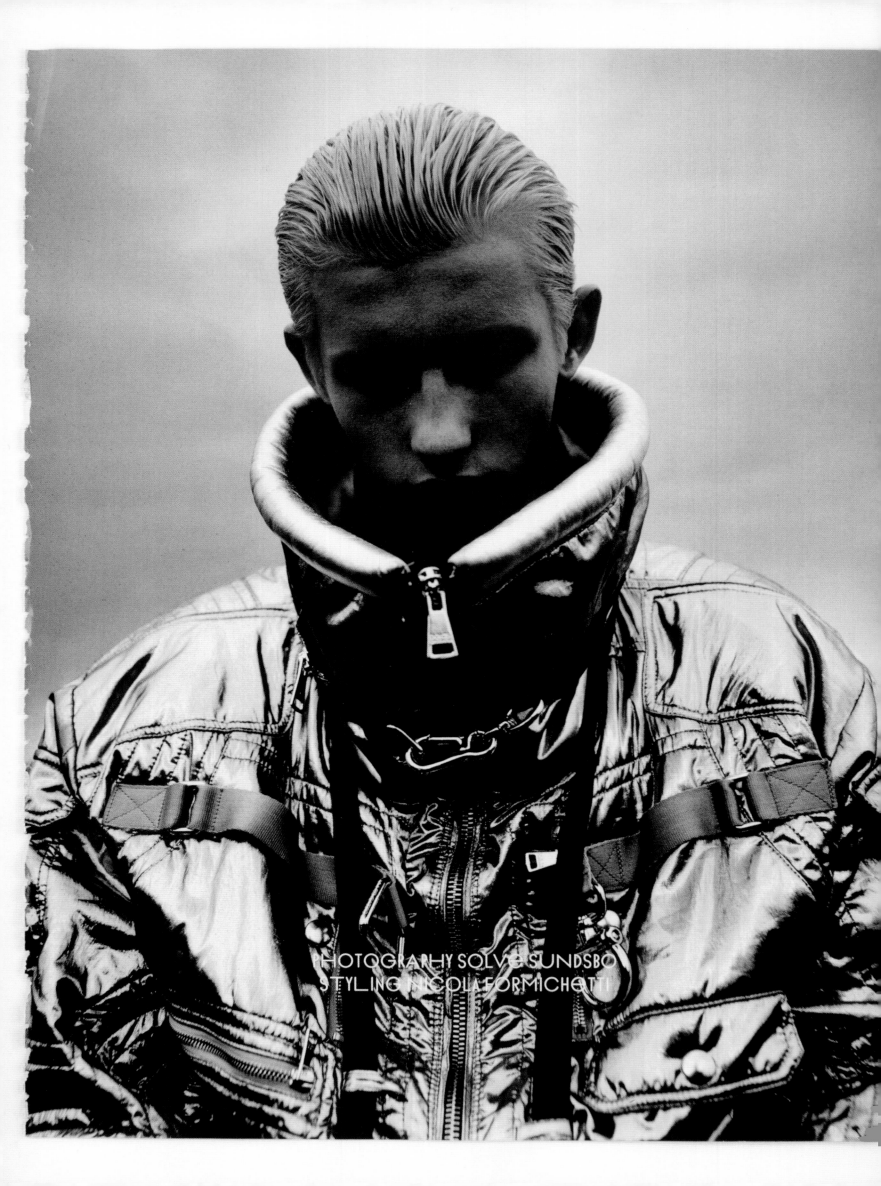

PHOTOGRAPHY SOLVE SUNDSBO
STYLING NICOLA FORMICHETTI

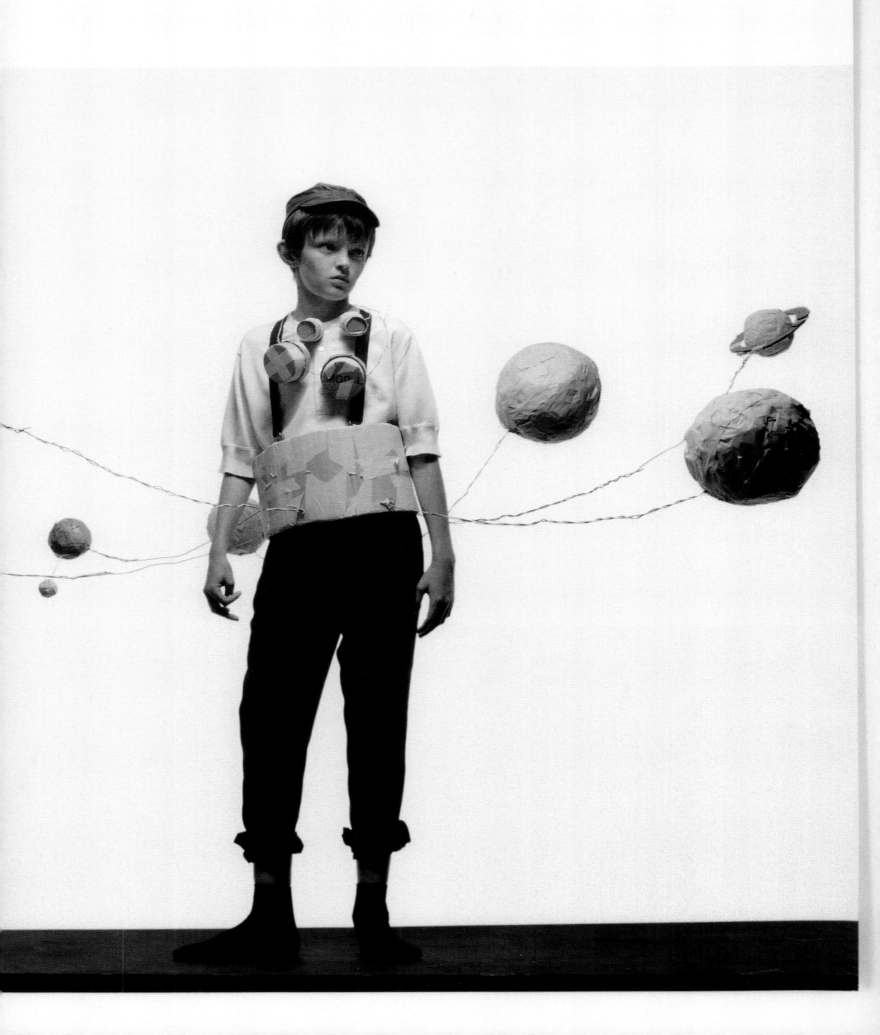

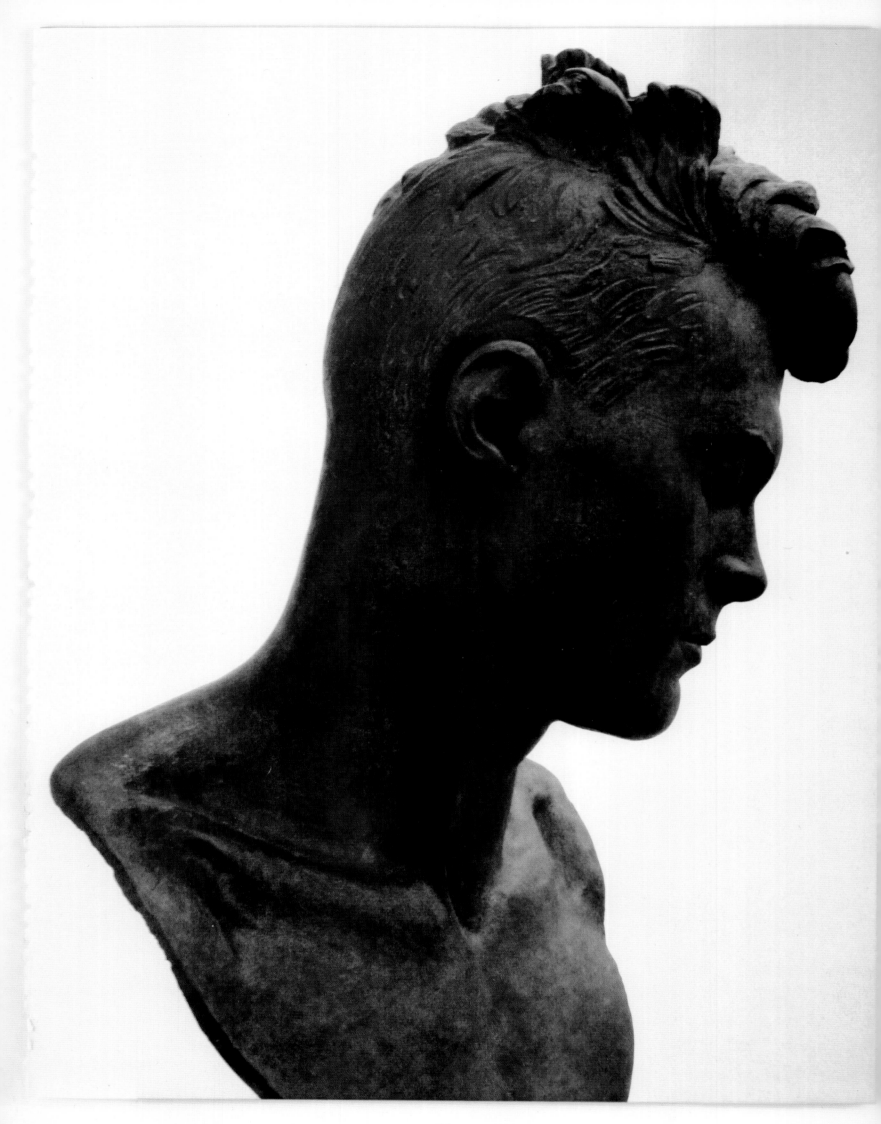

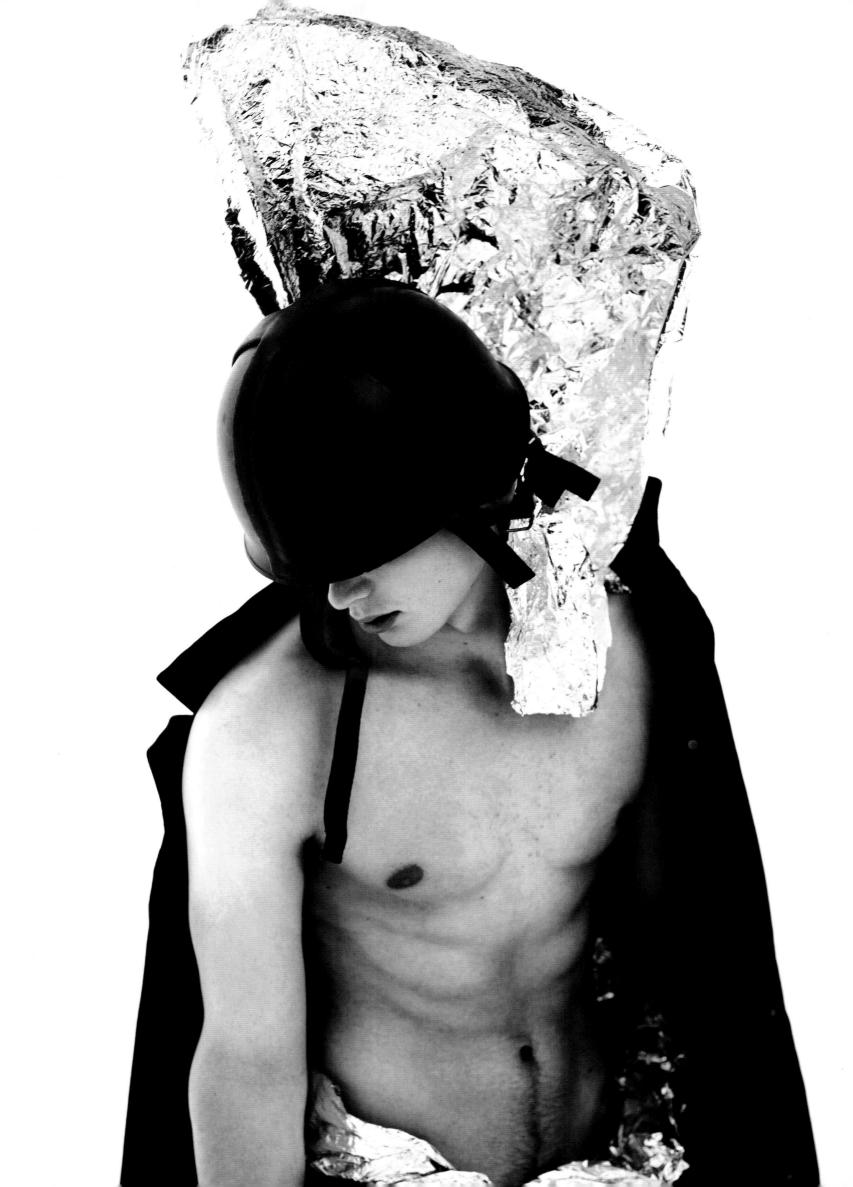

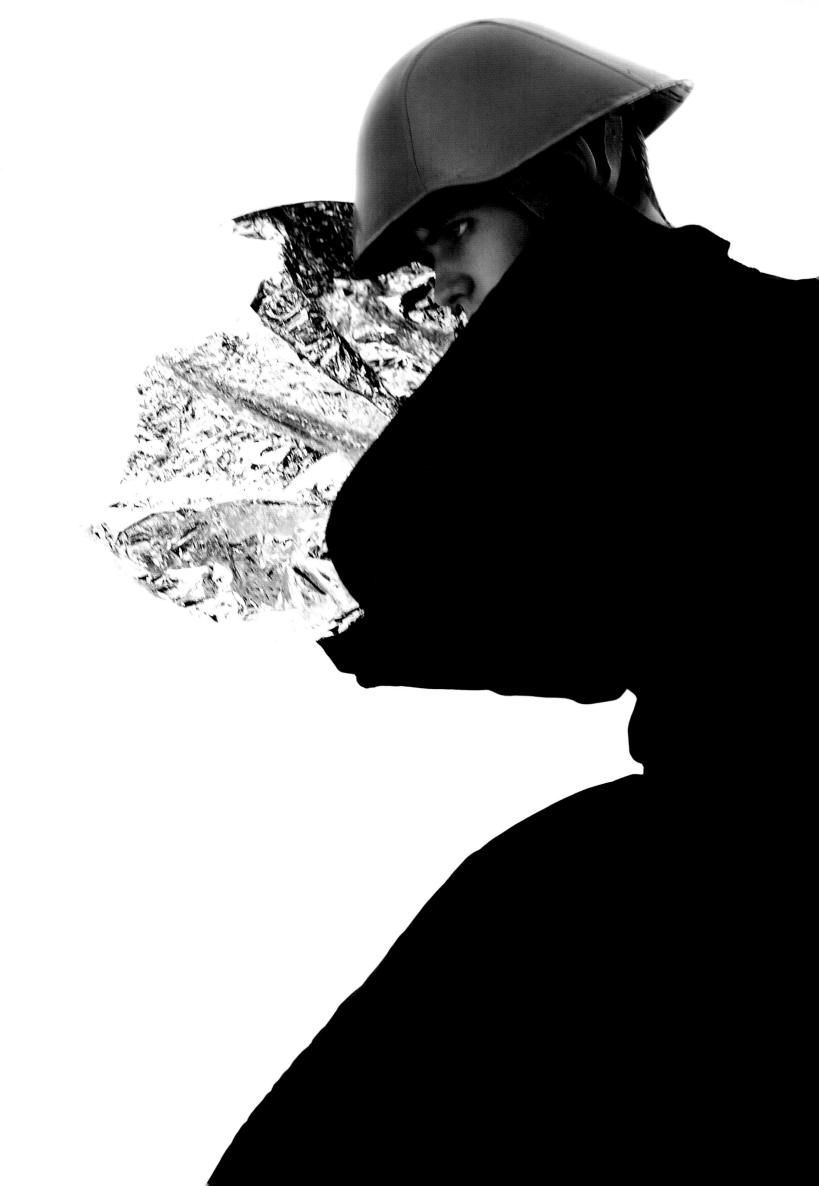

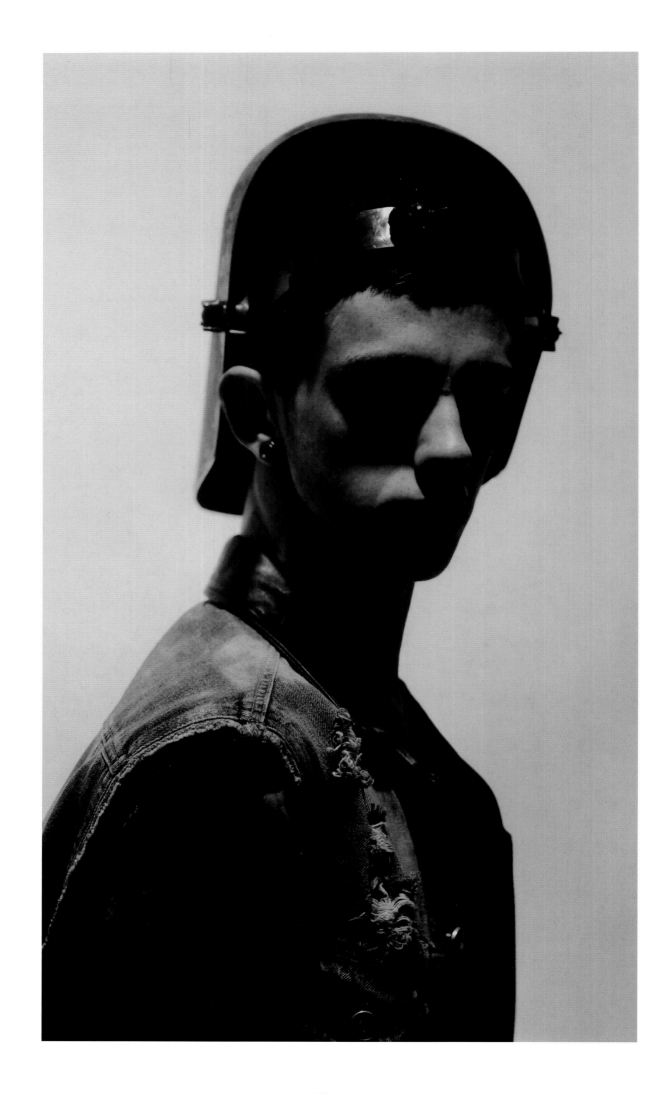

80

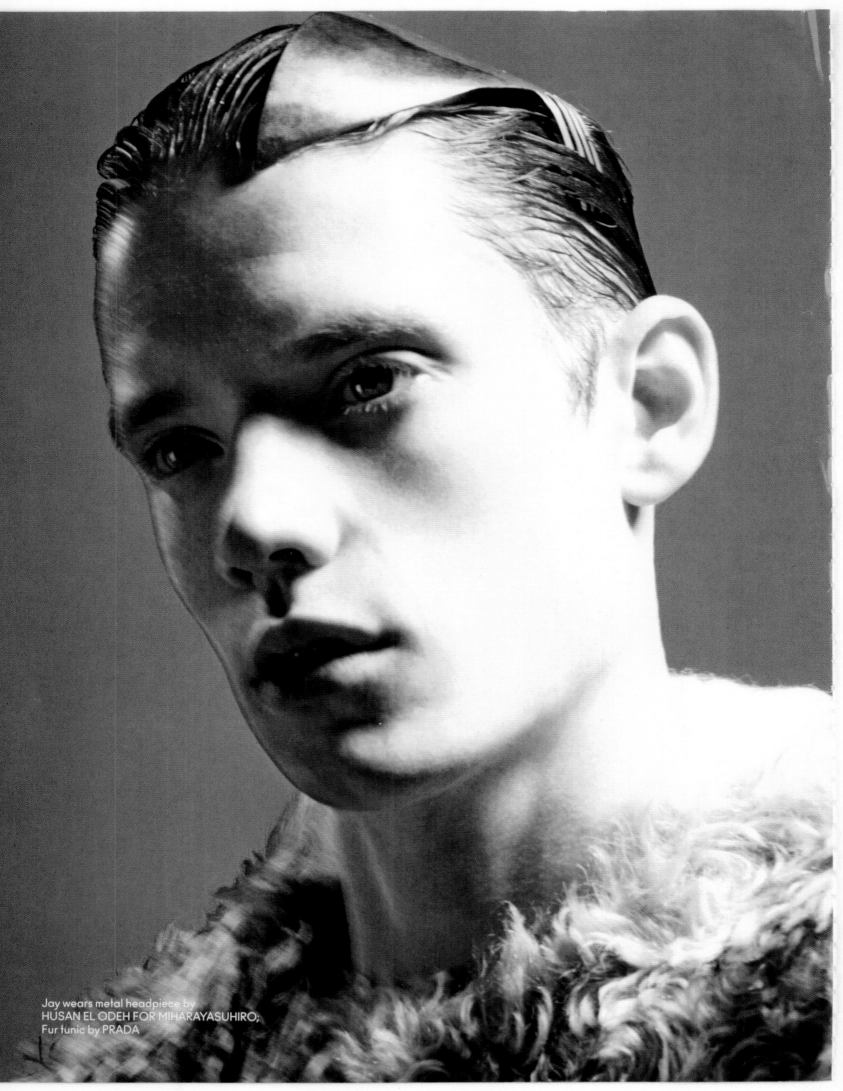

Jay wears metal headpiece by
HUSAN EL ODEH FOR MIHARAYASUHIRO;
Fur tunic by PRADA

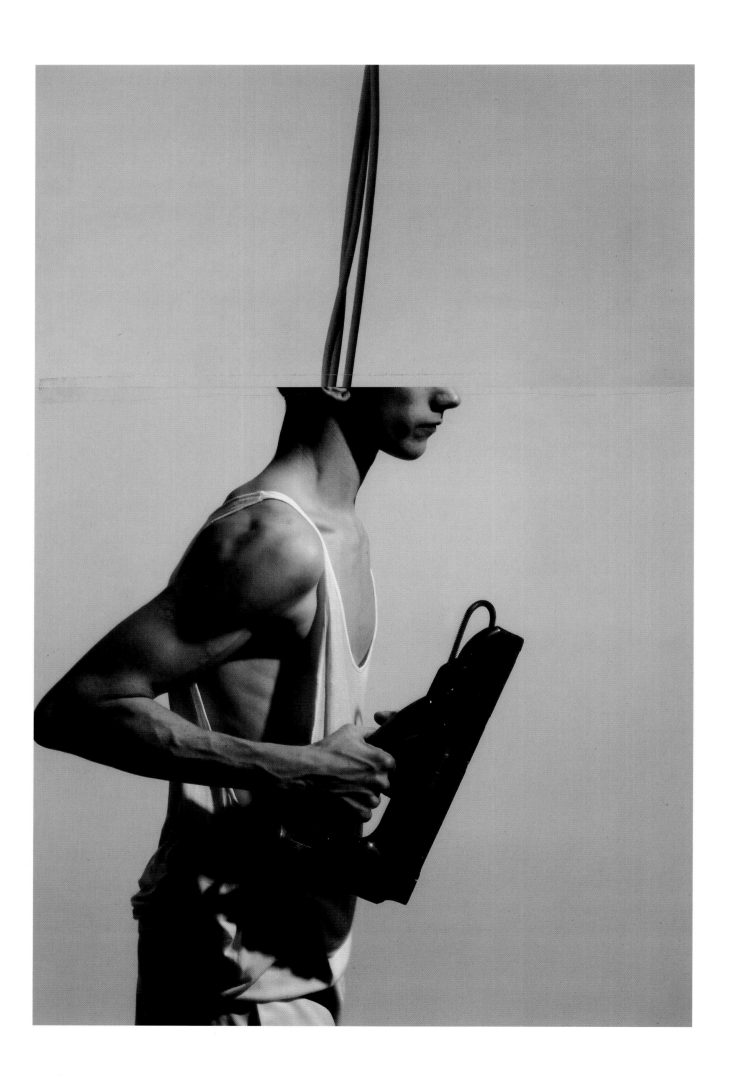

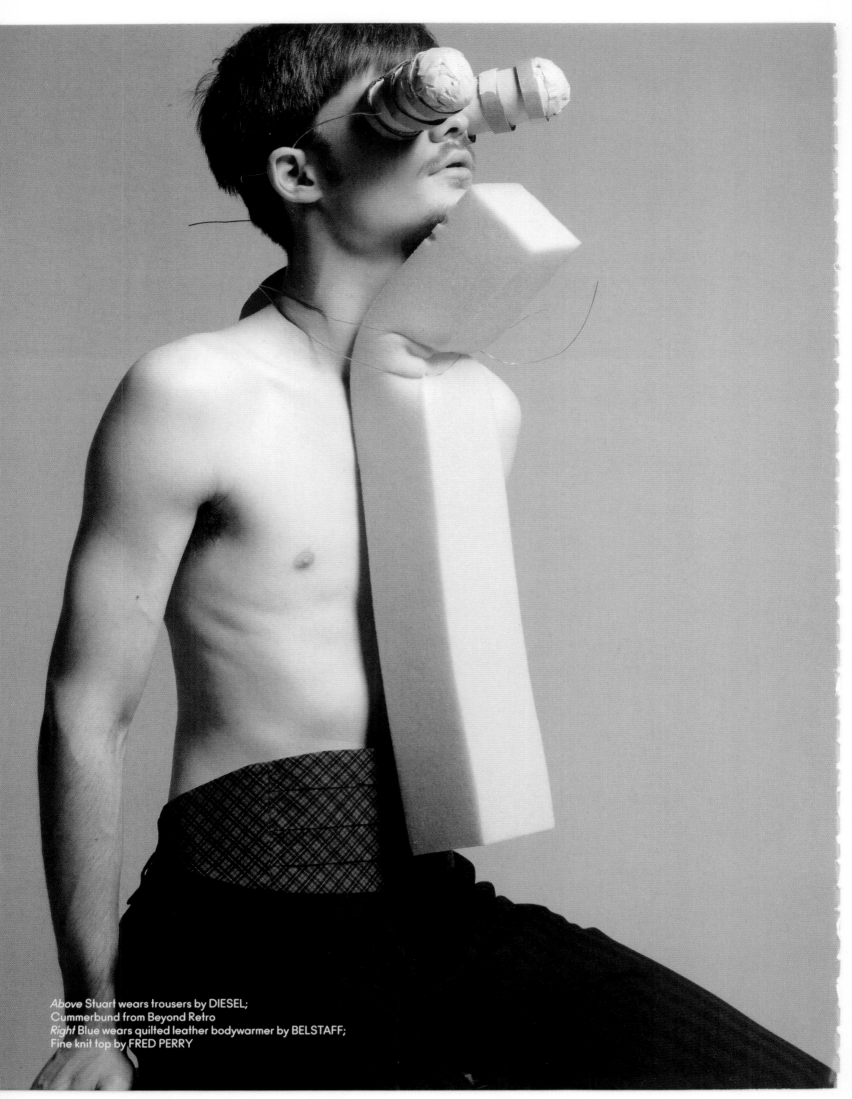

Above Stuart wears trousers by DIESEL;
Cummerbund from Beyond Retro
Right Blue wears quilted leather bodywarmer by BELSTAFF;
Fine knit top by FRED PERRY

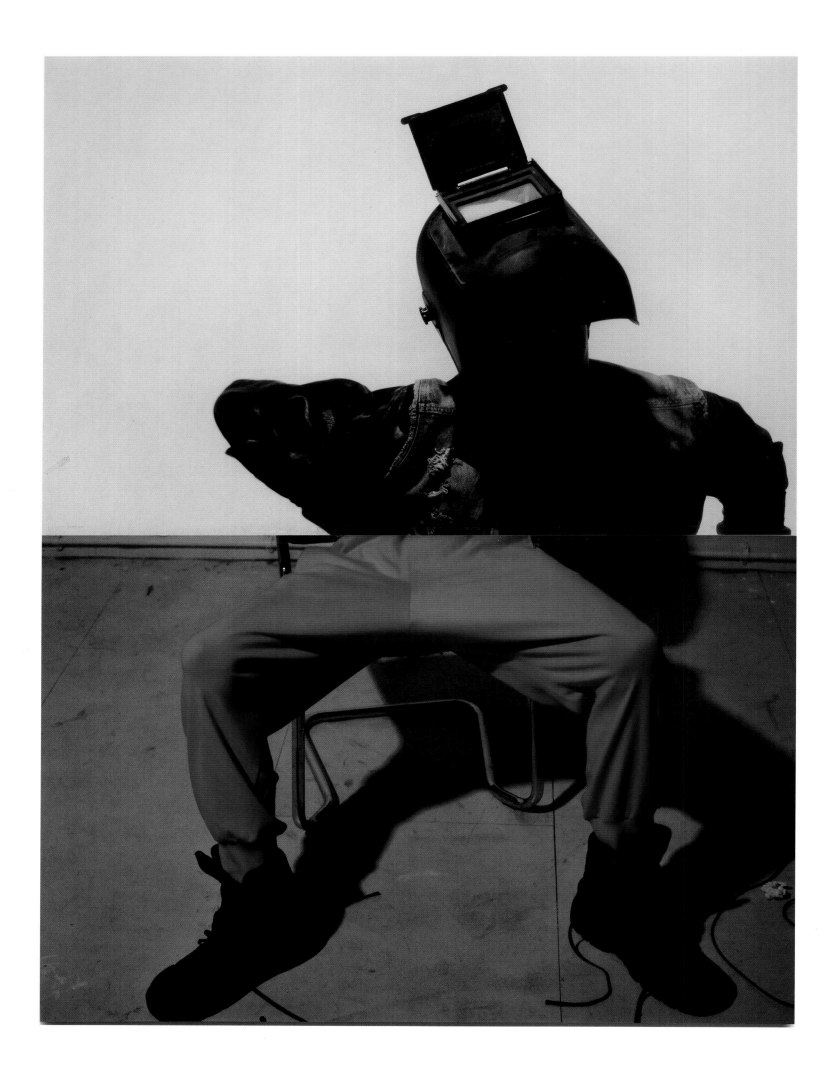

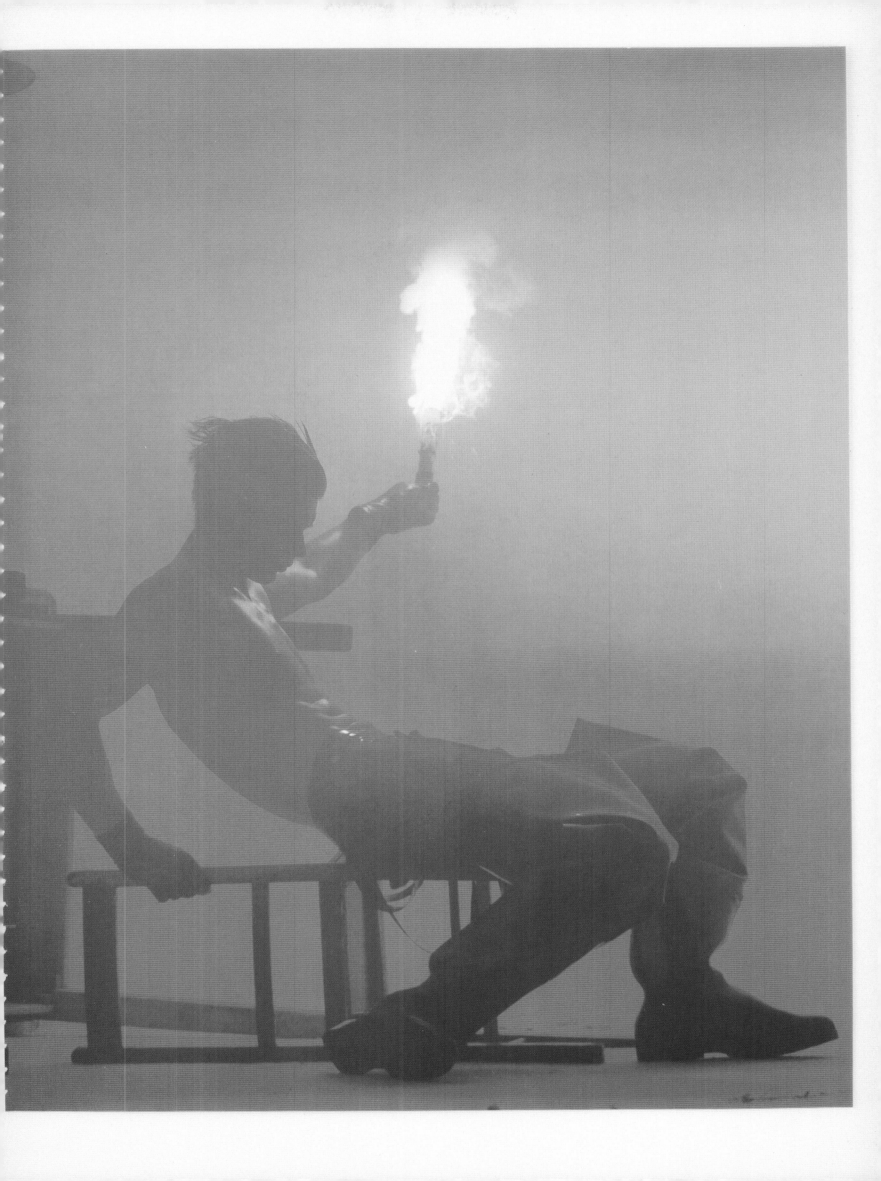

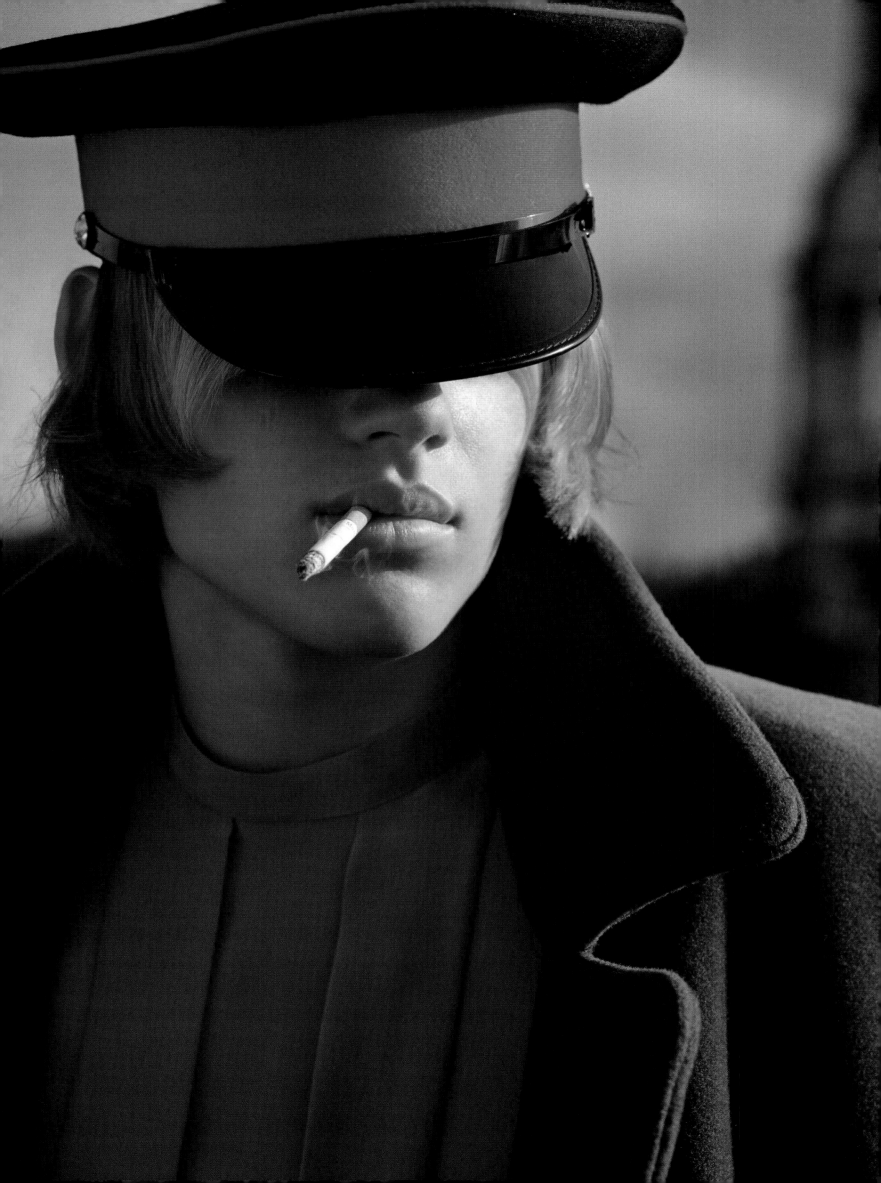

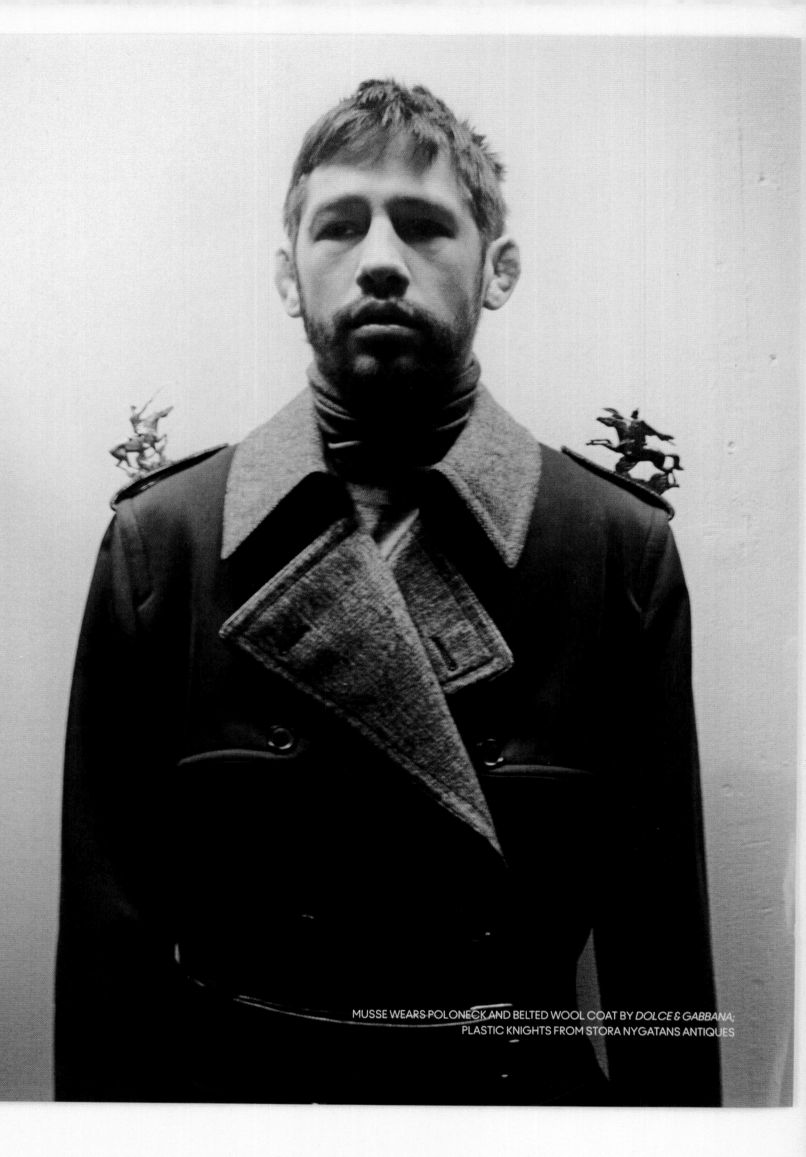

MUSSE WEARS POLONECK AND BELTED WOOL COAT BY *DOLCE & GABBANA*;
PLASTIC KNIGHTS FROM STORA NYGATANS ANTIQUES

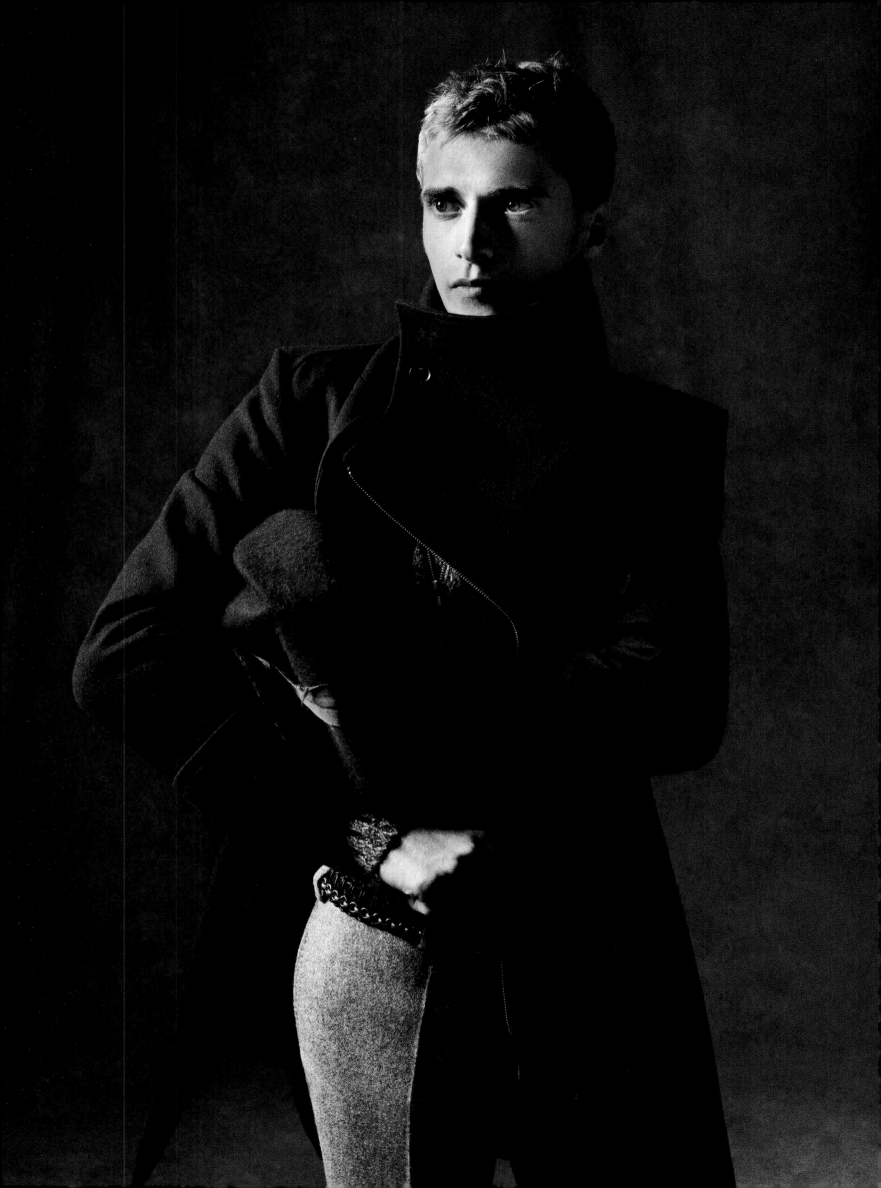

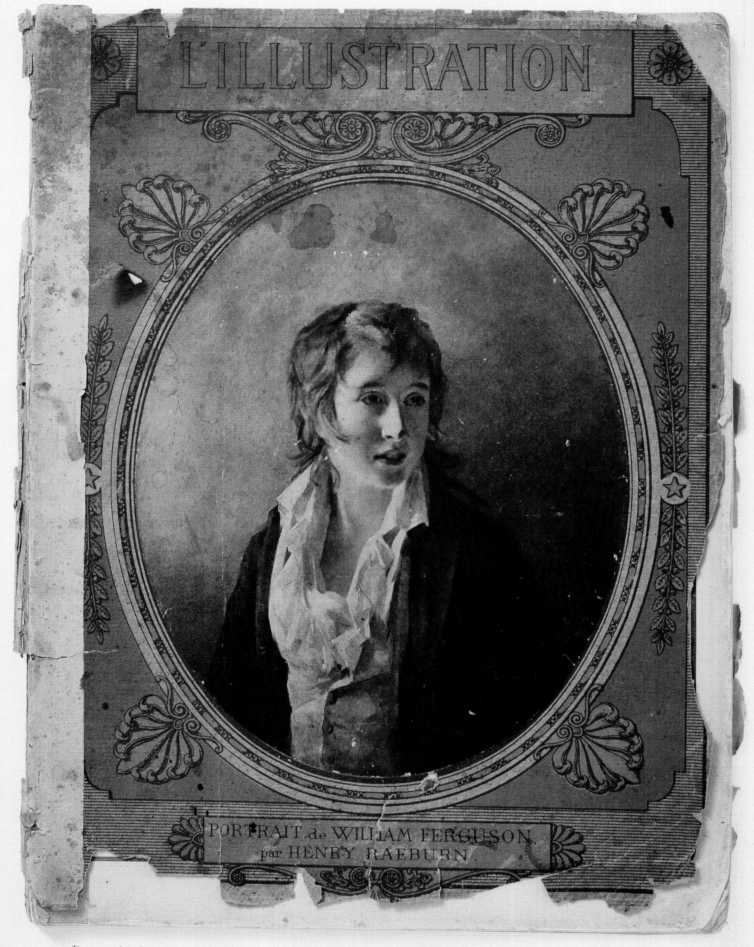

The cover of the December 20, 1919 edition of *L'Illustration*, featuring Scottish artist Henry Raeburn's 18th century portrait of William Ferguson of Kilrie.

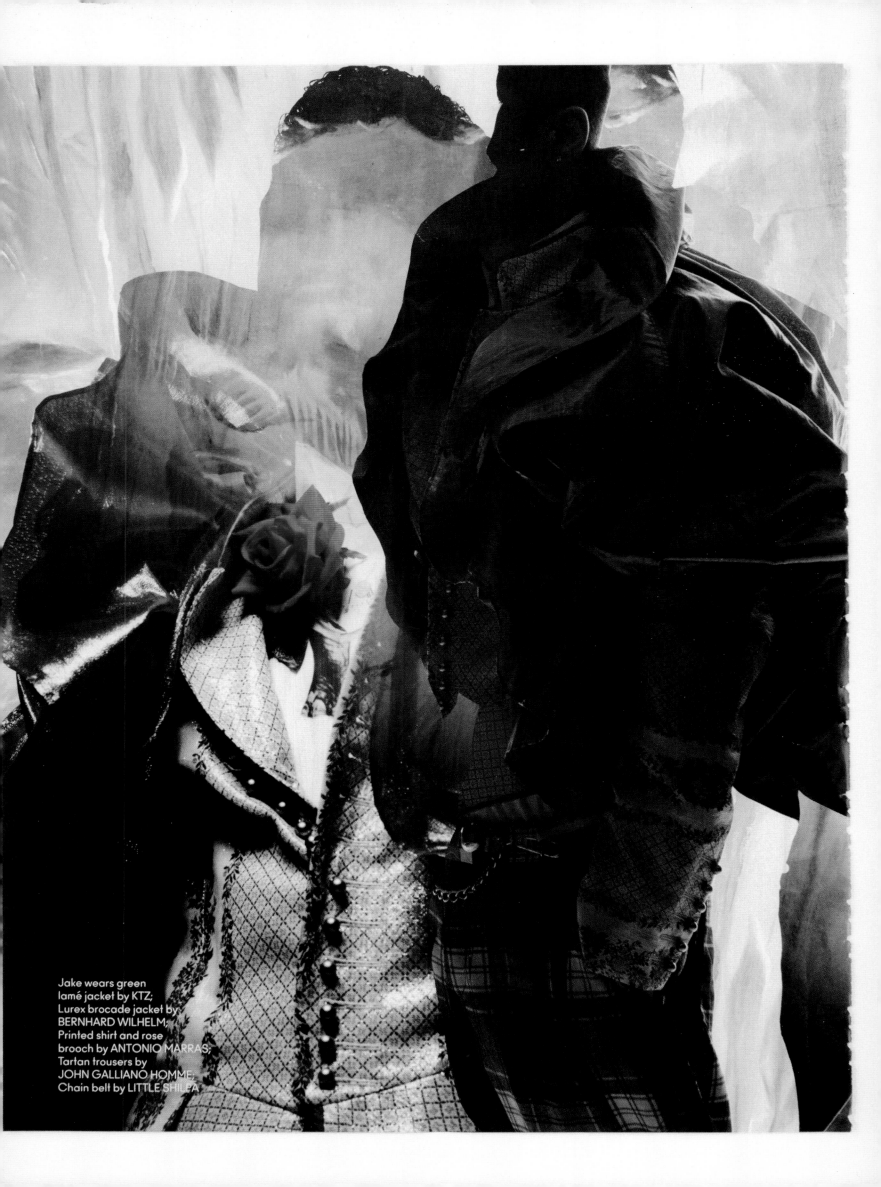

Jake wears green
lamé jacket by KTZ;
Lurex brocade jacket by
BERNHARD WILHELM;
Printed shirt and rose
brooch by ANTONIO MARRAS;
Tartan trousers by
JOHN GALLIANO HOMME;
Chain belt by LITTLE SHILPA

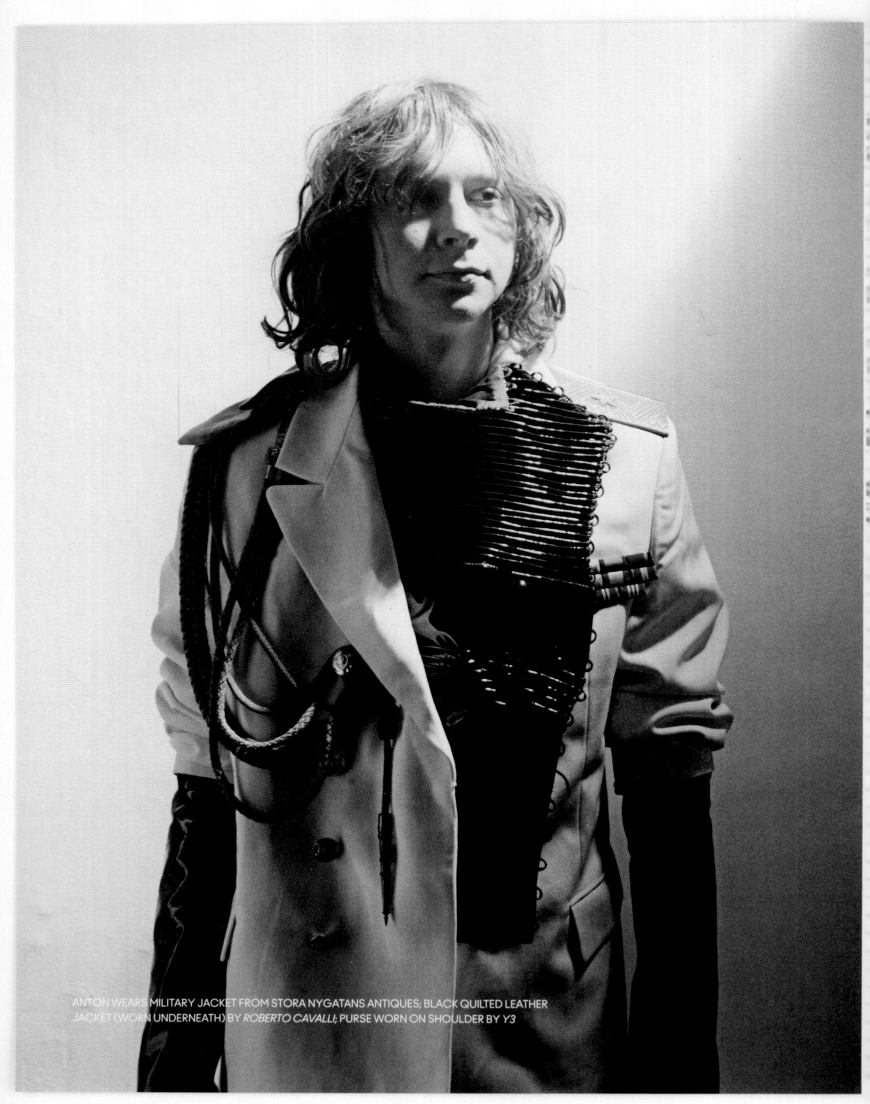

ANTON WEARS MILITARY JACKET FROM STORA NYGATANS ANTIQUES; BLACK QUILTED LEATHER JACKET (WORN UNDERNEATH) BY *ROBERTO CAVALLI*; PURSE WORN ON SHOULDER BY *Y3*

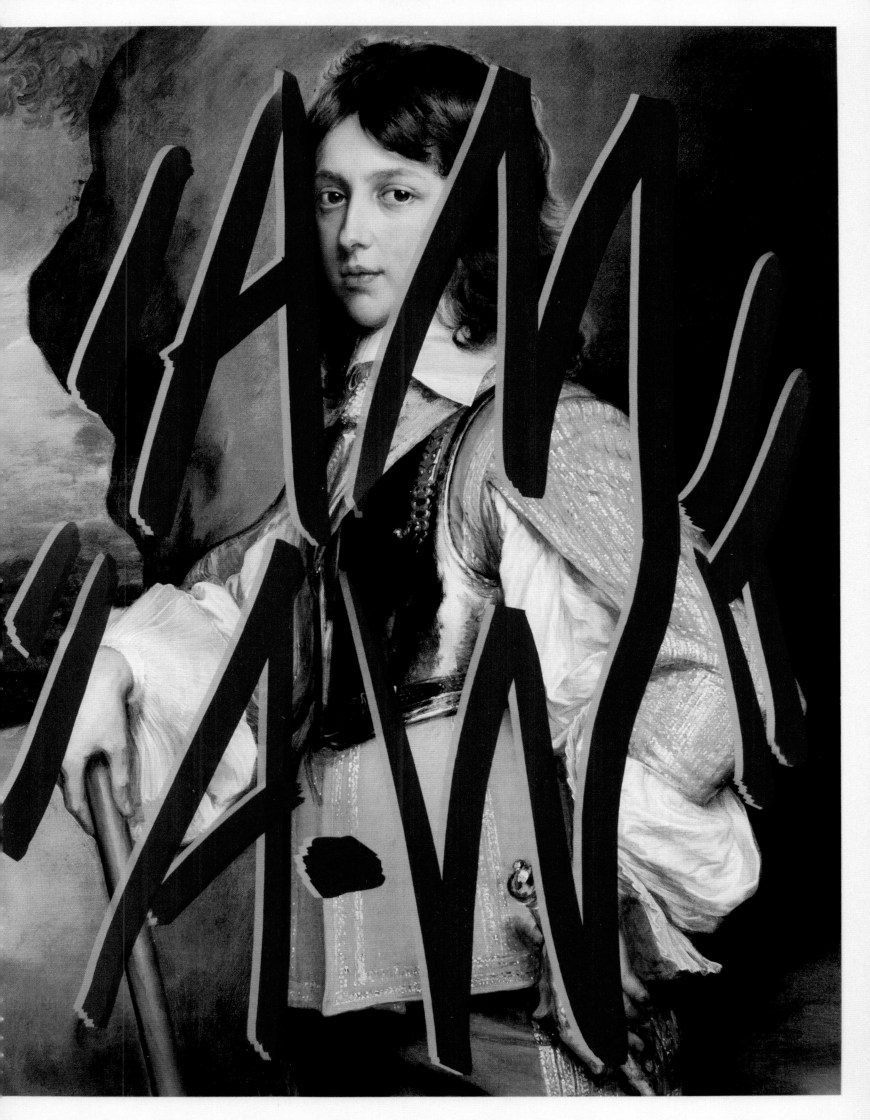

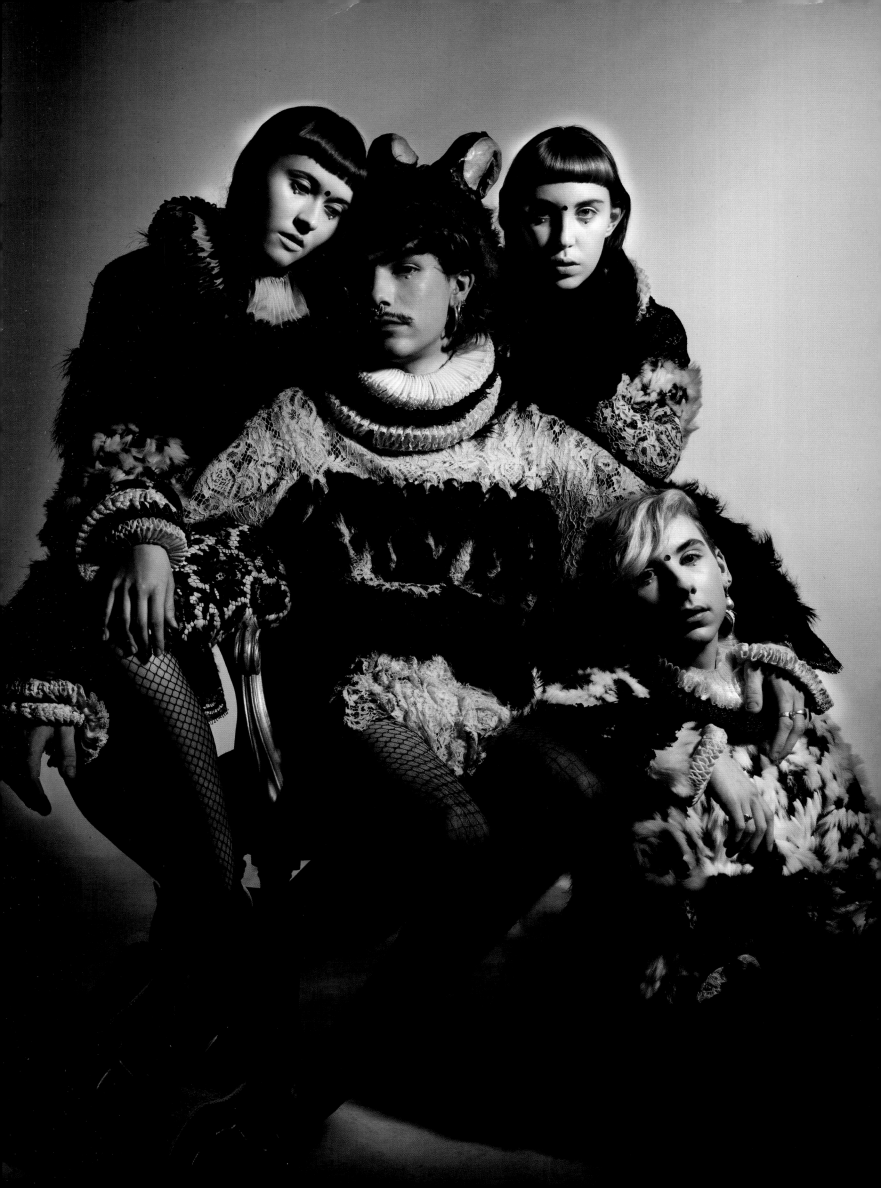

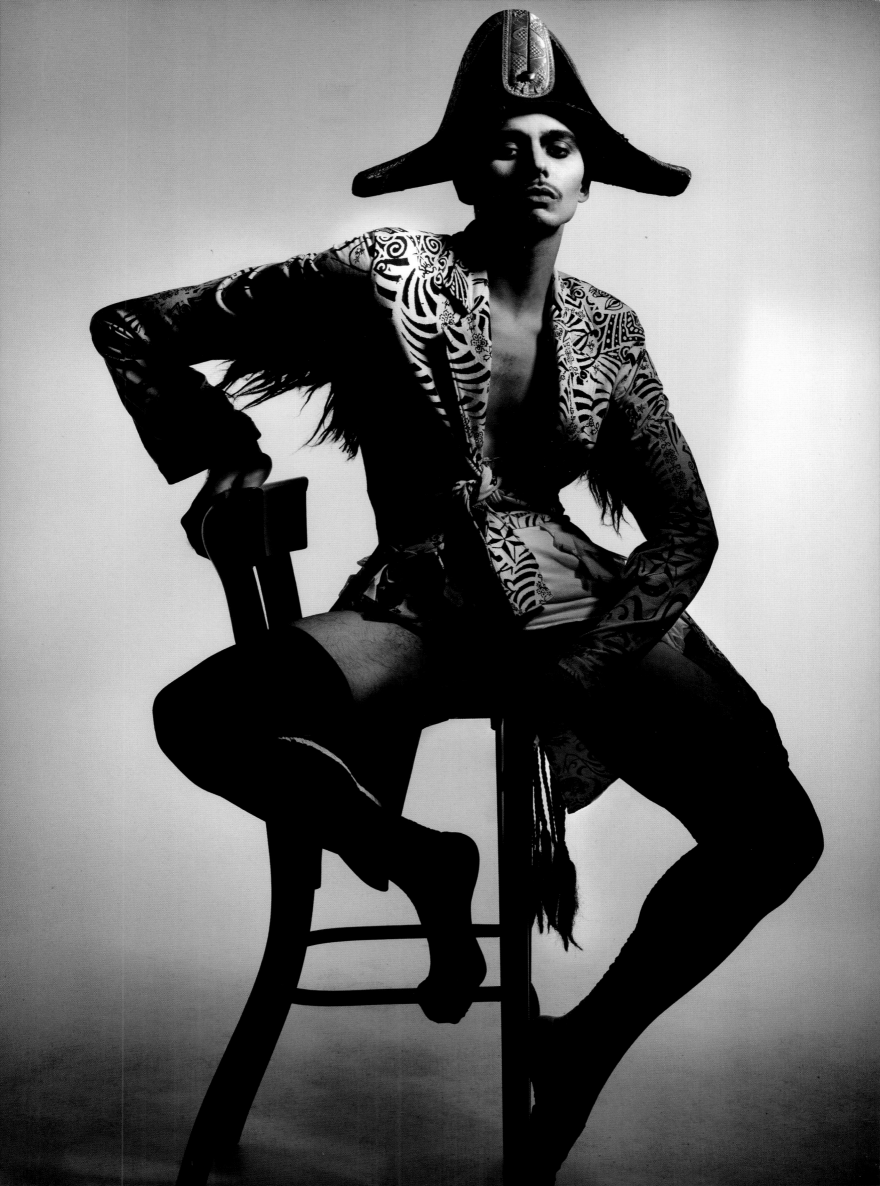

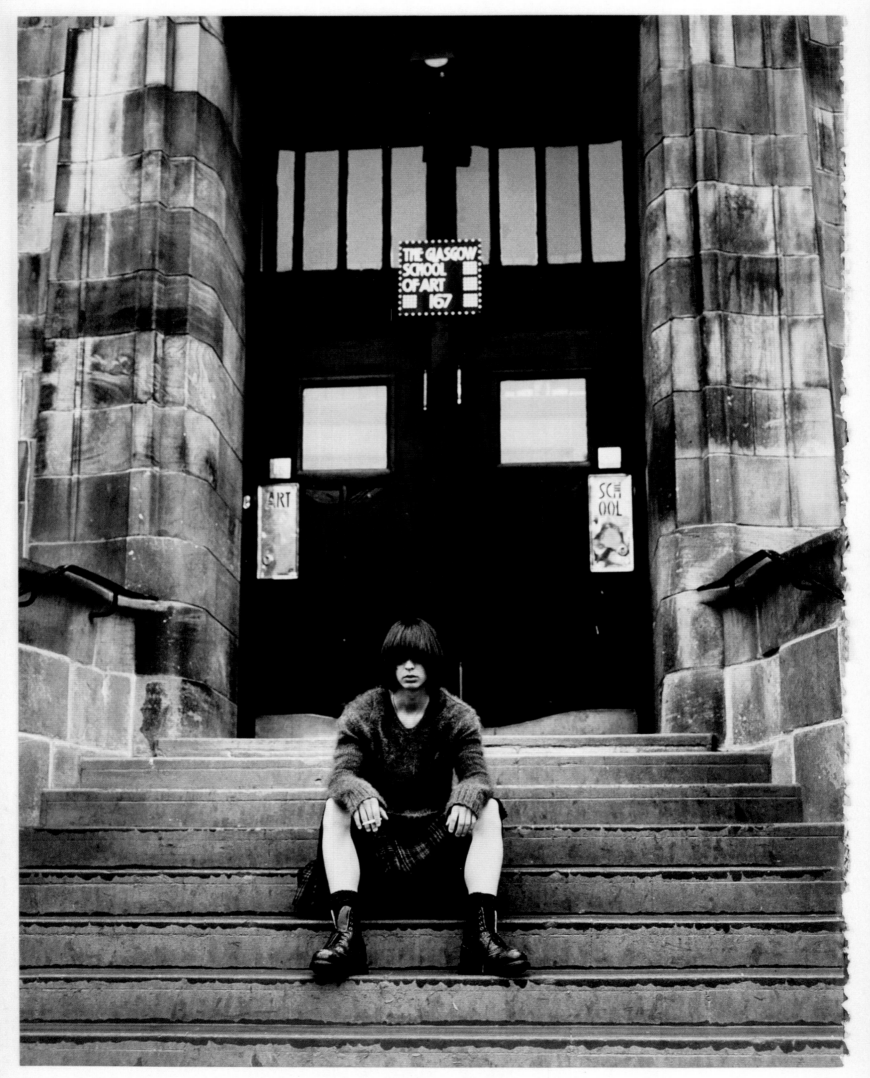

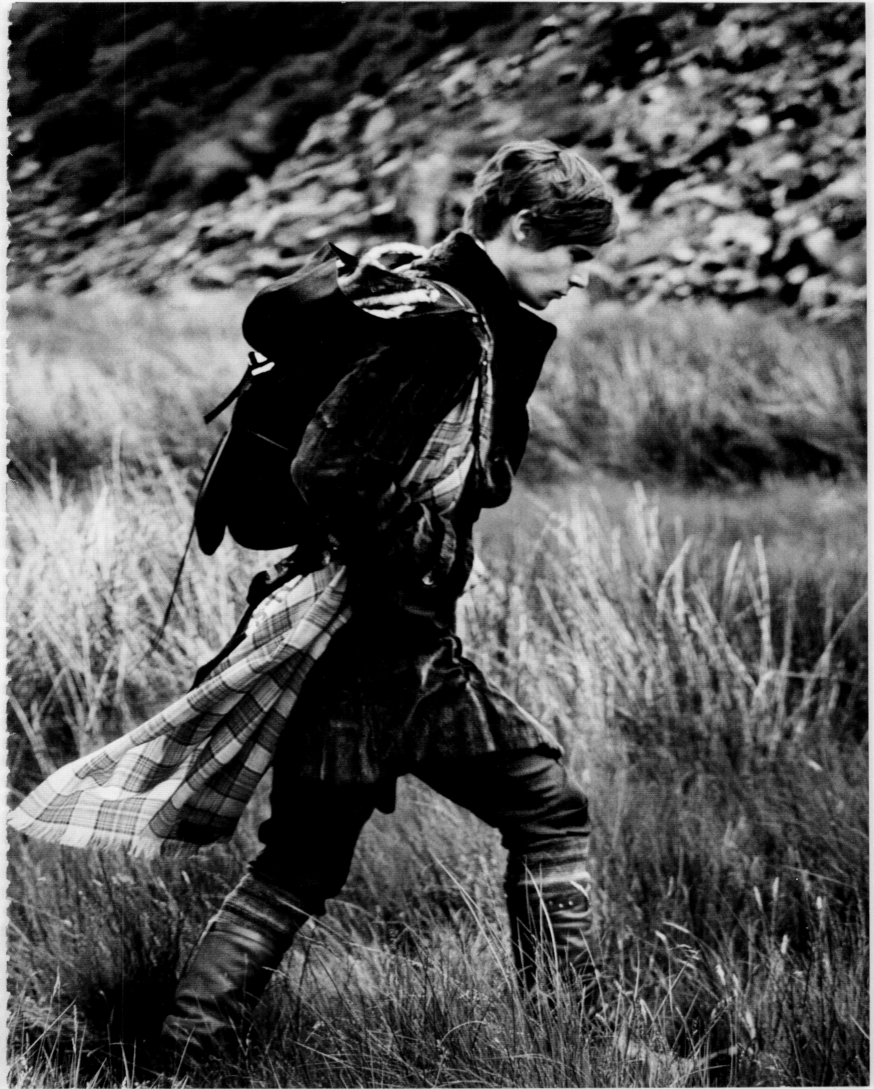

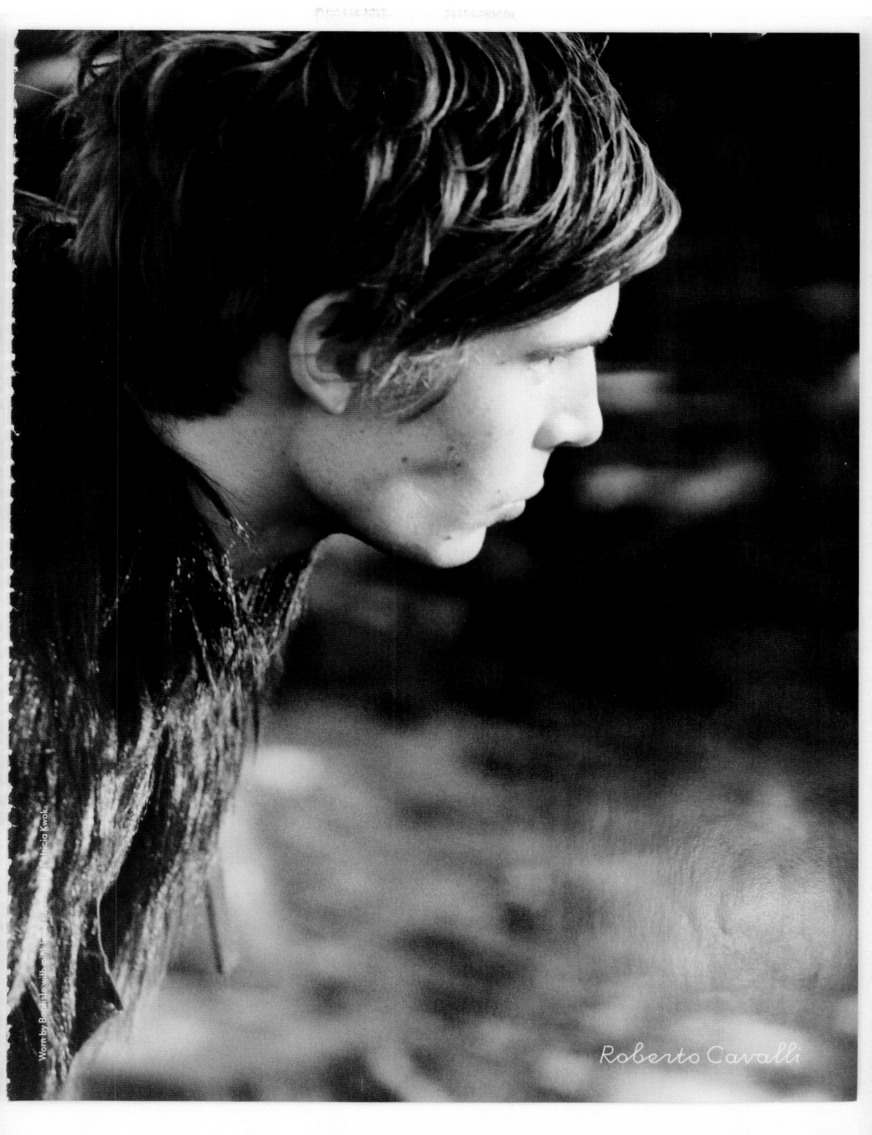

Roberto Cavalli

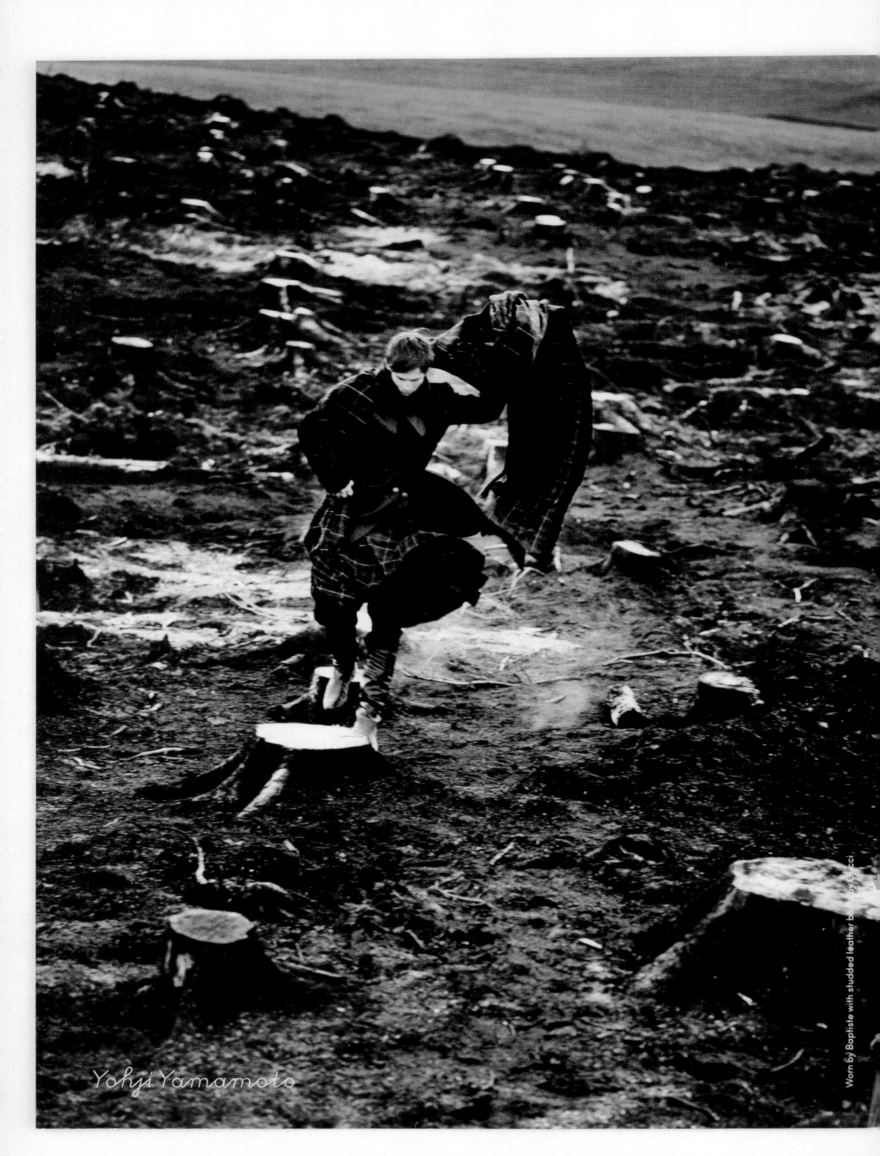

Yohji Yamamoto

Worn by Baptiste with studded leather boots by Gucci.

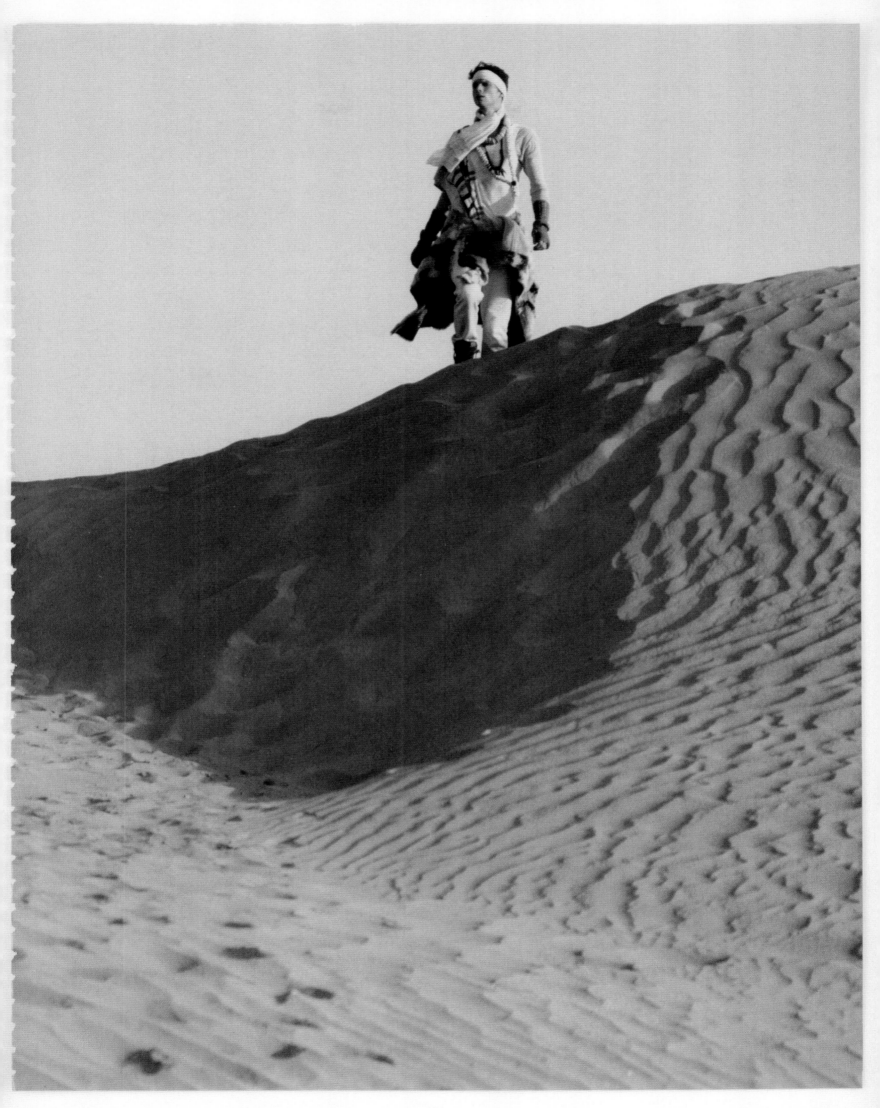

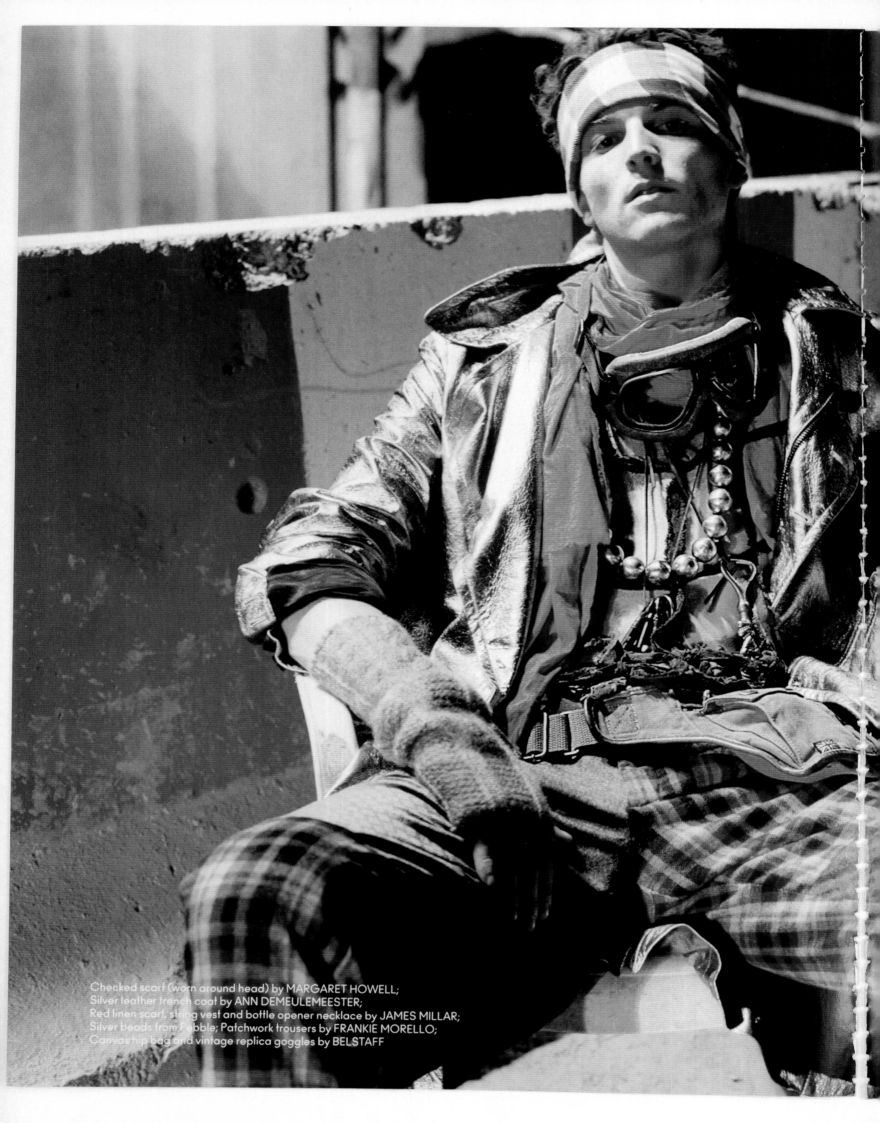

Checked scarf (worn around head) by MARGARET HOWELL;
Silver leather trench coat by ANN DEMEULEMEESTER;
Red linen scarf, string vest and bottle opener necklace by JAMES MILLAR;
Silver beads from Pebble; Patchwork trousers by FRANKIE MORELLO;
Canvas hip bag and vintage replica goggles by BELSTAFF

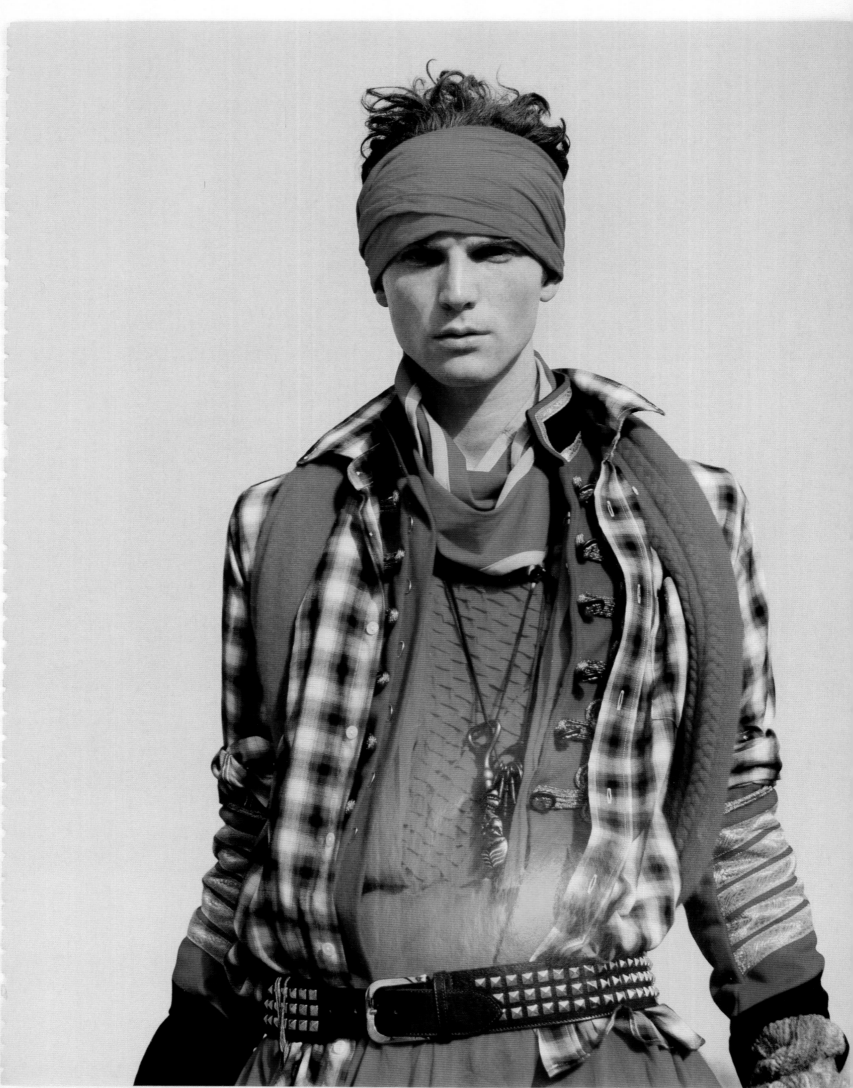

opposite page
Printed jacket, shirt
and trousers by ETRO;
Tartan jacket by PAUL SMITH;
Rope and wood necklace
by LITTLE SHILPA;
Knitted gloves by
FRANKIE MORELLO;
Patterned socks by BERETTA;
Sheepskin lined boots by D&G
this page
Suit jacket by DAKS;
Tartan shirt by BLAAK;
Knitted fingerless gloves
by BURBERRY PRORSUM;
Leopard coat by
ALEXANDER MCQUEEN;
Checked trousers by
VIVIENNE WESTWOOD MAN;
Patterned socks by BERETTA;
Hiking boots by
EMPORIO ARMANI

THE DREAMERS

"Only those who can leave behind everything they
have ever believed in can hope to escape."
—William S. Burroughs

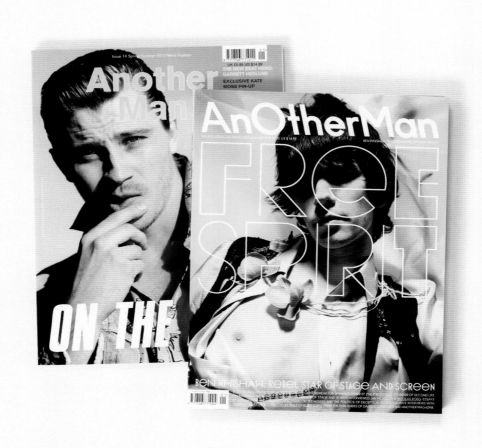

AN IMPOSSIBLE CONVERSATION:

ARTHUR RIMBAUD
and
JIM MORRISON

One was a nineteenth-century prodigy who fled provincial France for a glittering life of poetry, scandal and absinthe in Paris, before turning his back on literary stardom at the age of twenty to become a coffee trader in Ethiopia. The other was a US Navy brat–turned–hippy prophet, living on a Venice Beach rooftop and a diet of canned beans, Aldous Huxley and LSD, before transforming himself into a messianic 1960s rock god. Both were masters of reinvention. Both were restless searchers for an ultimate truth. And both were hell-bent on escaping conformity by any means necessary. Here, in their own words, Arthur Rimbaud and Jim Morrison finally speak…

ARTHUR RIMBAUD: My dear friend, what the devil are you up to? Give me your news.

JIM MORRISON: I've been kind of lazy lately. I'm just soaking it all in.

AR: That's too bad.

JM: I'll get back in the saddle. I will, don't worry.

AR: God be praised! For my part, I'm now making myself as shitty as I can.

JM: Oh yeah? Why?

AR: Why? I'm working at turning myself into a seer. The poet makes himself a seer by a long, immense and reasoned disordering of all the senses.

JM: William Blake said that the body was the soul's prison unless the five senses are fully developed and open. He considered the senses the windows of the soul.

AR: Yes, but the problem is to make the soul into a monster… It involves enormous suffering, but one must be strong and be a born poet.

JM: Poetry's my thing, man. I still enjoy singing but I'm a poet, that's what I'm meant to be. If my poetry aims to achieve anything, it's to deliver people from the limited ways in which they see and feel.

AR: Well, the first study for the man who'd be a poet is knowledge of himself. He searches himself.

JM: Yeah, I'm like an adventurer, an explorer. I seek meaning but rather than starting inside, I start outside and reach the mental. I used to have this magic formula to break into the subconscious. I would lie there and say over and over: 'Fuck the mother, kill the father… Fuck the mother, kill the father…'

AR: I used to believe in all magic but true alchemy lies in this formula: 'Your memory and your senses are but the nourishment of your creative impulse.'

JM: Maybe, I guess so…

AR: The idea is to reach the unknown.

JM: Right, to break through to the other reality, true reality: the meaningless nothingness. I'm like the shaman, touching the forces and power of other worlds, other… existences.

AR: However stupid his existence may be, man still clings to it.

JM: Why bother then, if that's the case?

AR: Because life is the farce which everyone has to perform.

JM: What a bummer!

AR: Happily this life is the only one, which is self-evident, since one can't imagine another life with a greater tedium than this one.

JM: This is the strangest life I've ever known… How do you see yourself?

AR: I am an inventor more deserving than all those who have preceded me; a musician, moreover, who has discovered something like the key of love.

JM: I see myself as a huge fiery comet, a shooting star. Everyone stops, points up and gasps: 'Oh look at that!' Then whoosh and I'm gone... and they'll never see anything like it ever again. And they won't be able to forget me — ever.

AR: Everything will be forgotten!

JM: Well, I'm not like everybody else. I've been different from the beginning.

AR: Yes, I left normal life more than a year ago.

JM: Nobody would stay interested in me if I was normal... I'm the Lizard King. I can do anything!

AR: You will always be a hyena.

JM: No, I'm Rimbaud in a leather jacket!

AR: I pity you.

JM: You're not so bad... Well, what now?

AR: I can't stay here any longer. Perhaps I shall go to Zanzibar, from where you can make long journeys into Africa, and perhaps China, or Japan. The world is very big and full of magnificent places which it would take more than a thousand lives to visit.

JM: I leave for France in a few months... I'll be glad to get out of here. I need to get away, work on my poetry. I need to try everything, experience everything. Paris is the place.

AR: It's a shitheap!

JM: Trying to be a hardass, huh? Let's go and get a drink.

AR: Yes, I still have a whole stack of things to say. There's one watering hole around here I prefer... despite the malevolence of the waiters!

Six months after having his right leg amputated, Arthur Rimbaud died from bone cancer at the Hôpital de la Conception in Marseilles on November 10, 1891. He was thirty-seven years old.

Jim Morrison died from a suspected heroin overdose on July 3, 1971. He was found in the bath at his rented apartment in the Marais, Paris. He was twenty-seven years old.

Text Ben Cobb

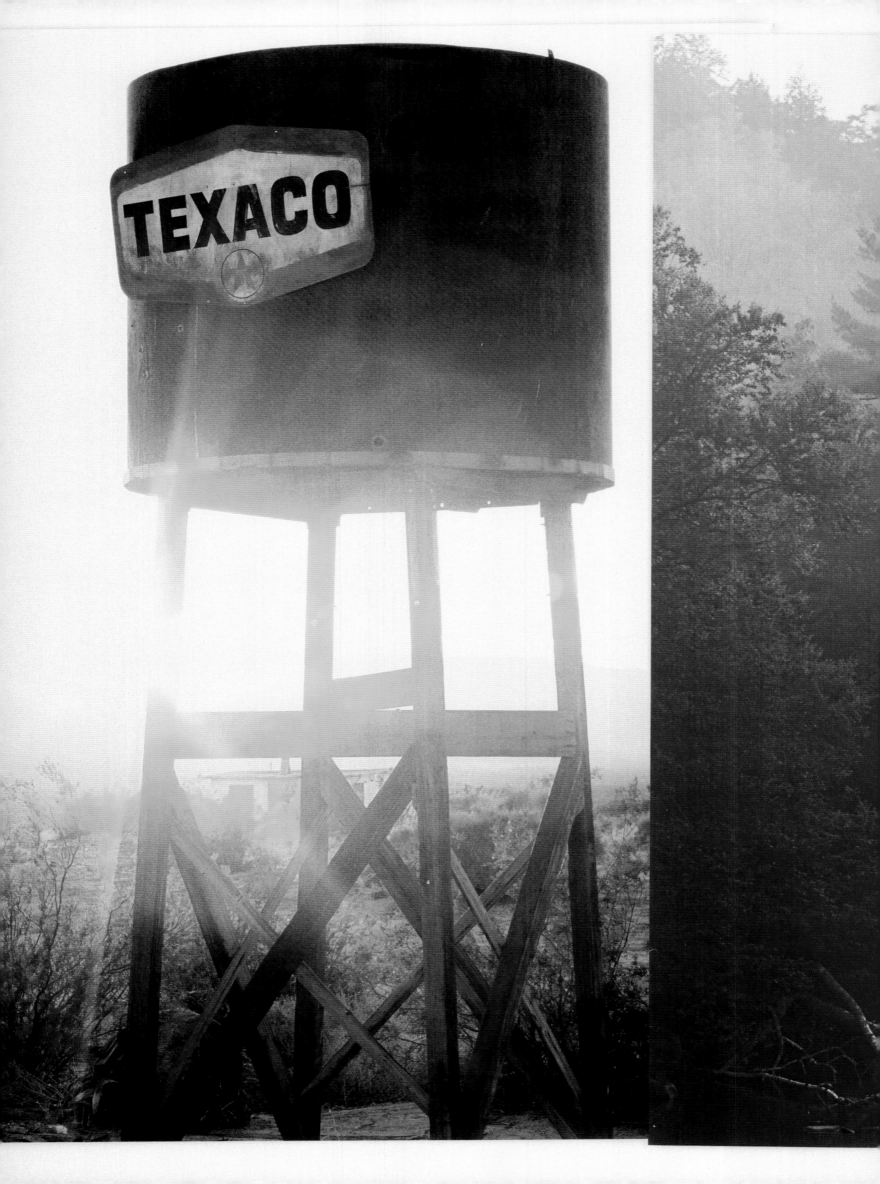

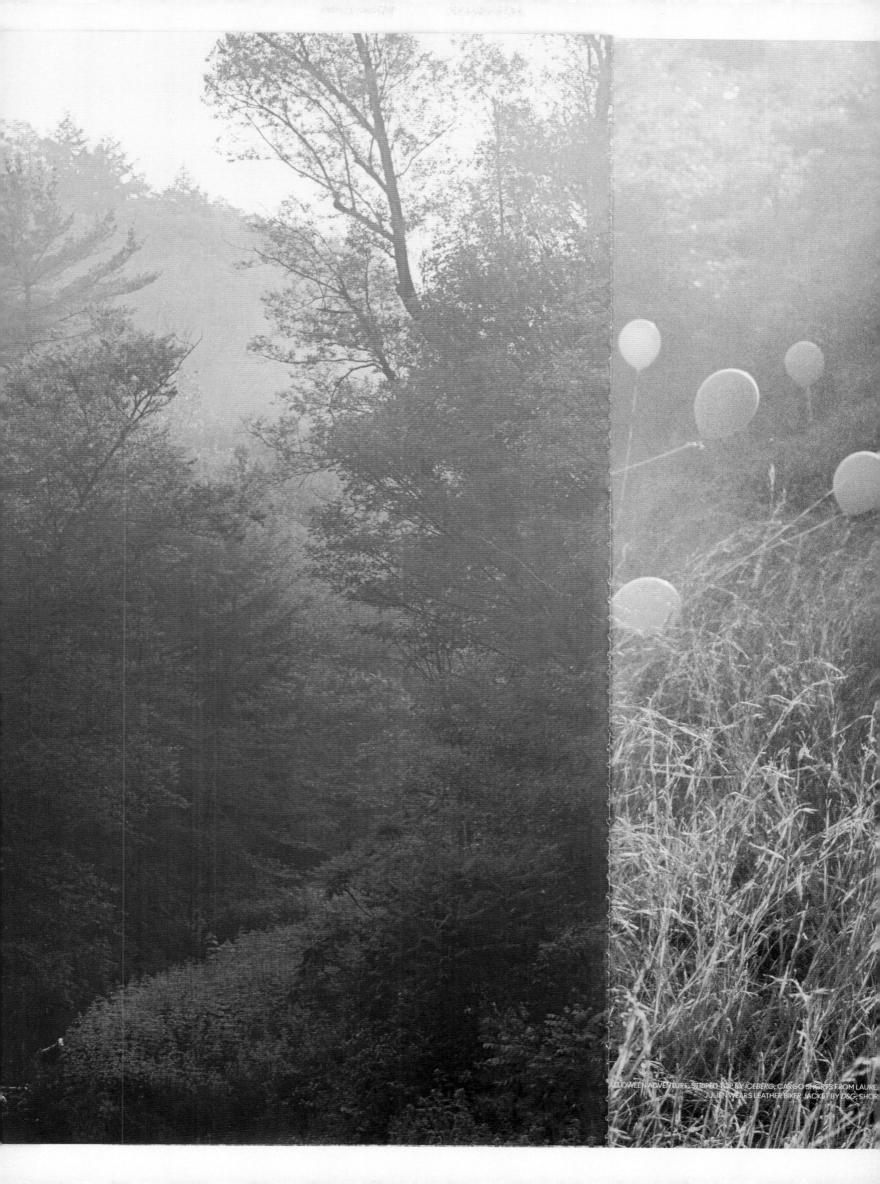

ALLOWEEN ADVENTURE. STRIPED TOP BY ICEBERG; CARGO SHORTS FROM LAURE
JULIEN WEARS LEATHER BIKER JACKET BY D&G; SHOR

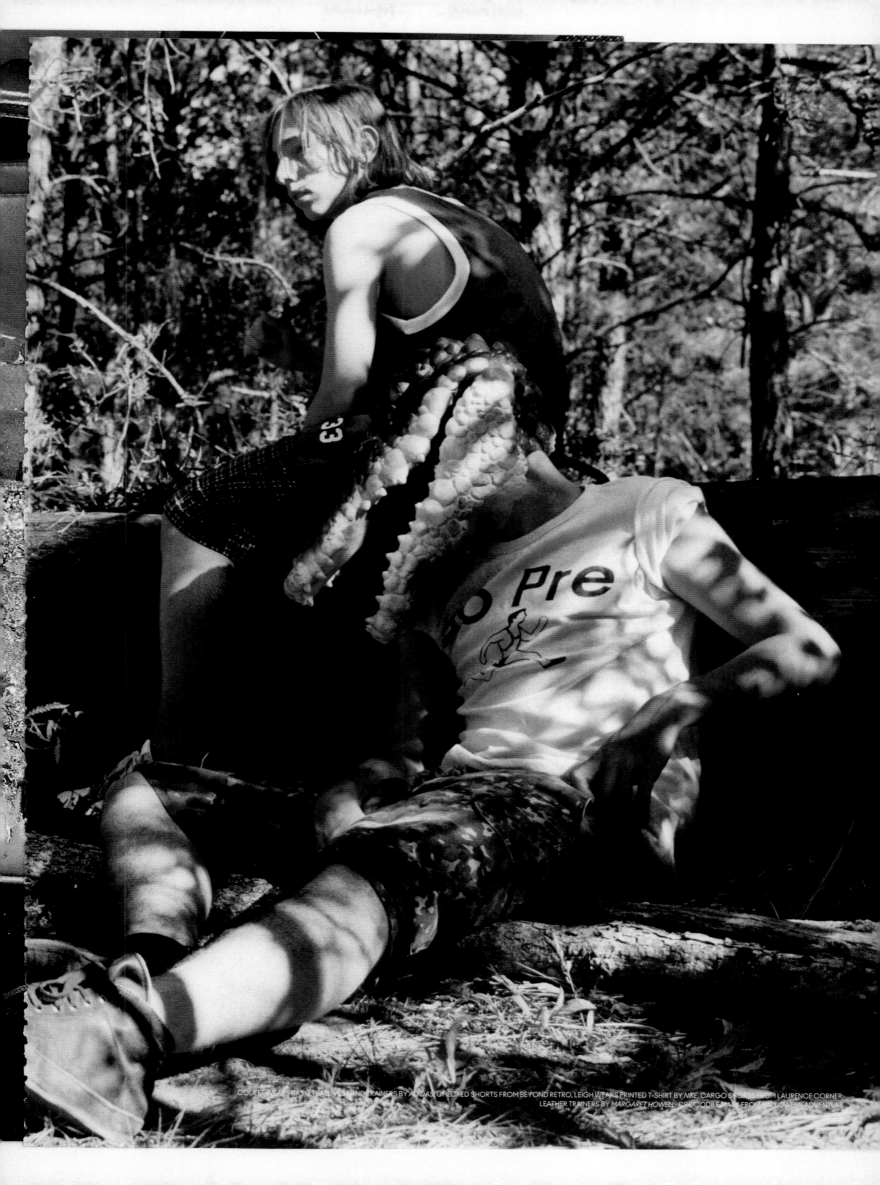

COULEE WEARS BASKETBALL VEST AND TRAINERS BY ADIDAS; CHECKED SHORTS FROM BEYOND RETRO; LEIGH WEARS PRINTED T-SHIRT BY NIKE; CARGO SHORTS FROM LAURENCE CORNER; LEATHER TRAINERS BY MARGARET HOWELL; CROCODILE MASK FROM HALLOWEEN ADVENTURE

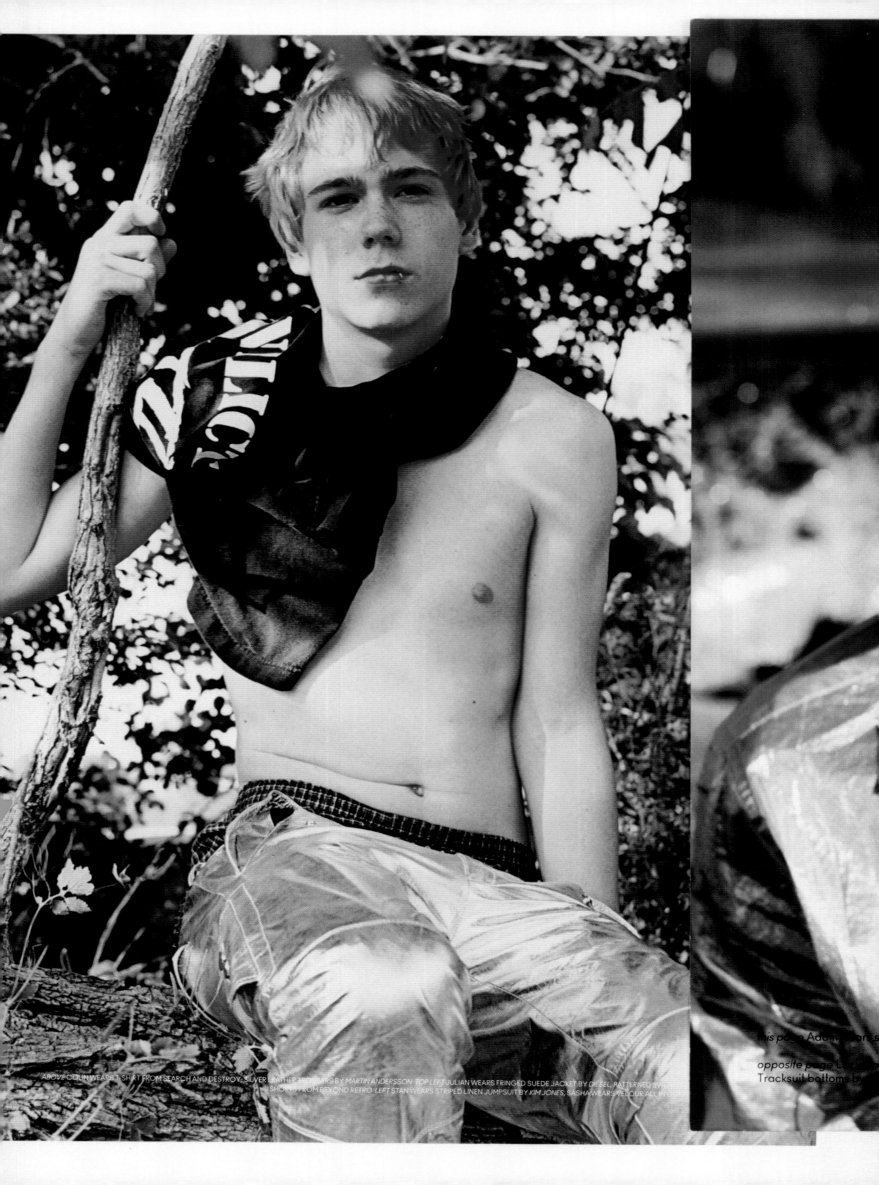

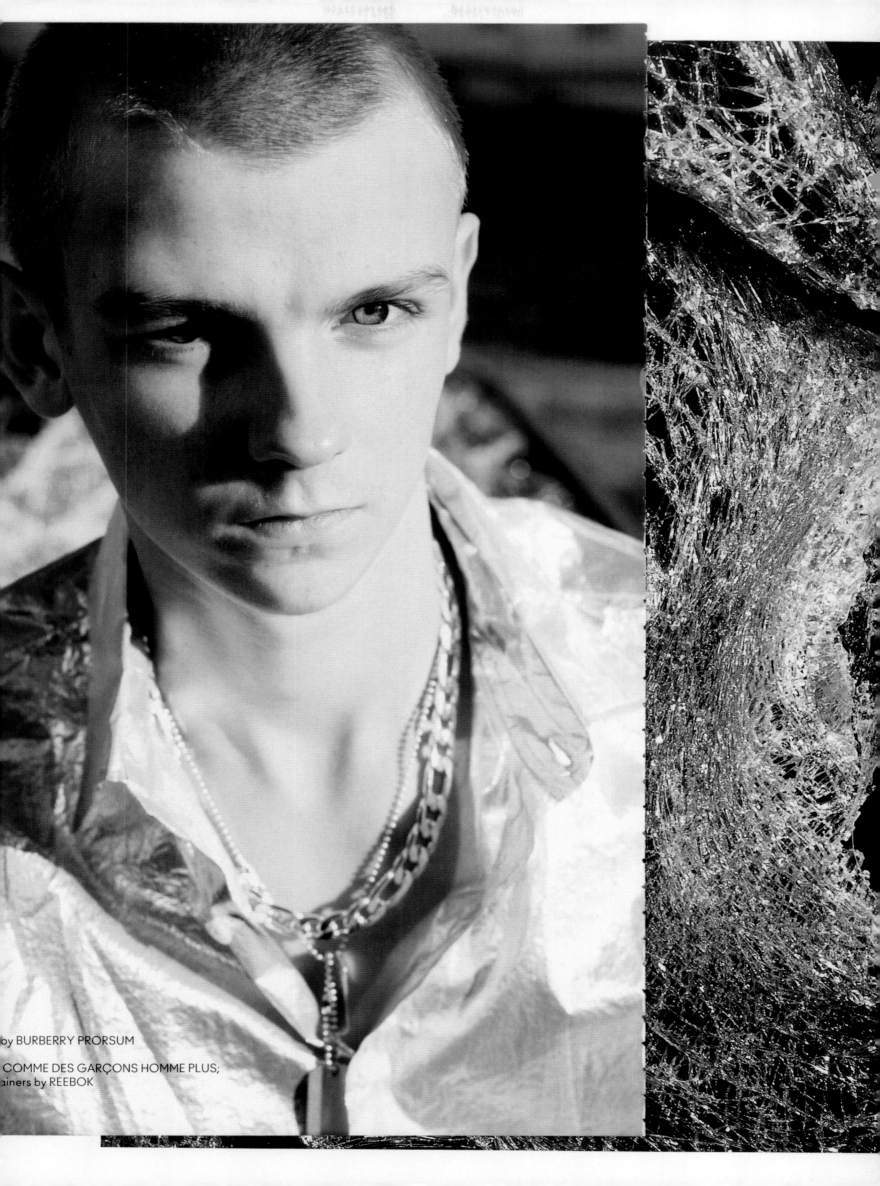

by BURBERRY PRORSUM

COMME DES GARÇONS HOMME PLUS;
ainers by REEBOK

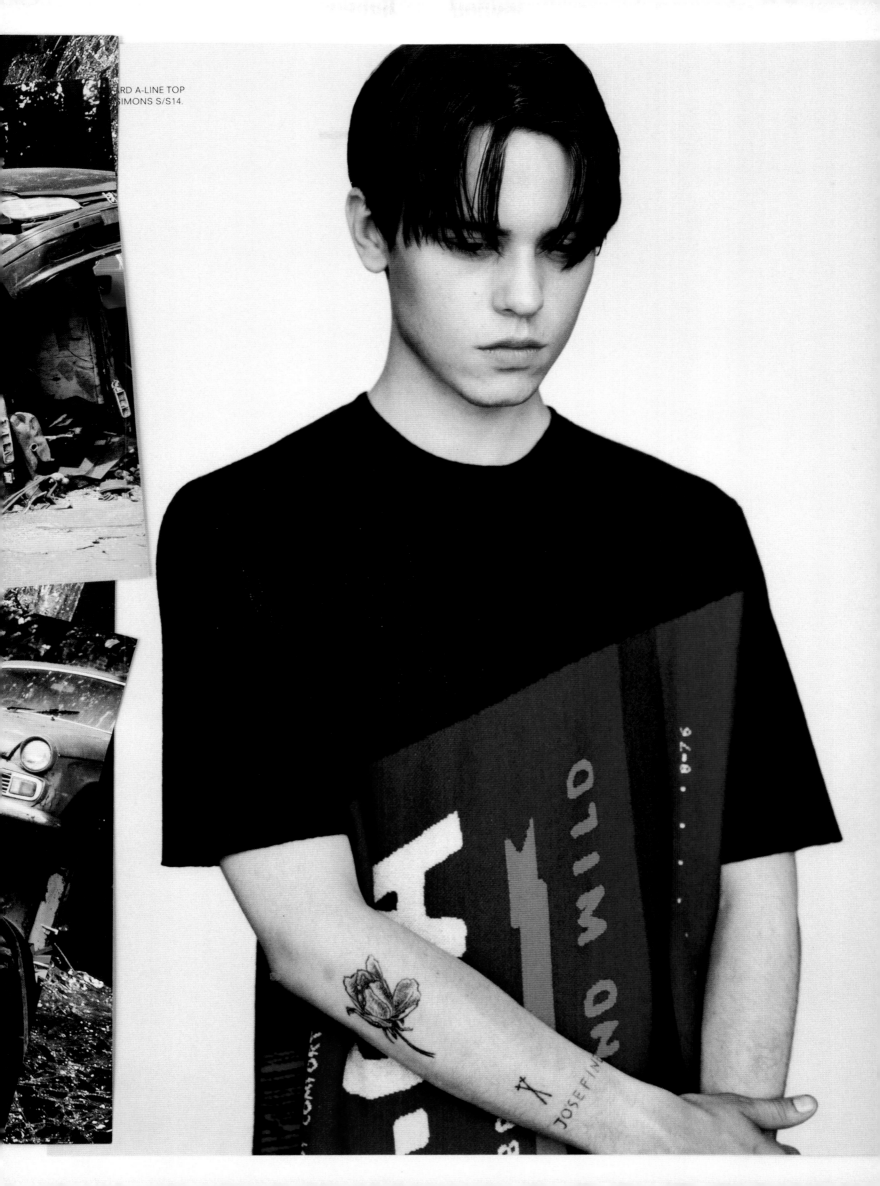

RD A-LINE TOP
SIMONS S/S14.

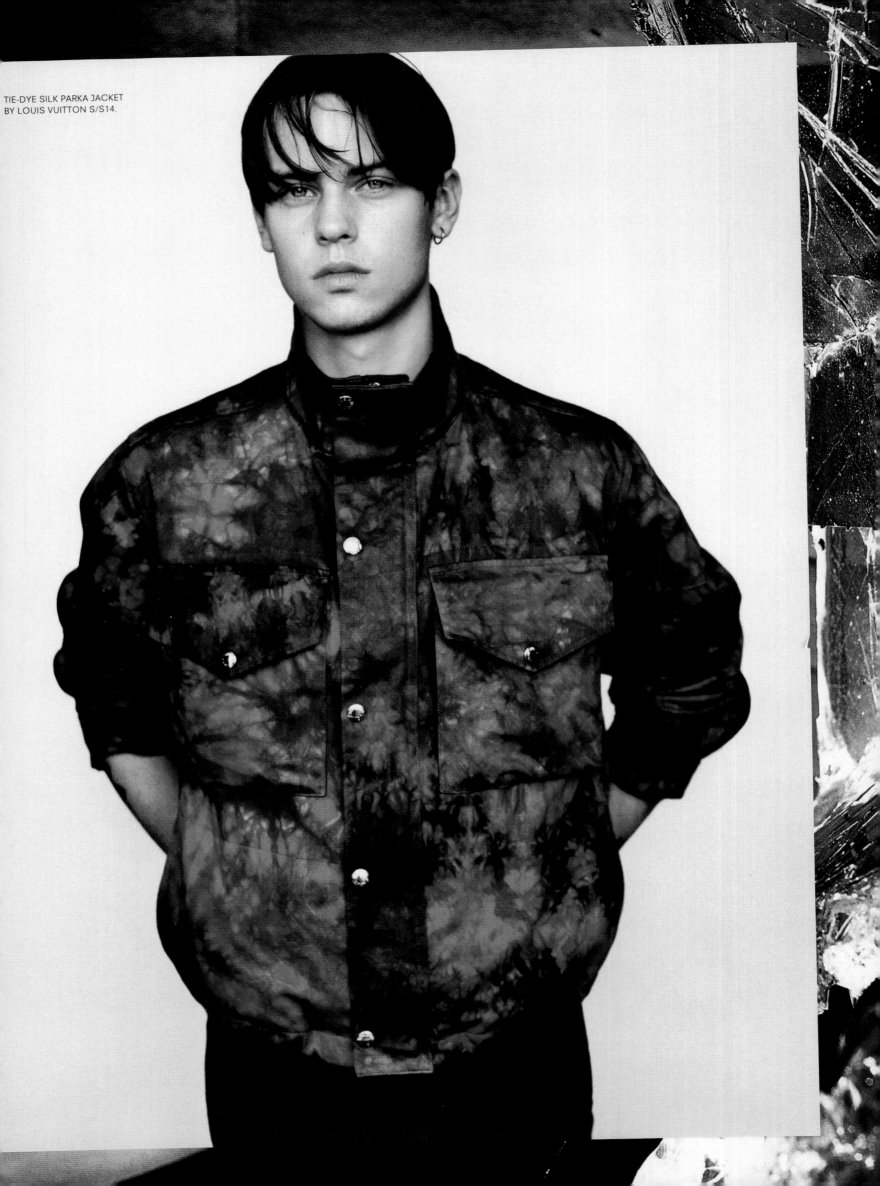

TIE-DYE SILK PARKA JACKET
BY LOUIS VUITTON S/S14.

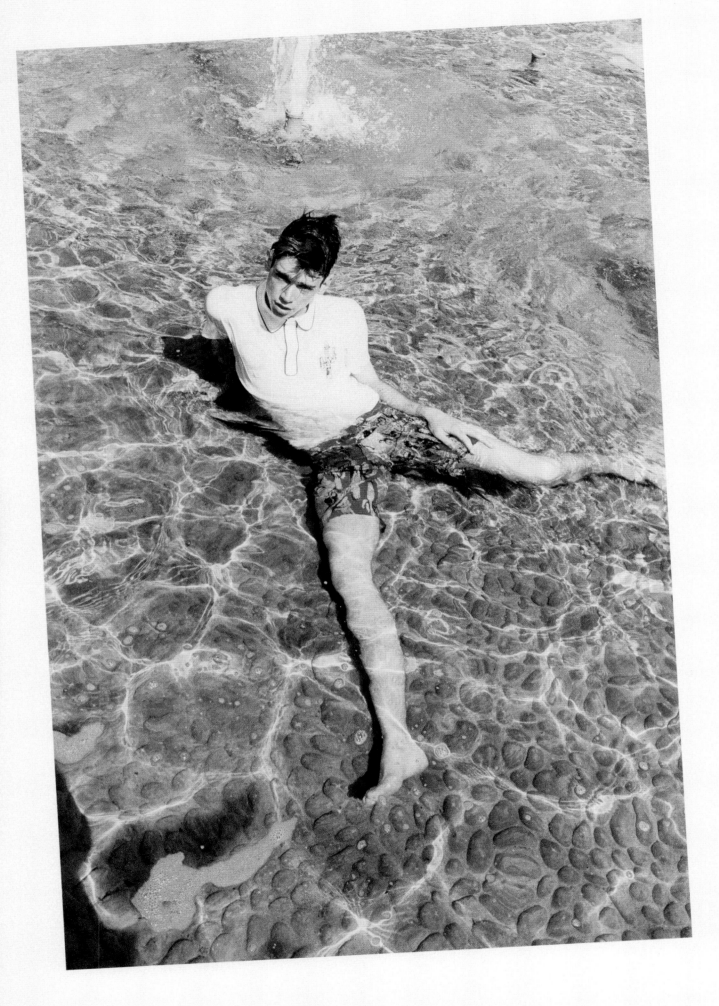

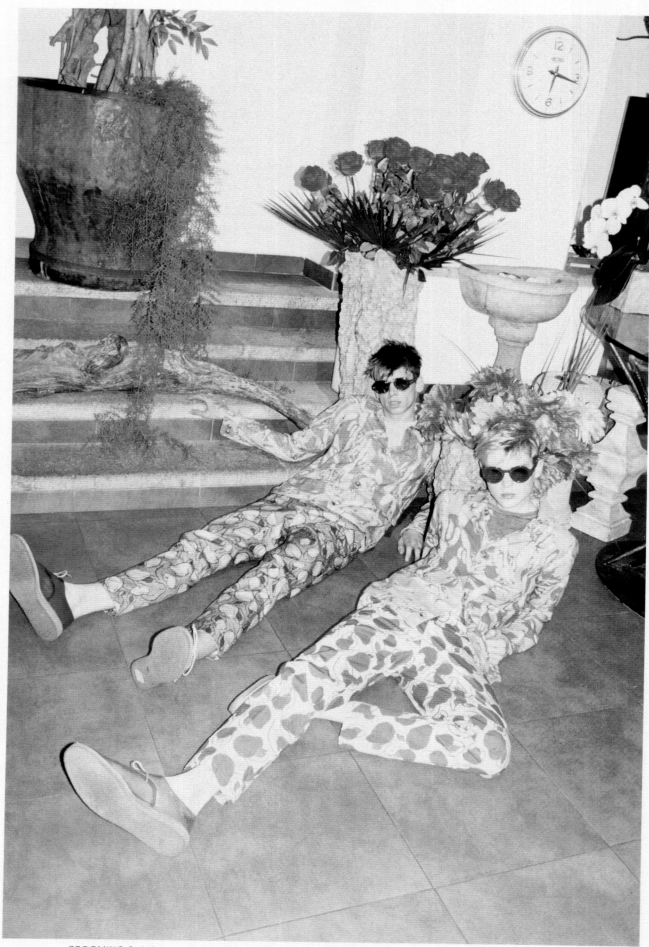

GROOMING Syd Hayes at Premier Hair and Make-up MODELS Cole Mohr, Eric Lyle Lodwick at Request Models,
Shane Gambill at Adams PHOTOGRAPHIC ASSISTANT Maxim Kelly STYLING ASSISTANT Ellie Grace Cumming

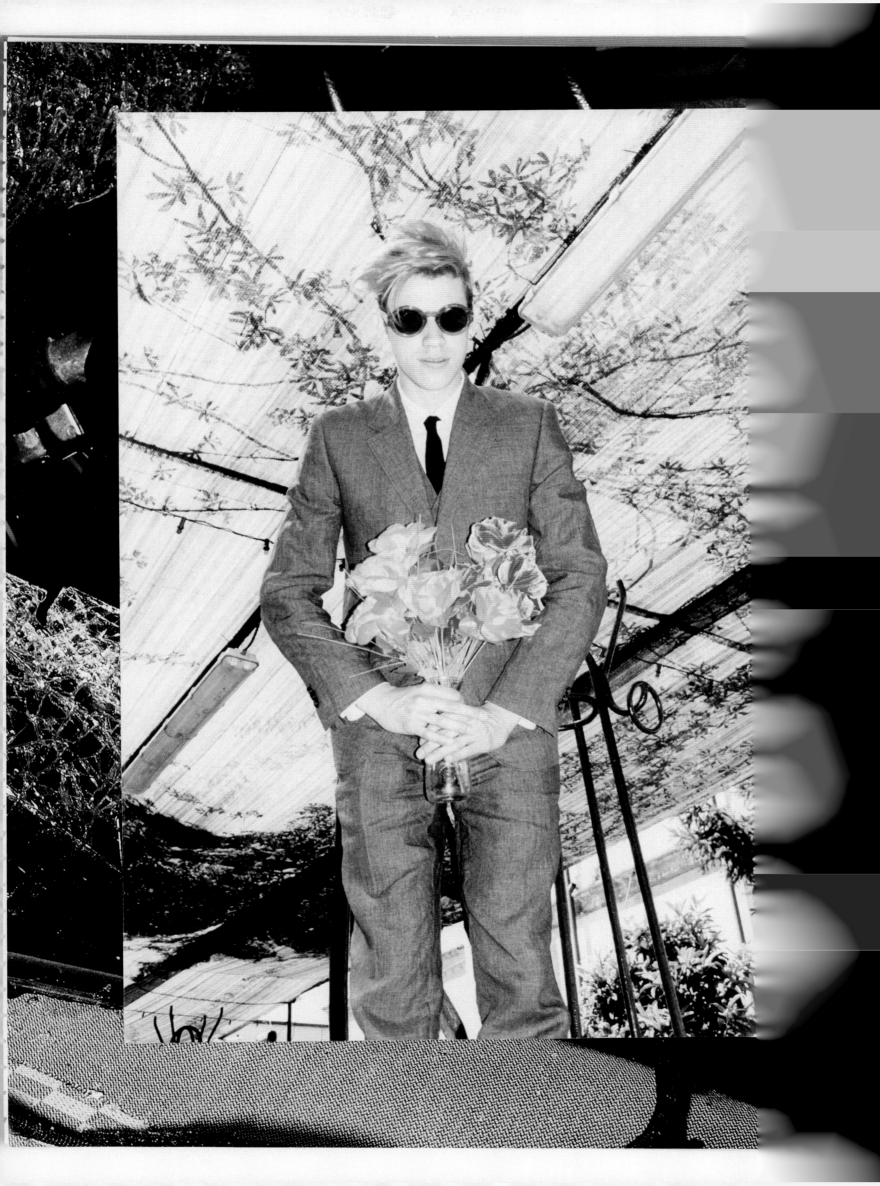

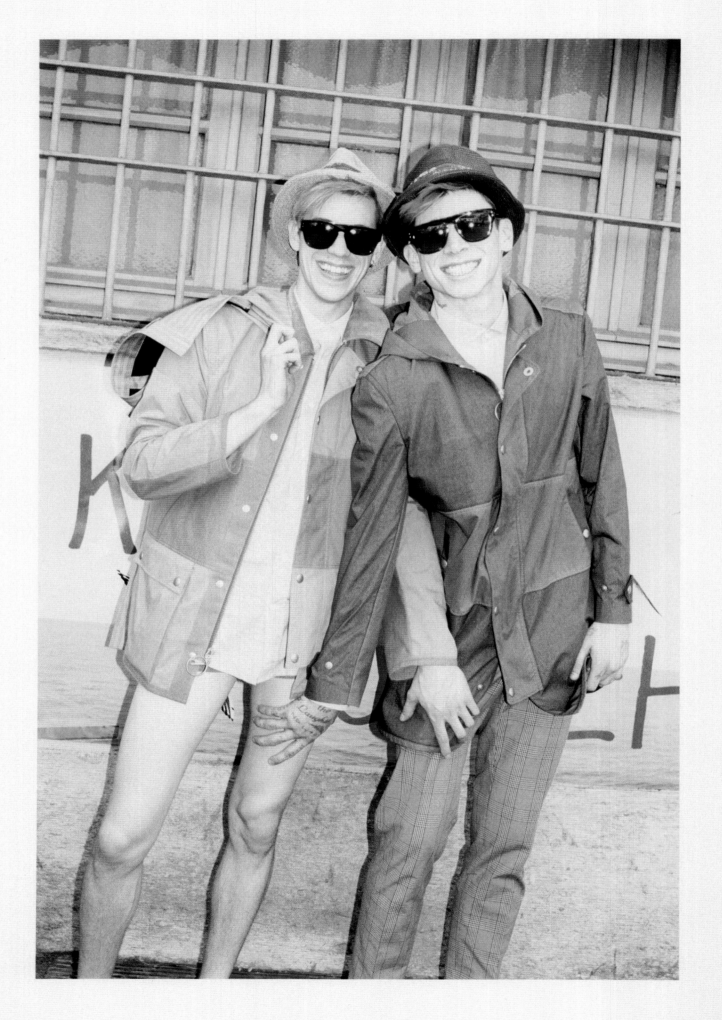

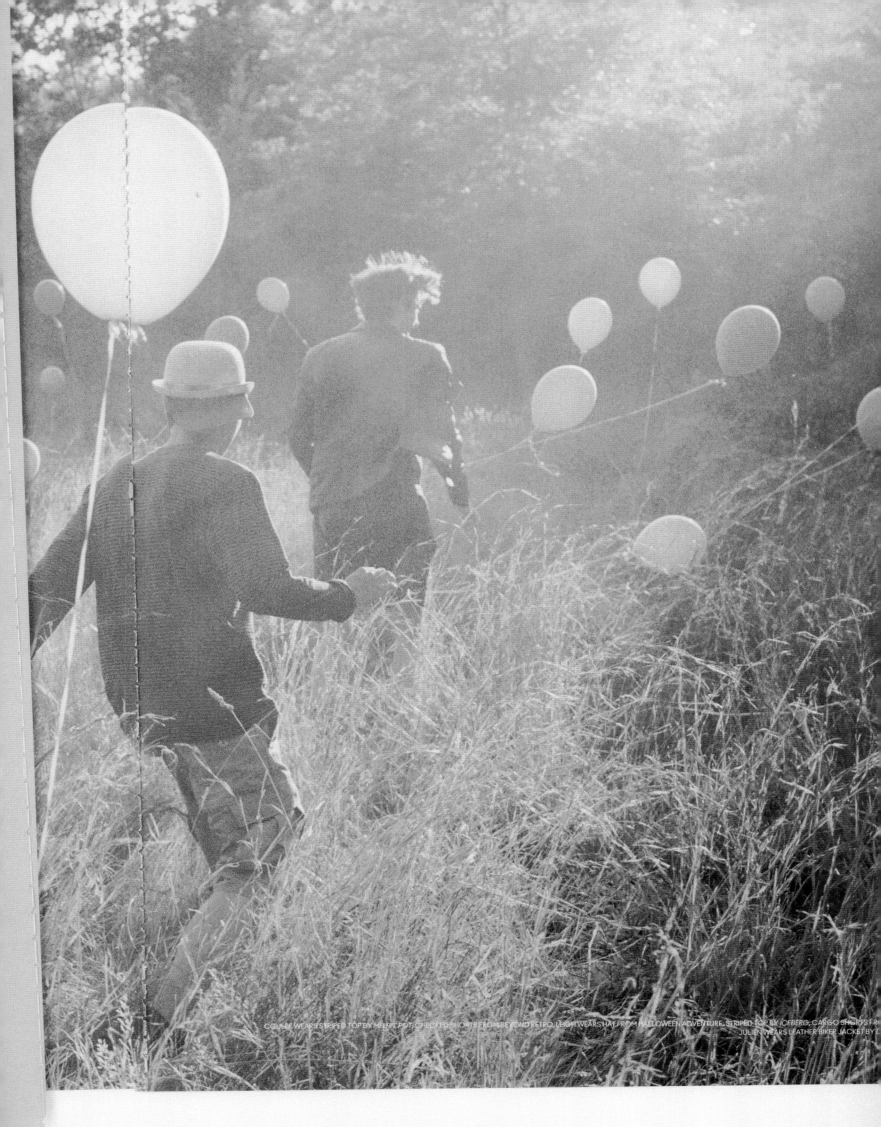

COLIN DE WEARS STRIPED TOP BY MELTIN' POT, CHECKED SHORTS FROM BEYOND RETRO. LEIGH WEARS HAT FROM HALLOWEEN ADVENTURE, STRIPED TOP BY ICEBERG, CARGO SHORTS FR... JULIEN WEARS LEATHER BIKER JACKET BY...

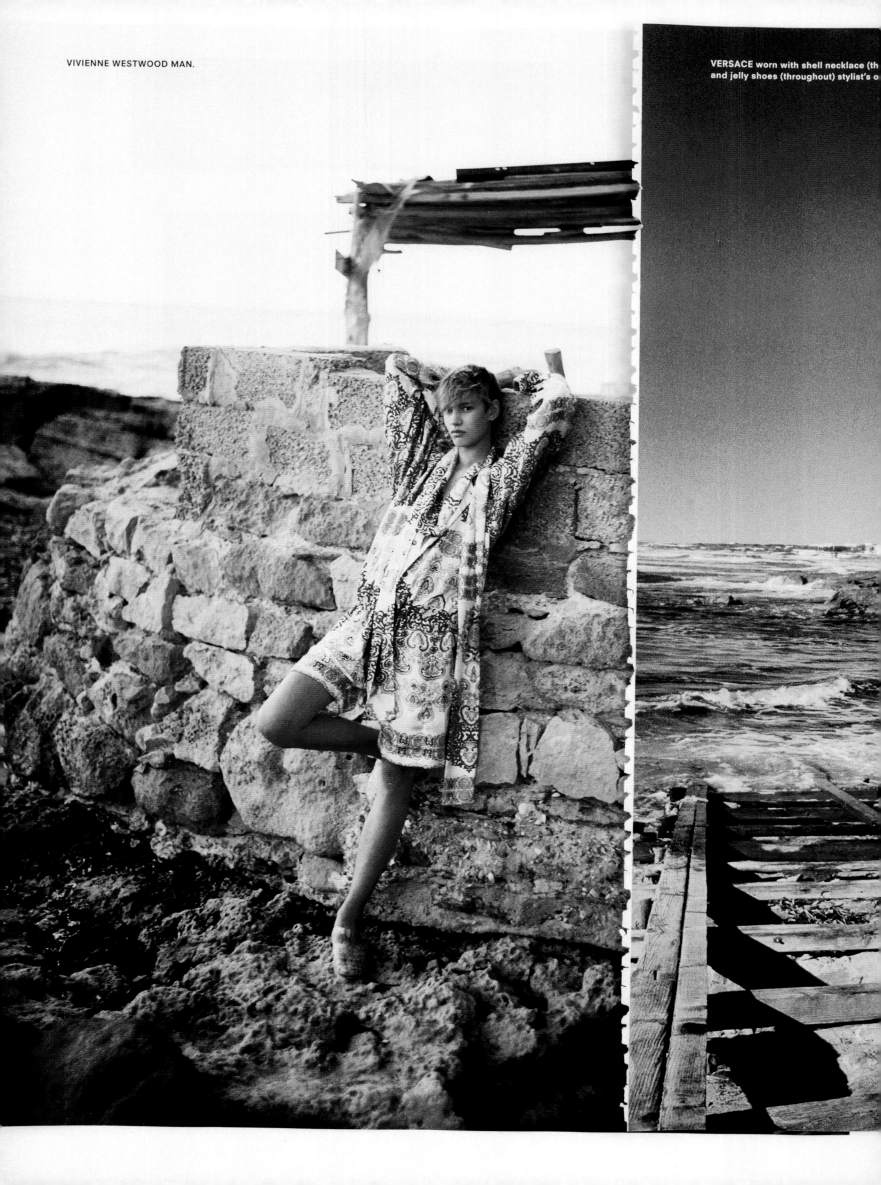

VIVIENNE WESTWOOD MAN.

VERSACE worn with shell necklace (th
and jelly shoes (throughout) stylist's o

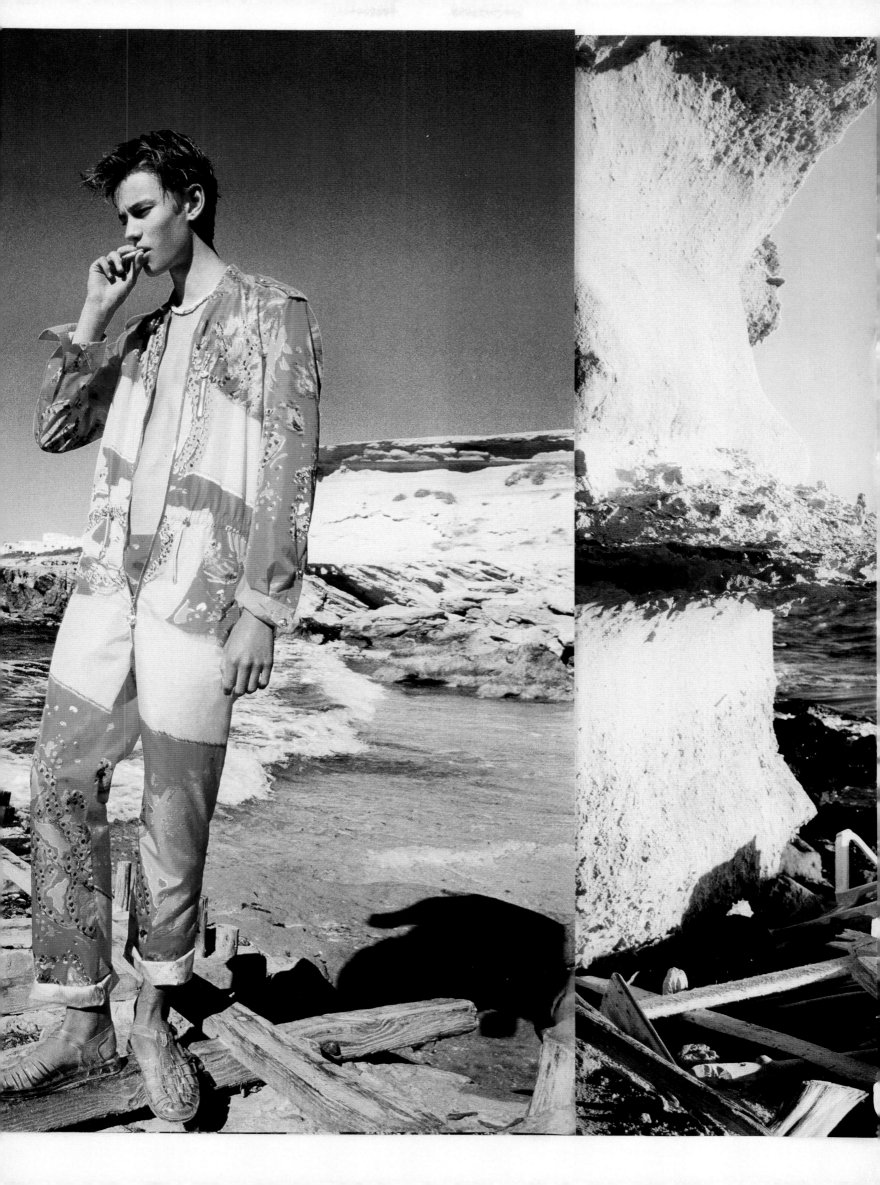

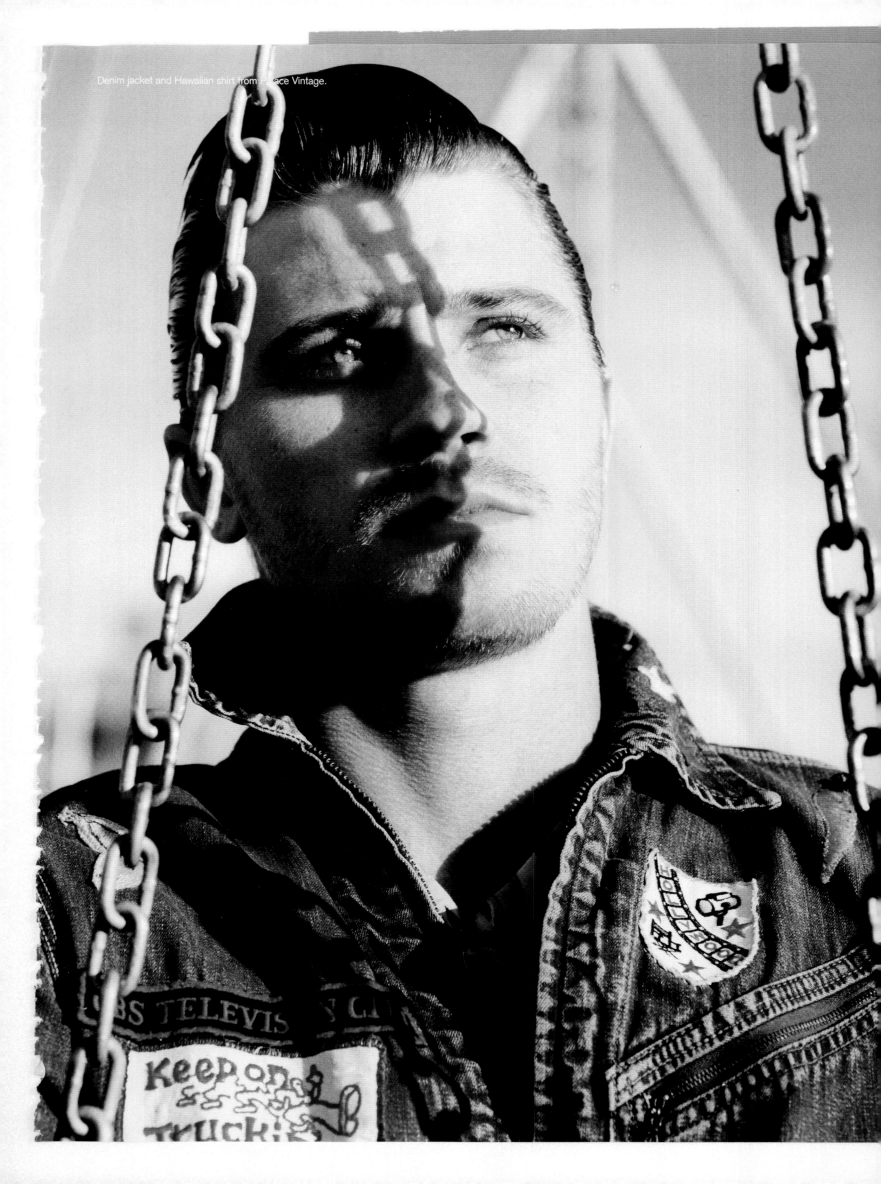

Denim jacket and Hawaiian shirt from Palace Vintage.

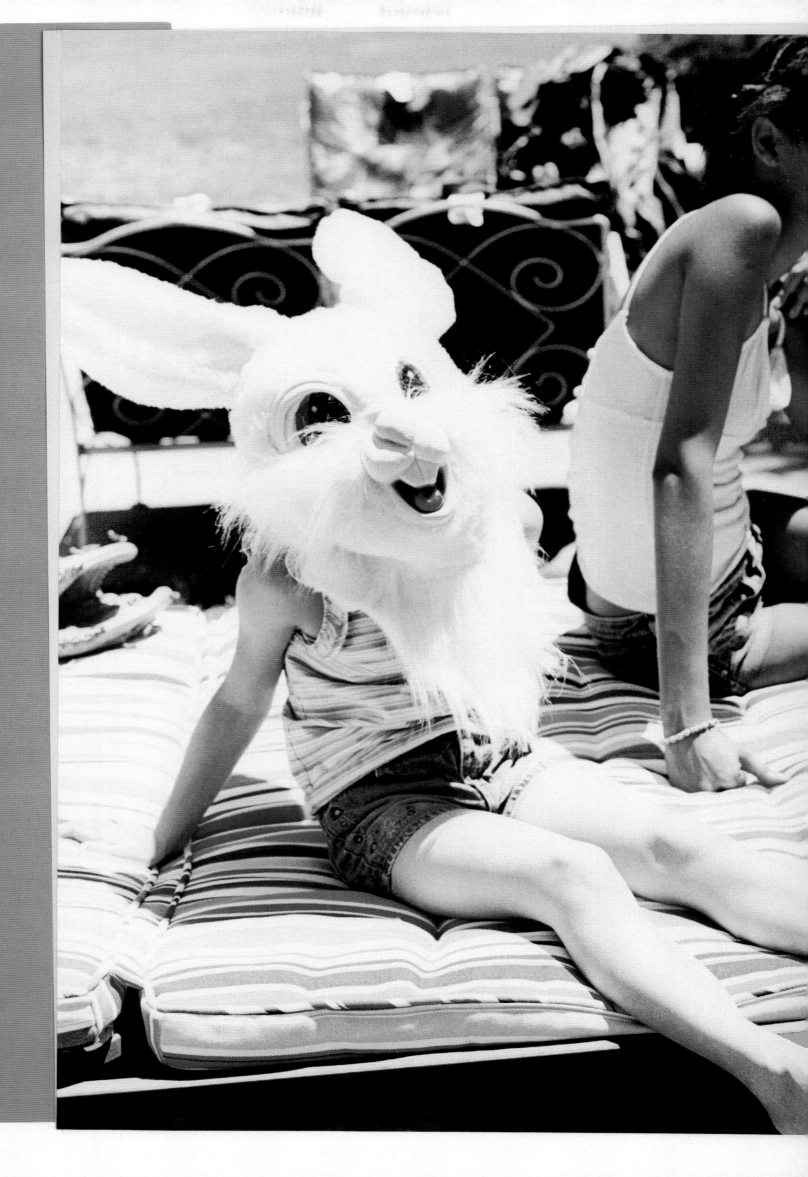

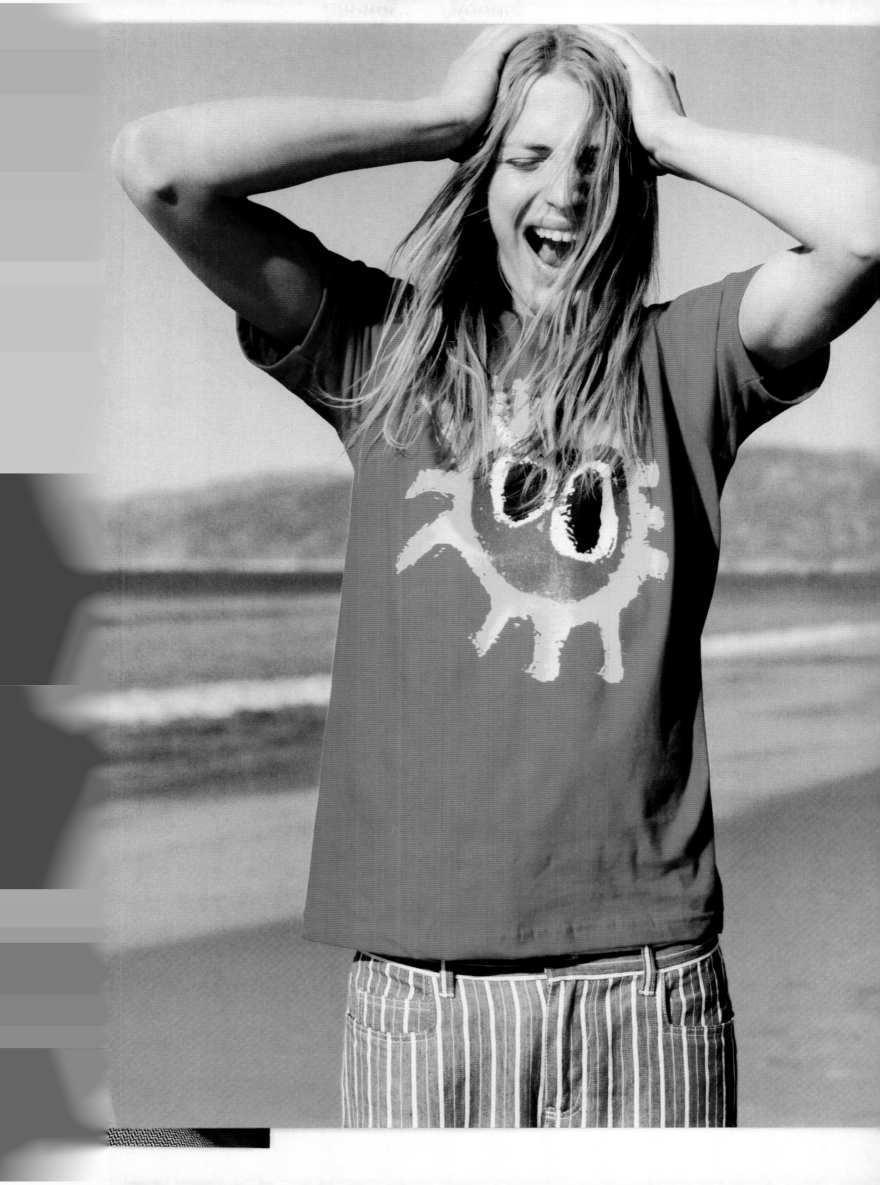

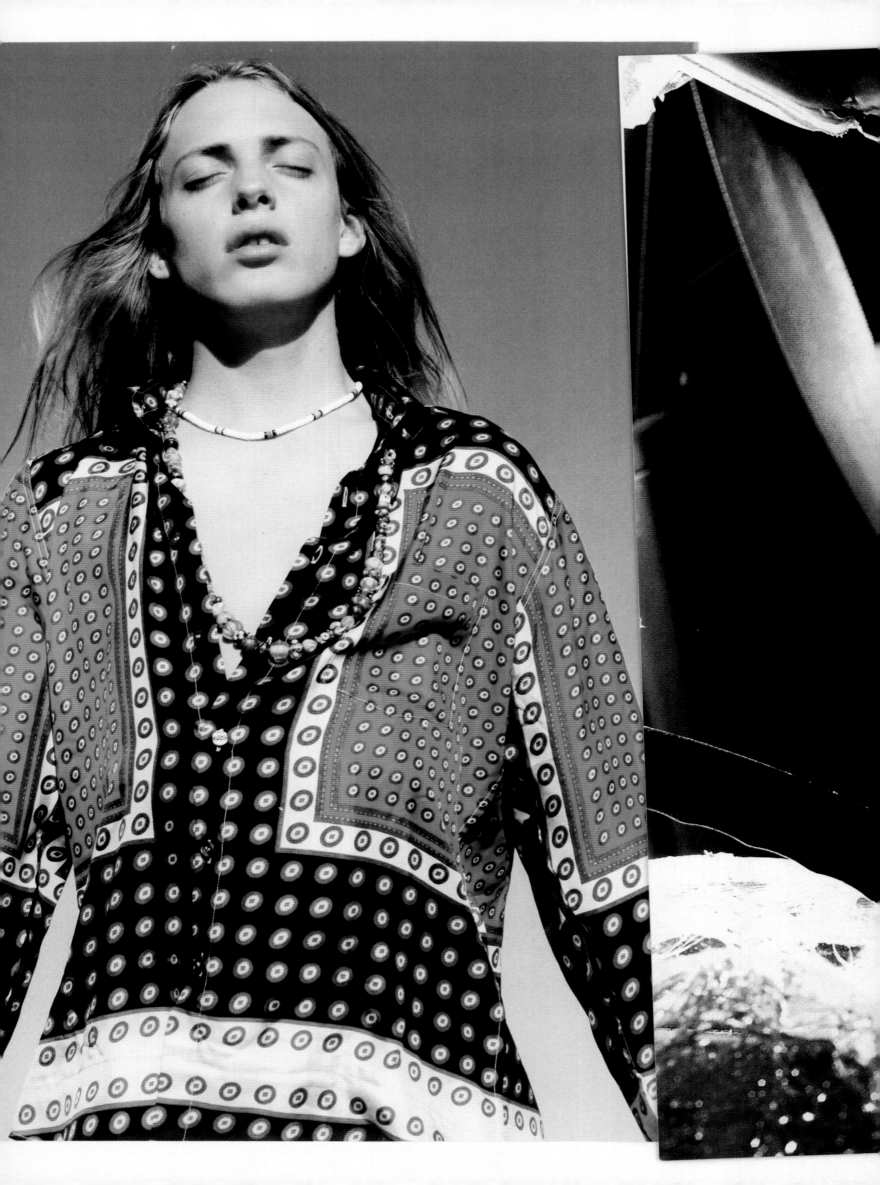

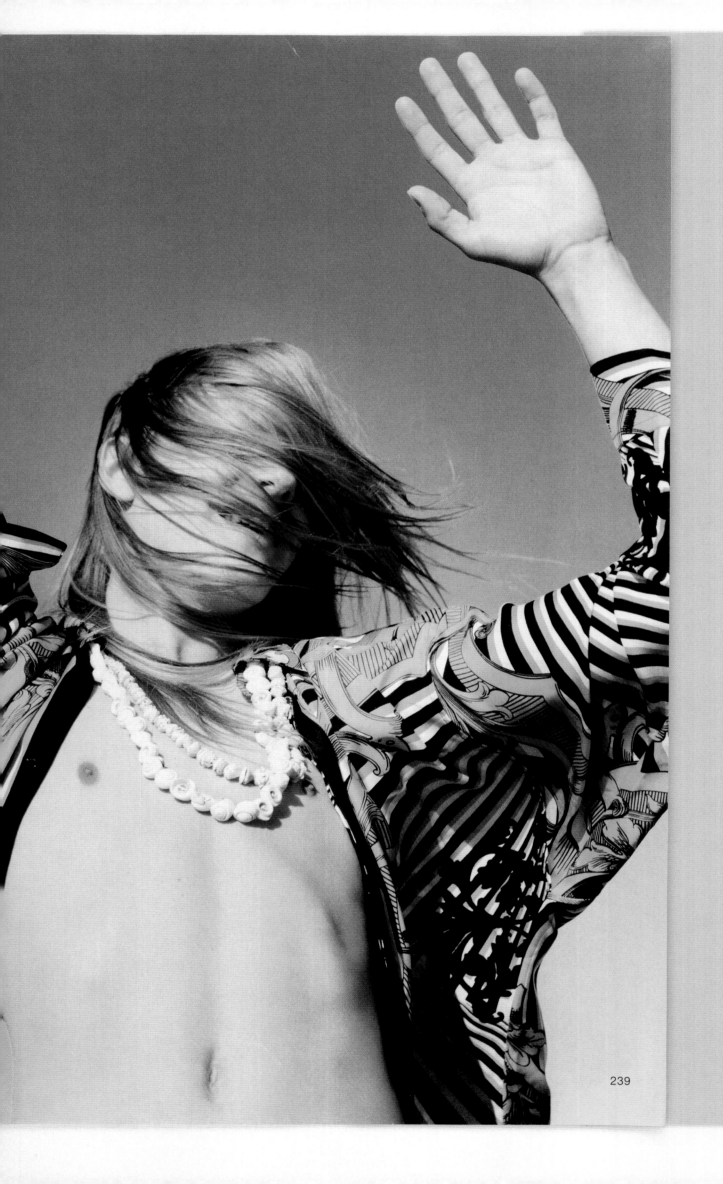

239

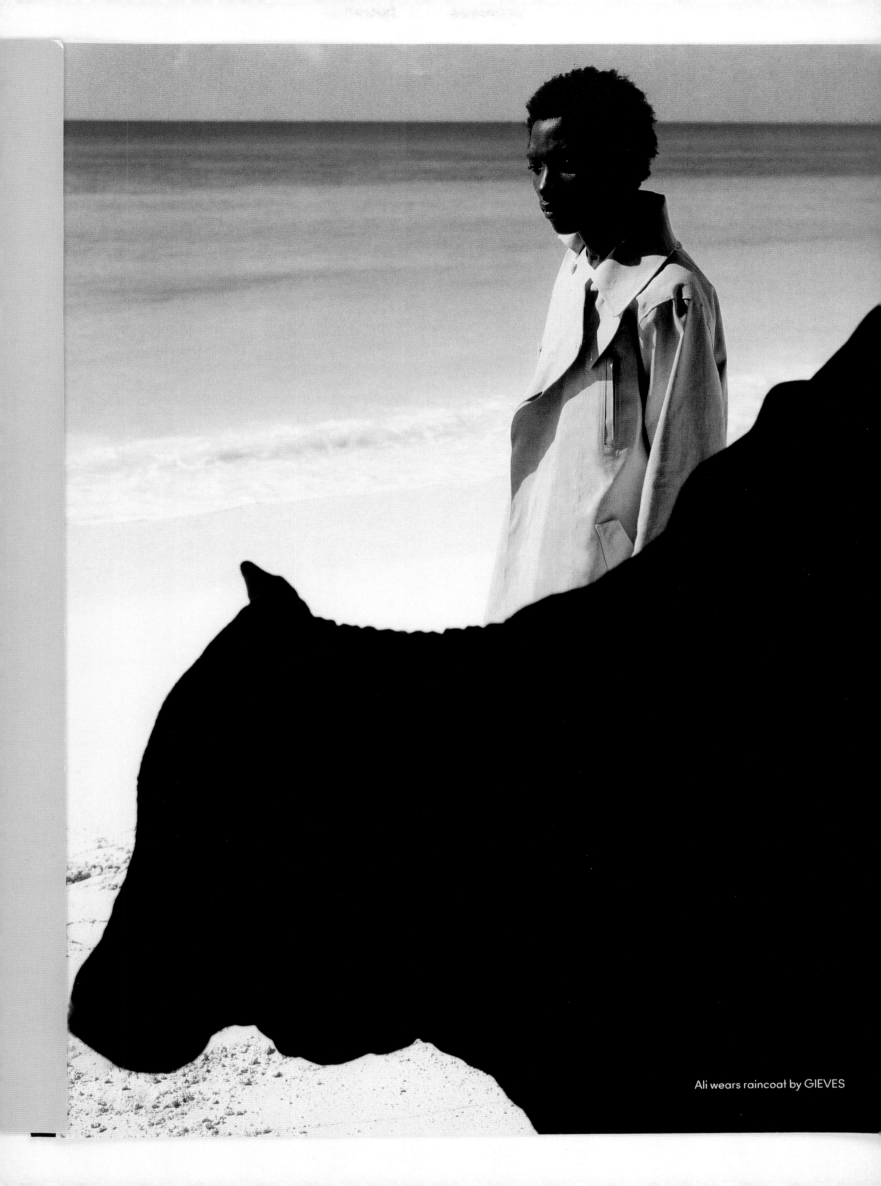

Ali wears raincoat by GIEVES

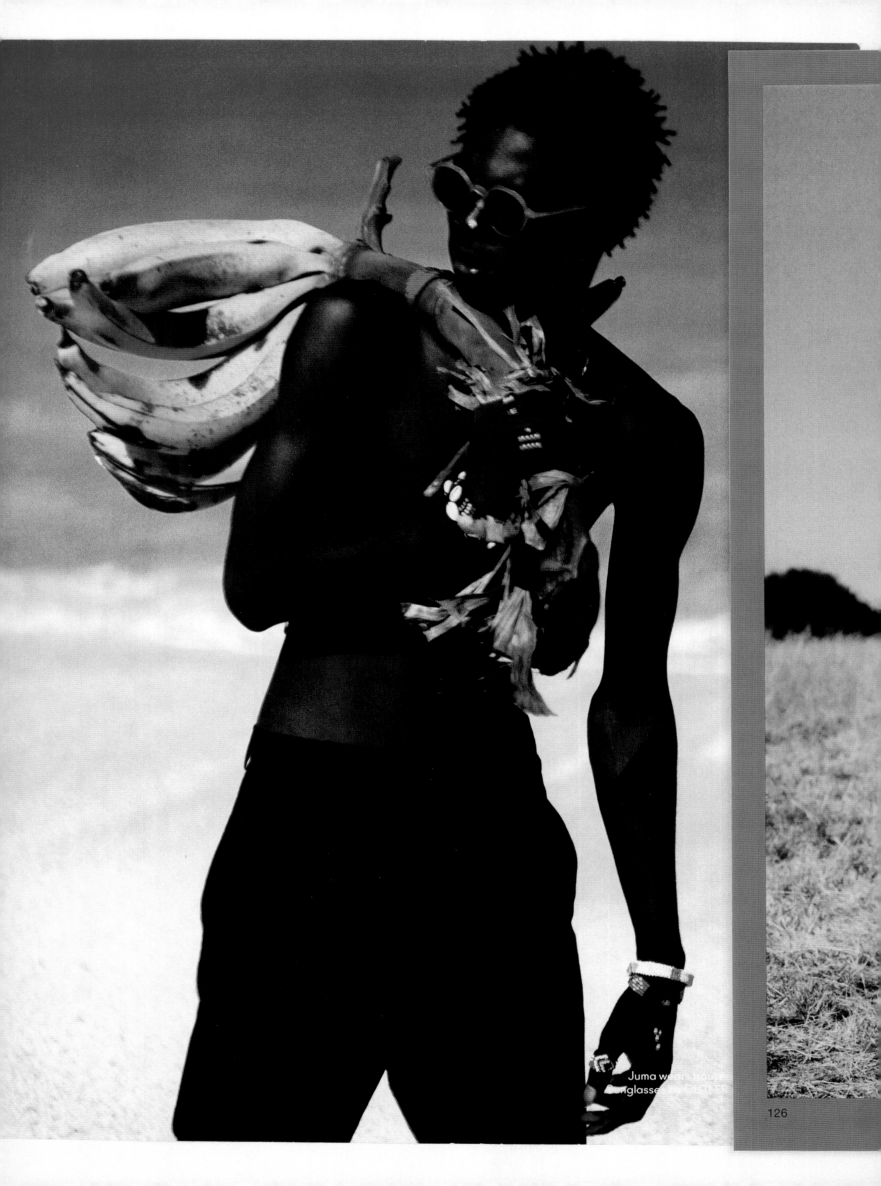

Juma wears Kouya
sunglasses by CUTLER

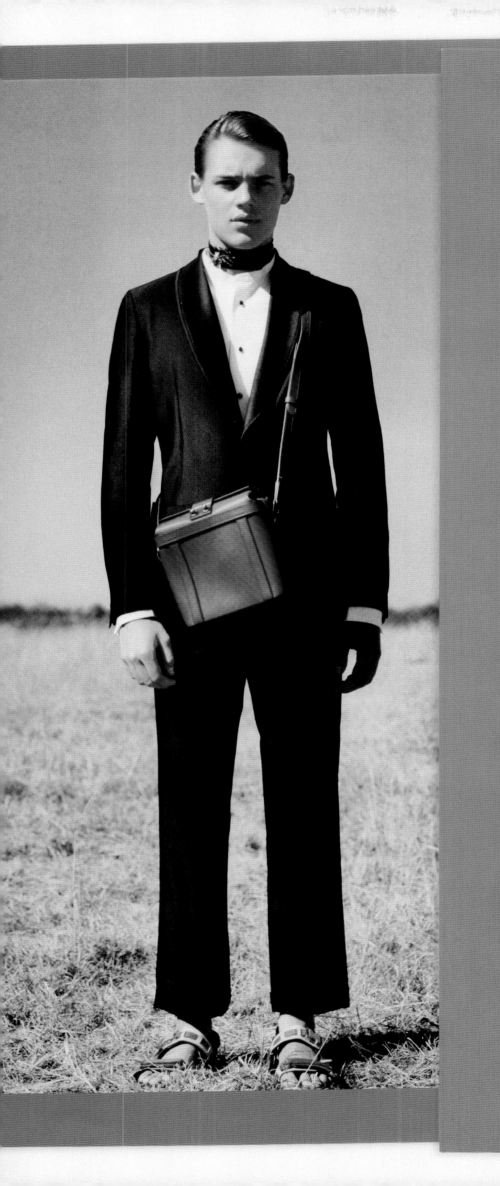

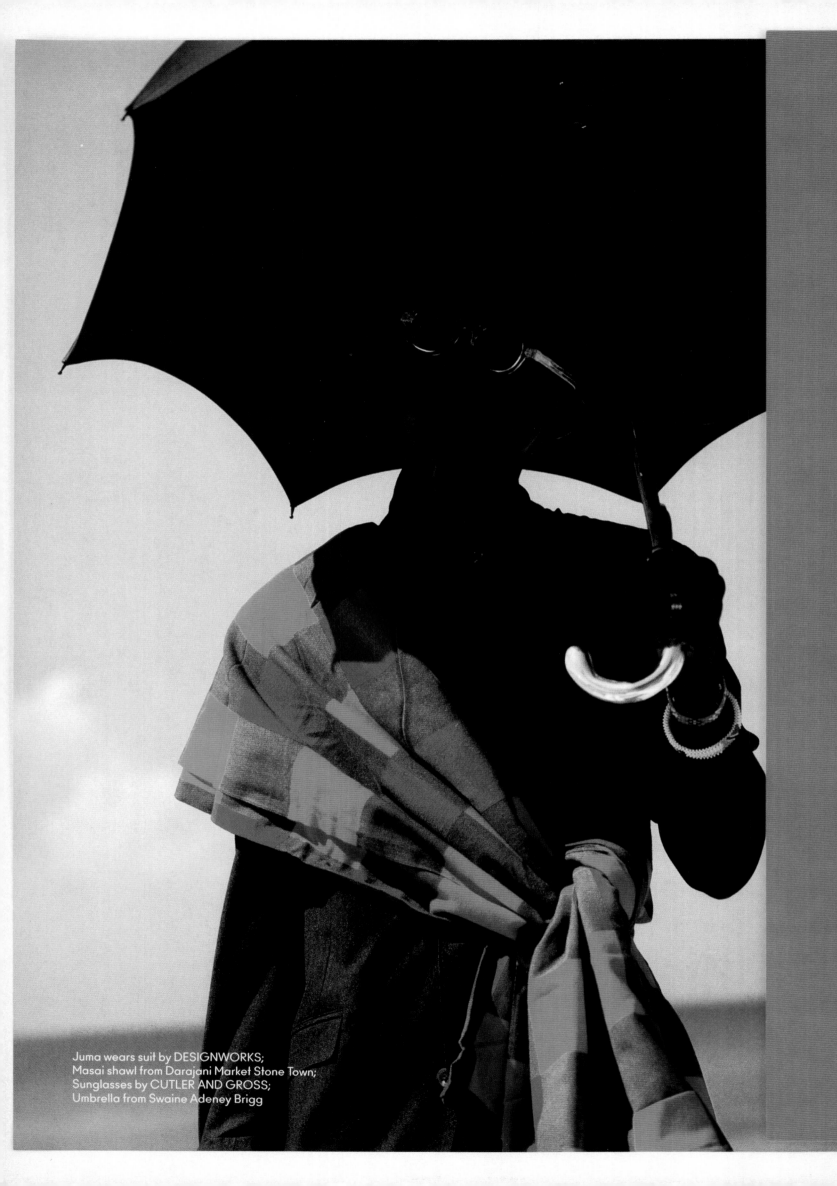

Juma wears suit by DESIGNWORKS;
Masai shawl from Darajani Market Stone Town;
Sunglasses by CUTLER AND GROSS;
Umbrella from Swaine Adeney Brigg

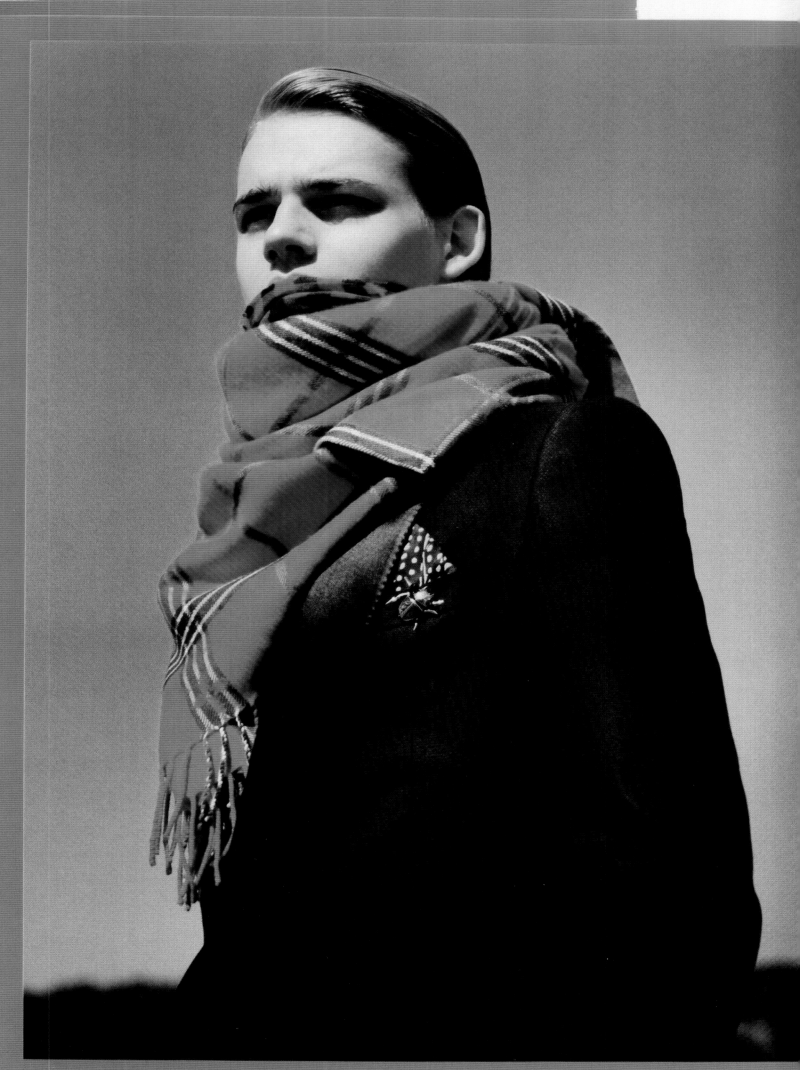

NOBLE SAVAGE

*"To look into the eyes of a wolf is to see
your own soul—hope you like what you see."
—Aldo Leopold*

JAKE & DINOS CHAPMAN

The brothers grim of the art world consider the savage beast within...

"I don't think one needs to describe humans as savage in order to describe them as animals. I don't think being human needs to have a concept of savagery to reduce it to what it is. I think rationality is animal and reason is animal—these things don't diverge from the mechanisms of animalistic behaviour and instinct, they are just elaborations of it. I don't believe in an opposition between good conduct and bad conduct, the idea that savage or bestial behaviour is more an index of animalistic behaviour than good conduct. I think that good conduct is equally animal."—*Jake*

"There are different notions of savagery, aren't there? I think savage is untamed, natural... man at base level. It's not necessarily a thing to be feared, but something to be desired—the desire to be unfettered by constructs. You don't have to do very much to make people shed a veneer of morality, to lose a sense of society. Just turn off the water or electricity for a couple of days and you're already halfway there! That savage aggression is very, very close to the surface in all of us, and it's just held in place by strong laws and some sense of morality. But it doesn't take much to get rid of it."—*Dinos*

Issue 17 Autumn/Winter 2013 Mens Fashion

UK £5.95 / US $14.99

Another Man

Ezra Miller

Photographed by Willy Vanderperre

Brian Eno, The Chapman Brothers, Alejandro Jodorowsky, Elias Bender Rønnenfelt

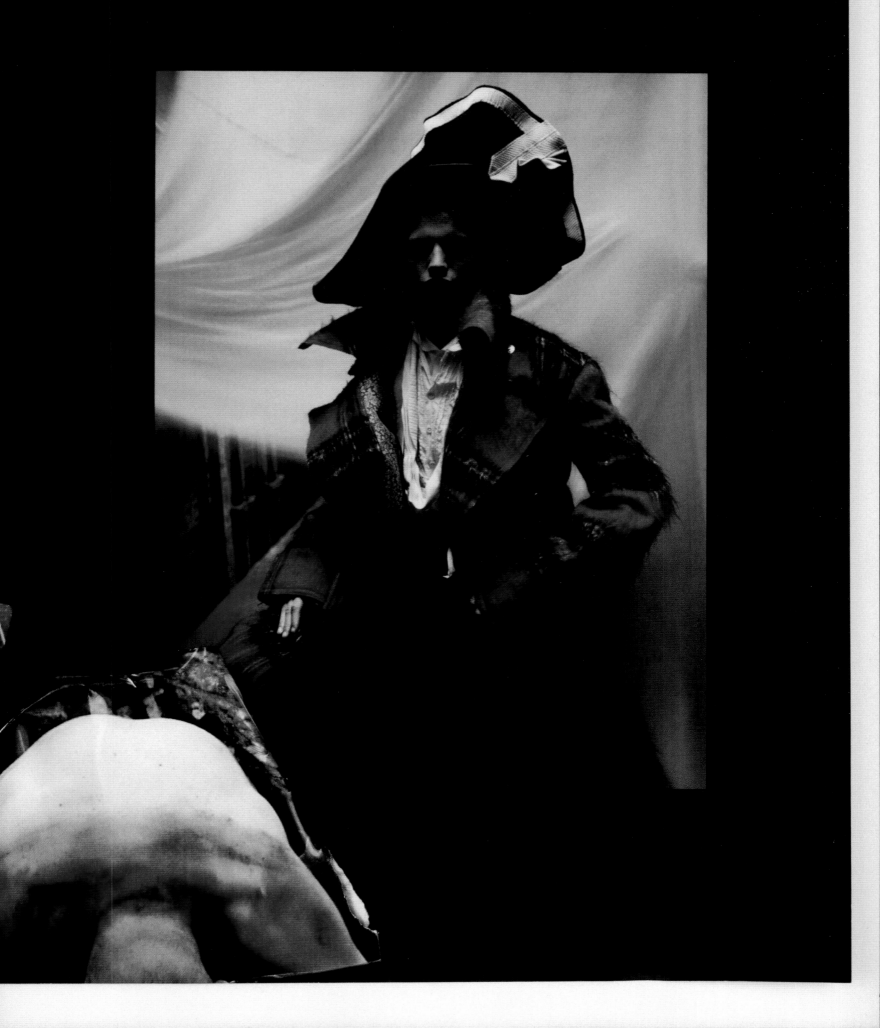

ABOVE JOHN WEARS TROUSERS BY *RAF SIMONS*; WOODEN BELT BY *ALEXANDER MCQUEEN STUDIO*; LEATHER BELT BY *BELSTAFF*
RIGHT TOMS WEARS EMBROIDERED SHEARLING COAT AND PINSTRIPE TROUSERS BY *BURBERRY PRORSUM*; POLKA DOT SHIRT (WORN UNDERNEATH) BY
VIVIENNE WESTWOOD MAN; POLKA DOT BOW TIE BY *RALPH LAUREN PURPLE LABEL*; BLACK SILK SHIRT AND BEADED SASH BY *ALEXANDER MCQUEEN*; WAISTCOAT,
CANE AND FLORAL PRINT SCARF FROM THE ROYAL NATIONAL THEATRE COSTUME HIRE; PATENT LEATHER SHOES BY *GUCCI*

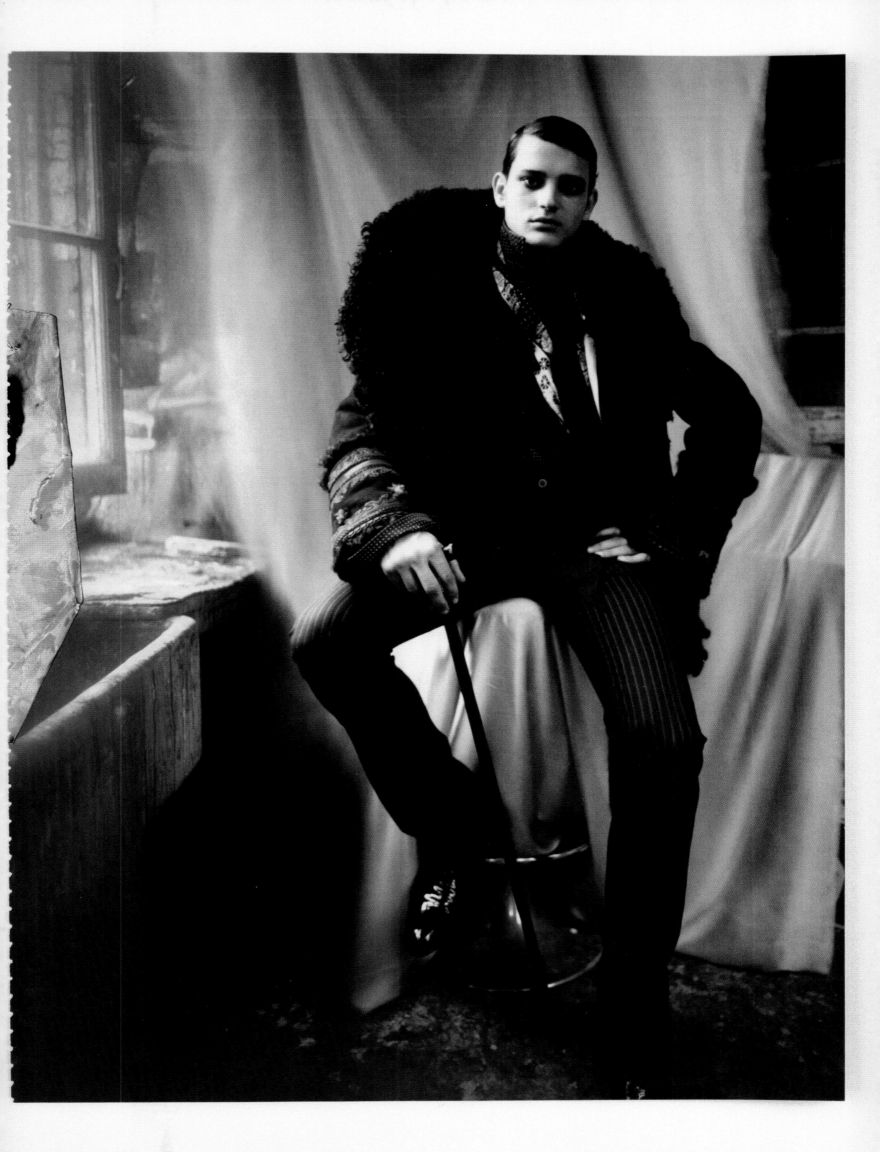

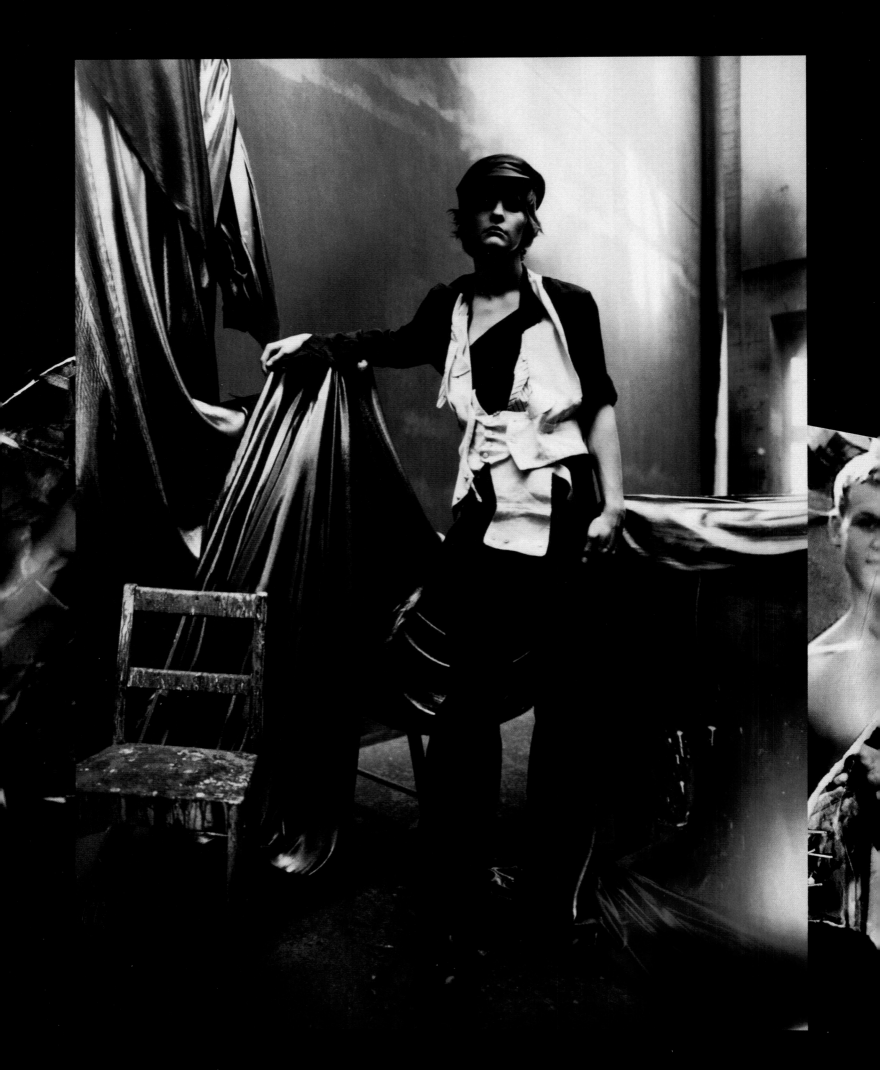

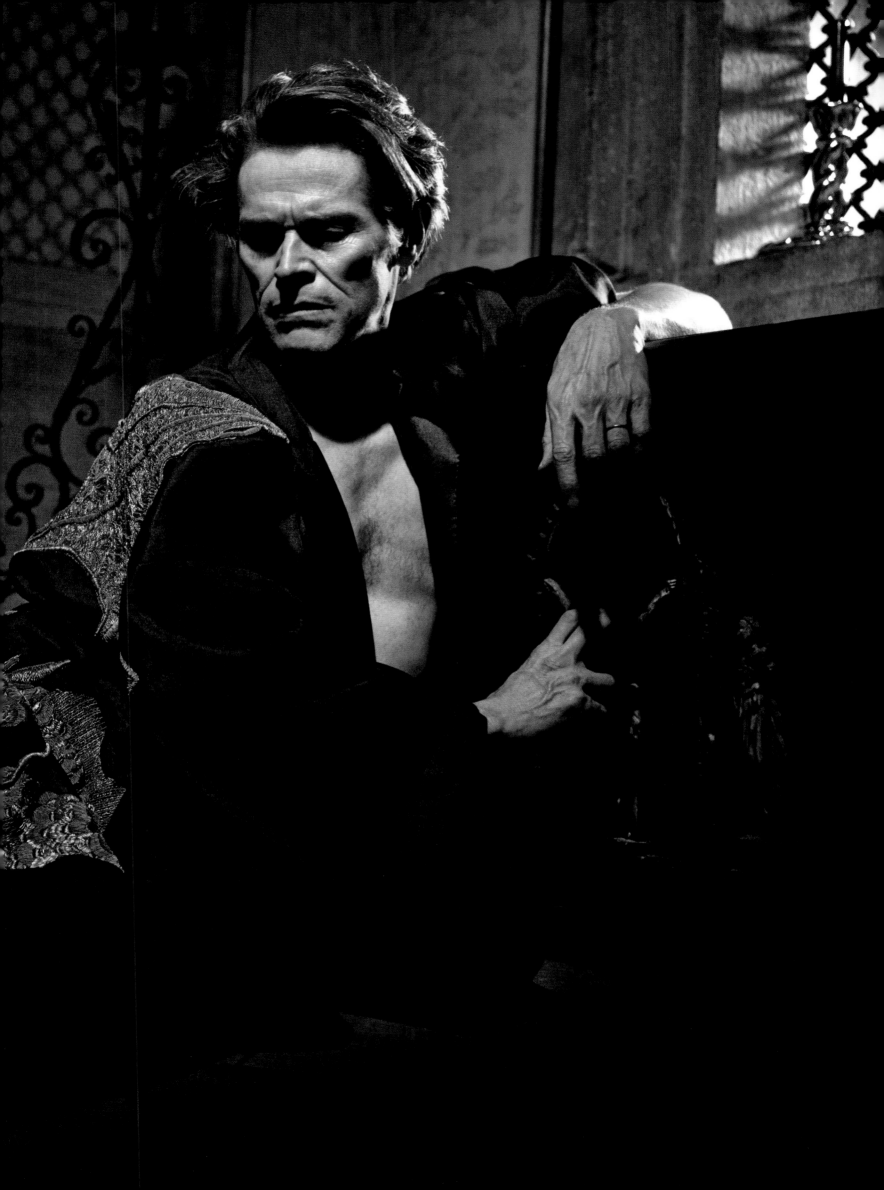

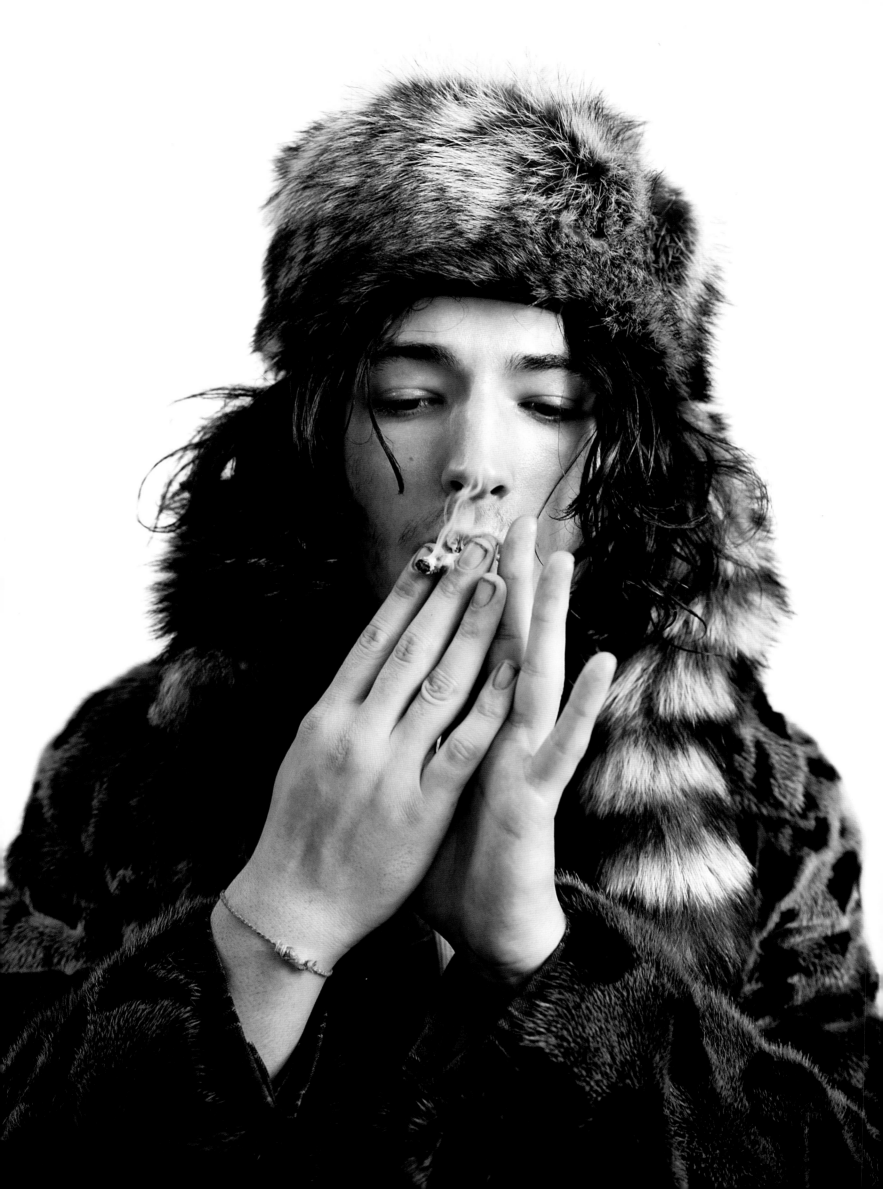

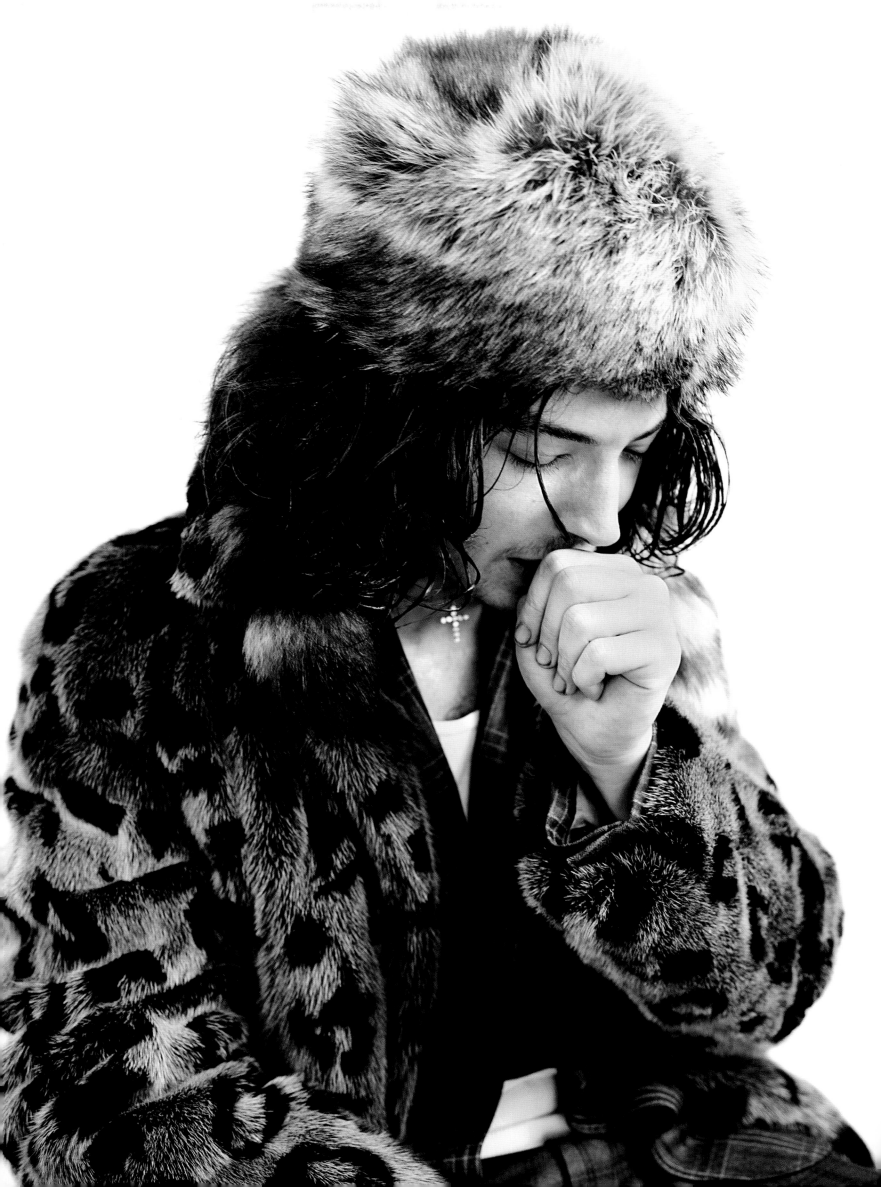

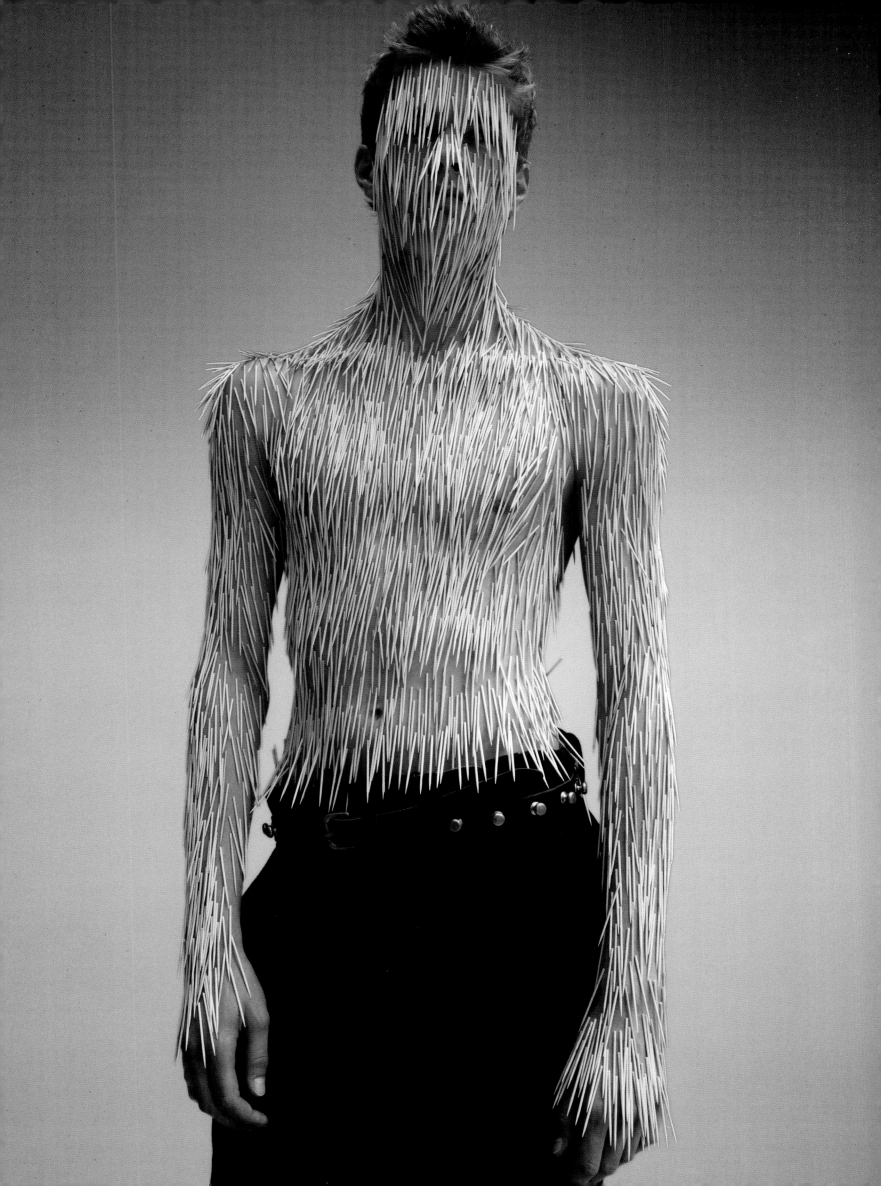

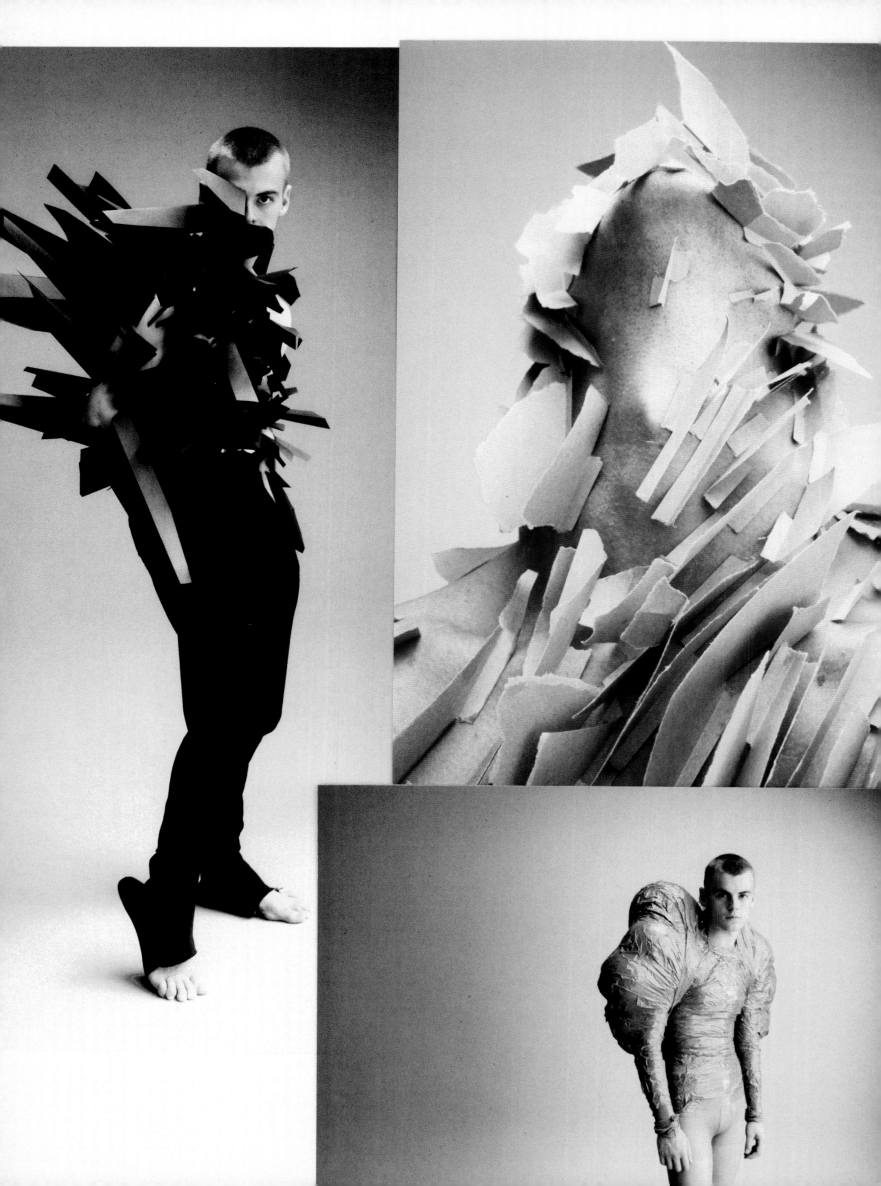

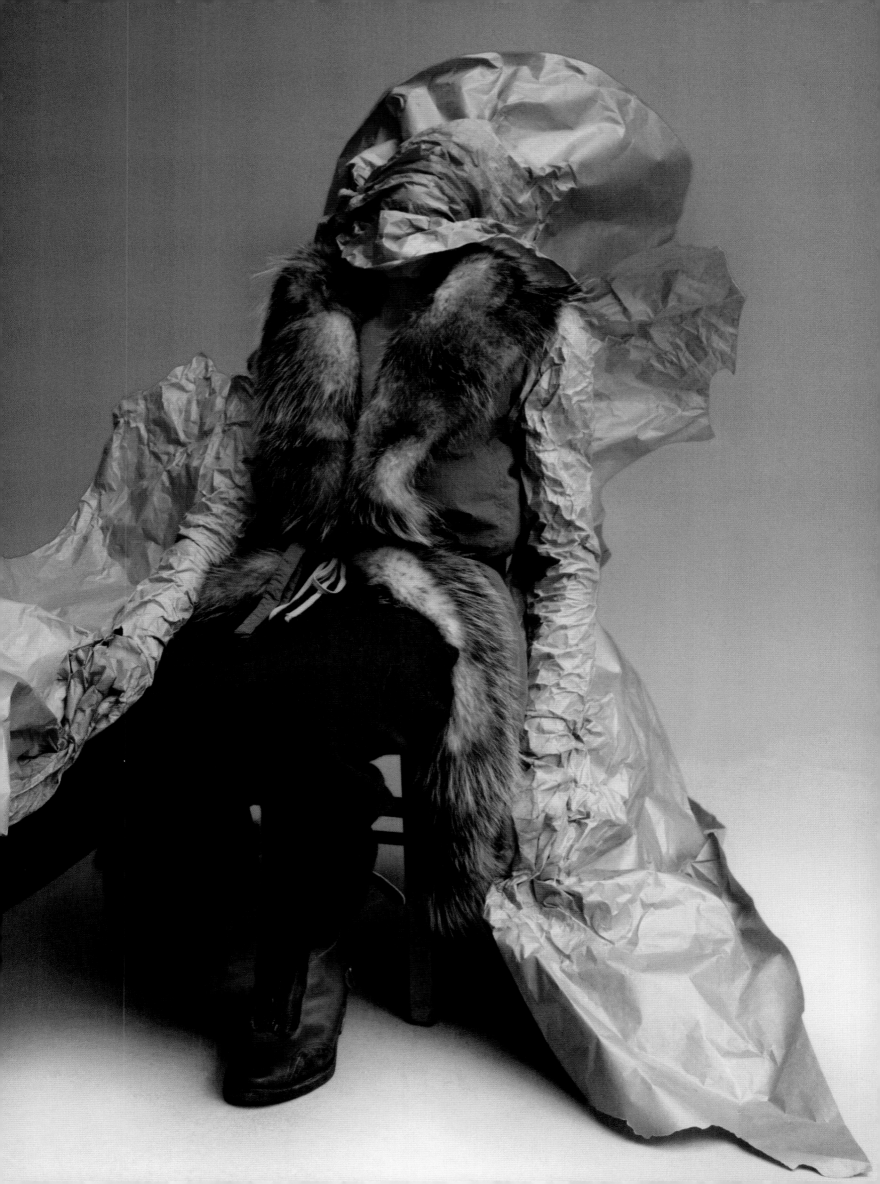

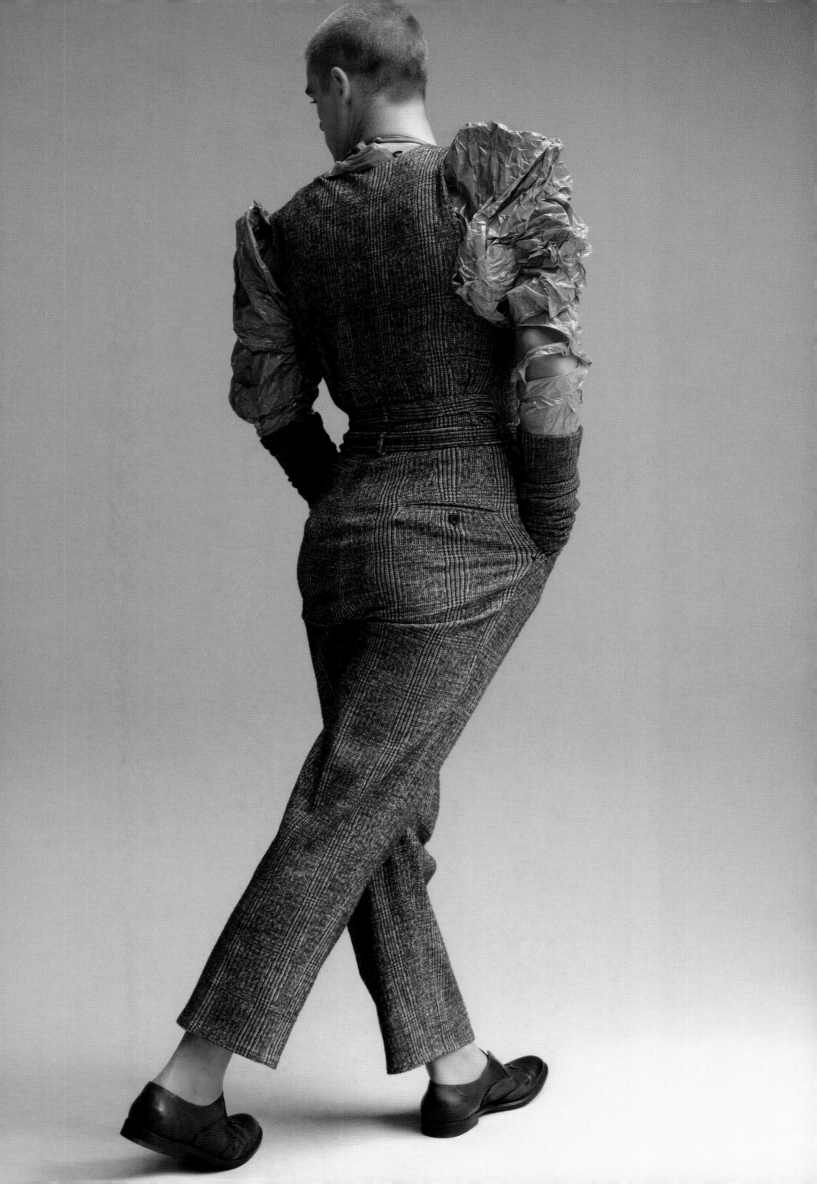

Richie wears sheer snake print top and trousers by Raf Simons

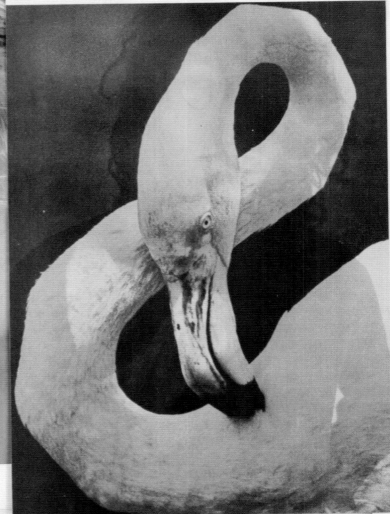

Michael wears fur lined parka by Topman Design; Shearling vest by Marc Jacobs

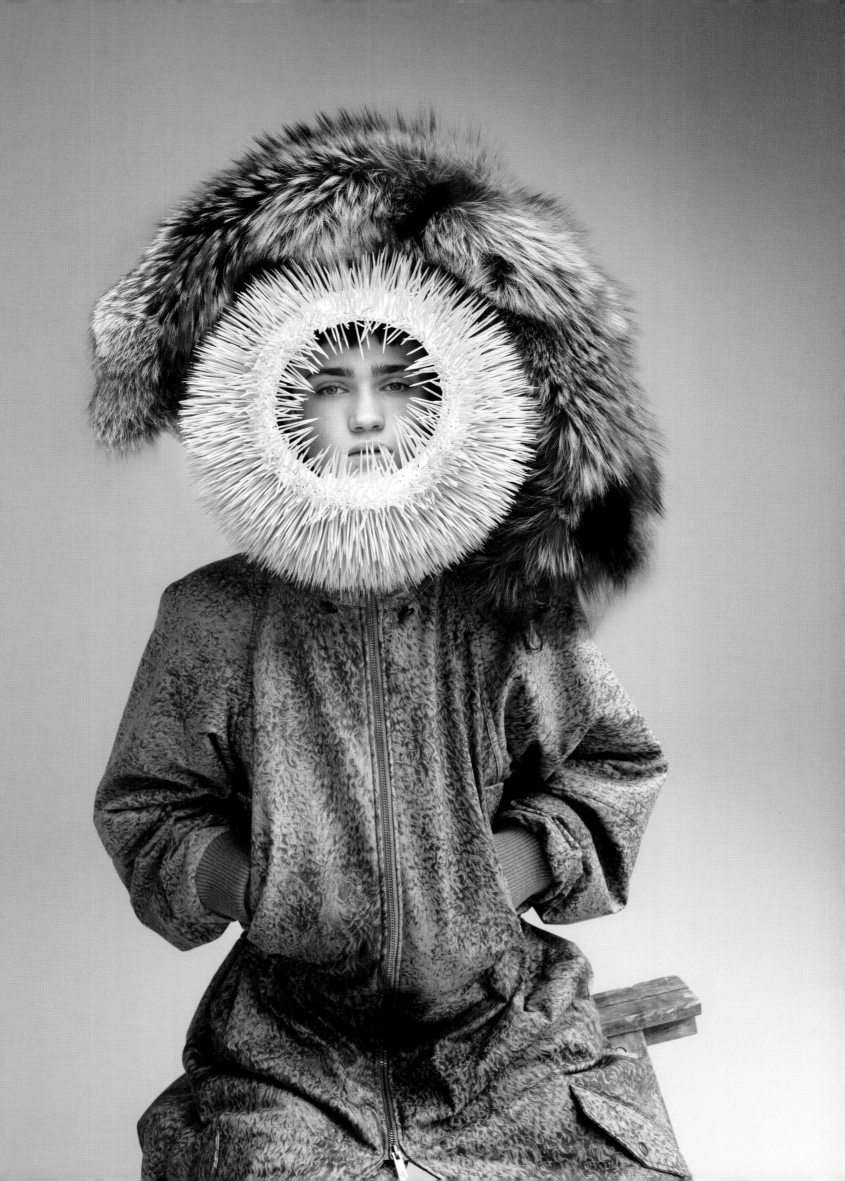

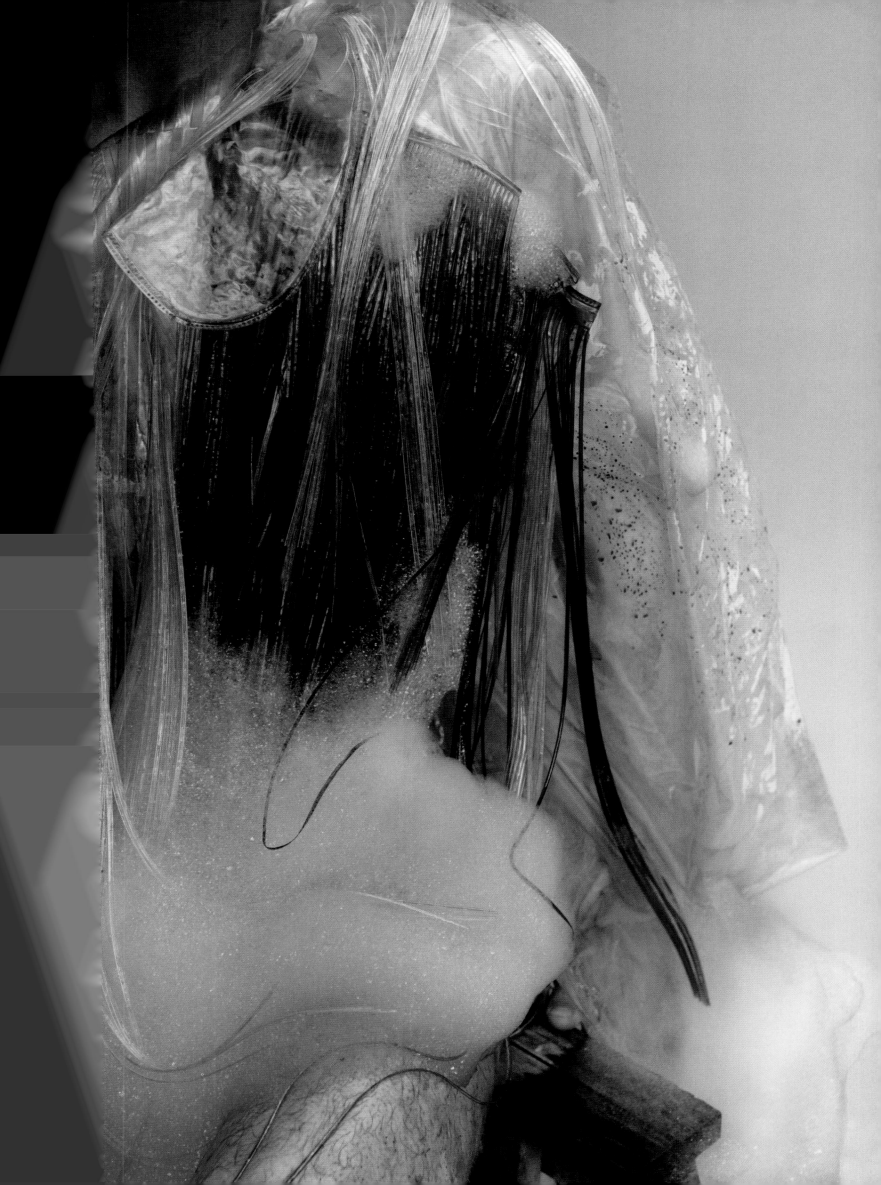

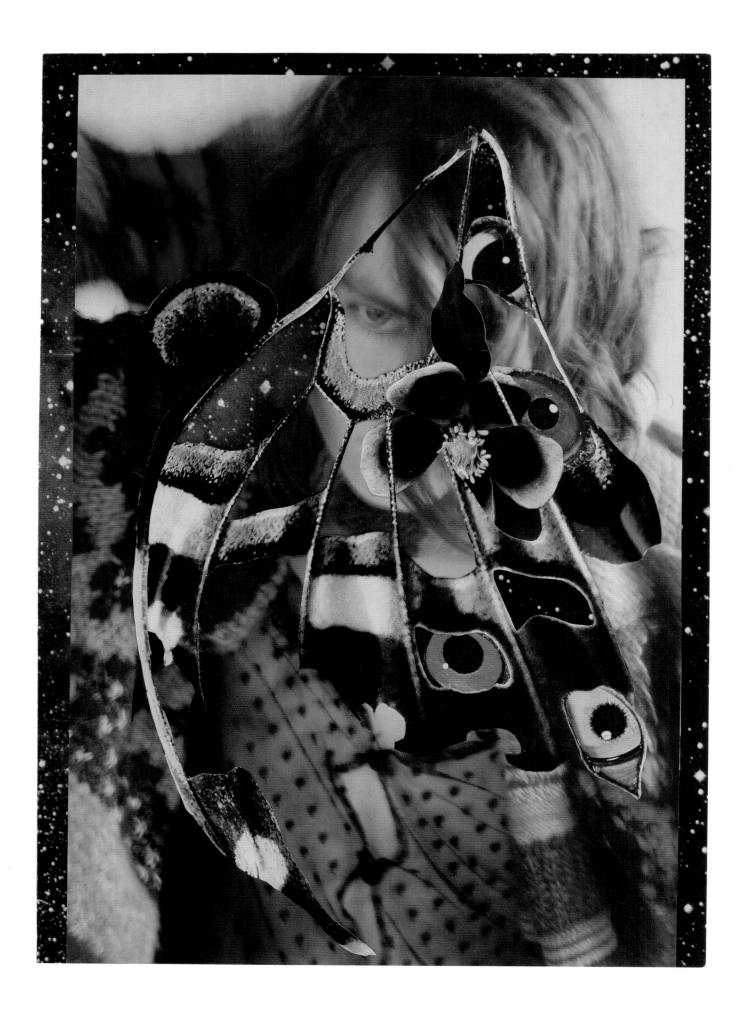

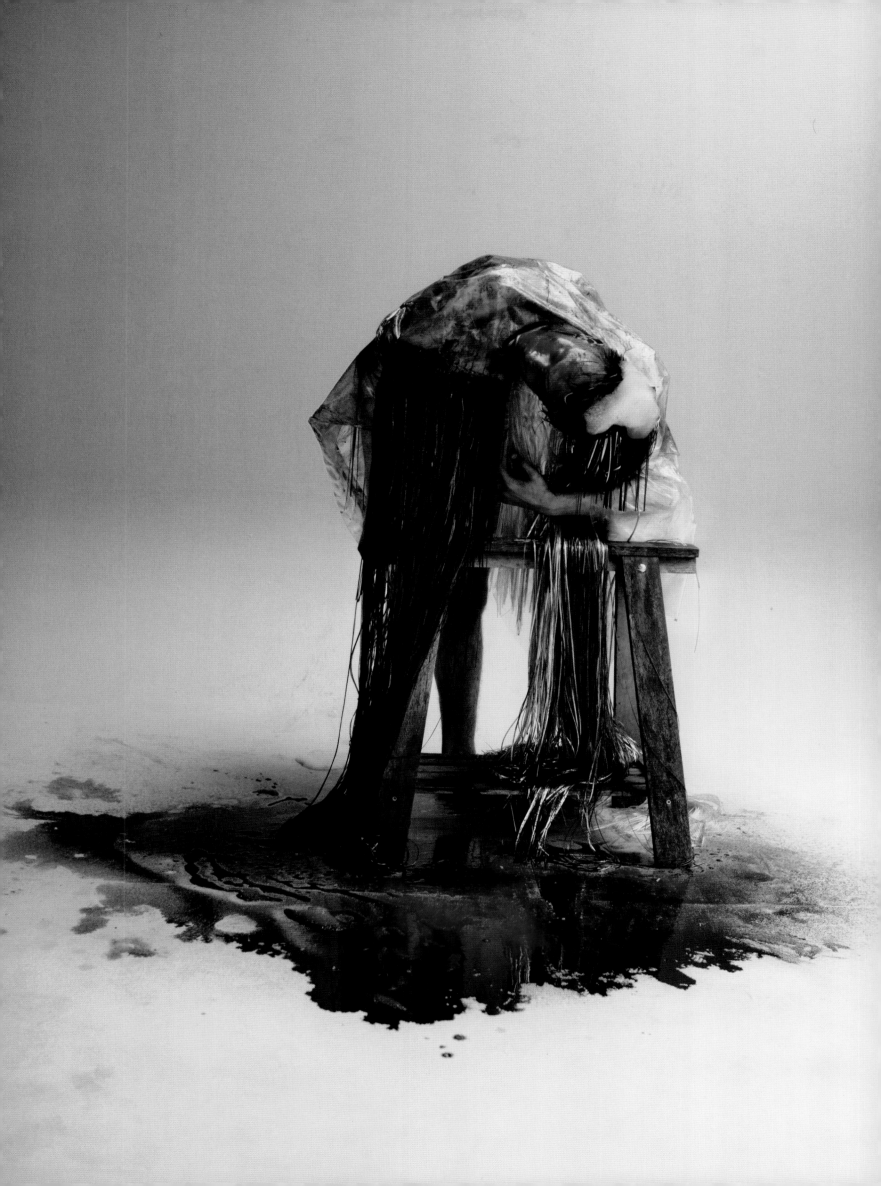

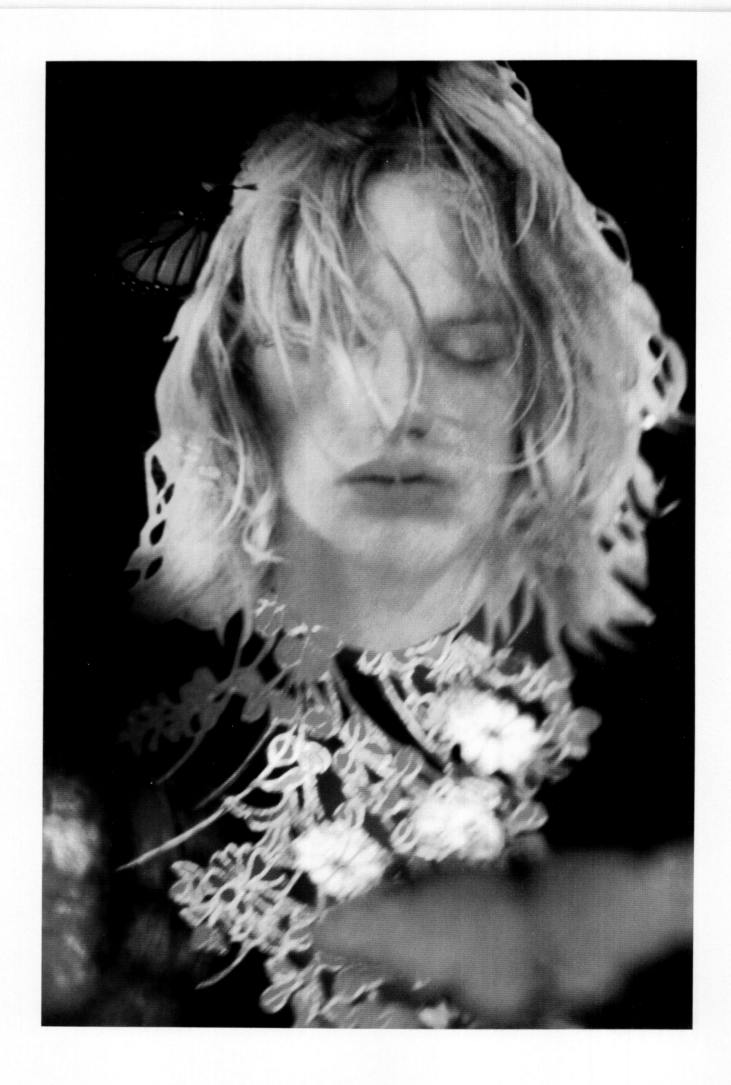

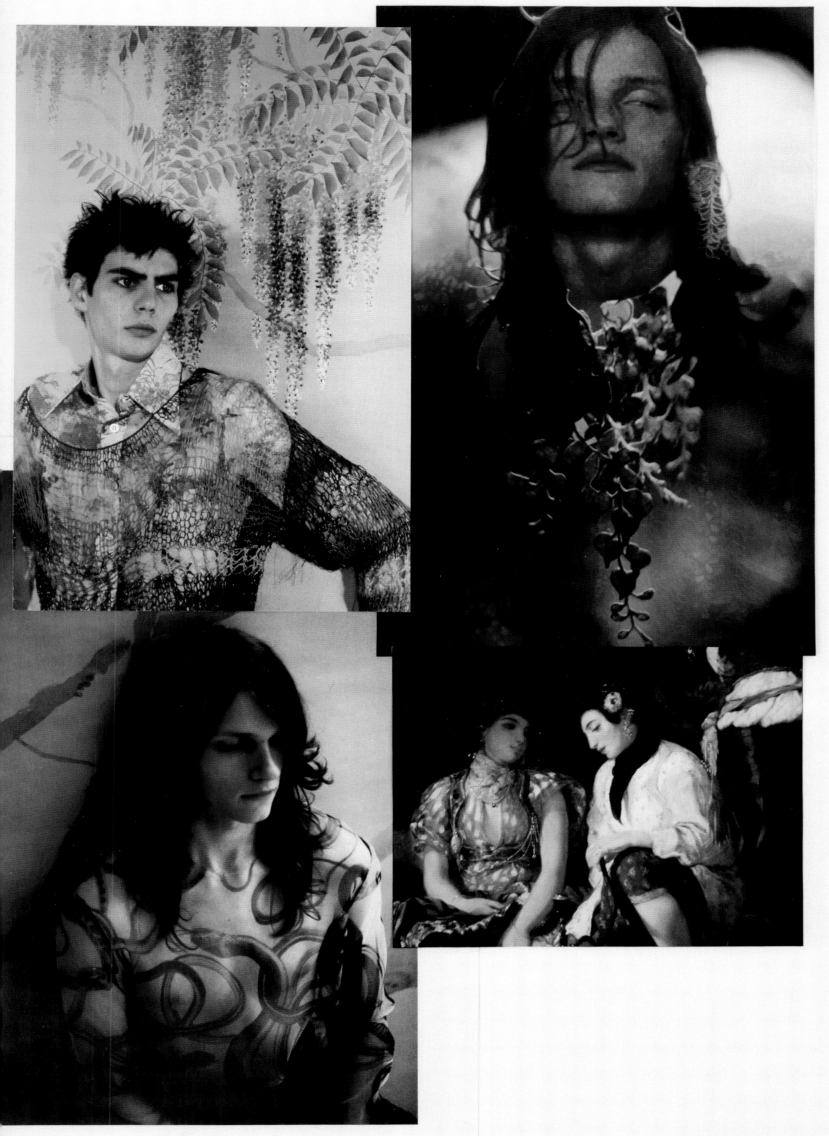

Tom wears sheer snake print top by Raf Simons; Printed silk trousers by Dries Van Noten

FATAL ATTRACTION

*"The work of my senses appeared to me
the work of my heart. I abandoned myself
to all the intoxication of that fatal moment."*
—Claude de Crébillon

KATE MOSS:

AN OBJECT OF DESIRE

She's fashion's ultimate shape-shifter, the queen of seductive allure and Another Man's perennial pin-up. Tim Blanks and Alister Mackie talk to the legend that is Kate Moss.

ALISTER MACKIE: The character of *Another Man* is a bit like a vampire. He's the same character who comes back through different periods of history: it could be Bobby Gillespie in the '90s, Mick Jagger in the '70s, Lord Byron in the early 1800s. It could be Christian Slater in *Heathers* or Nick Cave. It's actually the kind of man you're drawn to, so you're actually the love interest.

KATE MOSS: Wow!

TIM BLANKS: Who were your pin-ups?

KM: When I was really young, eleven or twelve, I had the Buffalo boys on my wall—Nick and Barry Kamen—and David Bowie. And when I was going out with Mario Sorrenti, and afterwards Johnny Depp... I suppose I didn't really have a pin-up then because the pin-ups were my boyfriends.

AM: You could have been just another girl from Croydon who was a hairdresser or a shop assistant, but you led a different life. Do you think you were chosen in some way?

KM: I had enough in me to know I was not meant for that world. I've always hung out with interesting people. When I was twelve I had Rastas picking me up from school in Croydon and giving me a lift home; by the time I was fifteen, they were taking me to clubs and giving me Long Island Iced Teas. I thought they said it was lemonade. I'd have three and fall asleep on the floor. At fourteen I already

thought I was hot shit. I'd lost my virginity, I could already skin up, I was smoking, and that's when I was spotted by Sarah Doukas in the airport. I was with my dad. He worked for Pan Am, so I'd go to America and when I got back, I'd be like, 'How can we still live in Croydon, knowing all that is out there?'

TB: When you met Bowie, I imagine he looked at you—Bromley looking at Croydon—and must have recognised the South London self-creation. Was there a mirror thing?

KM: Yeah, there was. I fell in love with him completely. Because of his eyes and his voice and his openness to me. We only had to be together in an interview for an hour and I was still there four and a half hours later. He was like, 'I want to know what you're doing.' I think he doesn't really get to hang out so I was his subject, and he was picking away: 'I've heard about the anorexia and the drug-taking in modelling, what's going on?' He was quite dad-ish but I suppose I would be too. I'm quite mum-ish with Cara Delevingne and all that lot; I'm quite strict, I get protective because I've been seventeen. But Bowie said something that made me cross. He said music can't mean the same to people now as it did when he had to save up tuppence ha'penny. I said, 'How can you say that? That's not fair.' When I first heard 'Life on Mars?'—I was fifteen—I thought it was written about me. I was just starting modelling— 'the girl with the mousey hair but her mommy is yelling no'—and I thought that's me in that song... David Bowie was saying he had to save up tuppence ha'penny and I was saying, well, I had to tape it off

the radio. It's a different thing now, but you can't say that the music you hear doesn't affect people because you don't have to save up for it. It still touches you... I listened to Kate Bush over and over when I was growing up—'Hounds of Love' was my song.

AM: I think 'Gimme Shelter' is your song—it sums you up.

KM: Yeah. I'd been dancing around to it forever and when Keith told me it said, 'Rape, murder! It's just a shot away', I was like, 'Whaaaaat?' And also 'Sympathy for the Devil'—they don't make them like that anymore... yet. But it will come around again, I'm sure.

TB: If this was the Stones' story, you'd be the Anita Pallenberg character. When did you first become aware of her?

KM: I was best friends with her son Marlon. We were seventeen and not really interested in the Stones. They were dads. We went to Keith's birthday party, and we sat down in the corridor by the loos while they were all playing upstairs. Phil Spector had a gun and was waving it around—I remember that bit. It was only when I got older, after Johnny, when I moved back to London, that I became close friends with Anita. Then I saw *Performance*. I can watch that film over and over again.

AM: I always think of you when I see the scene in *Scarface* with Michelle Pfeiffer coming down in the lift. It reminds me of when we came down in the lift at the Georges V hotel, and the Japanese paparazzi were waiting for us.

KM: I had Alister's shirt on, tights and a leather cap.

TB: *Night Porter*!

AM: Marc Jacobs said he based his Vuitton show on that moment.

KM: Yeah, and it was quite a moment.

AM: Or in Malibu, in the car coming back from Beth Ditto's, driving up the Pacific Coast Highway, listening to The Doors. You were wearing the white marabou from Hidden Treasures. You had all the diamonds on, like Marilyn Monroe, and we held hands over the roof of the car. It was a death-defying stunt. And the outfit was unforgettable.

TB: Do abandonment and style always go together?

KM: I think in those abandoned moments you do think (*voice shivers with pleasure*), 'Ooooo, that's a really good idea for a shoot.' You can get locked in as a human, you want to be organised and not chaotic, but while I strive for order, it's in chaos that beauty occurs. You definitely have to be free to let yourself go to explore all avenues. Those are the best moments, when I think of some of the outfits you've had me in... Ali, what's your favourite shoot?

AM: My favourite day of going to work was when I dressed you in this special coral bikini that Sarah Burton from Alexander McQueen made for you, and you were dancing on the podium to Tina Turner. It was like Raquel Welch filmed by Derek Jarman.

KM: And then Lila came in and said, 'Oh, mummy, are you breathing in?'

TB: When you let yourself go like that, can you bring yourself back with a... (*snaps fingers*)?

KM: Yeah, it's not method acting, or 'I believe I am.' Because some girls do that, you know.

AM: It's their downfall—they don't last... You're appearing in many guises throughout our book.

Remember with Willy Vanderperre, we shot you very natural, as a boy wearing men's clothes. And we've got you as a pin-up with Nick Knight. You're kind of a vision; you're not really a real person. You're—

KM: —a body... very Veruschka-ish.

TB: An object of desire.

AM: When you look at that Nick Knight picture of you naked, do you see you?

KM: I think, 'Oh, that's a good picture,' but it's not really like I look at it and think, 'Oh, that's a good picture of *me*.' Sometimes when I catch myself I see *her* and I think, 'I like that girl,' but I'm not that girl. I take on that girl.

TB: So when you're sprawled out naked, you have to become that girl to do it, because you couldn't do it as you?

KM: Definitely. I always channel someone. There's no way you could do all the things you have to do as yourself, because you get embarrassed or self-conscious, so you have to pretend in your mind that you're actually somebody else.

AM: That's when the magic happens.

KM: Especially when there's that clicking from the camera, and you get into the zone and you become focused. That's why it's really hard for me to do snapshots, or even to act. When they say, 'Just be completely unaware of the camera,' I can't, because for so many years I've been so aware of the camera and where the light is and where I need to be in the frame.

TB: Elizabeth Taylor could apparently feel where every single light was at any time.

KM: I'm not technical like that. They put me in some clothes, then I become the person who would wear the clothes. That's when it feels more natural, and that's what's conveyed to the camera.

TB: What happens when you're naked and you don't have those props?

KM: You still have hair and make-up. But most photographers never give you any clue to who you are. You have to guess.

TB: So, even naked you can be many people?

KM: Nudity has many facets (*laughs*)! But you can tell from the feeling when you're given certain things. I went out with Mario Sorrenti so I've got all those references. I know the '20s, '30s, '40s, '50s, actors, movies... put me in a wide trouser and a skinny top and I'm Katharine Hepburn. It's a boy/girl thing so I have a reference in my head to go to, though it may be nothing to do with their reference.

TB: So would you say that your education in fashion, models, actresses and film was actually an education in image?

KM: I don't know, because I think it is instinctive too. I remember the first time I worked with Bruce Weber, I just knew the kind of models he liked, so I just became one of those. I knew who Avedon's girl was as well, even though he wouldn't say—he was so much fun. He was saying (*imitates Avedon's voice*), 'Fall and fall', getting me to jump and do all those falling things. But I don't jump ever. I don't jump or run, though I have done running under pressure. And the first time I worked with Nick Knight, I knew the way he liked girls to move so I'd just do that—it was all that lighting and you had to be a bit more... animated.

AM: I think that's why your pictures are so natural, because you allow yourself to be a bit vulnerable and nervous.

KM: I'm always nervous! I still don't know who I'm going to be until I get on set. It's literally the moment the camera clicks and then I know.

TB: What about when you're in a situation where the environment or the people you're working with isn't particularly inspiring?

KM: Then I have to find inspiration.

TB: I imagine that must happen quite often.

KM: Not with me it doesn't (*laughs*)! But, you know, sometimes you have to make something really naff feel cool in yourself.

TB: I love that you're nervous all the time—that's such a humanising thing.

KM: I never take anything for granted. I never walk onto a set and say, 'Right, let's get this over with.'

TB: Still, there's the control that comes from everyone looking to see what you're going to do.

KM: But when Sam McKnight and Val Garland come to touch up my hair and make-up, I'm always asking, 'Any tips, any tips? Is it working?' because they're all looking at a screen and I can't see it. I think screens should be banned. I'm an editor now for *Vogue* and I was working with the model Freja Beha Erichsen and she is the most gorgeous thing ever, but I was *still* looking at the screen. It's like television. If it's on, you look at it, even though Freja was standing right there.

AM: How did you feel now that you're the editor and another girl is the object?

KM: I loved it so much and I knew what she needed because I've done it. I'm such a girl's girl. I don't think I'm a jealous type; I love it when a girl looks good. I want to make a girl look good. It's like I never want to let anyone down when I do shoots. I want to be loyal... I suppose that's what Lucian Freud did. He said, 'My work is so important and if you let me down, I can't do my picture.' He couldn't do my picture without me, so I would never let him down.

AM: Let's talk about romance, because you've lived your life in a very romantic way.

KM: I got a book called *The Libertine* for my birthday, and it's so me (*leaves the room and returns with a huge, glossy book*). When I read the introduction, 'The Art of Love in Eighteenth-Century France', it's actually everything we're talking about: the style, the abandonment.

TB: So you're a female libertine.

KM: Exactly. Look at this woman here... She's just havin' it! (*Begins reading an extract*) 'I must admit that I have never had so much pleasure as I have had with her, nor have I ever known one who was so beautiful or who I loved so much. The anger she feigned after the above incident seemed mild to me, I pretend to be offended by said incident but in truth I was

delighted by what she'd done.' (*Flicks to another page and reads another quote*) 'But trust and discretion are rare in this century in which we live because there are very few honourable men.'

TB: Were you born in the wrong time?

KM: Deffo.

AM: Let's take her back to the eighteenth century...

TB: ... where she would be the mistress of kings.

KM: Darling, I lived in Melina Place, which was where all the concubines lived.

AM: But the power of these women depended on men's appraisal of them. Your power isn't dependent on men.

KM: I am occasionally powerless to men, of course.

TB: Do you resent that?

KM: No, I don't resent that—I want it. I want to be powerless because I don't want to be in control all the time. It's erotic to surrender. You don't want to be so powerful in your daily life that you're powerful over the person you love, because you also want them to take control.

AM: Marc Quinn sculpted you as the Sphinx, which had ultimate control over men. So even the Sphinx lets someone else take control?

KM: Yes (*emphatically*)... to a point (*less emphatically*)... for a millisecond (*much less emphatically*)... I pretend.

TB: Have you ever wished you were a man?

KM: Yeah, when I saw Leah T, the transsexual from Brazil who I snogged in a magazine shoot. When I first met her she had a massive cock and the next time she didn't. She was wearing these frilly panties and she said, 'Dah-ling, look!' She's so gorgeous. And she said her boyfriend left her because she hadn't got a cock anymore. I said, 'Where's the cock? I'll have it.' How amazing would that be? You live half your life as a woman, half your life as a man. Why wouldn't you if you had that opportunity?

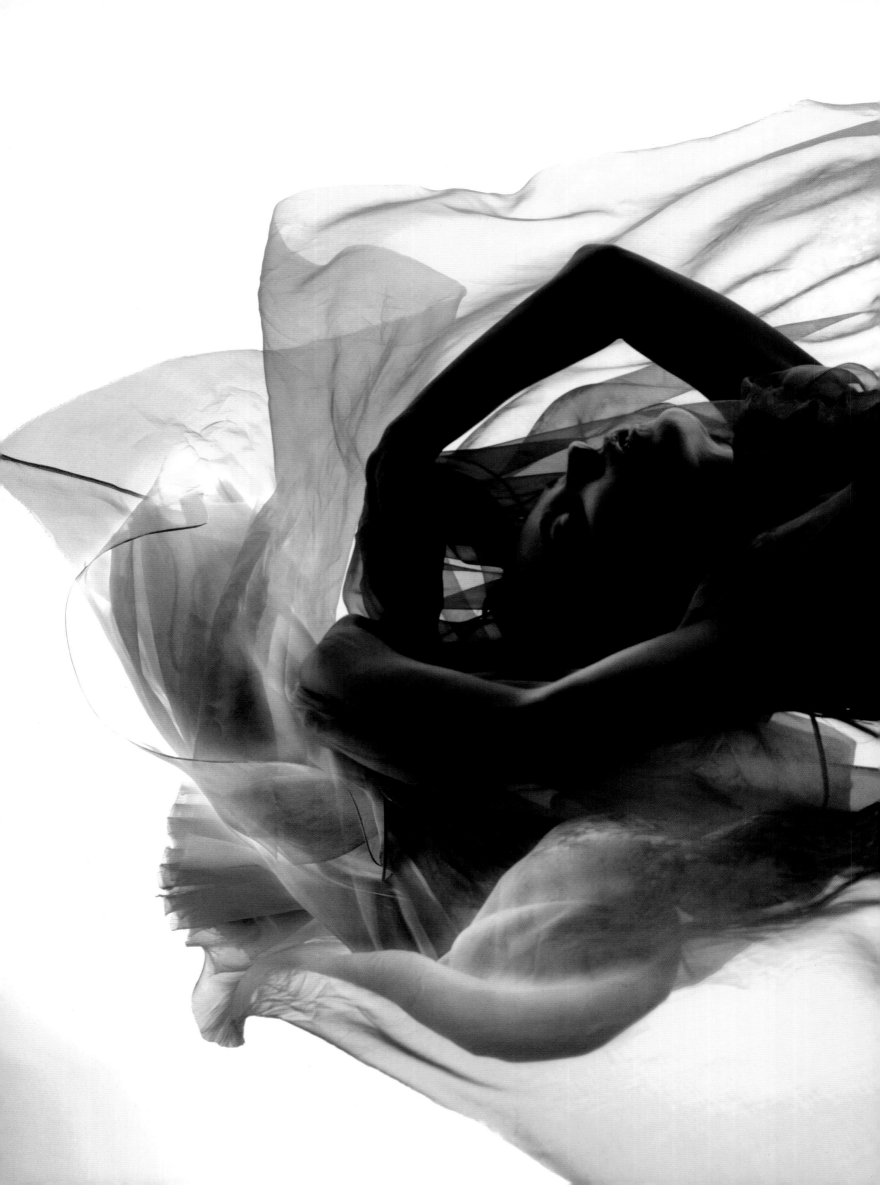

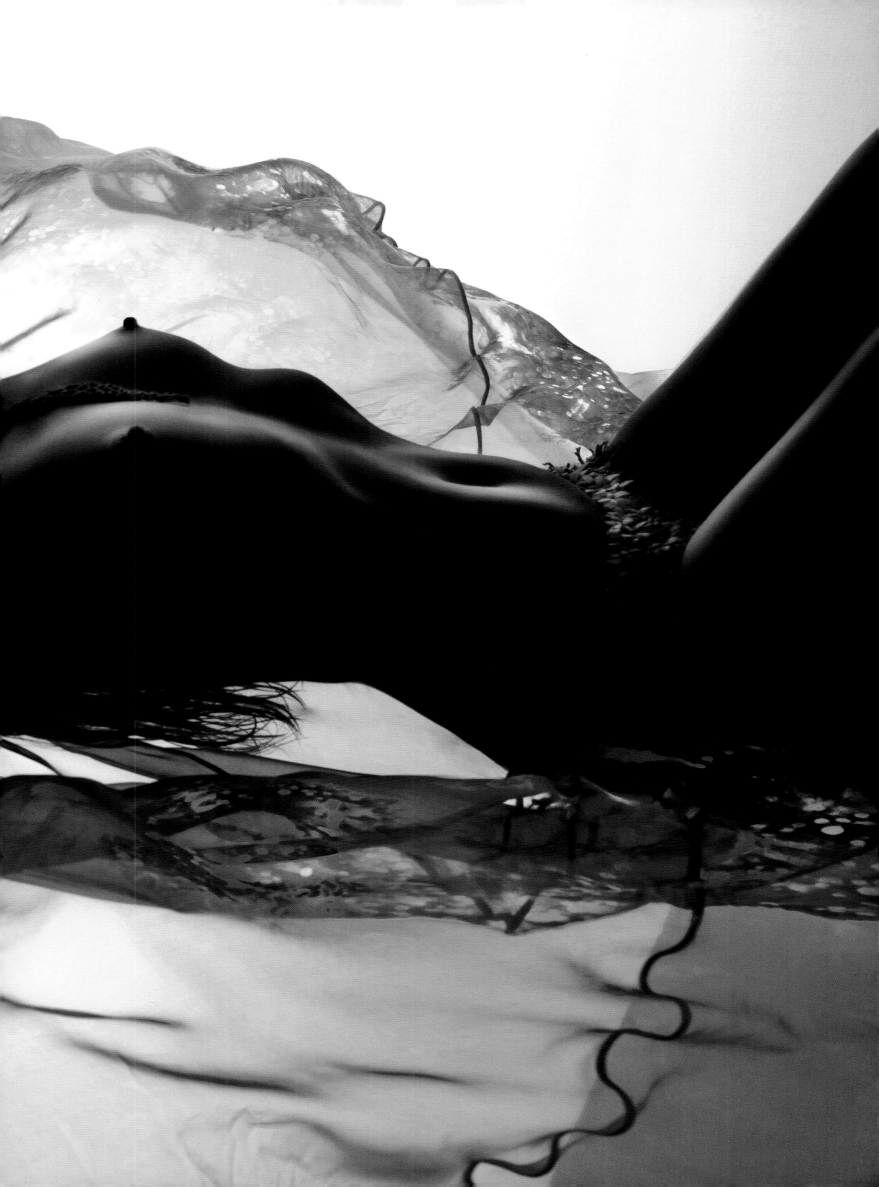

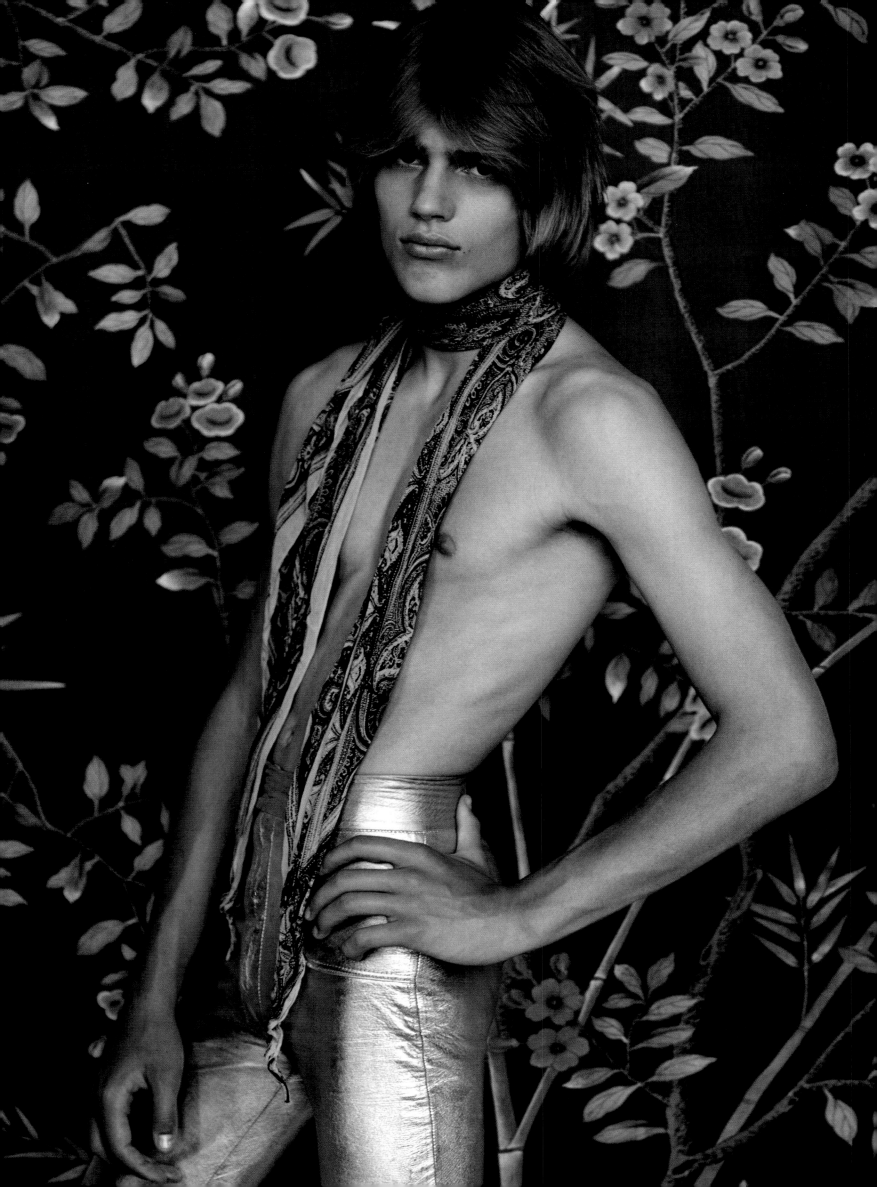

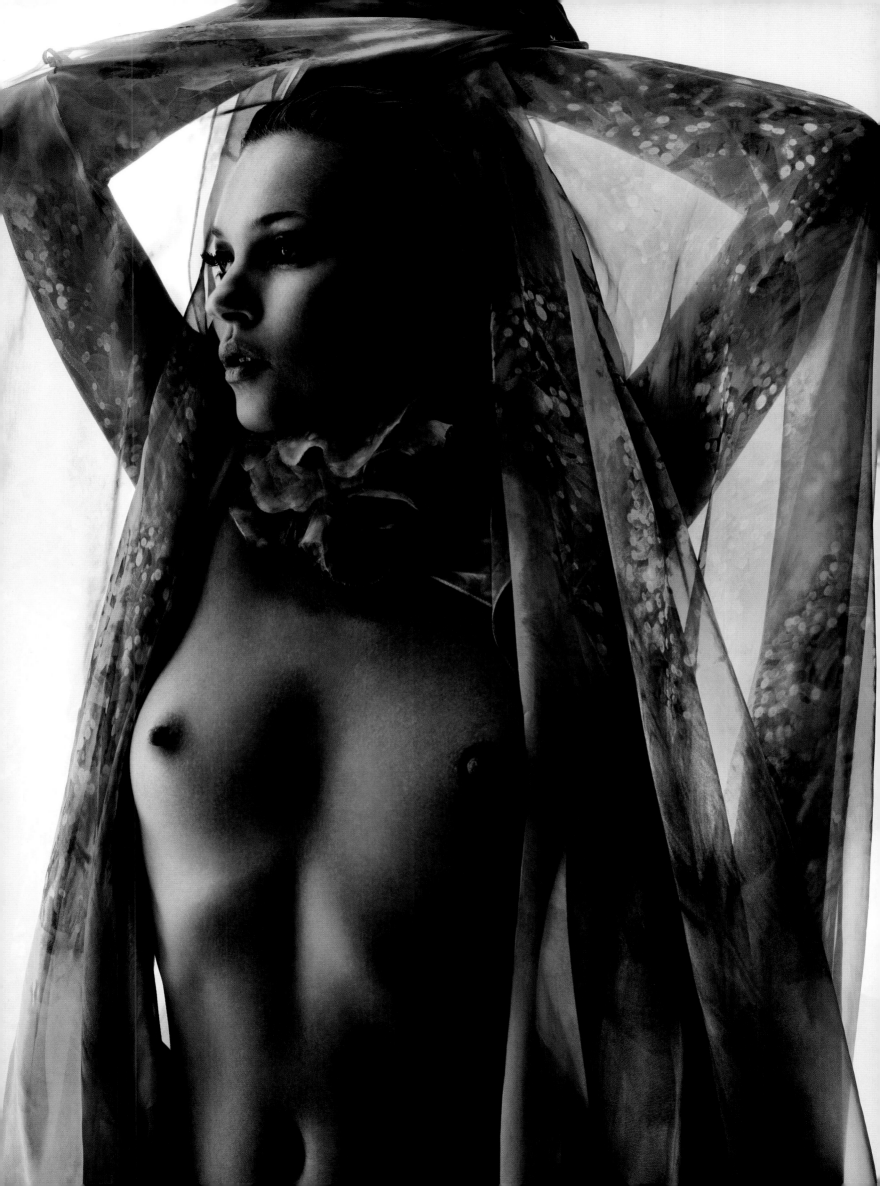

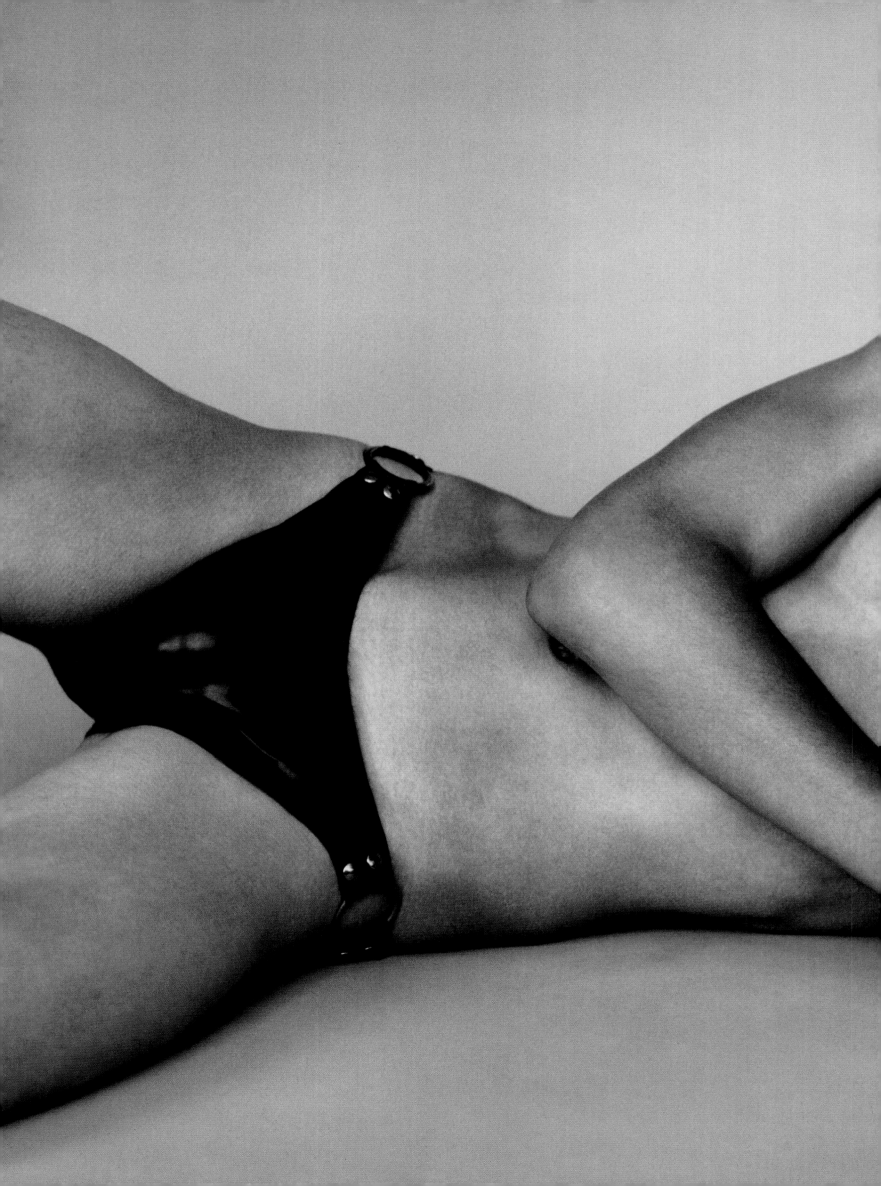

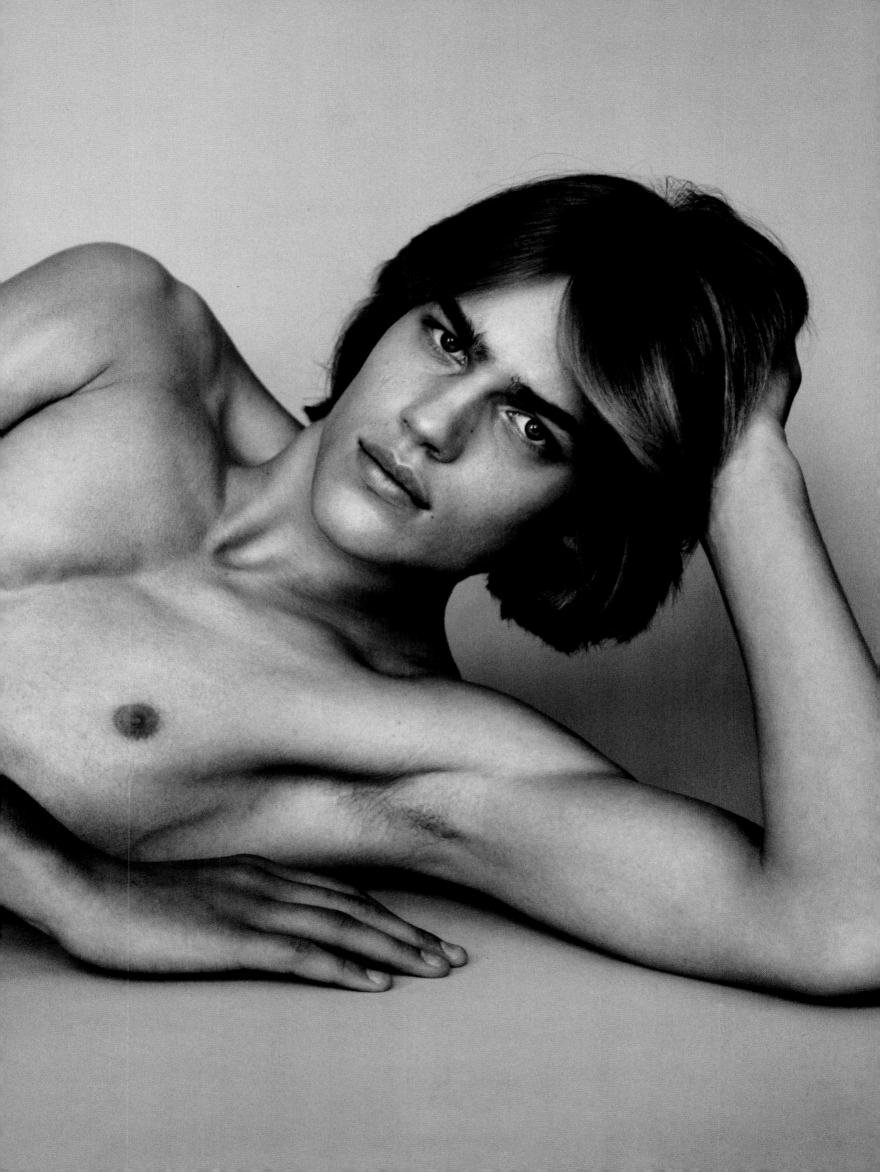

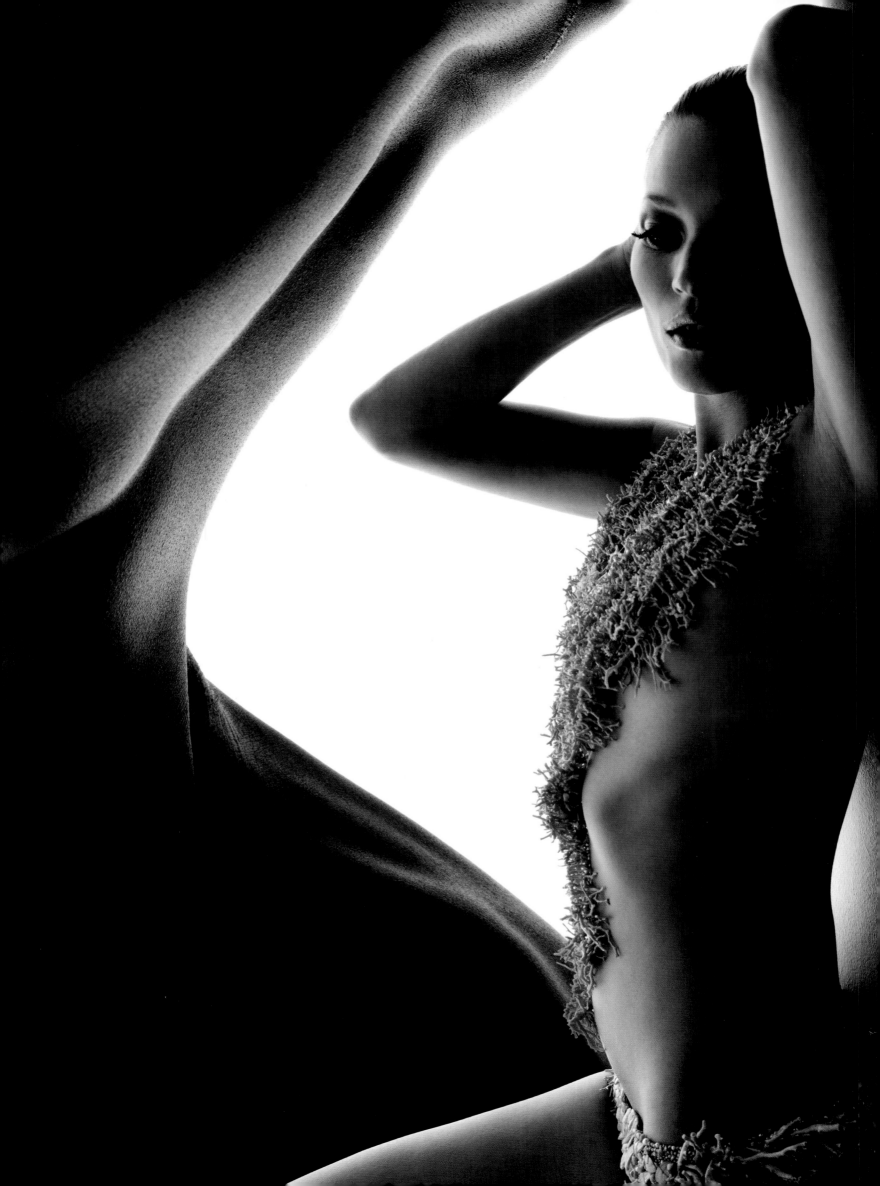

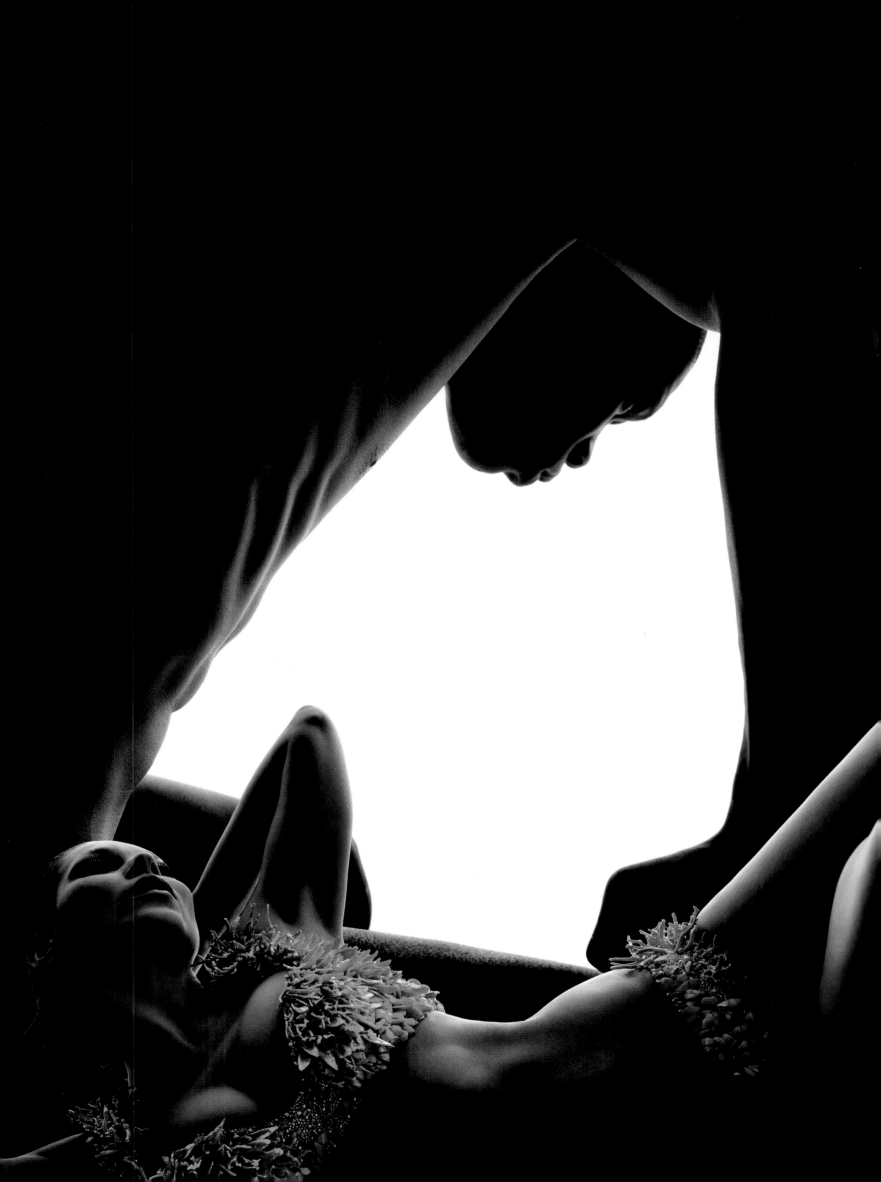

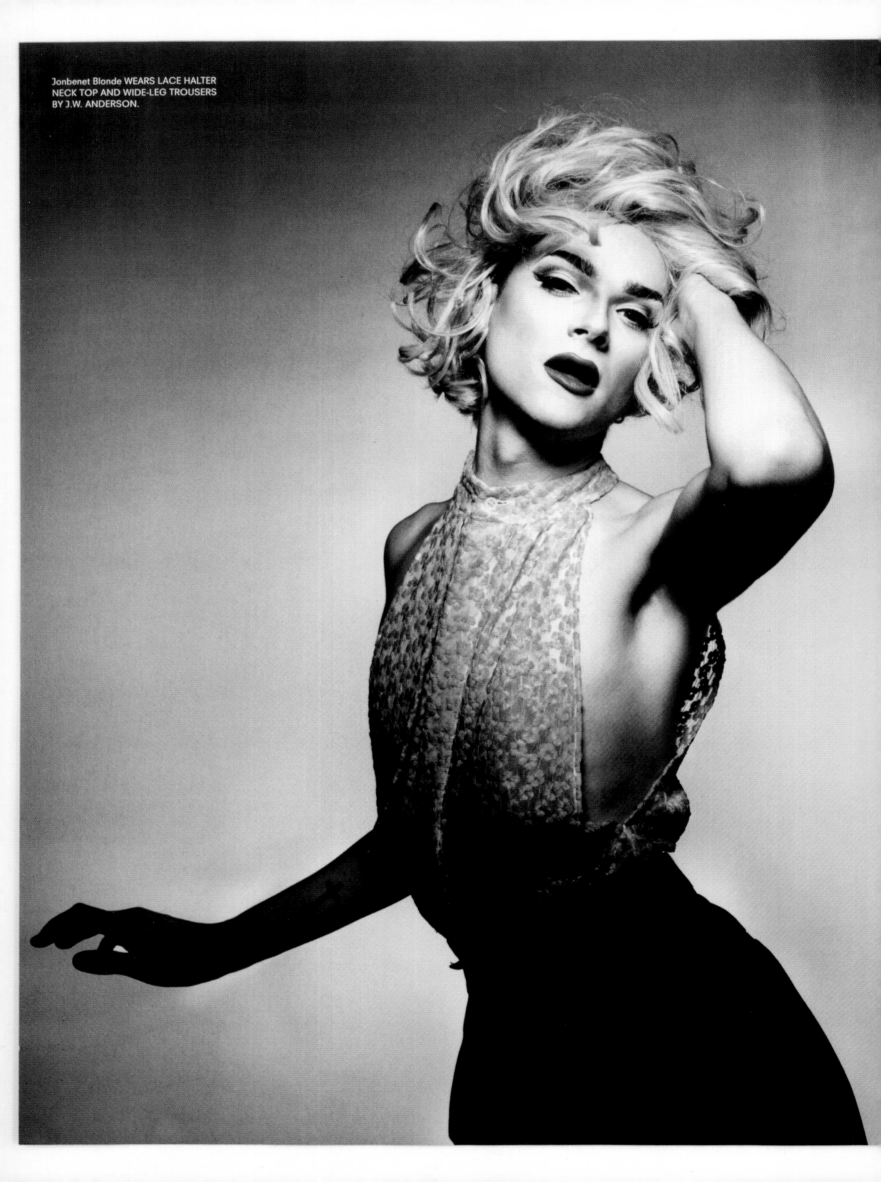

Jonbenet Blonde WEARS LACE HALTER NECK TOP AND WIDE-LEG TROUSERS BY J.W. ANDERSON.

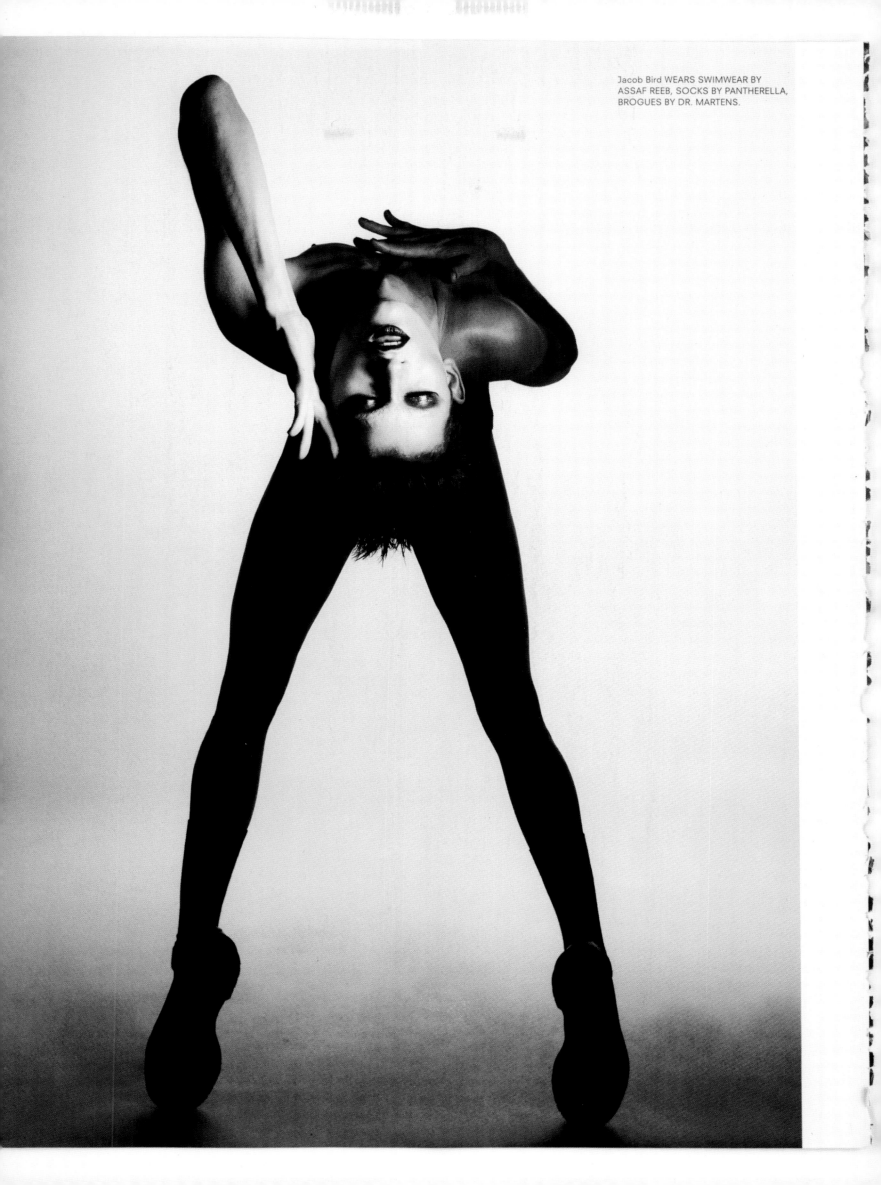

Jacob Bird WEARS SWIMWEAR BY
ASSAF REEB, SOCKS BY PANTHERELLA,
BROGUES BY DR. MARTENS.

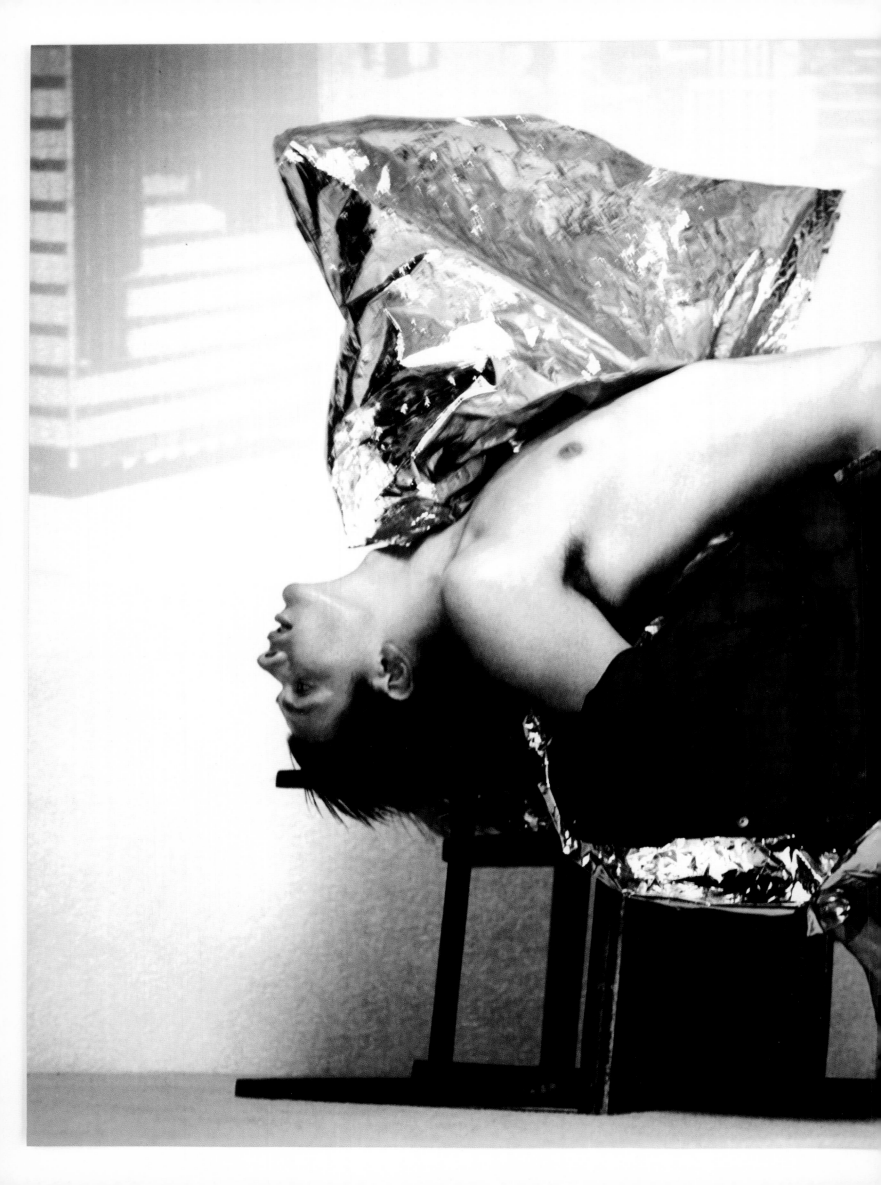

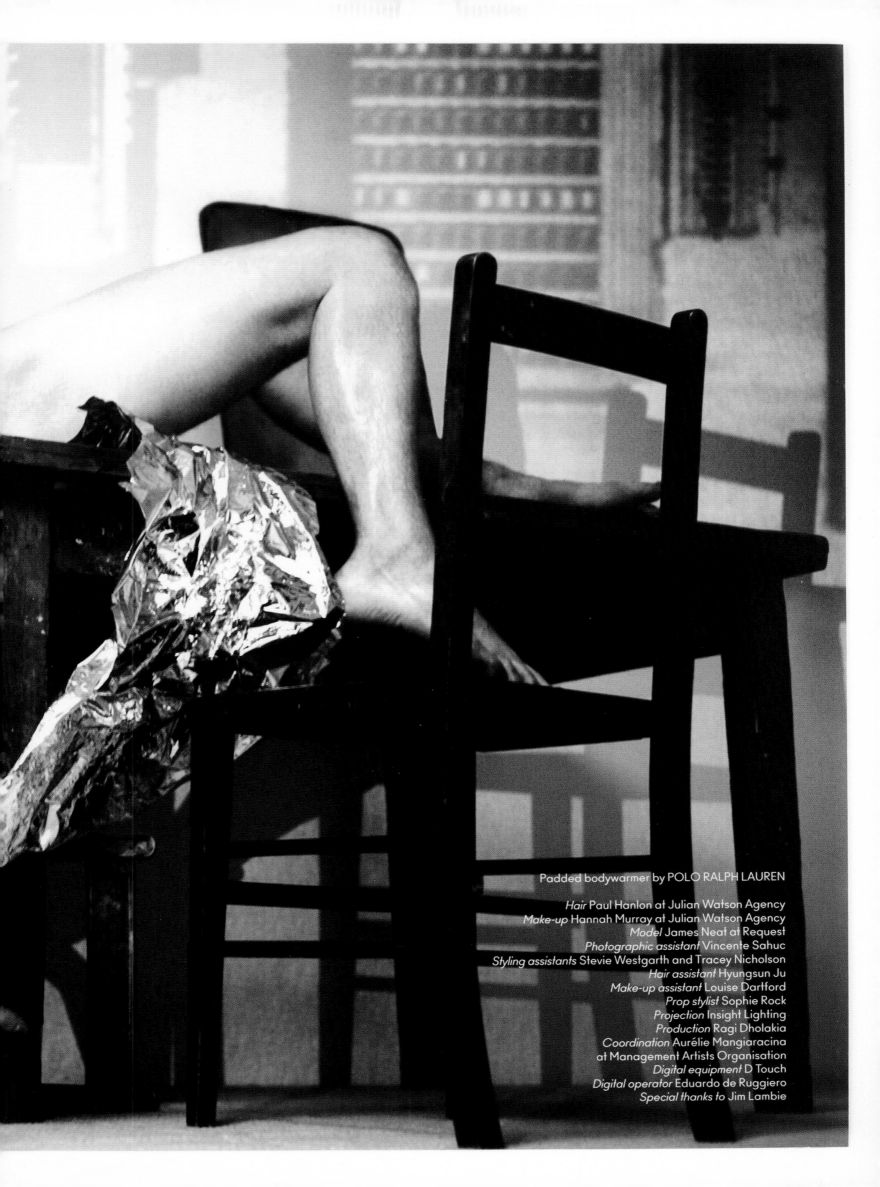

Padded bodywarmer by POLO RALPH LAUREN

Hair Paul Hanlon at Julian Watson Agency
Make-up Hannah Murray at Julian Watson Agency
Model James Neat at Request
Photographic assistant Vincente Sahuc
Styling assistants Stevie Westgarth and Tracey Nicholson
Hair assistant Hyungsun Ju
Make-up assistant Louise Dartford
Prop stylist Sophie Rock
Projection Insight Lighting
Production Ragi Dholakia
Coordination Aurélie Mangiaracina
at Management Artists Organisation
Digital equipment D Touch
Digital operator Eduardo de Ruggiero
Special thanks to Jim Lambie

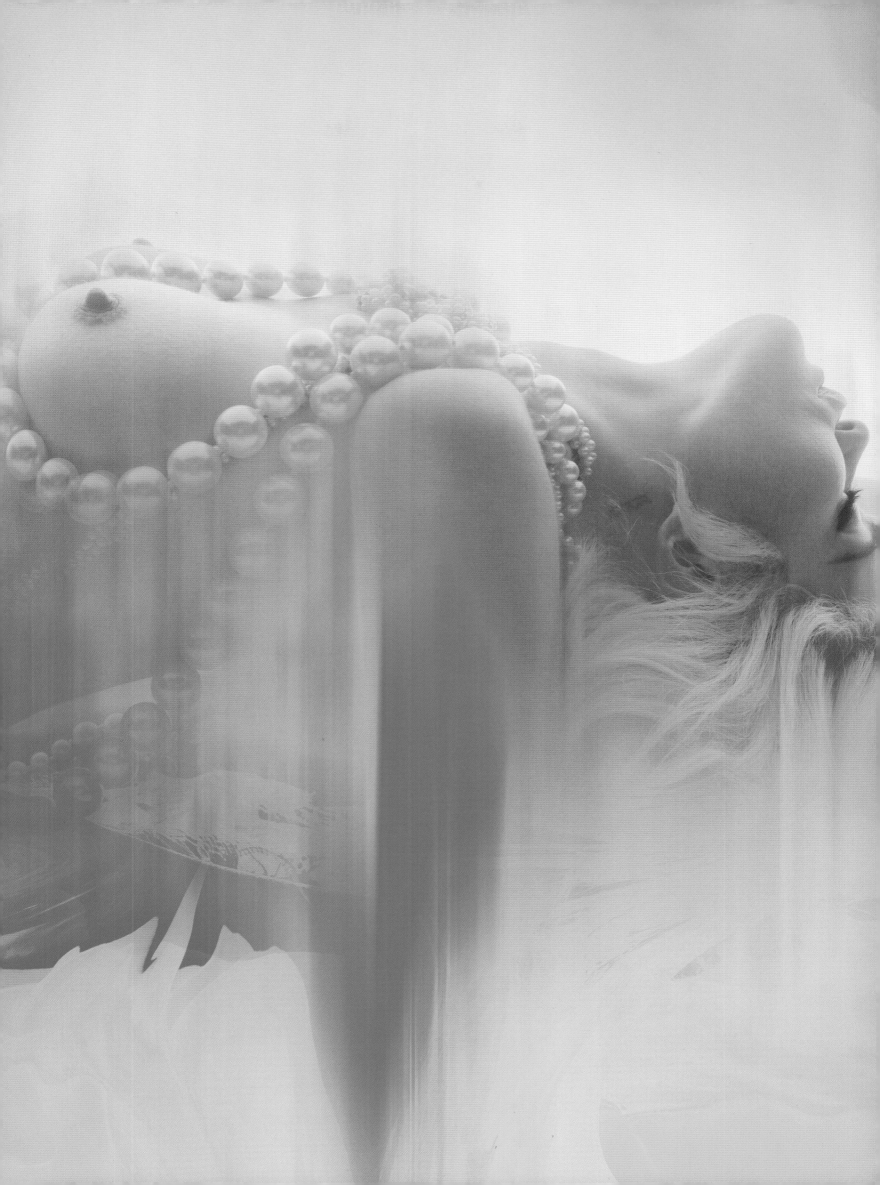

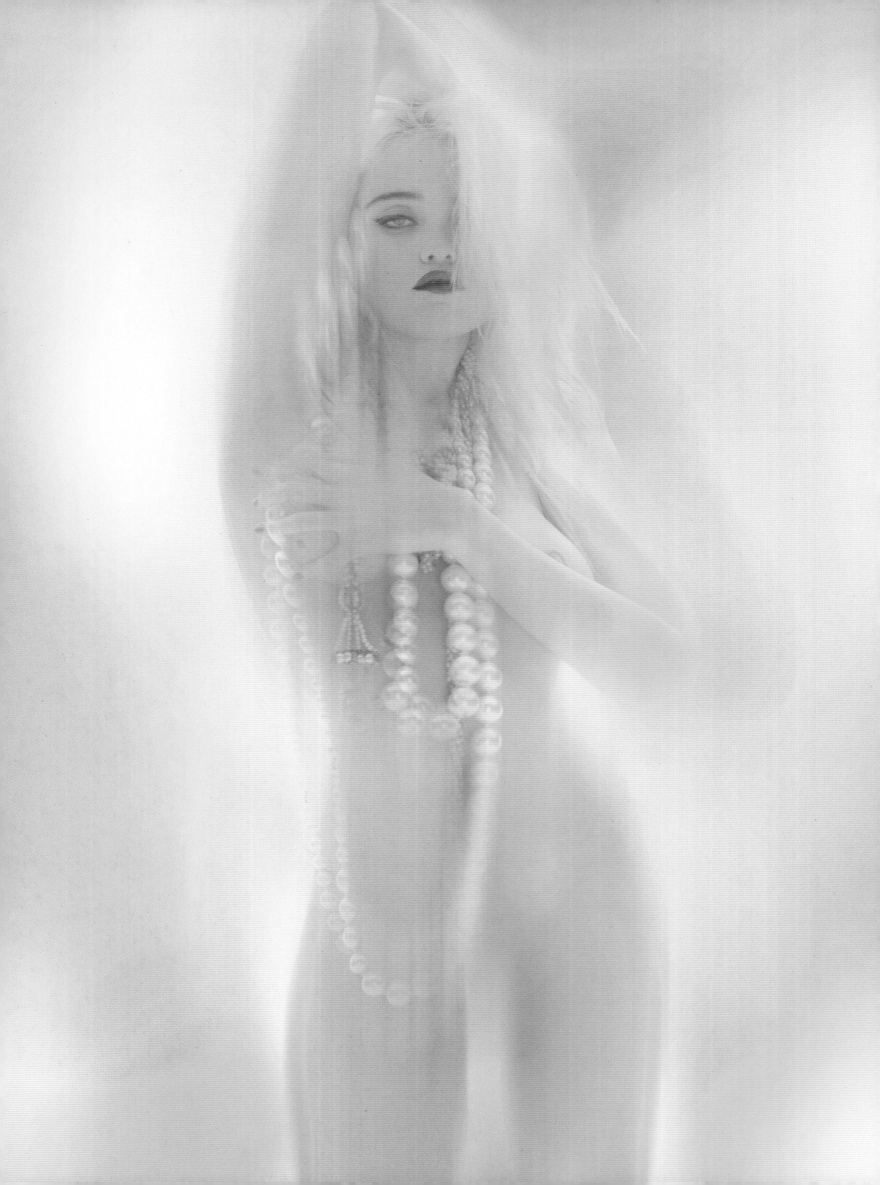

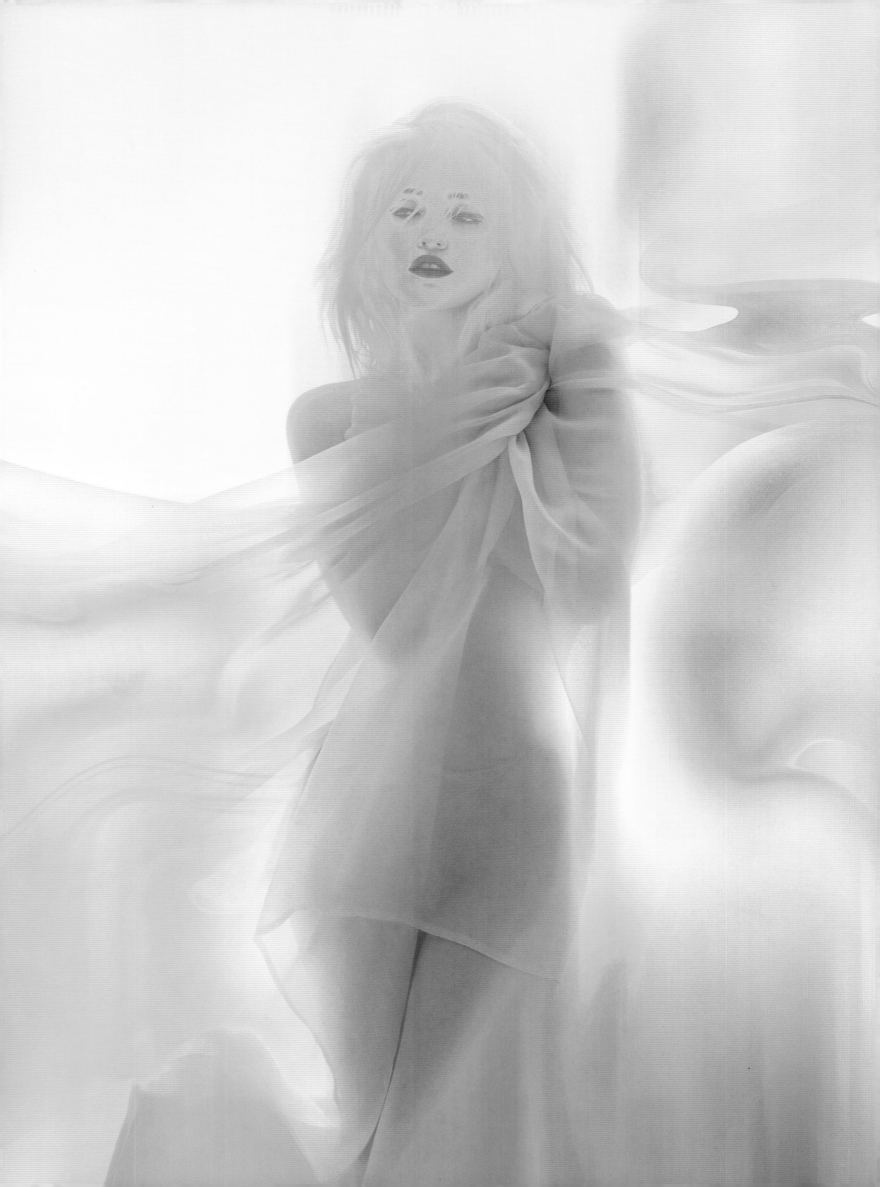

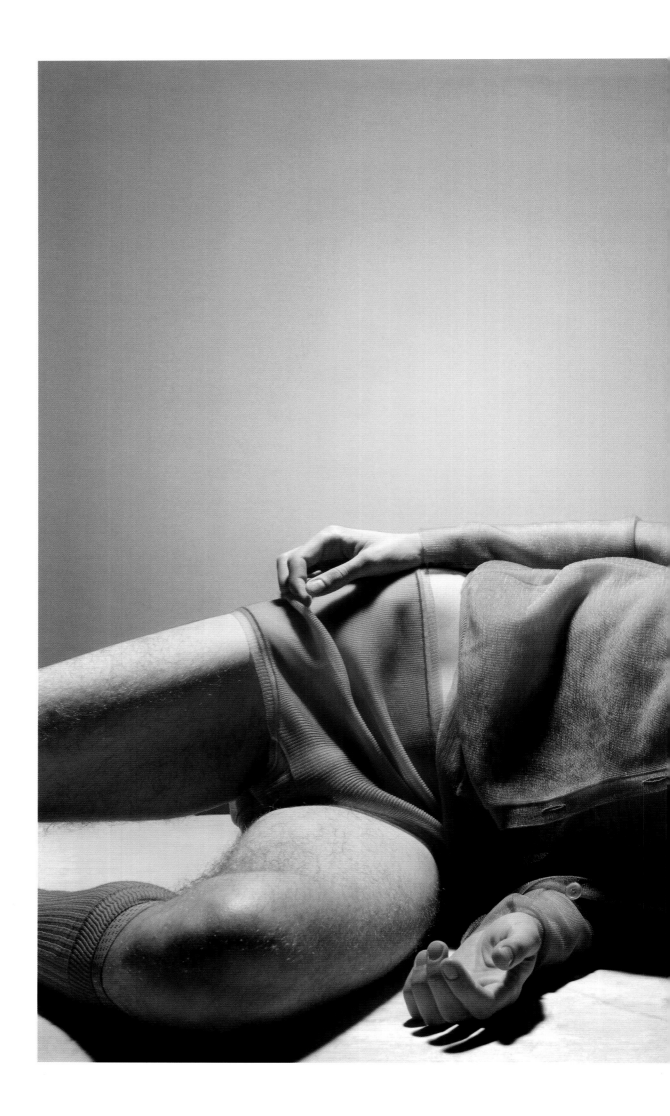

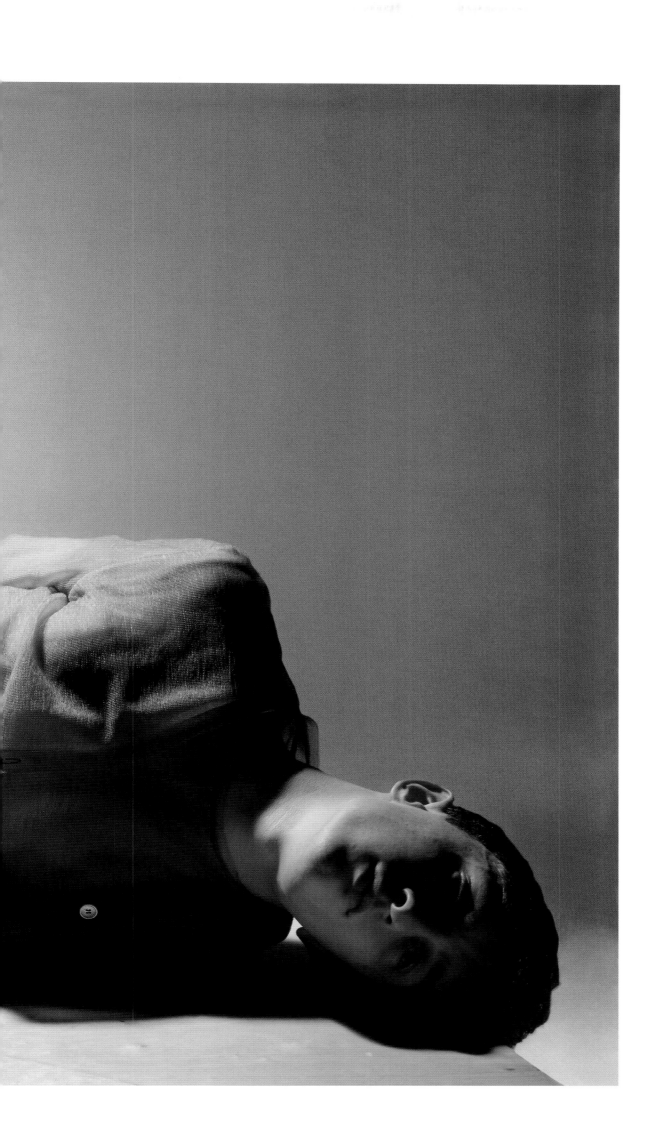

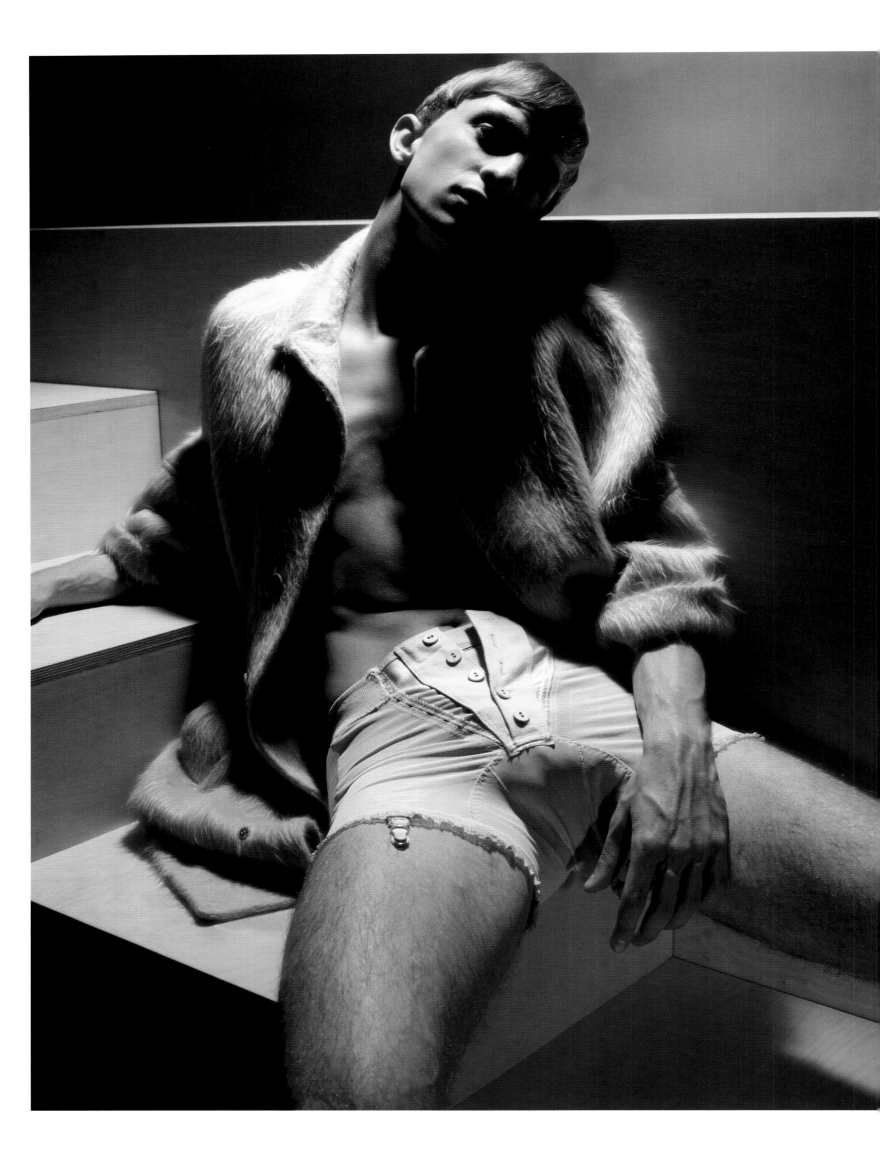

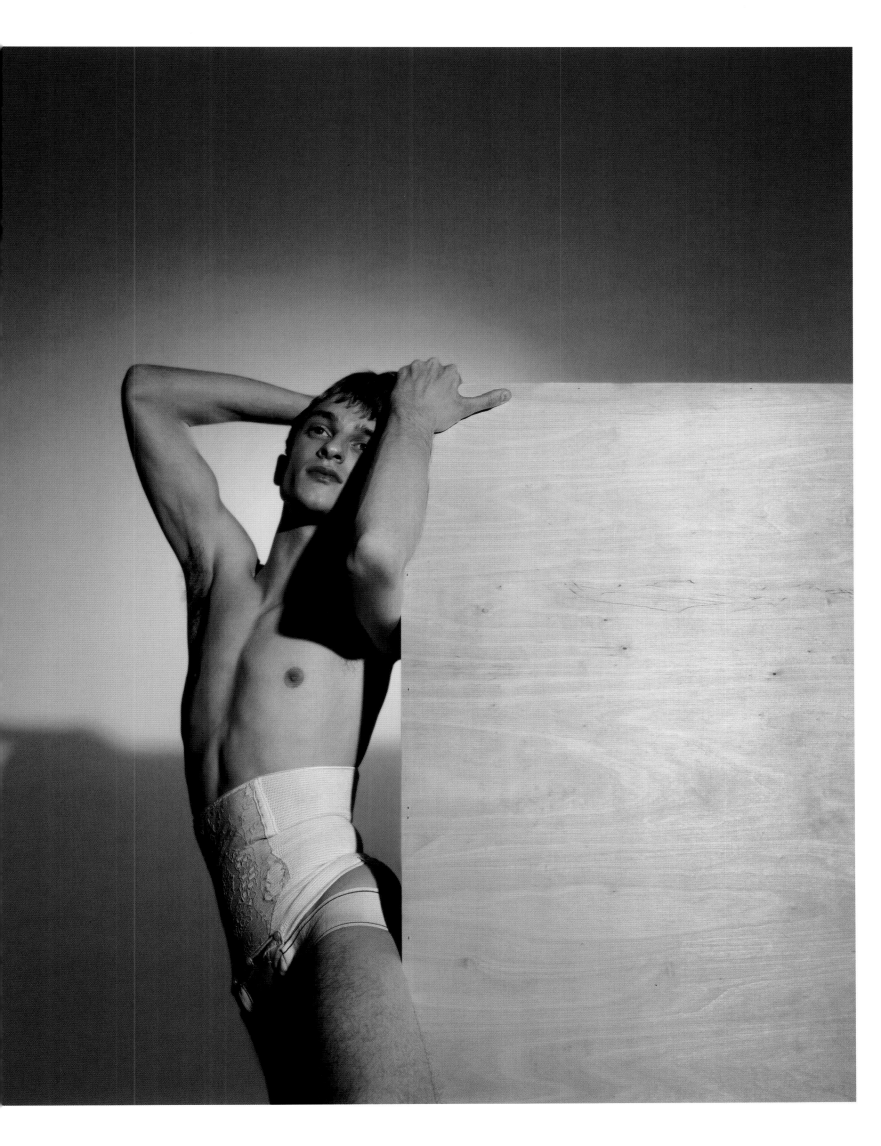

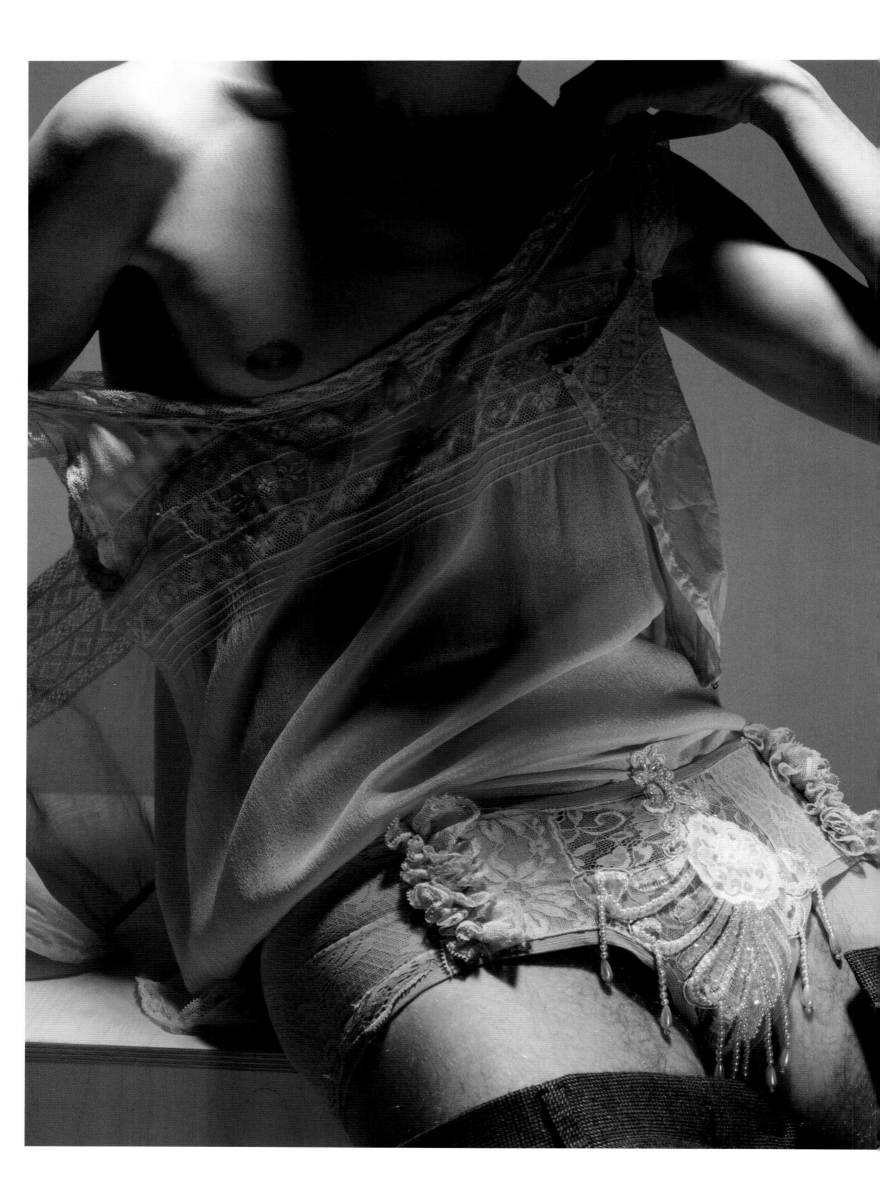

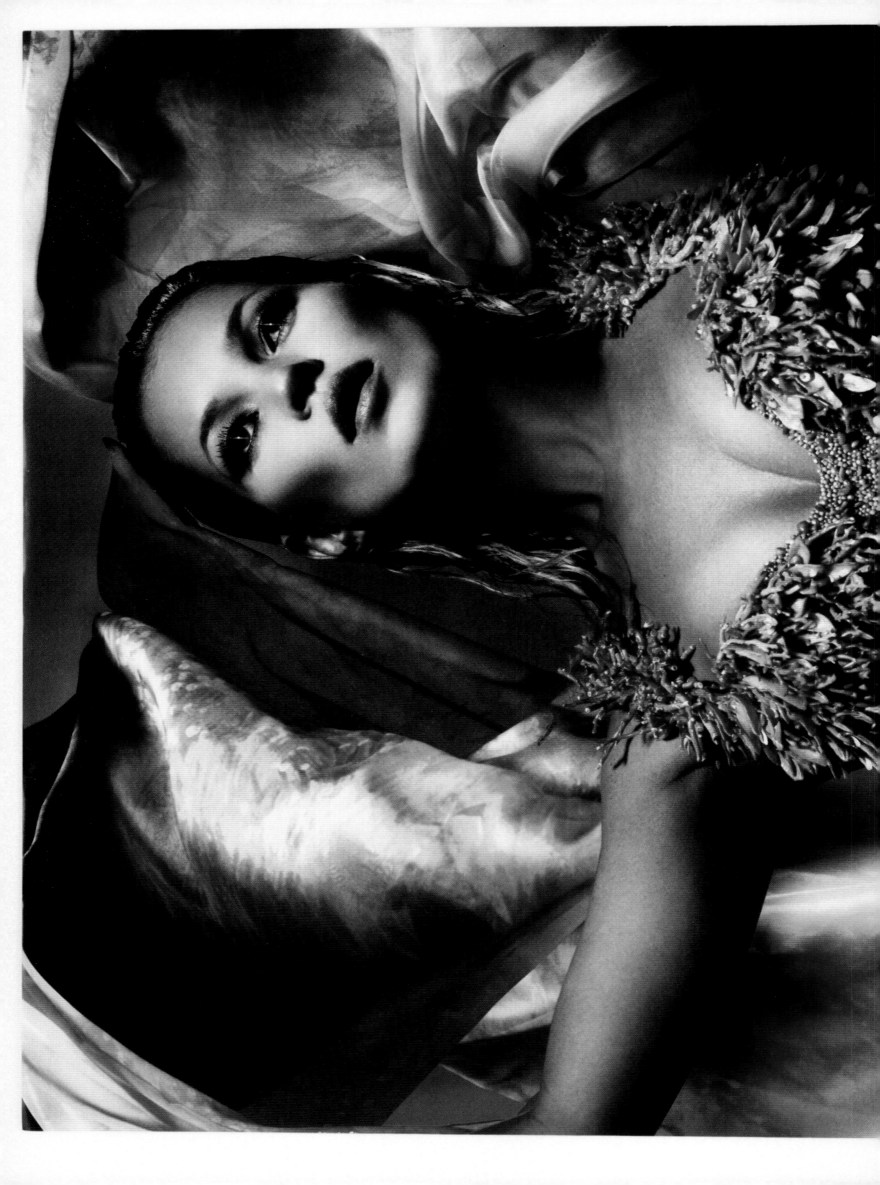

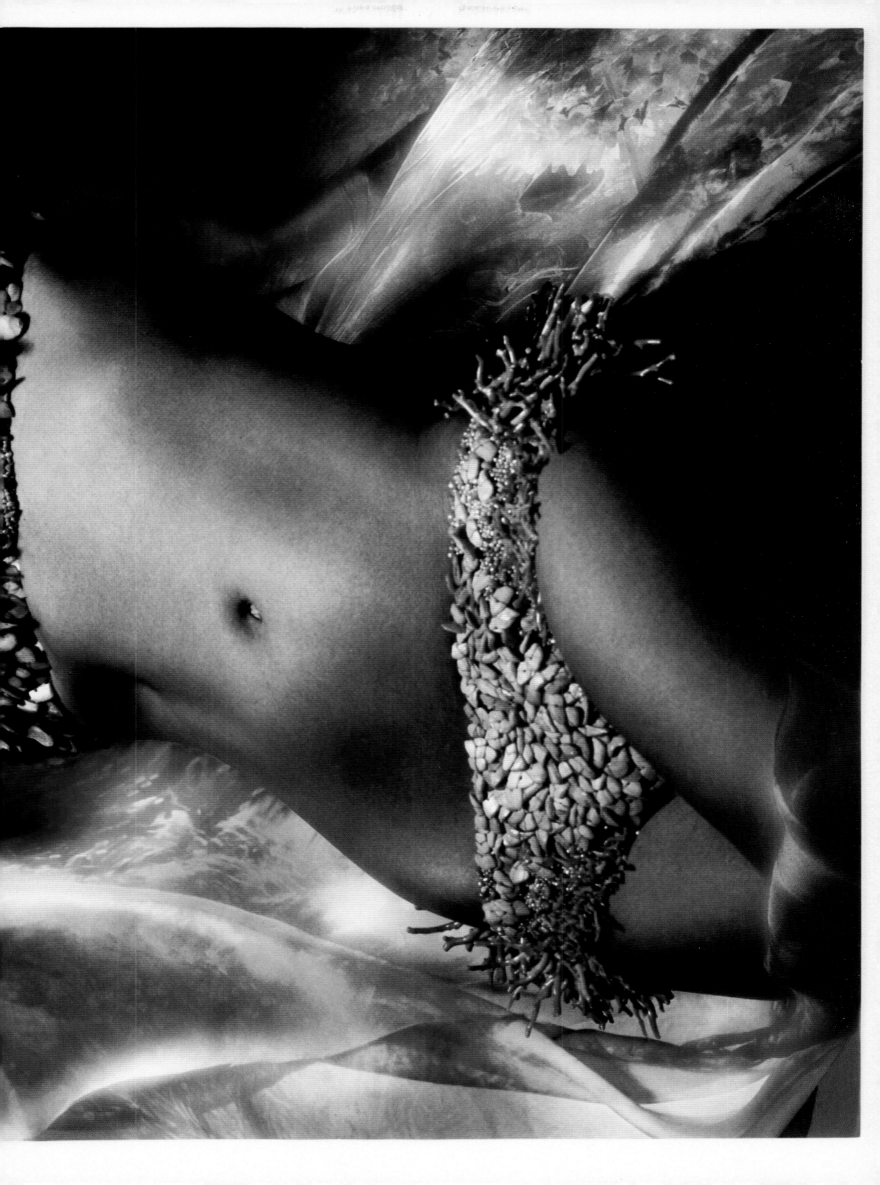

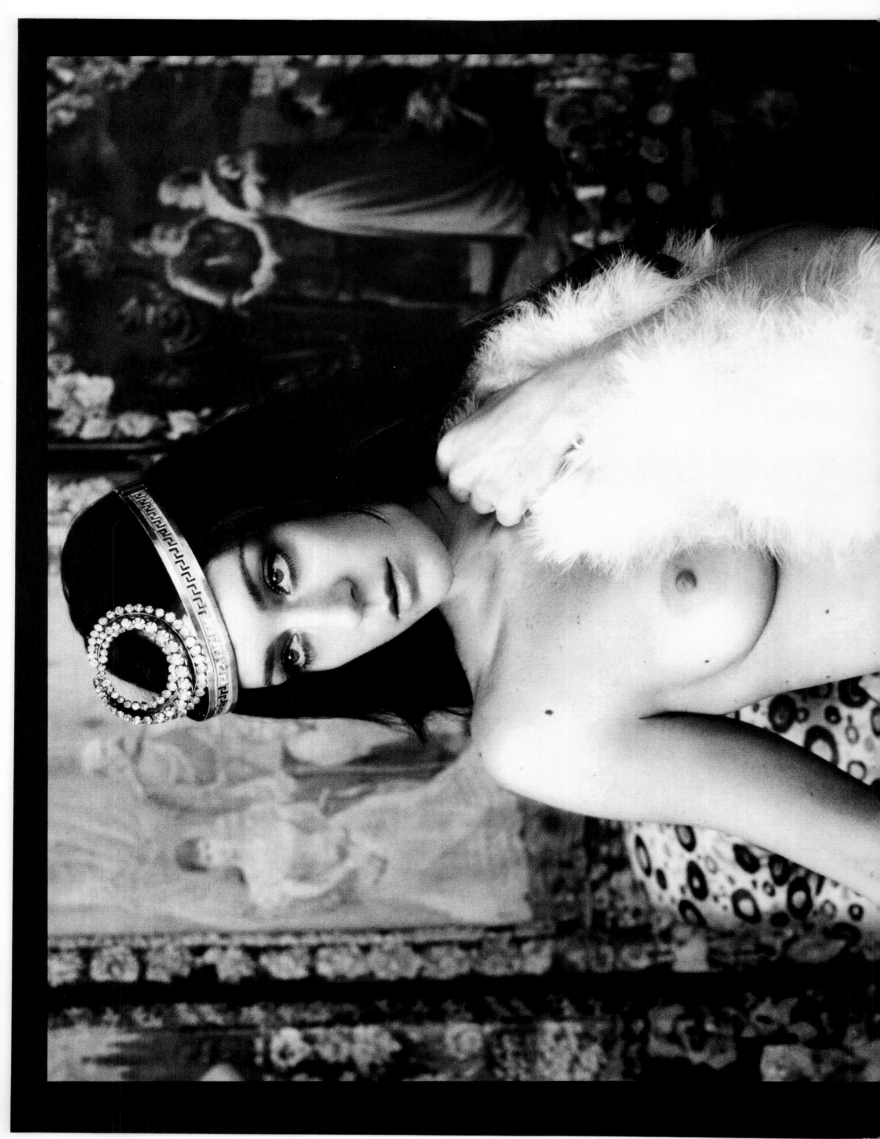

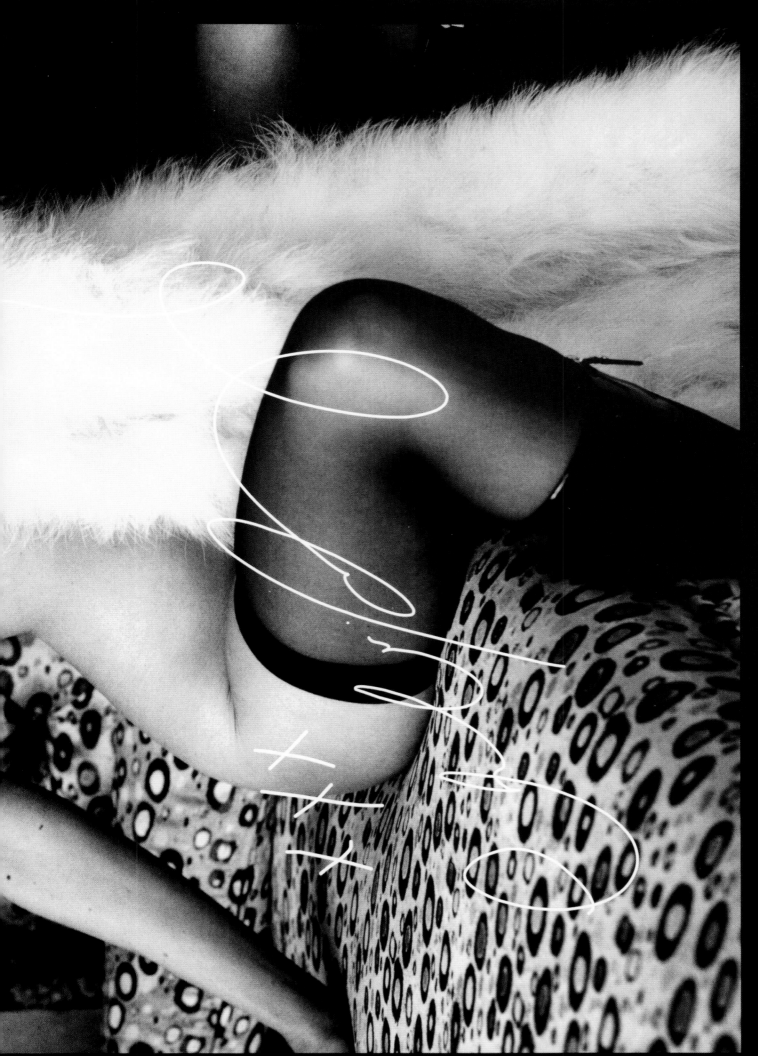

photography Alasdair McLellan styling Alister Mackie

Antique jewelled tiara from Mairead Lewin Vintage; Marabou feather cape from Virginia's; Stockings by Wolford; Laced patent leather boots by Louis Vuitton.

talent Chloe Sevigny; hair Anthony Turner at Art Partner using TIGI; make-up Lauren Parsons at Premier Hair & Make-up using Chanel A/W11 Collection; manicure Jessica Hoffman at Caren using Sally Hansen; photographic assistants Gareth Powell, Simon Bremner, Lex Kembery; styling assistants Ellie Grace Cumming, Melissa Thompson, Gerry O'Kane; production Ragi Dholakia; production assistants Alex Hill, Tim Clifton-Green; special thanks to Amanda Horton

PERFORMANCE

*"I love performing. I can get to be that person
I always wanted to be—godlike."*
—Nick Cave

BAND OF BROTHERS:

PAUL SIMONON

and

BOBBY GILLESPIE

Monday, November 11, 2013 — 1 p.m. Somewhere in London W2. The Clash's brooding bass player Paul Simonon and Primal Scream's irrepressible frontman Bobby Gillespie — longtime friends, rock'n'roll icons and kindred spirits — discuss the origins of their style...

PAUL SIMONON: We didn't have a TV when I was a kid, so I took my tips from other sources. By 1966 my mum and dad had separated and my mum's boyfriend won a scholarship to study music in Italy for a year. I didn't have to go to school there, so during the afternoons I would go to the cinema and watch Spaghetti Westerns. Like all kids I loved them — riding around on horseback with two pistols is a good look! The funny thing is, when I got back, all my mates were listening to these Ska and Rocksteady records by Lee Perry which were all about Clint Eastwood and Lee Van Cleef. I couldn't believe it — I knew who they were because I'd seen all the films before they'd been released in the UK. So that really resonated with me. On top of that, we were living around the Brixton and Ladbroke Grove areas at the time, and I'd see these really cool Caribbean guys who'd just arrived on the *Windrush* wearing big hats looking like they'd just come from the O.K. Corral.

BOBBY GILLESPIE: It's funny you should say that because when I first came to London in '84 or '85 I used to stay in this little flat Alan McGee had in Tottenham. We'd go to this little café down the street and at the same time every day an elderly Jamaican guy in his fifties would show up. He would be dressed head to toe in burgundy, wearing cowboy boots, tight trousers, a cowboy hat and a gun belt

with holsters and two guns strapped to his legs. I'm not kidding, he looked like he was walking into a gunfight! He was probably hell to live with, but he was an individual (*laughs*).

PS: All that matters is, he looked great!

BG: What makes guys like that cool isn't that they're outside the law, but that they're nonconformists. They're operating outside of most people's consensual reality. You have to admire them because they're basically saying 'Fuck You' to society. They're making a statement through their clothes, which is a very powerful thing.

PS: Definitely. Style is important. It's not like fashion; it operates on a different level. Going back to the Jamaican guys... I think a lot of that gangster/cowboy crossover came from *The Harder They Come*. I remember seeing it at the Classic Cinema in Brixton, which is now the Ritzy, and being really blown away. I loved the way it referenced Sergio Corbucci's original Italian movie *Django*, when Jimmy Cliff goes to the cinema and watches the scene where Django pulls the machine gun out of the coffin and shoots everyone (*laughs*).

BG: I'm not sure what you think, but I love winding up musicians by saying that the image is more important than the music.

PS: In some ways I agree with you. Before a band even starts playing you instantly make a judgement on what they look like. When I was a kid, if I saw a band with long hair and flares I would instantly know that they had nothing to do with me. Whereas if they had short hair I always felt that there might be a connection.

BG: That's exactly how I felt when I first saw Johnny Rotten. Someone had pinned up a photo of him on the notice board at school and I was completely transfixed. It was taken at one of the early 100 Club gigs. He's wearing these baggy trousers and Teddy Boy shoes with this fucked-up crop, and he's on his knees screaming into the microphone. I stood there looking at it for ages, thinking, 'What the fuck is that?' It was the first time I'd ever seen a Punk… I guess what I'm saying is, I knew I was going to like the Sex Pistols before I'd even heard a note!

PS: I think Punk broke down the doors for a whole generation who wanted their own music. It also acted as a way for kids to express themselves in new ways.

BG: Oh yeah! I remember going to see The Clash at the Apollo in Glasgow with Richard Hell and being totally blown away by the crowd before the gig had even started. They looked like they'd come from Mars. There were kids with safety pins through their mouths, with chains, crazy haircuts—like Soo Catwoman—girls in fishnet tights wearing S&M gear. It felt like an attack on reality. It was beautiful but confrontational at the same time.

PS: Well, in the early days Punk was totally anti-consumerism because it put the power back into the hands of the people wearing the clothes. The trouble was, it became a uniform. I remember when we did the *Combat Rock* album we deliberately decided to wear military gear because we knew that everywhere in the world you'll find an army surplus store. The problem was, by the time we toured America every gig looked like we were playing an army base! It was like that scene in Tony Hancock's *The Rebel* where he goes to Paris and all the beatniks are dressed in exactly the same clothes, yet they're still calling themselves individuals.

BG: The great thing about The Clash is that you changed your image from album to album in the same way The Beatles did. What inspired your look at the start?

PS: We took from all sorts of things. I remember having long discussions with Joe Strummer about how you can use clothes to intimidate people, and how the original skinheads had achieved that. The idea was that if you walk along in Dr. Marten boots and mirrored sunglasses people will give you a wide berth. So it was about using clothes as self-protection, in a way.

BG: Was it easy getting hold of the gear you wanted in the mid-'70s?

PS: You had to look for them. We used to get straight-leg Mod trousers from second-hand stalls or jumble sales, fluorescent socks from Ted shops, and brothel creepers from Johnsons on the Kings Road. It was a strange mix, but it felt totally natural for us. Later on, the mix of looks also helped to pacify the different factions in the crowd, because there was a lot of friction between rival groups in those days, especially the Punks and the Skinheads.

BG: Aye. As a teenager I went to a lot of football matches and at Celtic versus Rangers I saw some terrible violence. People forget, but it was everywhere in society in the '70s, and it spilled over into gigs. Actually, I remember seeing you get arrested at a gig in Glasgow, and loads of people followed you down to the police station to show their support.

PS: Yeah, we ended up in the cells all night. Luckily Joe was wearing his Clash trousers which had lots of pockets in them, so even though the police searched us he still had a little bit of speed to keep us going (laughs).

BG: You couldn't sleep anyway because everyone was serenading you with Clash songs!

PS: Yeah (laughs). Going back to the look, we took it all very seriously. I would sit around for hours with Bernie Rhodes—our old manager—talking about the tiniest sartorial details: the size of your turn-ups, having a cigarette behind the ear. We would have these band meetings where we would ask, 'What is the point of us?' and discuss everything from Robert Rauschenberg to the situation in South Africa before we'd even play a note! The look was vital. Bernie used to say, 'If the audience is better dressed than the band, why should they have to listen to what the band's got to say?'

BG: That's brilliant! I couldn't agree more. I felt the same way in the early '90s. There was no flash in rock 'n' roll. All the American indie bands were wearing plaid shirts and jeans and the British bands were wearing baggy clothes; nothing was fitted. I would say to Kevin Shields from My Bloody Valentine, 'I can't believe you're going onstage in sweatshirts.' So as a reaction to it, I had these metallic gold and silver shirts made up around the time of *Screamadelica*, which I wore in the videos for 'Movin' On Up' and 'Higher Than the Sun'. I wanted to be quite glam but also refer back to the mid-'60s Stones look Jagger had around the time of 'Have You Seen Your Mother, Baby, Standing in the Shadow?' and the early days of rock 'n' roll with Elvis. I would wear them with blue velvet trousers and jodhpur boots, which I picked up from a gentlemen's outfitter on the Kings Road. The only reason that I started wearing them was because Mick Jones had a pair. Talking of which, I always wanted a pair of motorcycle boots because I liked the way you used to wear them with a suit.

PS: I started wearing those because as a kid I had great memories of being on the bus and seeing the 59 Club go roaring by. They were called Ton Up Boys, working-class kids with motorbikes. On top of it being a great way of getting about and them looking great, there was an added charge to it. They represented something outside of normal society.

BG: Talking of which, I'd like to ask you a question. I was fascinated about it when I was young and wondered if you were inspired by seeing people do the Wall of Death?

PS: Not so much, but I've always liked that outlaw aspect of riding a bike, which goes back to Brando and Lee Marvin in *The Wild One*. I also love the way that the Ton Up Boys would save up and work overtime to afford a bike, in the same way that the Mods saved up to get their scooters. It was an important part of their cultural make-up as working-class kids.

BG: I think it's the same thing with rare-breed dogs these days. We've got a Staffordshire Bull Terrier and wherever I go, kids from the estate come up to me and go, 'What a dog, mate.' People love those dogs because they're beautiful and they're within their reach.

PS: That's the great thing about style—it's affordable. But it has to come with some meaning behind it.

BG: Oh aye. That's why I hated the New Romantics. What's the point of looking like dandies and dressing up when the music has got nothing to say?

PS: And some of the clothes were awful. You wouldn't catch me in a pair of jelly shoes.

BG: But then around the same time you had The Specials. It was weird because I saw them supporting The Clash in '78 when they were still The Automatics, and Terry Hall looked like he had a white kaftan on. Then a year later 'Gangsters' had come out and we drove to Edinburgh to see them and they had the image totally together. The Tonik trousers...

PS: Funny you should mention them because in the early days of The Clash I used to wear this

two-tone jacket which I borrowed from my mate at school. I later heard from Bernie Rhodes that Jerry Dammers had seen me wearing it at our rehearsal studios one day and it had inspired their whole 2-Tone thing.

BG: Does it bother you that The Clash's look has now become part of the mainstream? For instance, about four years ago all these designers started doing high-end versions of The Clash's motorcycle boots which ended up on the high street. I've seen women pushing prams wearing these boots and I'm thinking, 'I'm old enough to know this all started with Johnny Thunders and The Clash!'

PS: It doesn't bother me because everything is part of the same process. There's no difference between a kid buying a Clash T-shirt in Topshop today and a kid buying a James Dean T-shirt in the '70s. It's an entrance into a different world. What is important is that style will always allow working-class kids to dress up and feel good about themselves.

Interview Paul Moody

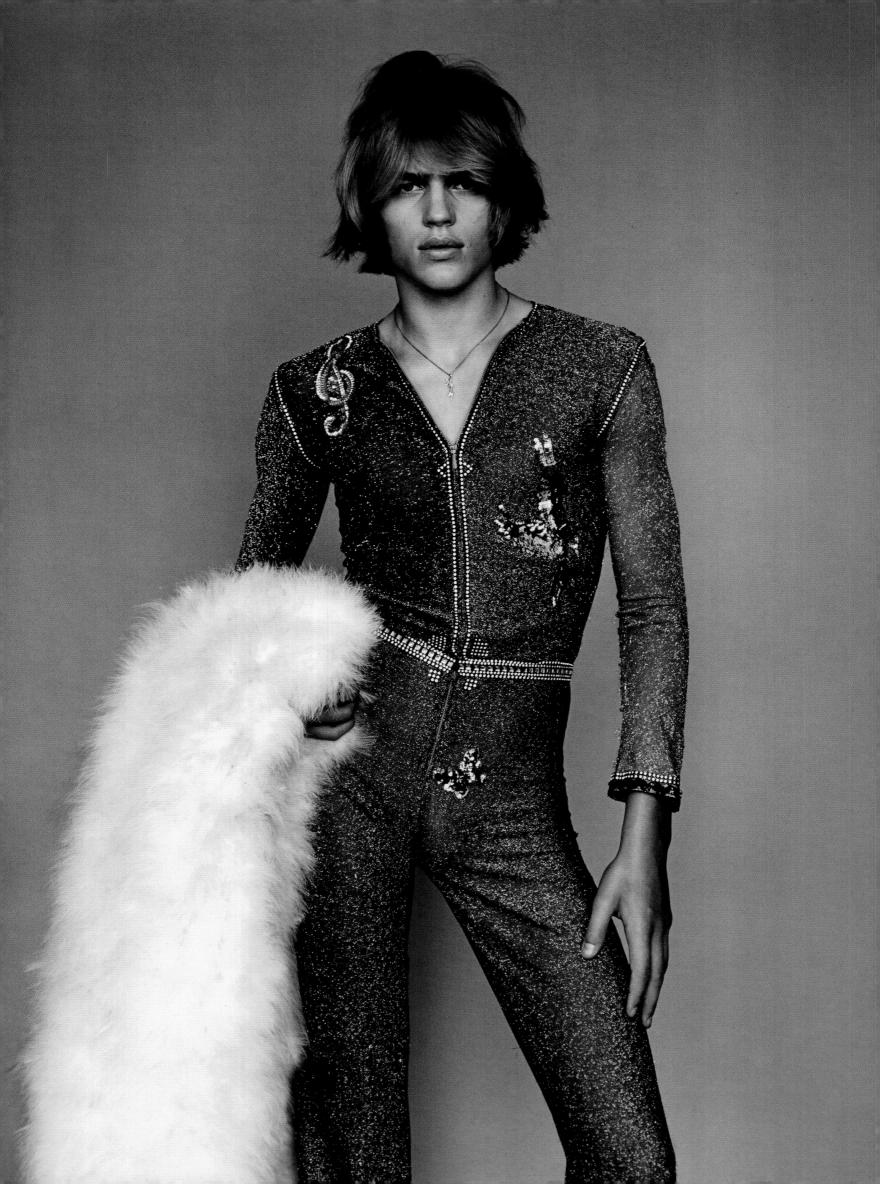

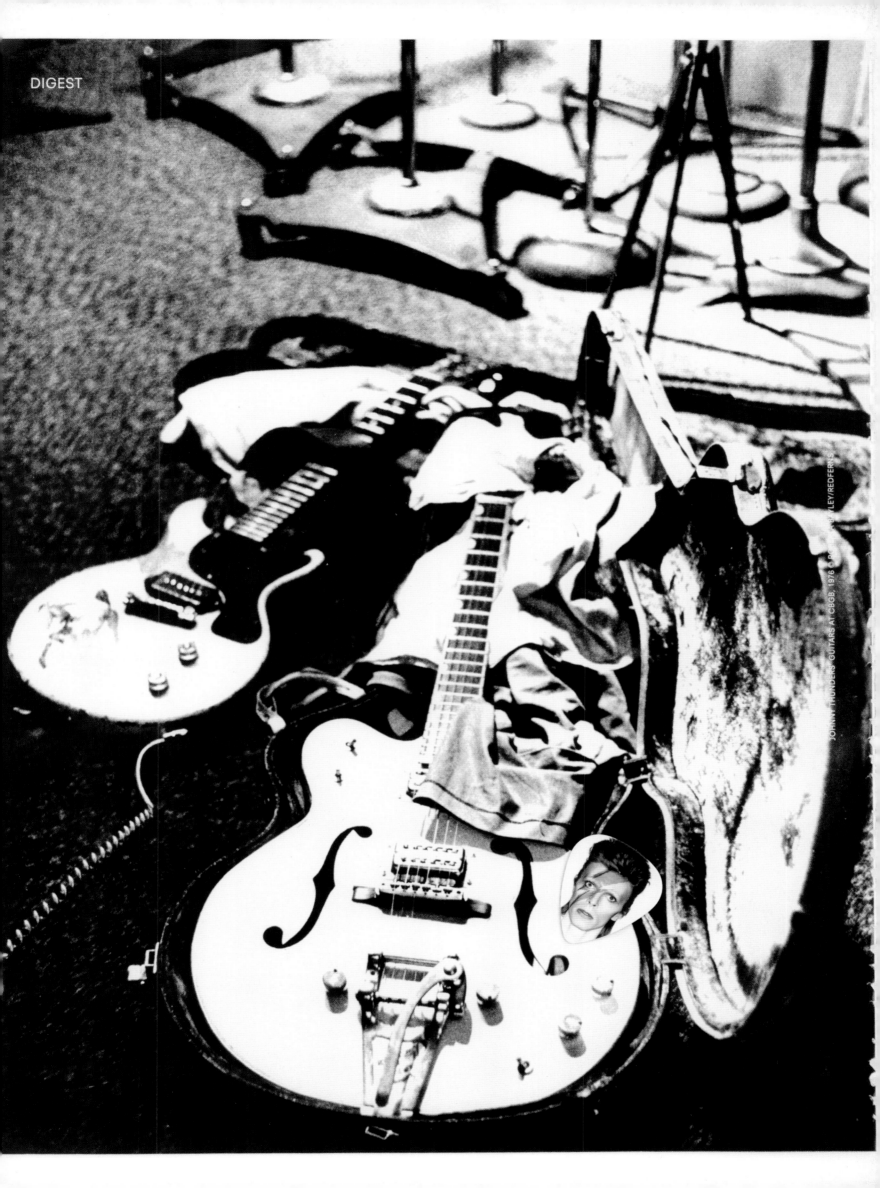

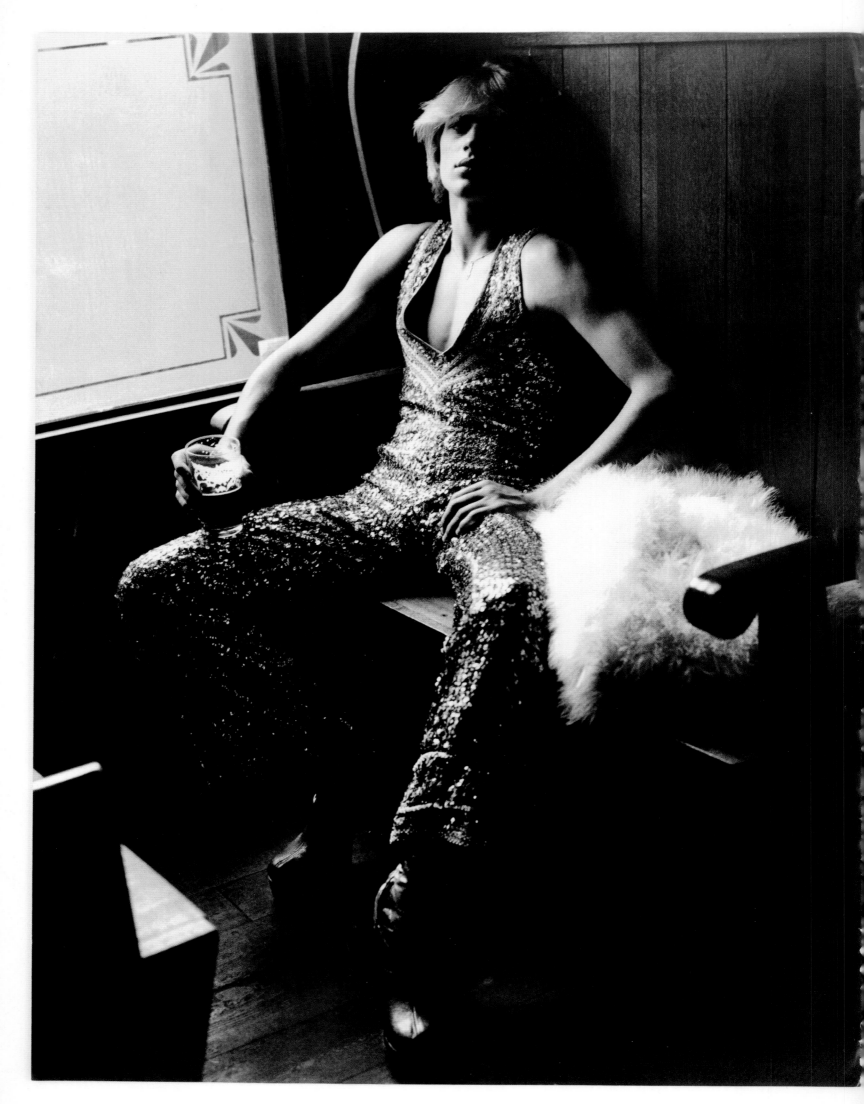

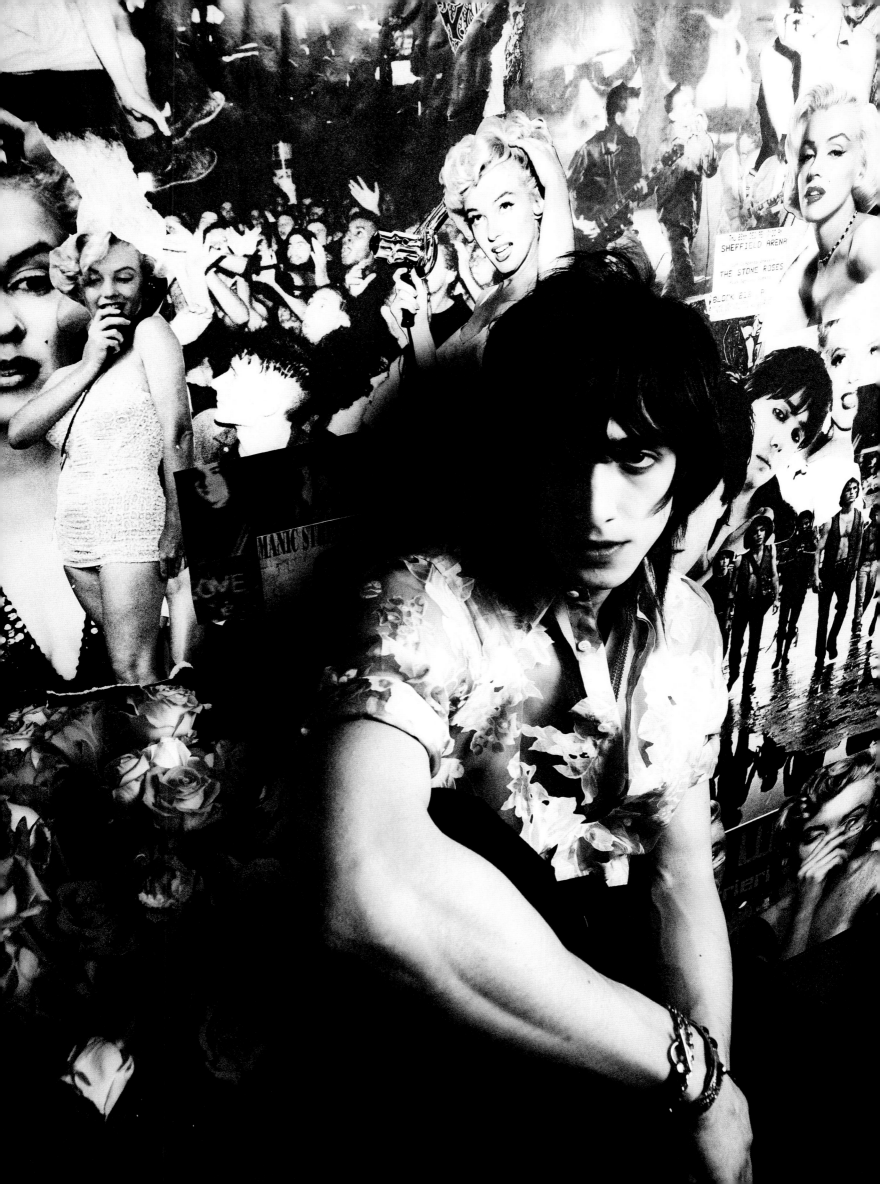

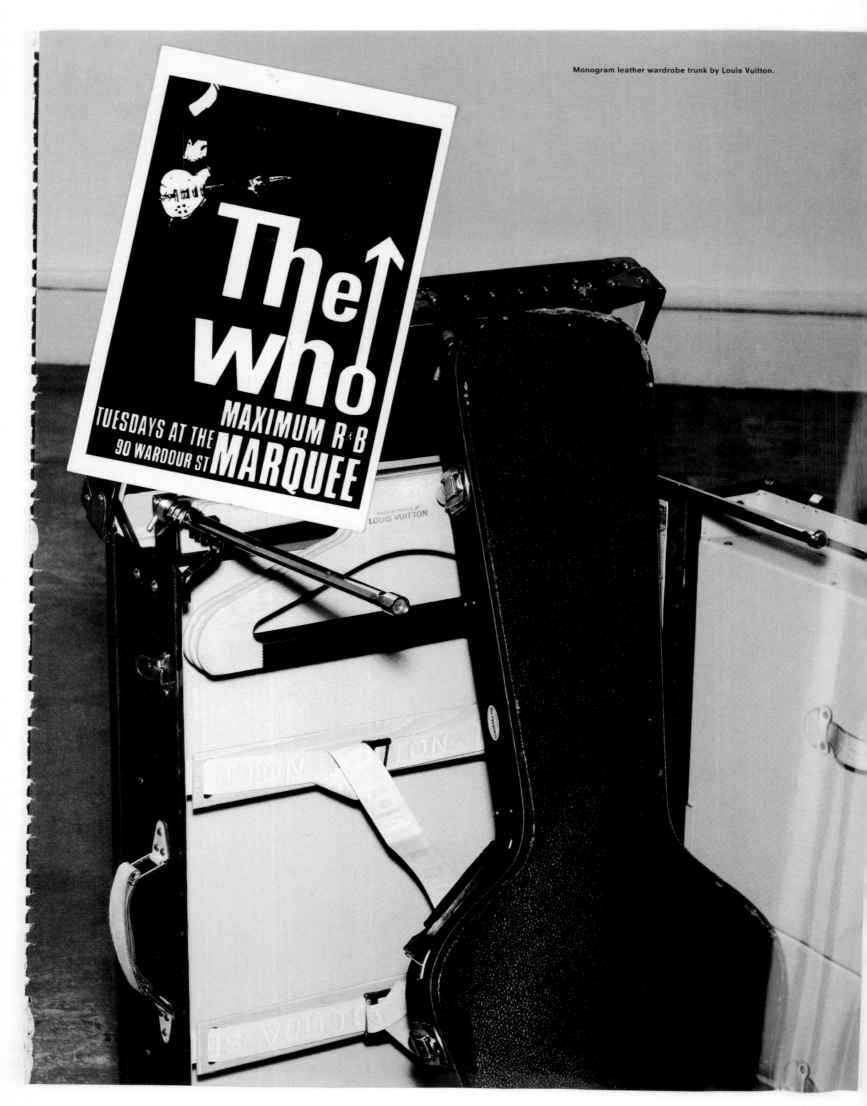

Monogram leather wardrobe trunk by Louis Vuitton.

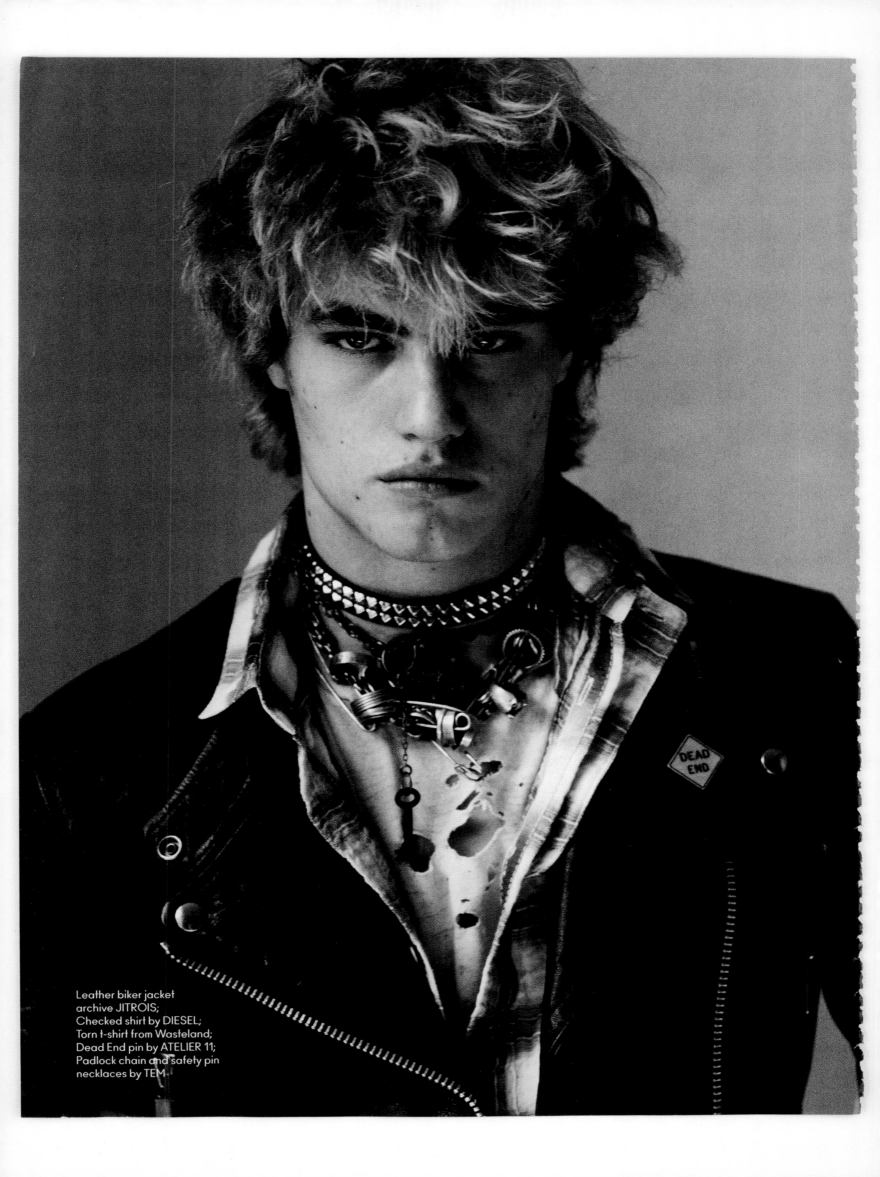

Leather biker jacket
archive JITROIS;
Checked shirt by DIESEL;
Torn t-shirt from Wasteland;
Dead End pin by ATELIER 11;
Padlock chain and safety pin
necklaces by TEM

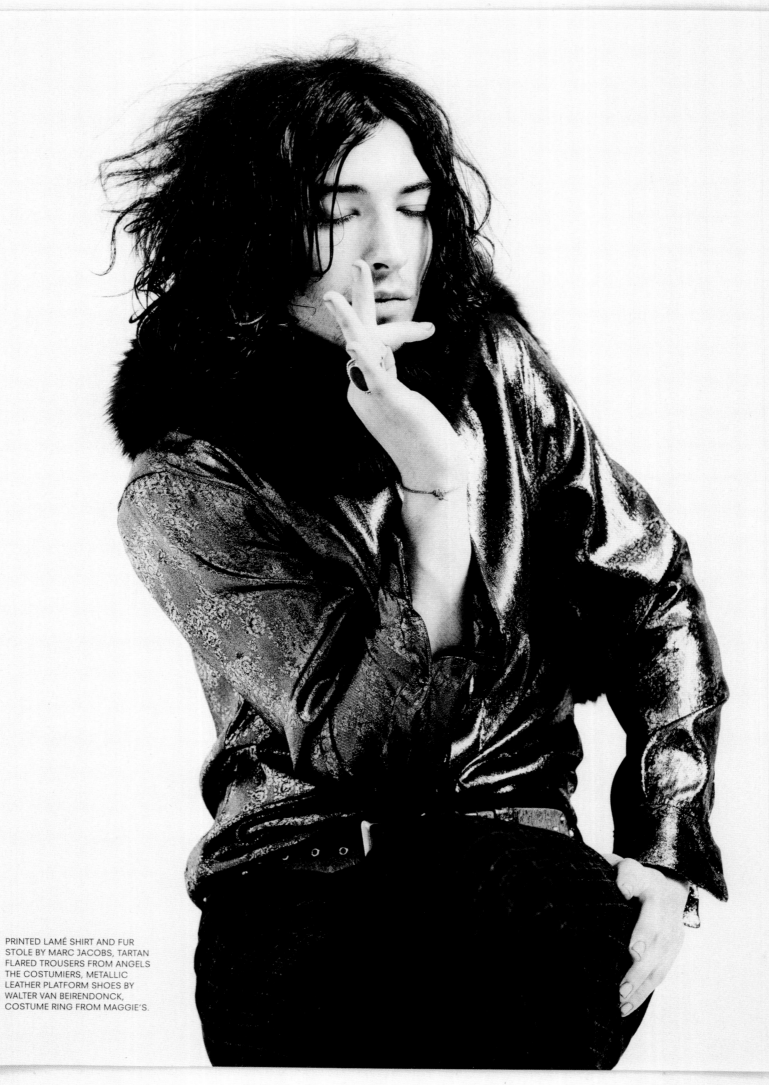

PRINTED LAMÉ SHIRT AND FUR
STOLE BY MARC JACOBS, TARTAN
FLARED TROUSERS FROM ANGELS
THE COSTUMIERS, METALLIC
LEATHER PLATFORM SHOES BY
WALTER VAN BEIRENDONCK,
COSTUME RING FROM MAGGIE'S.

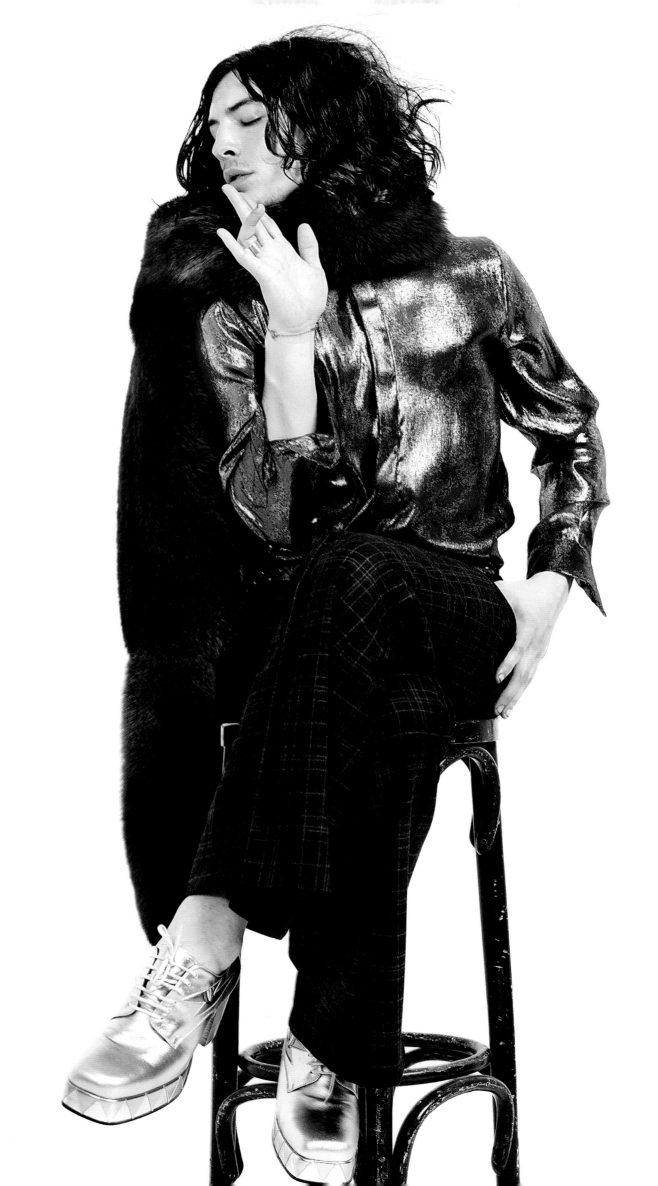

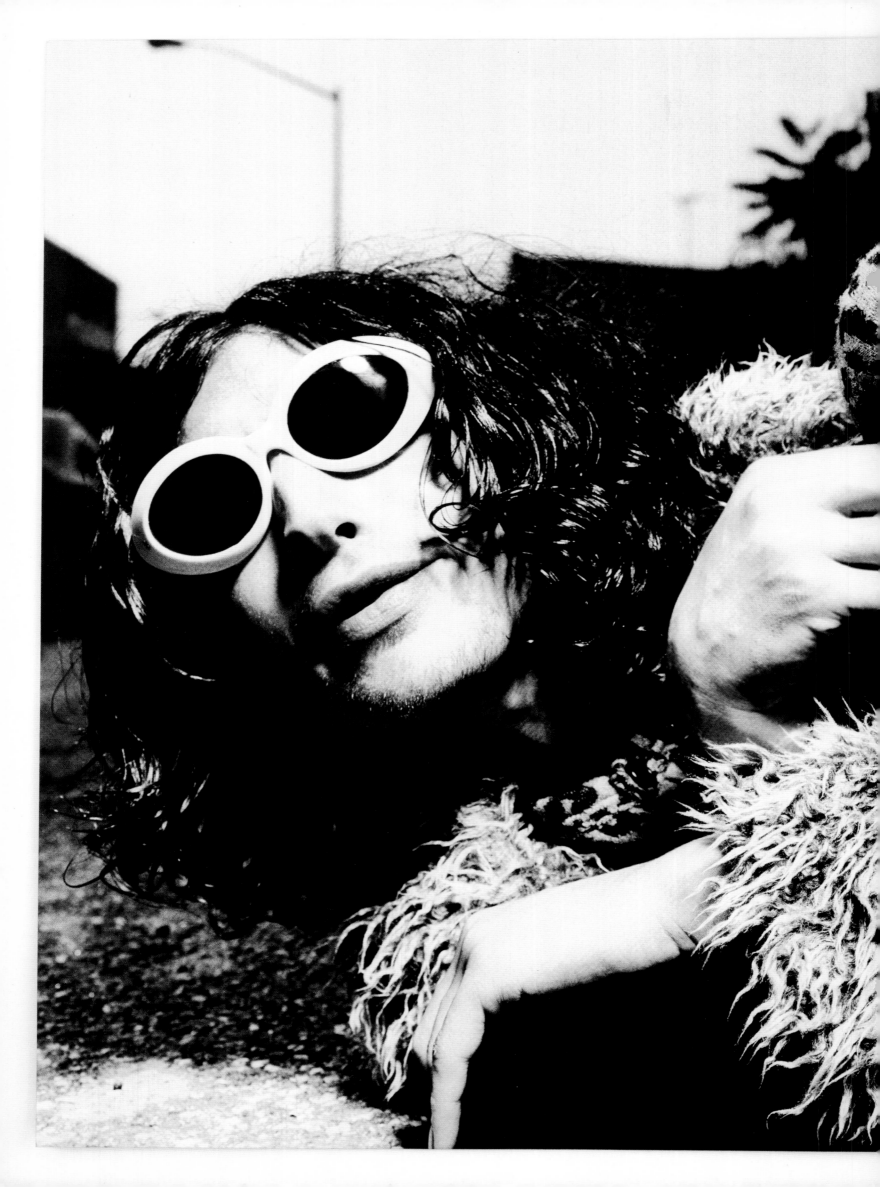

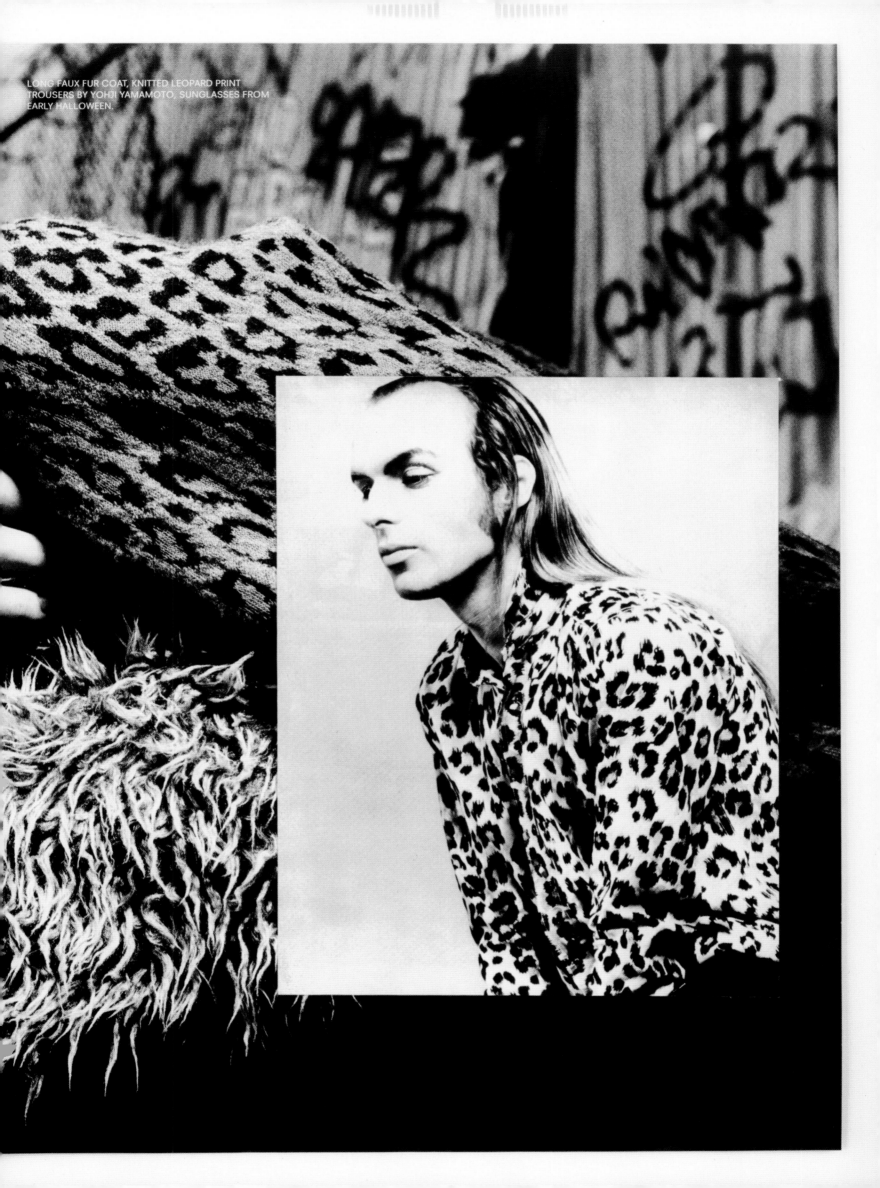

LONG FAUX FUR COAT, KNITTED LEOPARD PRINT
TROUSERS BY YOHJI YAMAMOTO, SUNGLASSES FROM
EARLY HALLOWEEN.

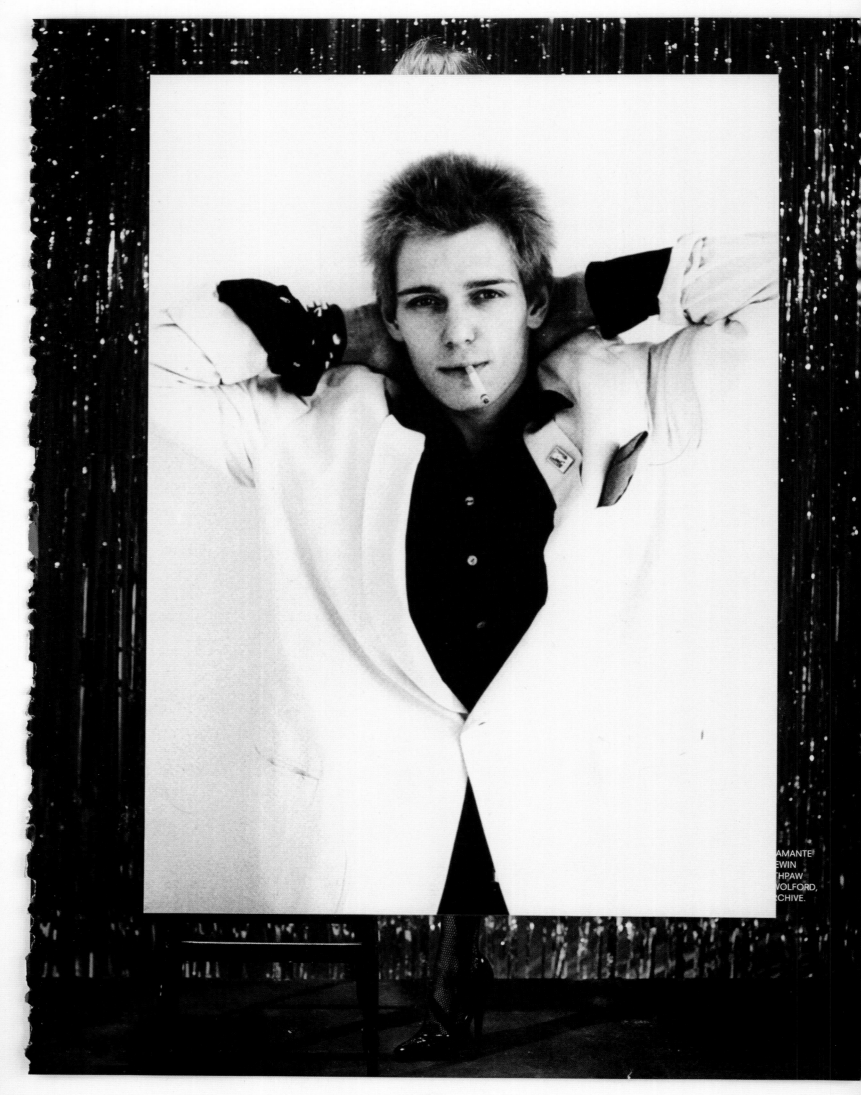

AMANTE
EWIN
THPAW
WOLFORD,
RCHIVE.

222

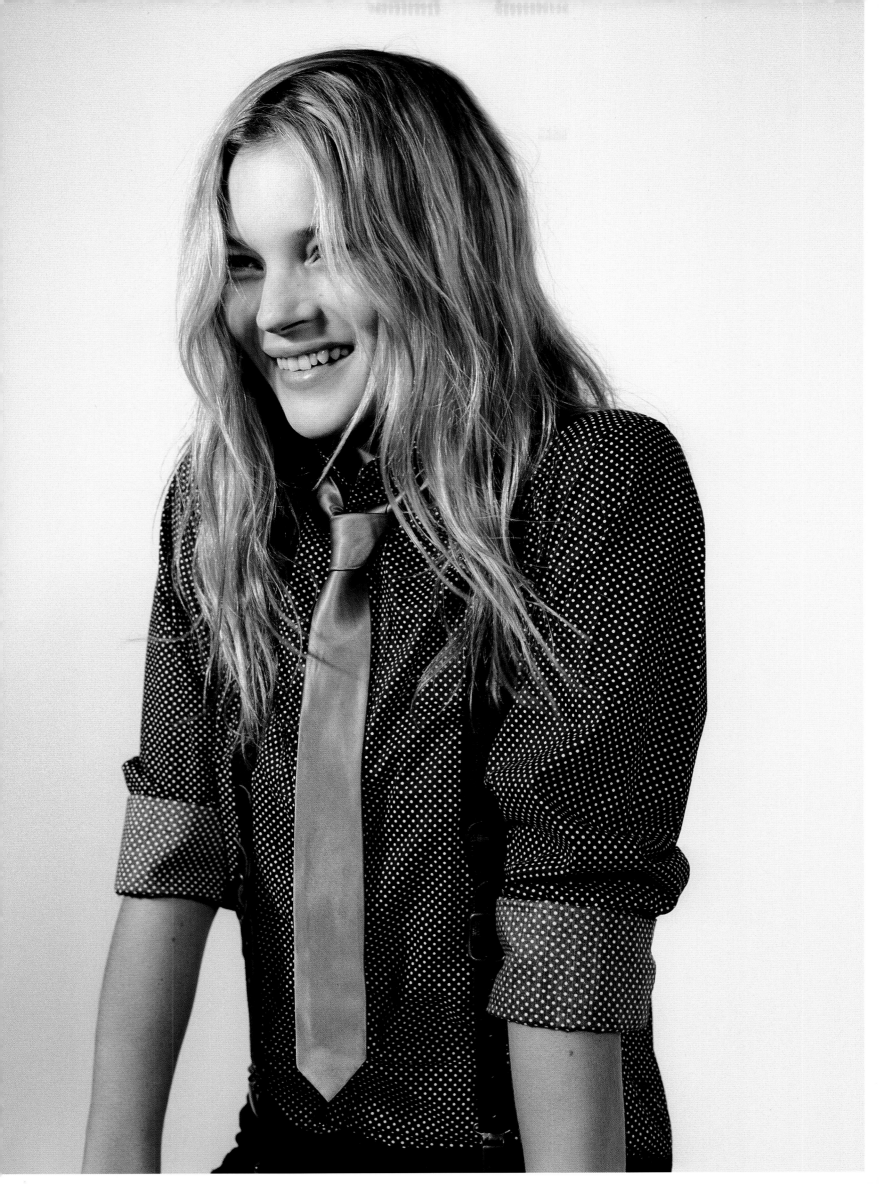

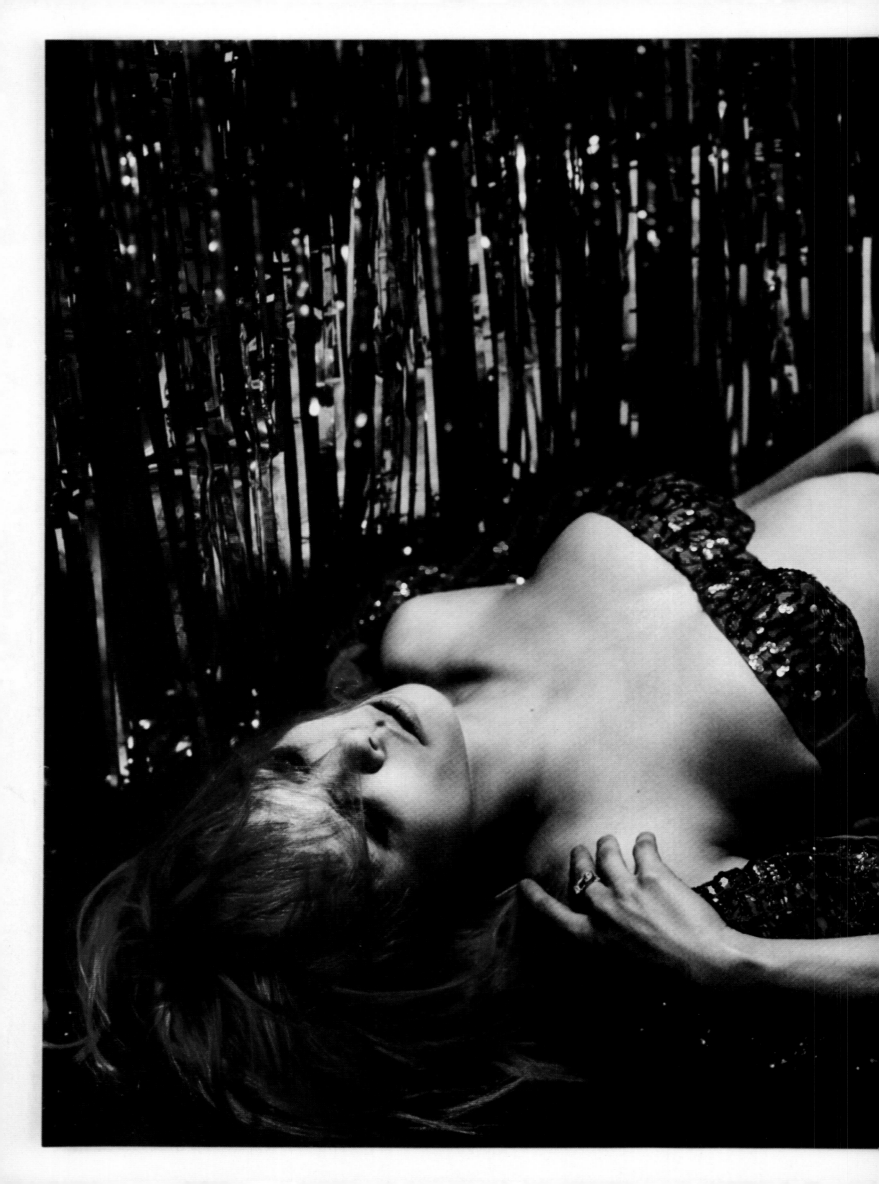

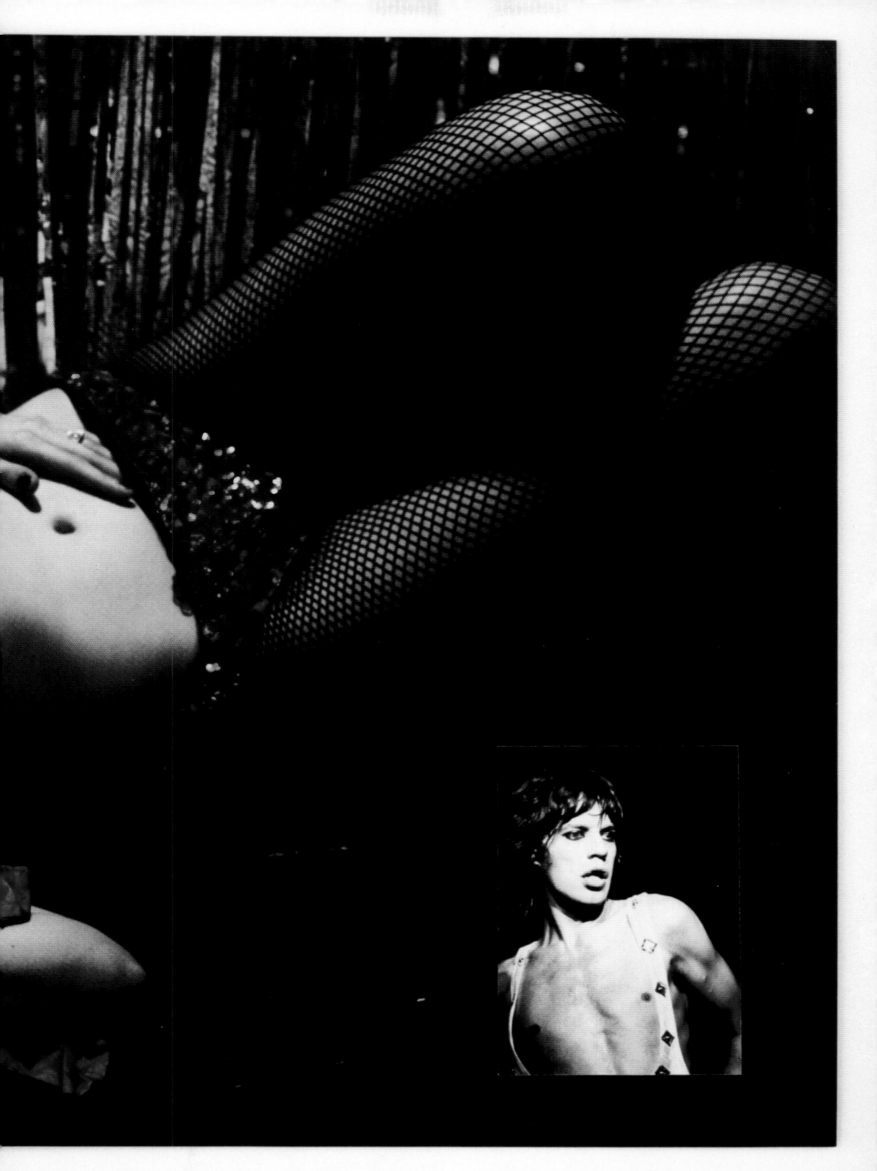

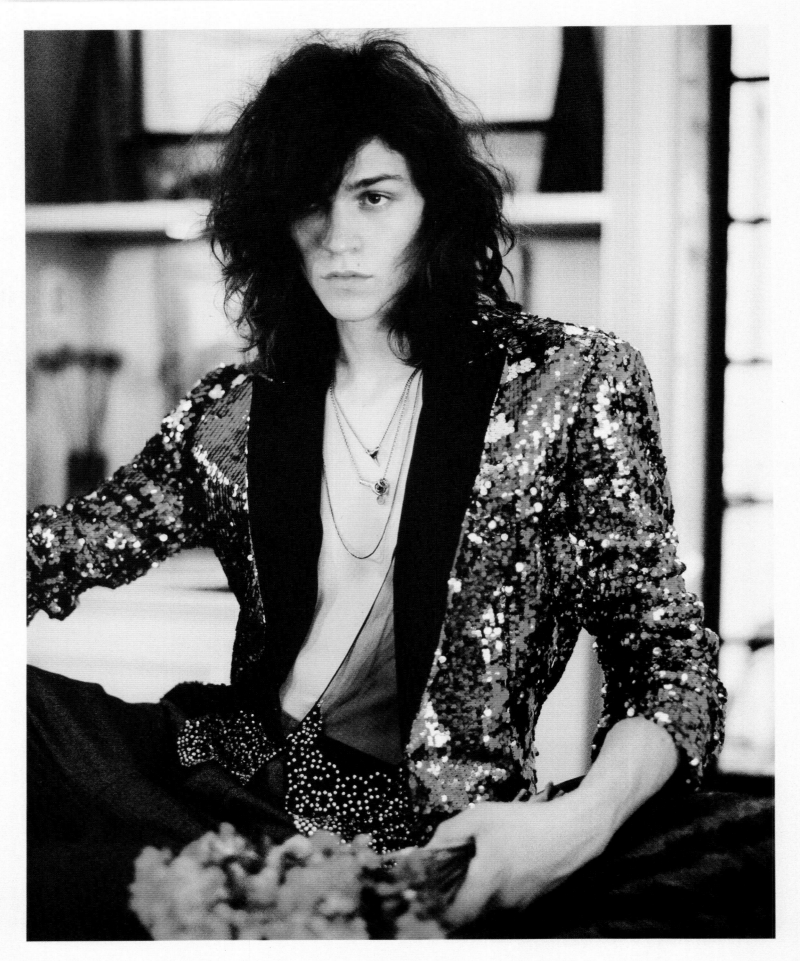

DOLCE & GABBANA

Worn with diamanté waistcoat from New York Vintage, tooth necklace and oxidised brass and silk necklace by Alyssa Norton, tube necklace by Tobias Wistisen.

Another Man

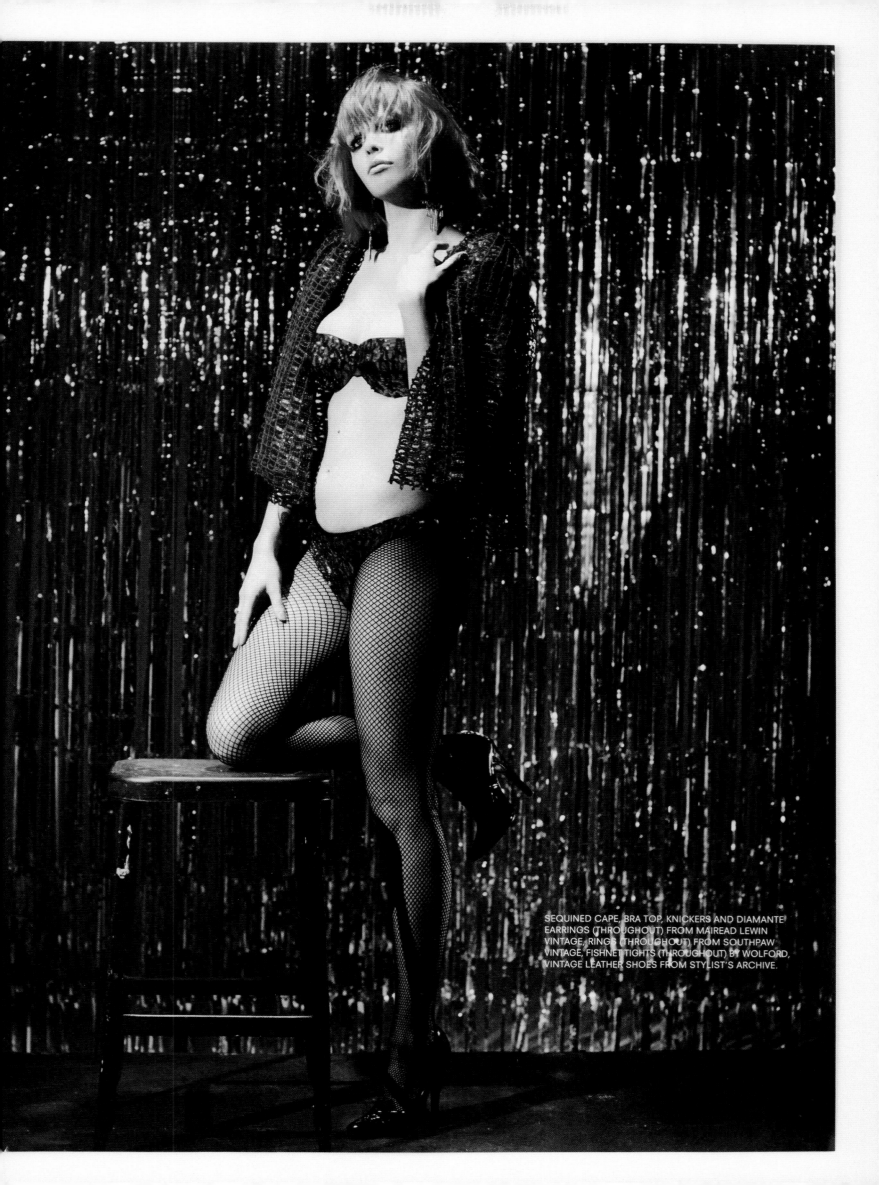

SEQUINED CAPE, BRA TOP, KNICKERS AND DIAMANTE
EARRINGS (THROUGHOUT) FROM MAIREAD LEWIN
VINTAGE, RINGS (THROUGHOUT) FROM SOUTHPAW
VINTAGE, FISHNET TIGHTS (THROUGHOUT) BY WOLFORD,
VINTAGE LEATHER SHOES FROM STYLIST'S ARCHIVE.

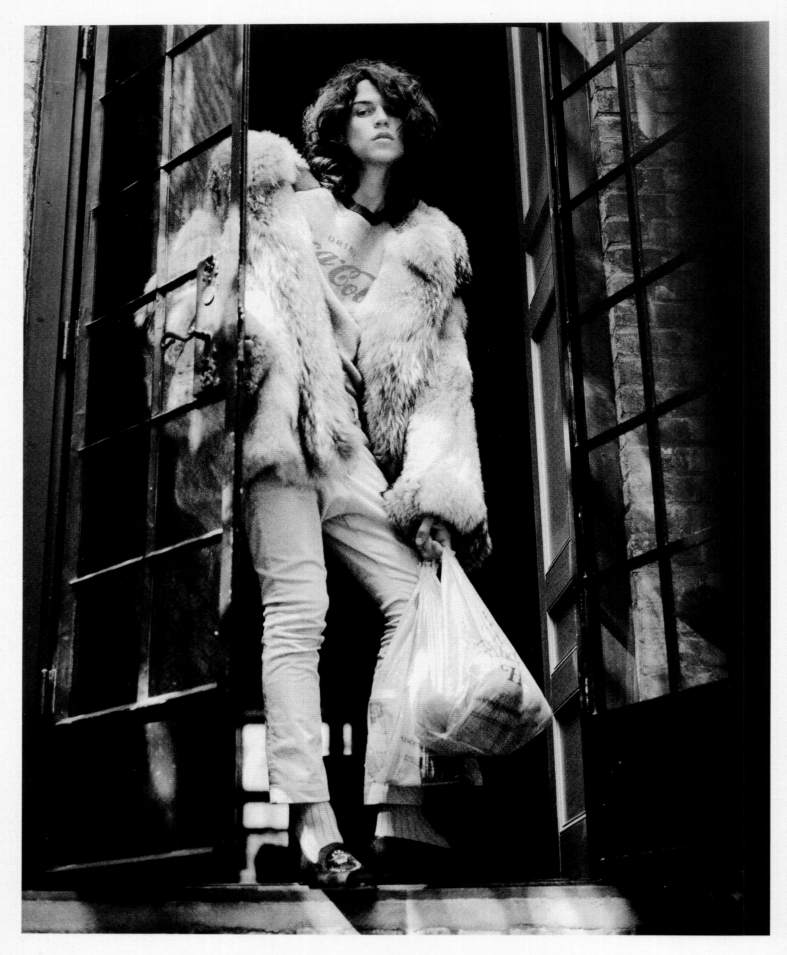

D&G

Worn with socks by Tabio and slippers by Etro.

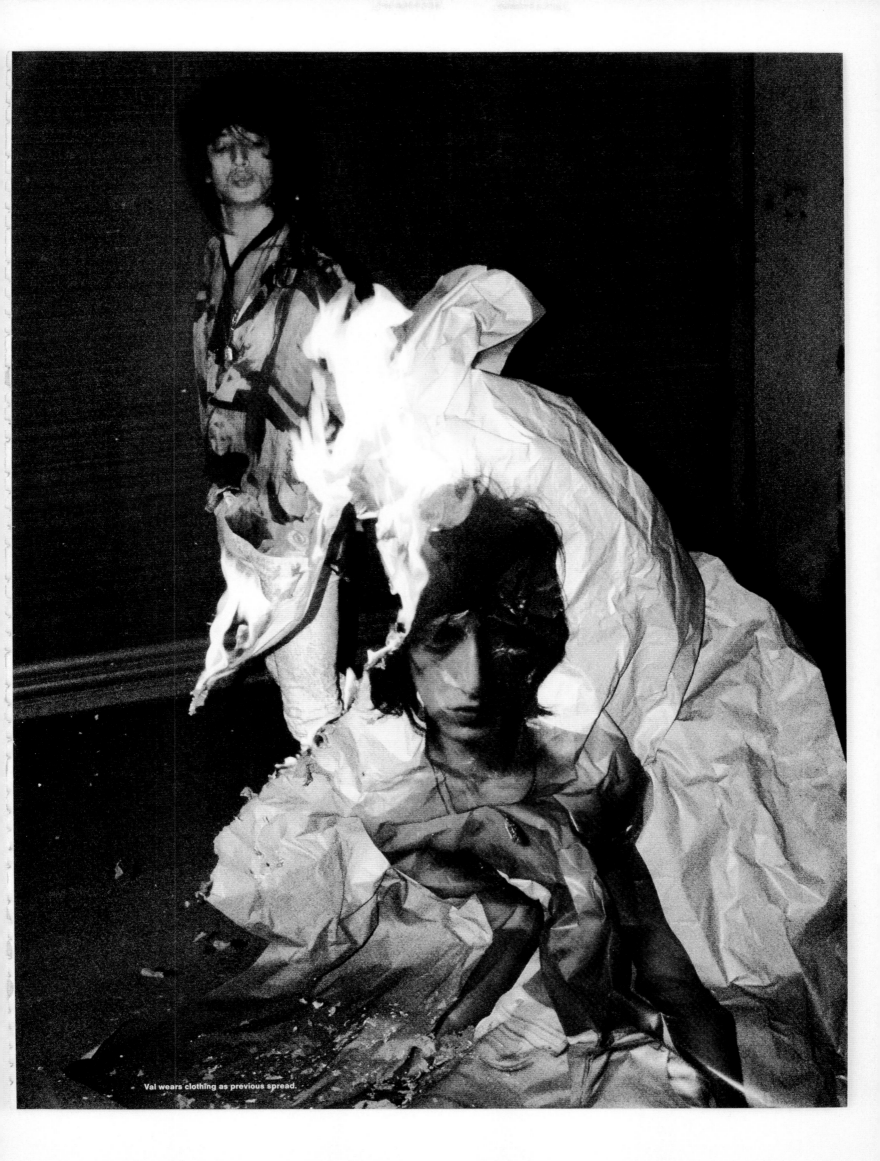

Val wears clothing as previous spread.

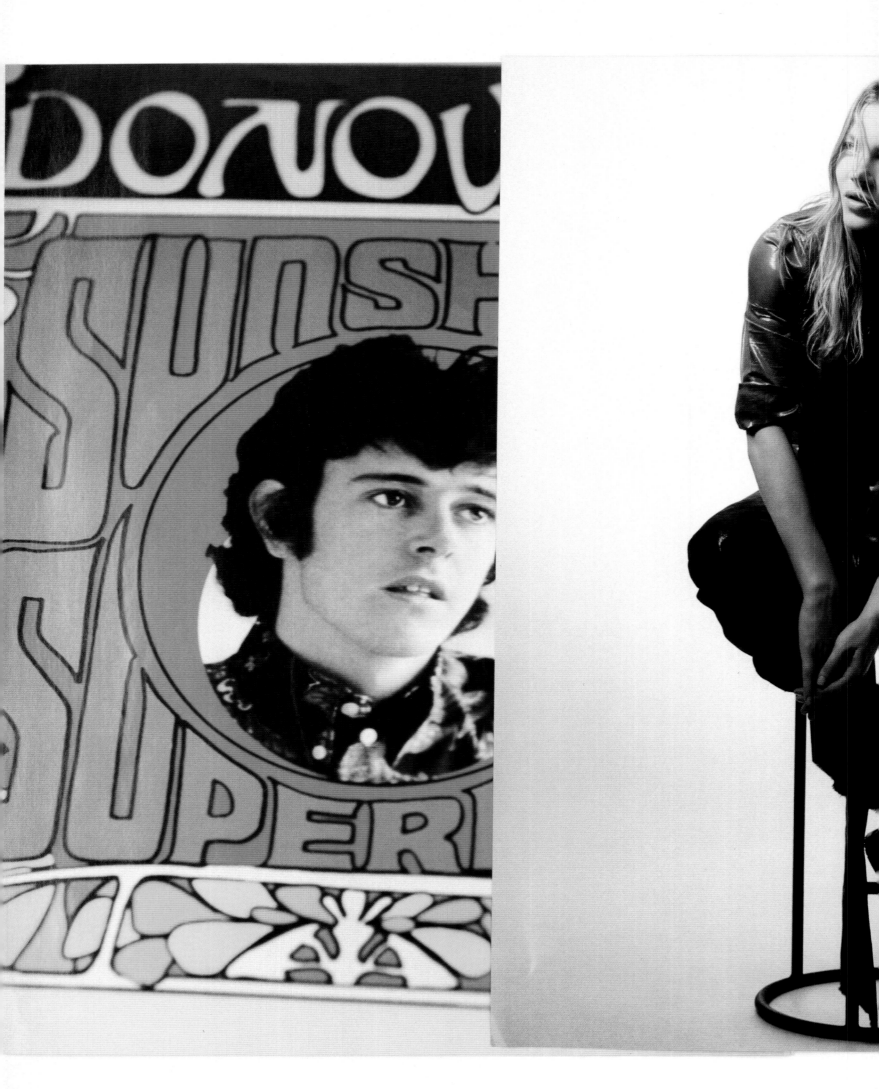

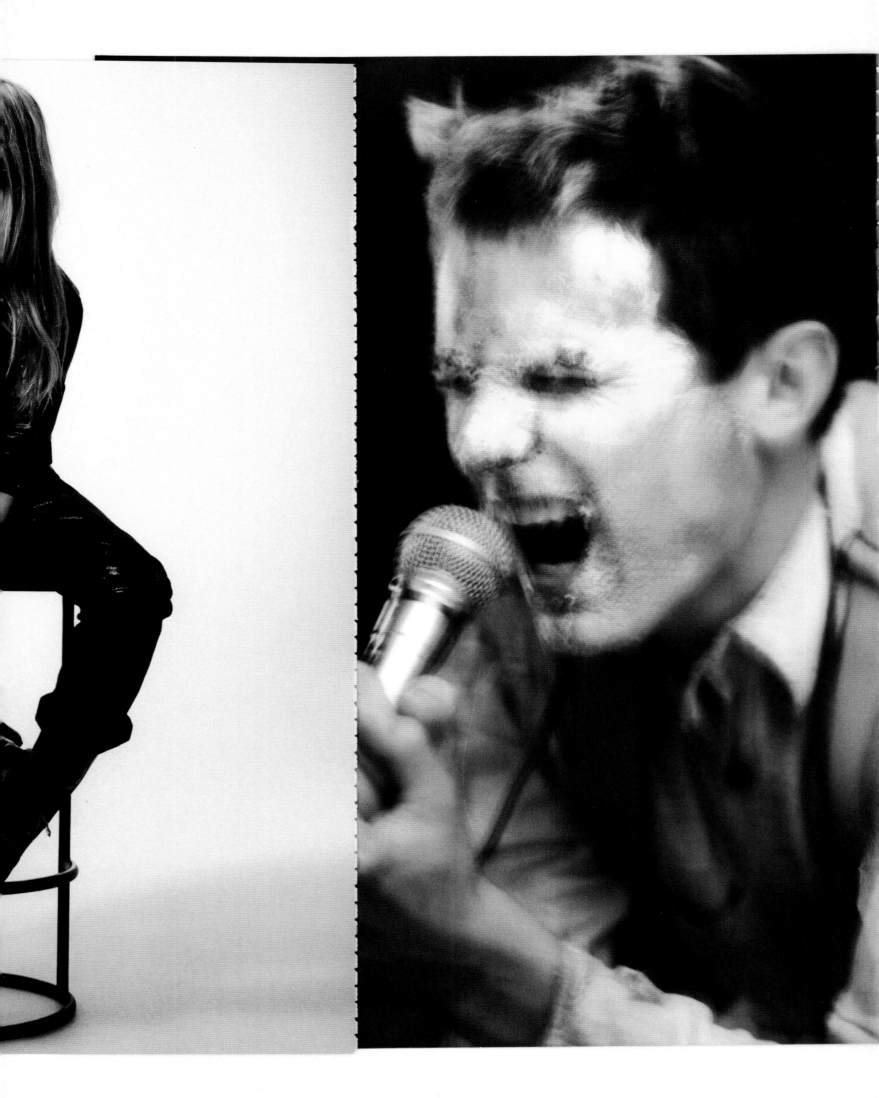

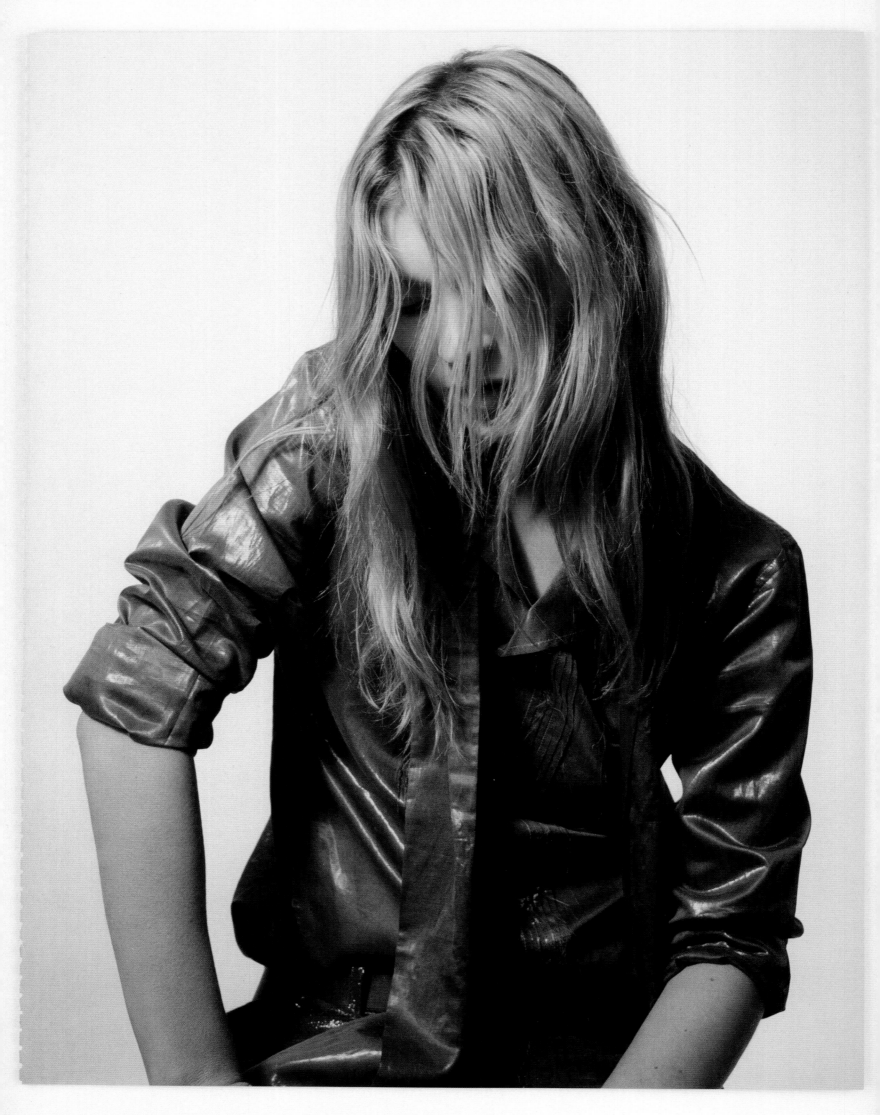

232

РАДИО 101

День рождения Russian Go

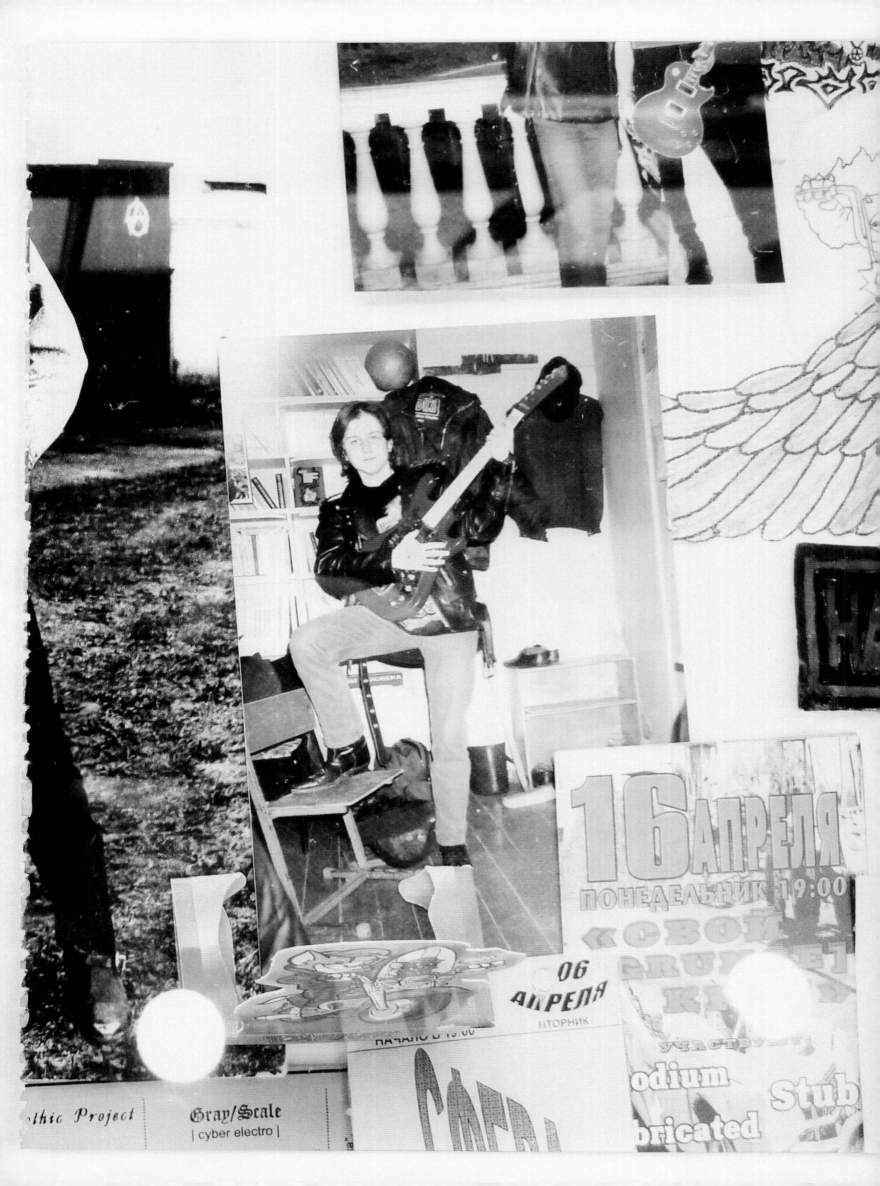

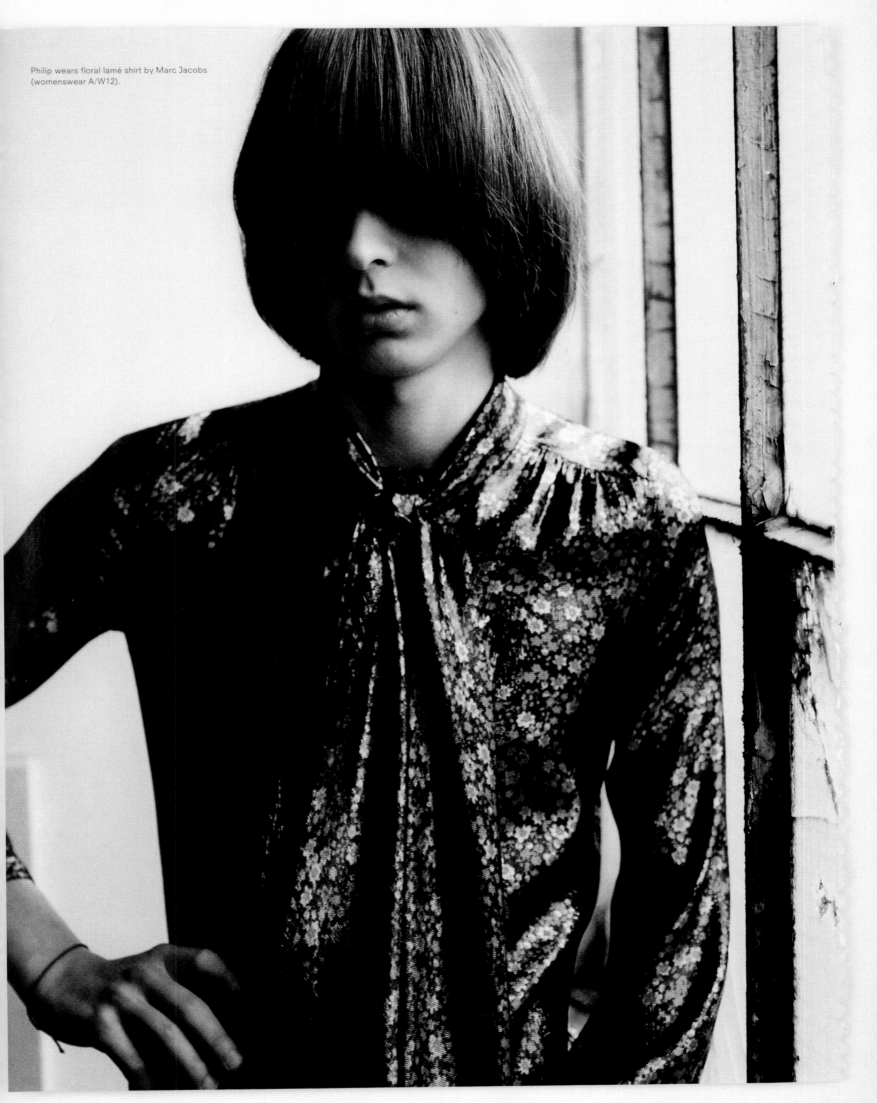

Philip wears floral lamé shirt by Marc Jacobs
(womenswear A/W12).

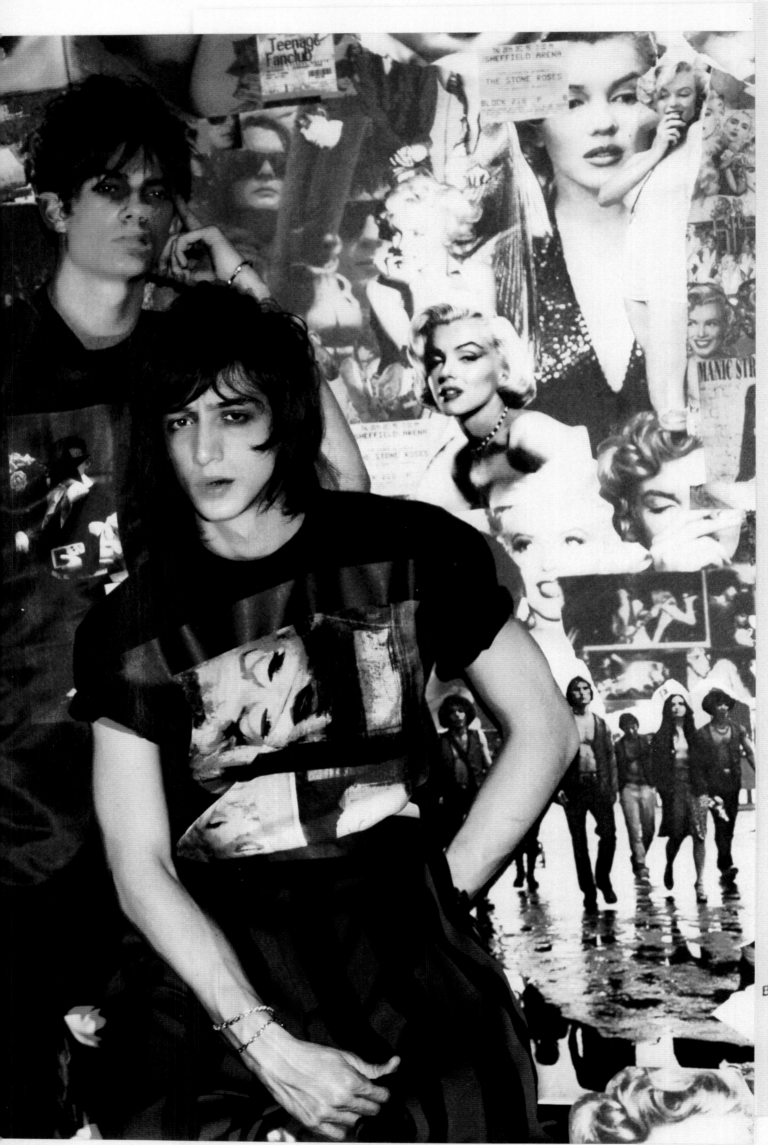

LEAD VOCA
GUITAR
GUITARS
BASS
DRUMS
BACKUP VOCALS
DO

REC

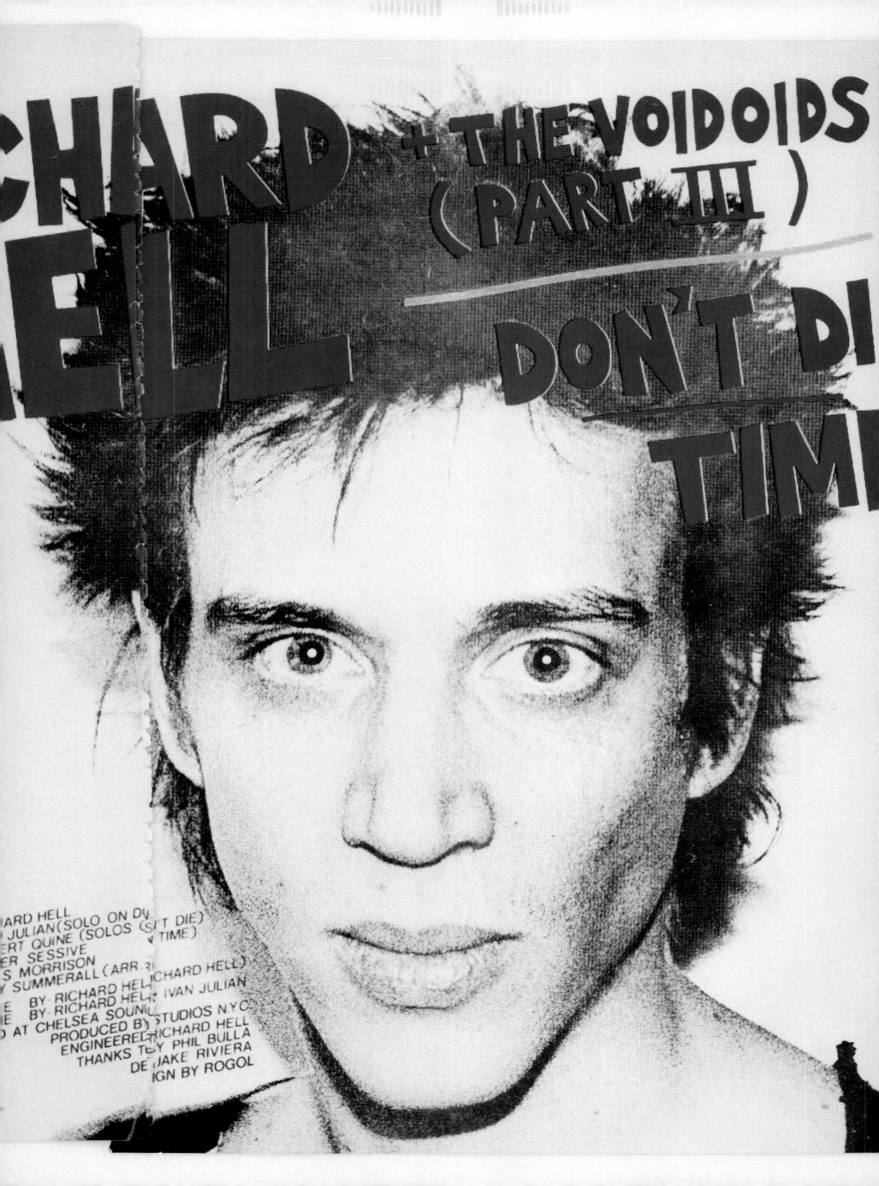

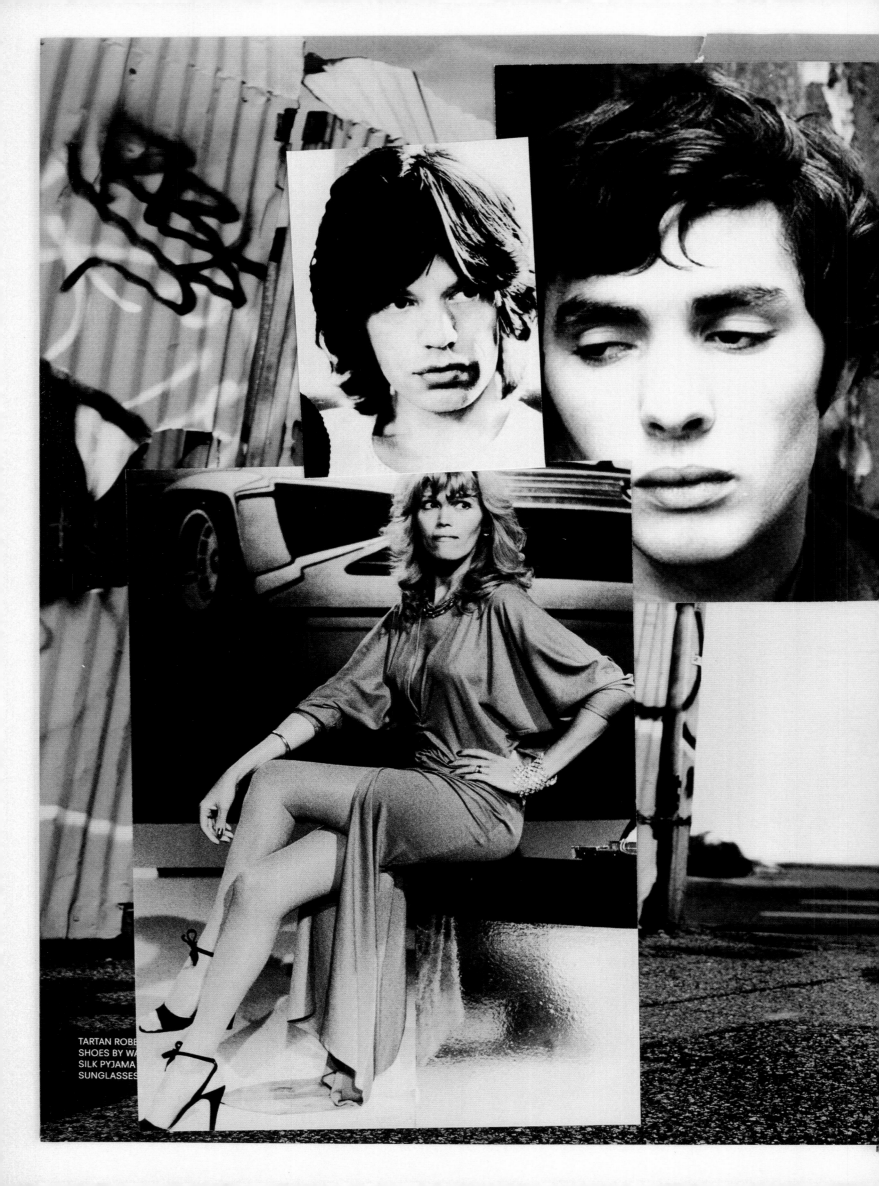

TARTAN ROBE
SHOES BY WA
SILK PYJAMA
SUNGLASSES

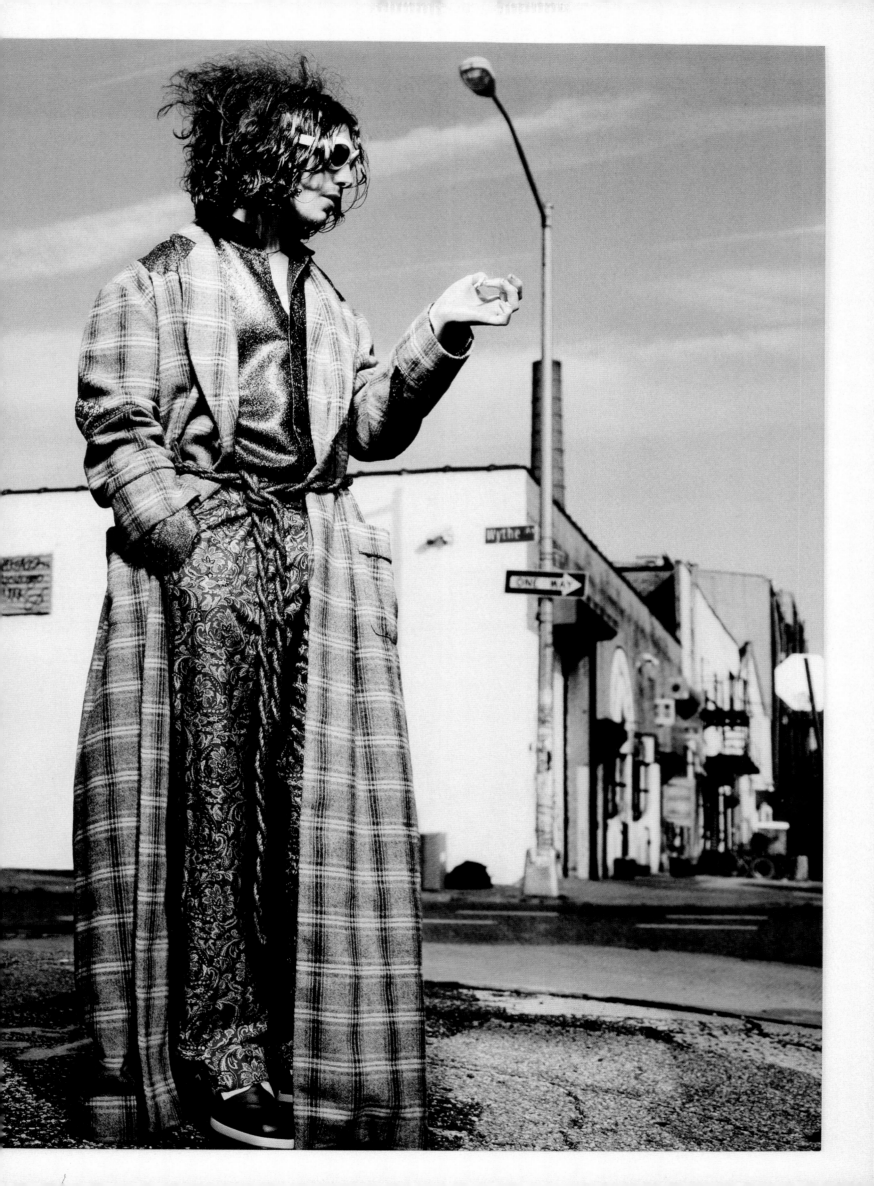

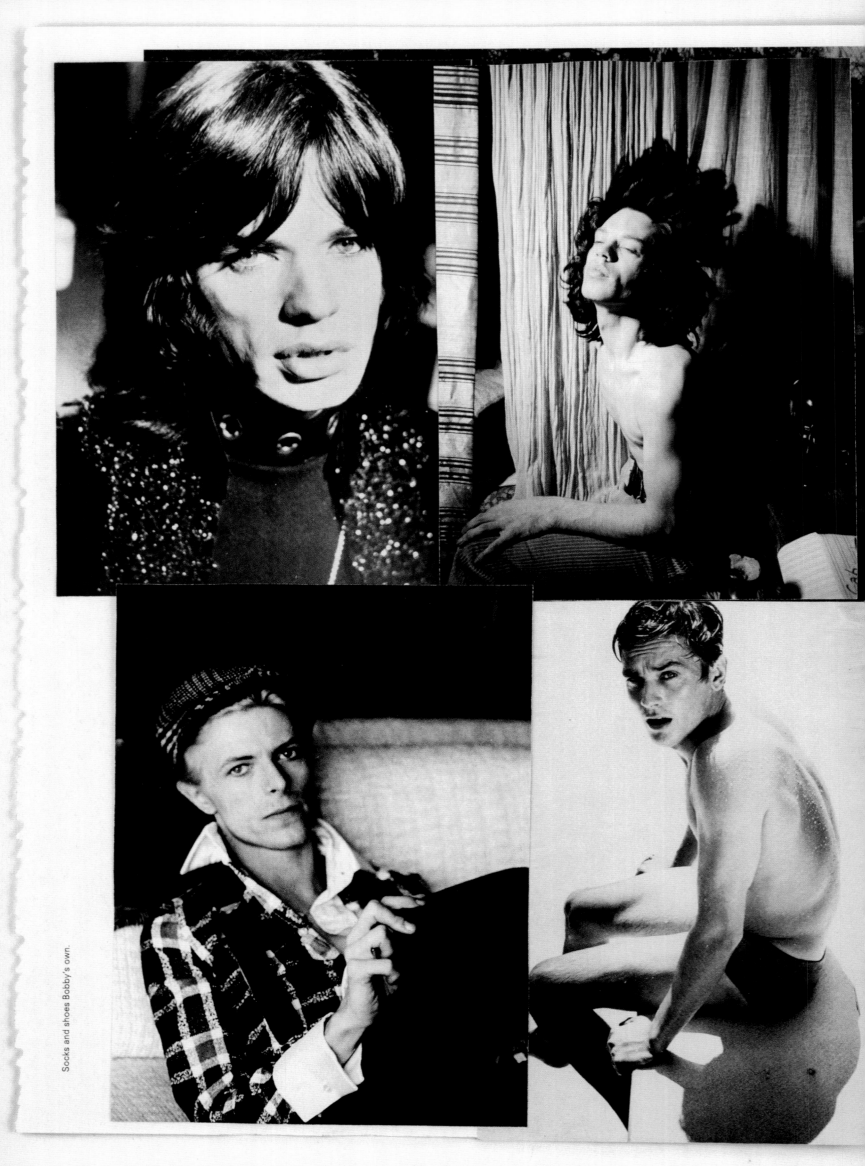

Socks and shoes Bobby's own.

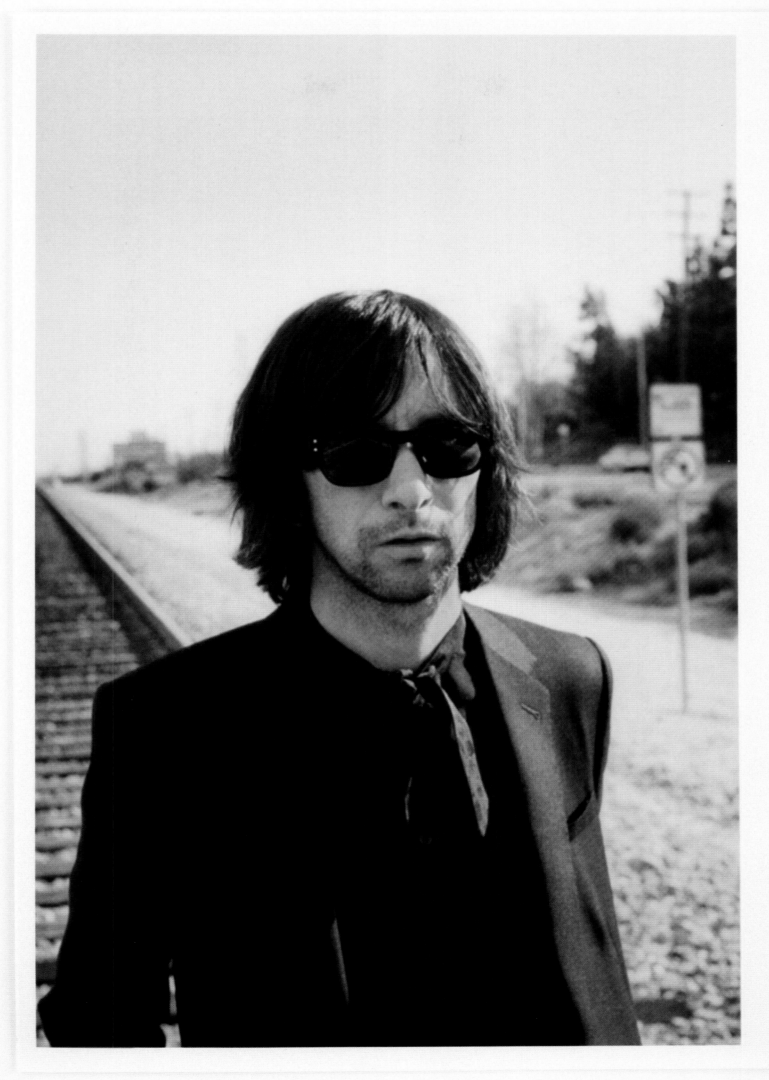

Sunglasses Bobby's own.

241

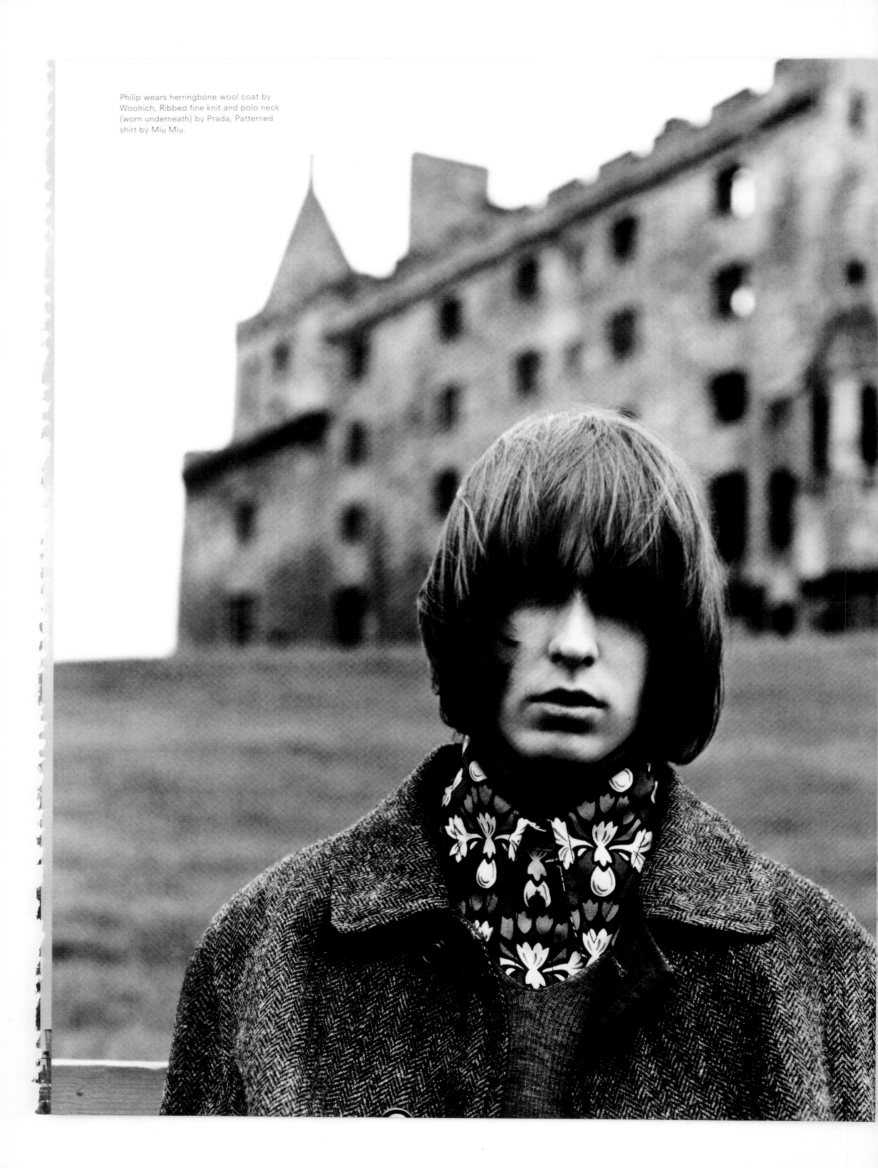

Philip wears herringbone wool coat by
Woolrich, Ribbed fine knit and polo neck
(worn underneath) by Prada, Patterned
shirt by Miu Miu.

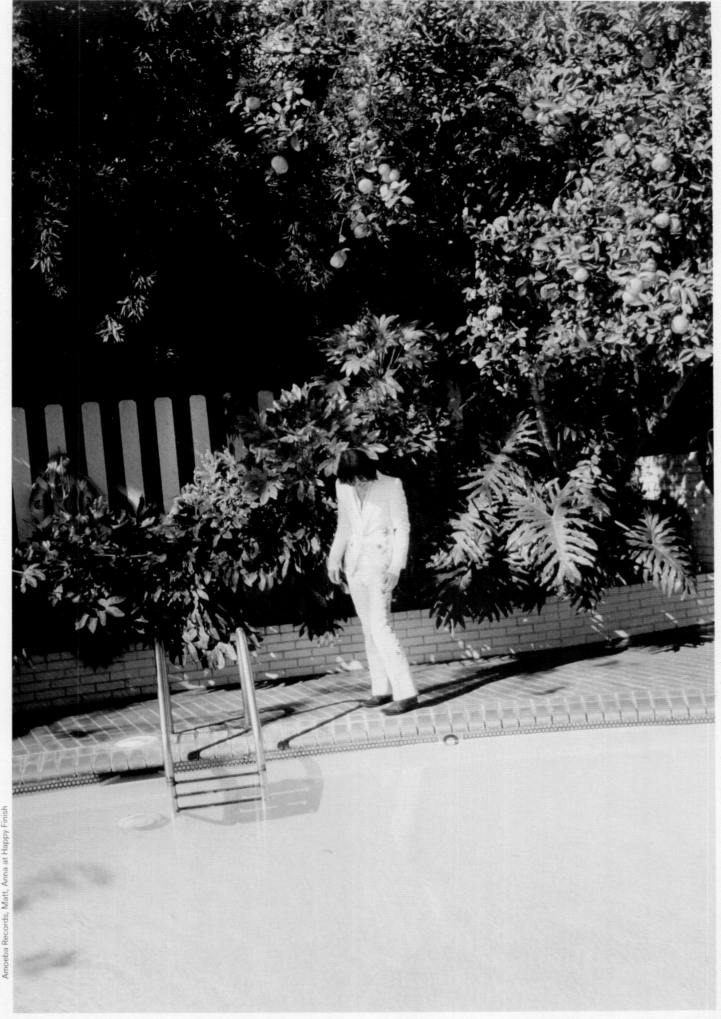

Floral embroidered suit Bobby's own.

PHOTOGRAPHIC ASSISTANT Olivia Jaffe STYLING ASSISTANT Kerry Panaggio PRODUCTION Wes Olson for Connect The Dots Inc POST PRODUCTION Happy Finish London SPECIAL THANKS TO Chateau Marmont, Federica Carrion, Amoeba Records, Matt, Anna at Happy Finish

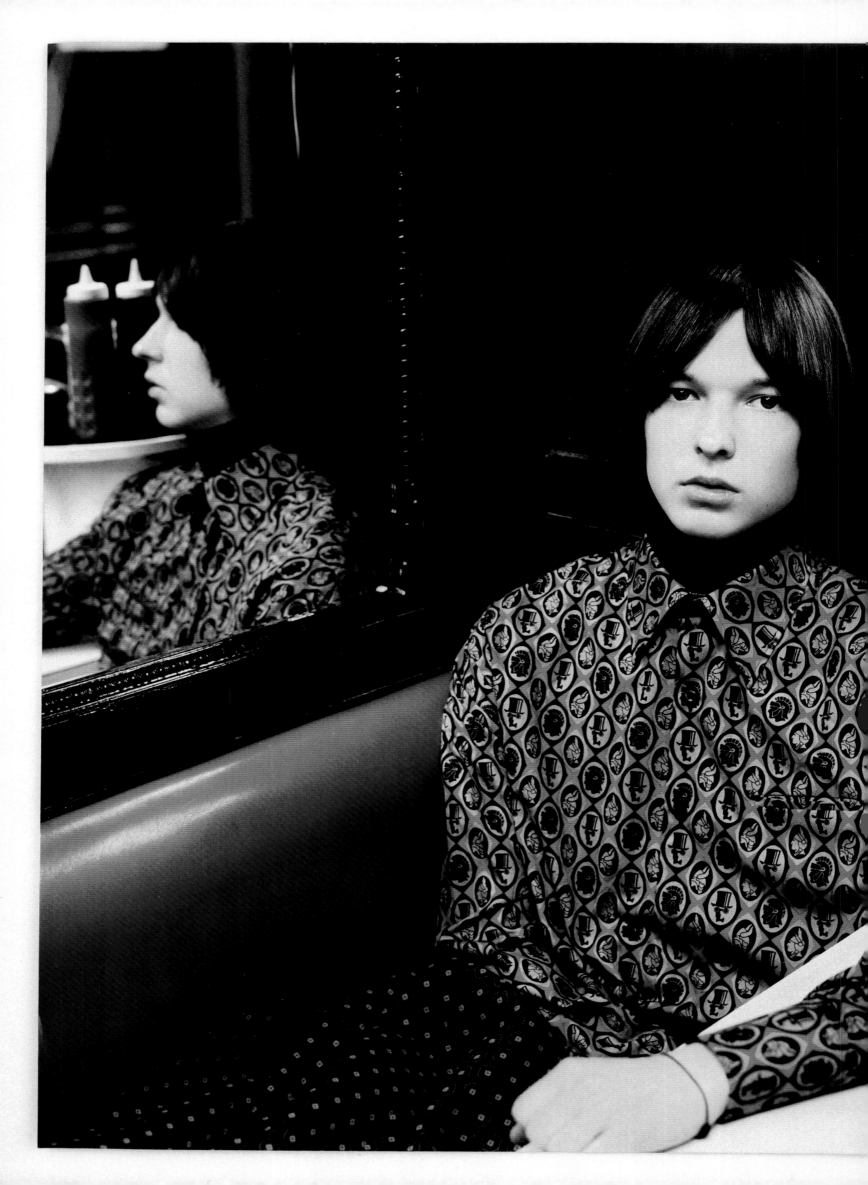

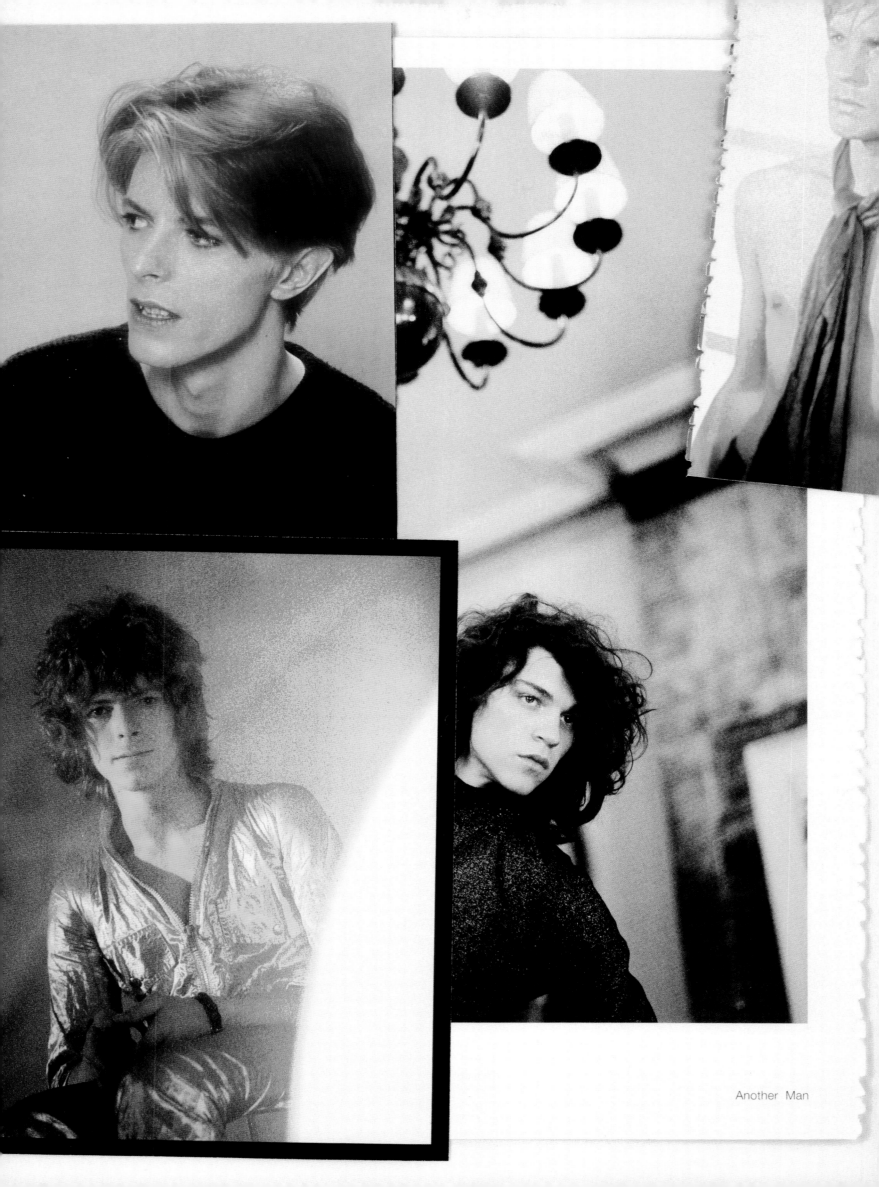

Another Man

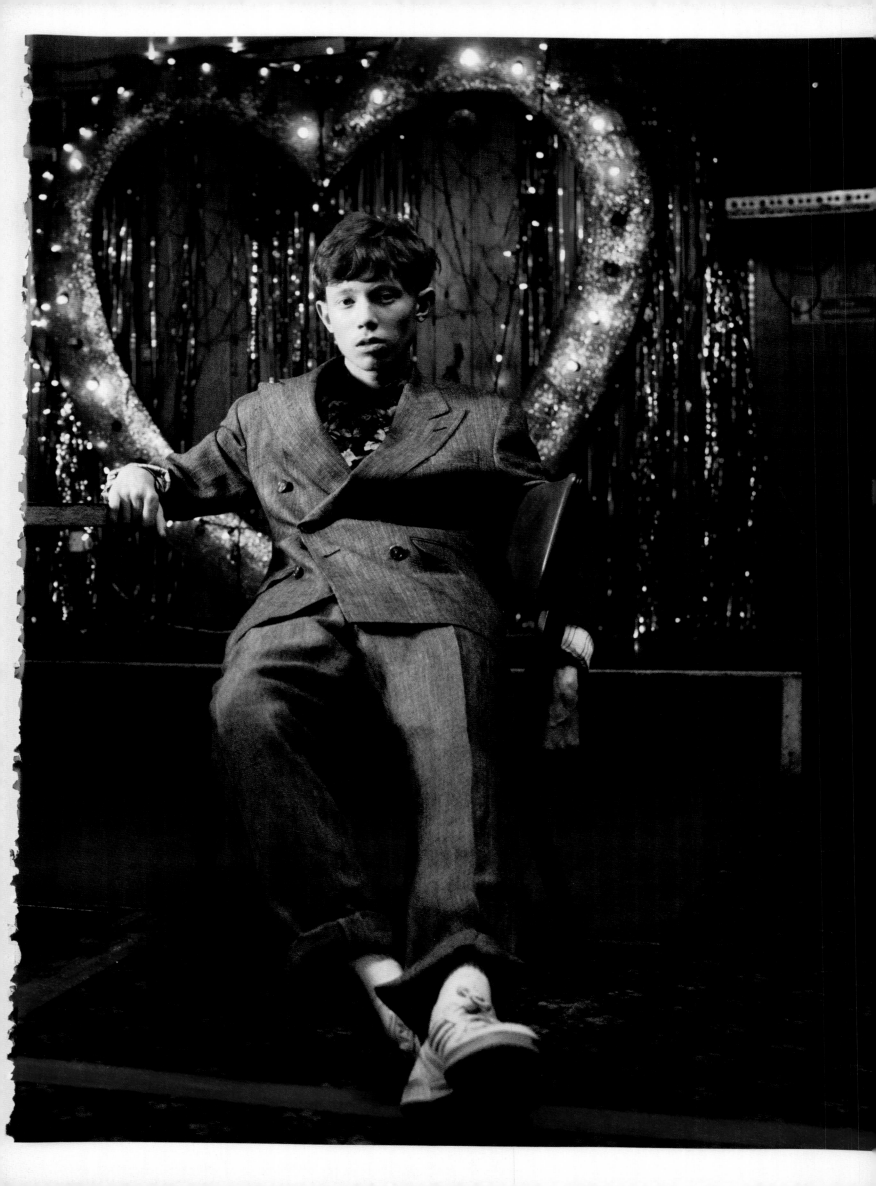

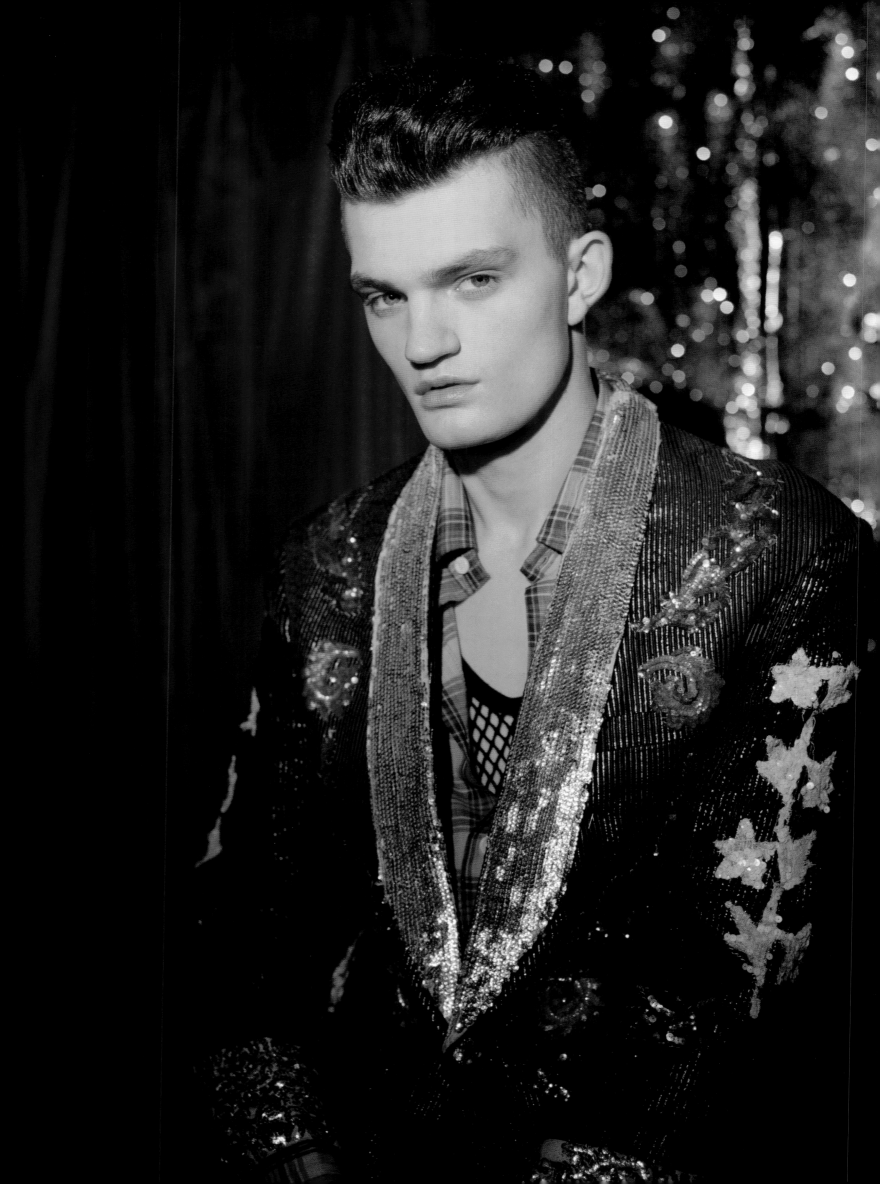

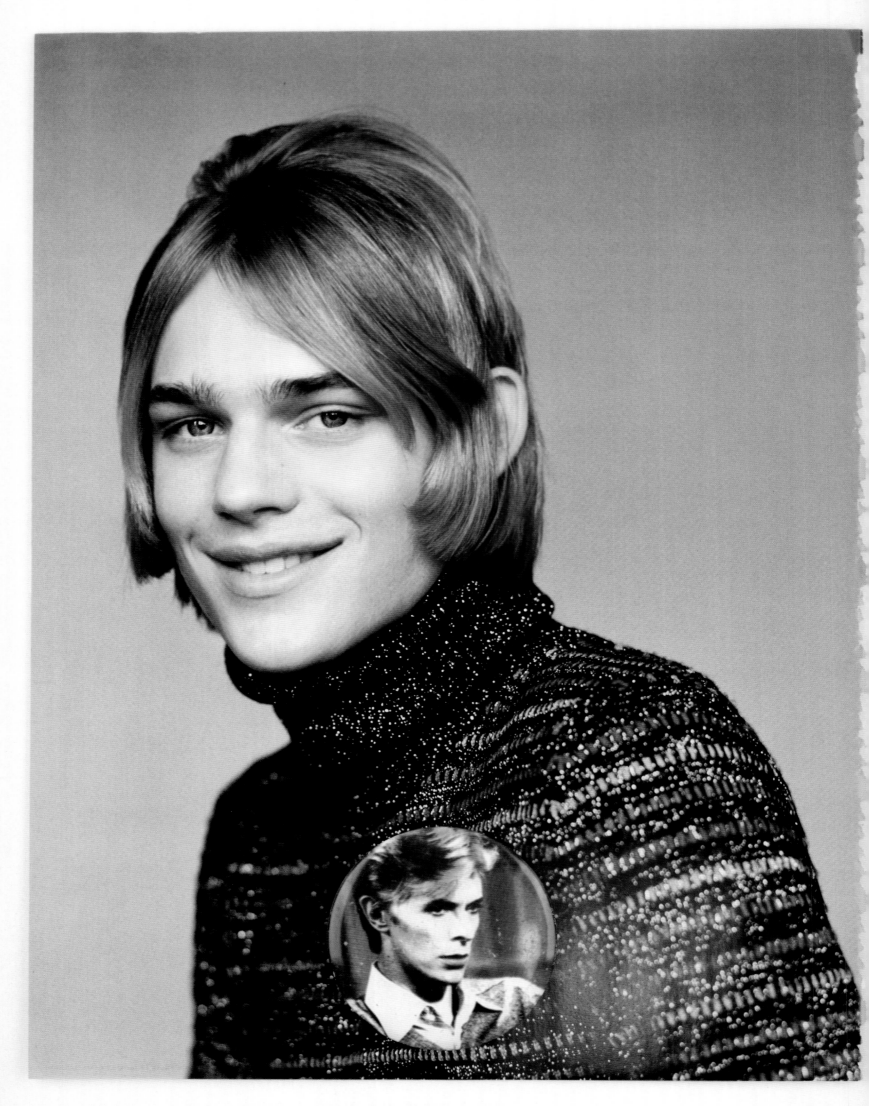

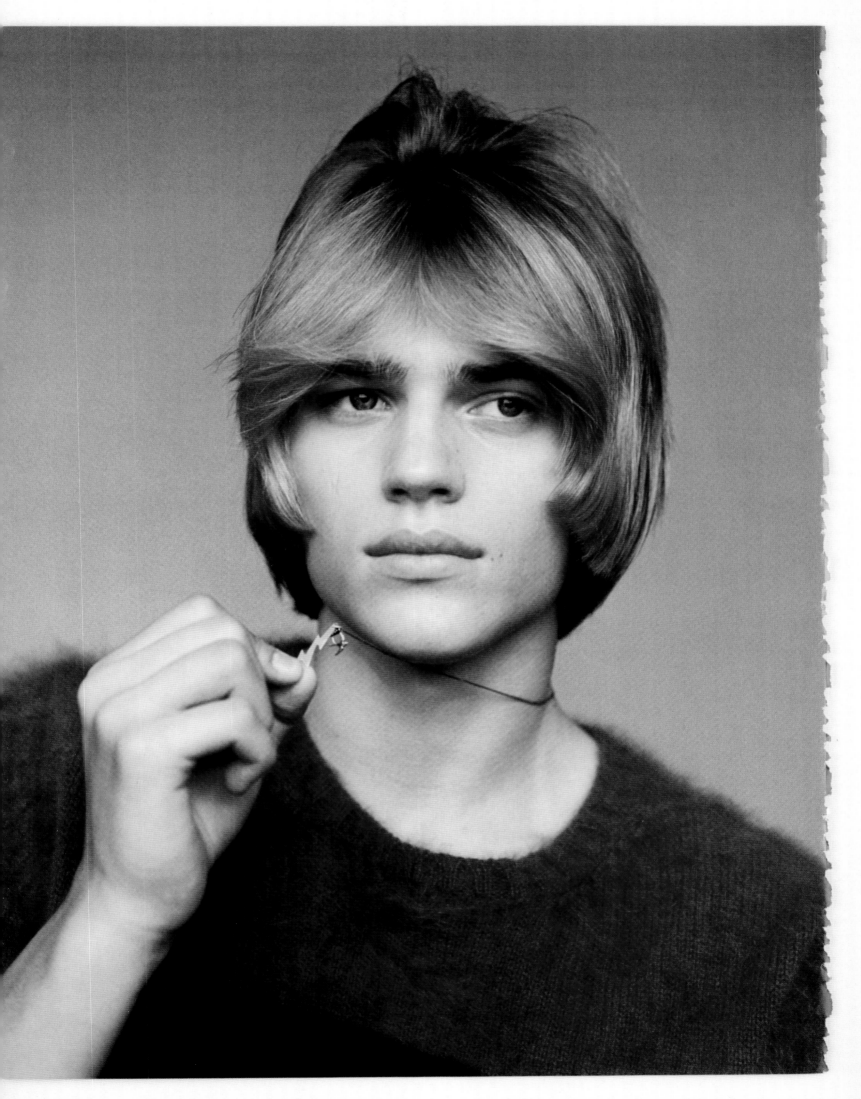

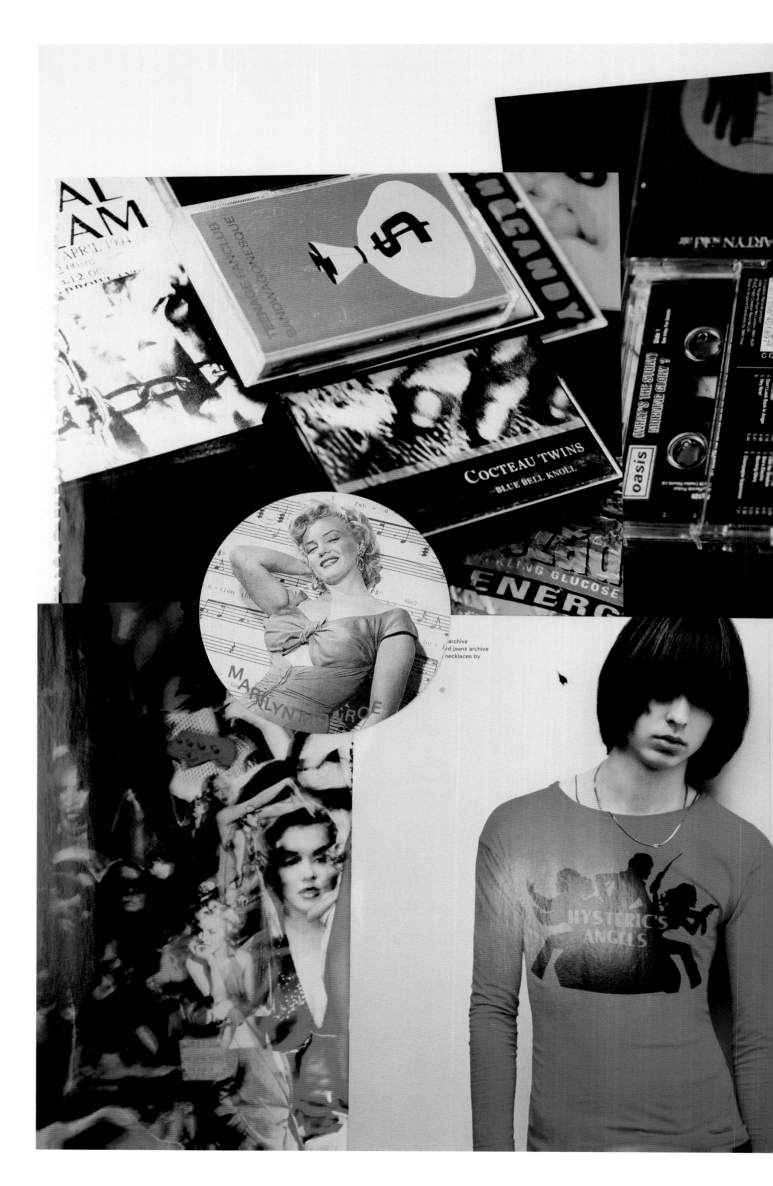

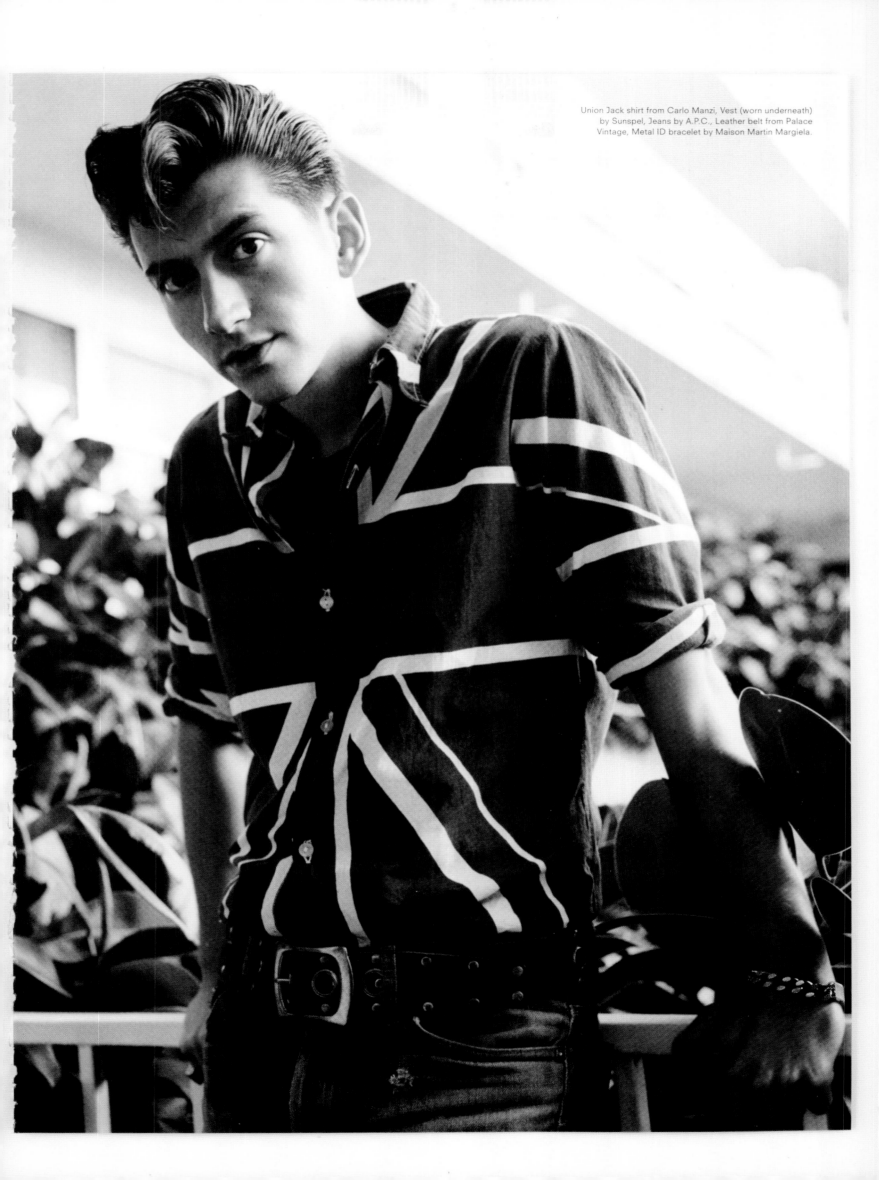

Union Jack shirt from Carlo Manzi, Vest (worn underneath) by Sunspel, Jeans by A.P.C., Leather belt from Palace Vintage, Metal ID bracelet by Maison Martin Margiela.

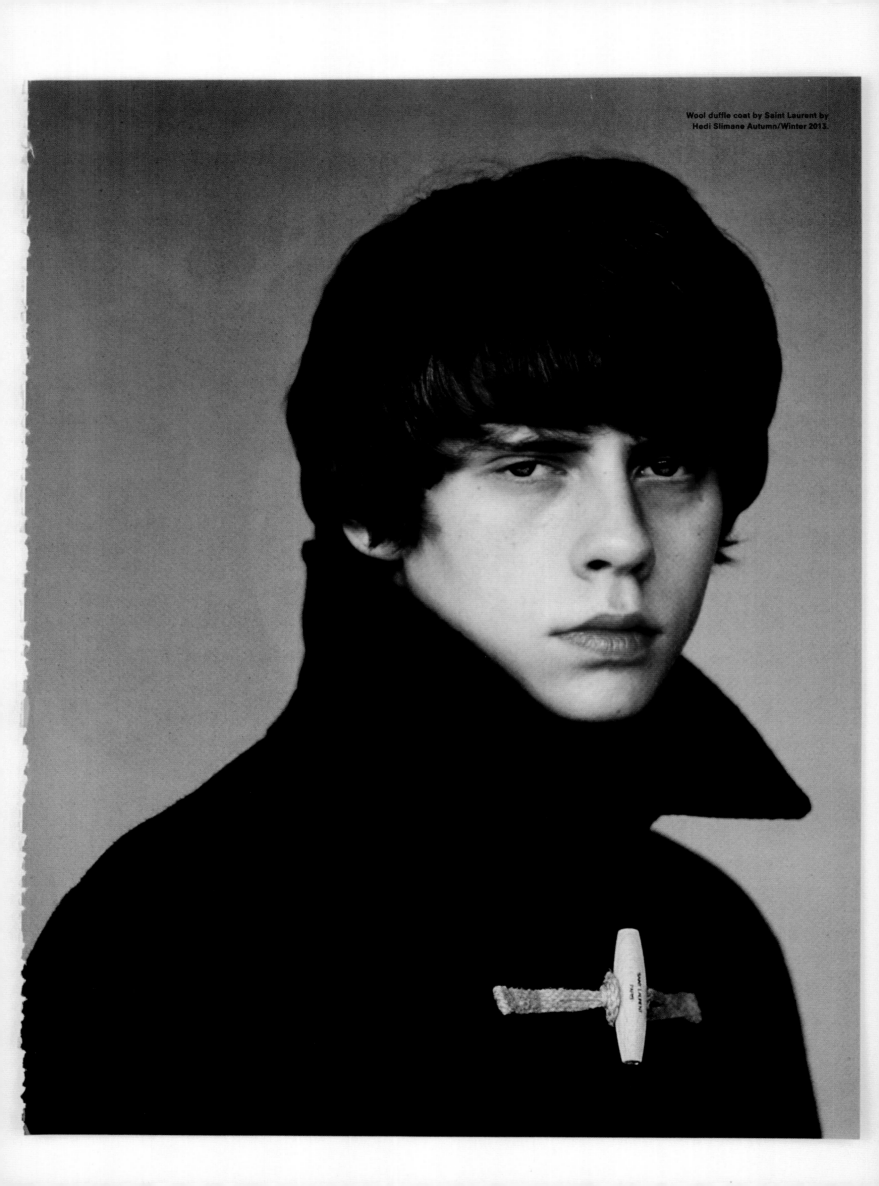

Wool duffle coat by Saint Laurent by
Hedi Slimane Autumn/Winter 2013.

JOHN MARTYN

oasis

(WHAT'S THE STORY)
MORNING GLORY?

Side 1

THE WHO

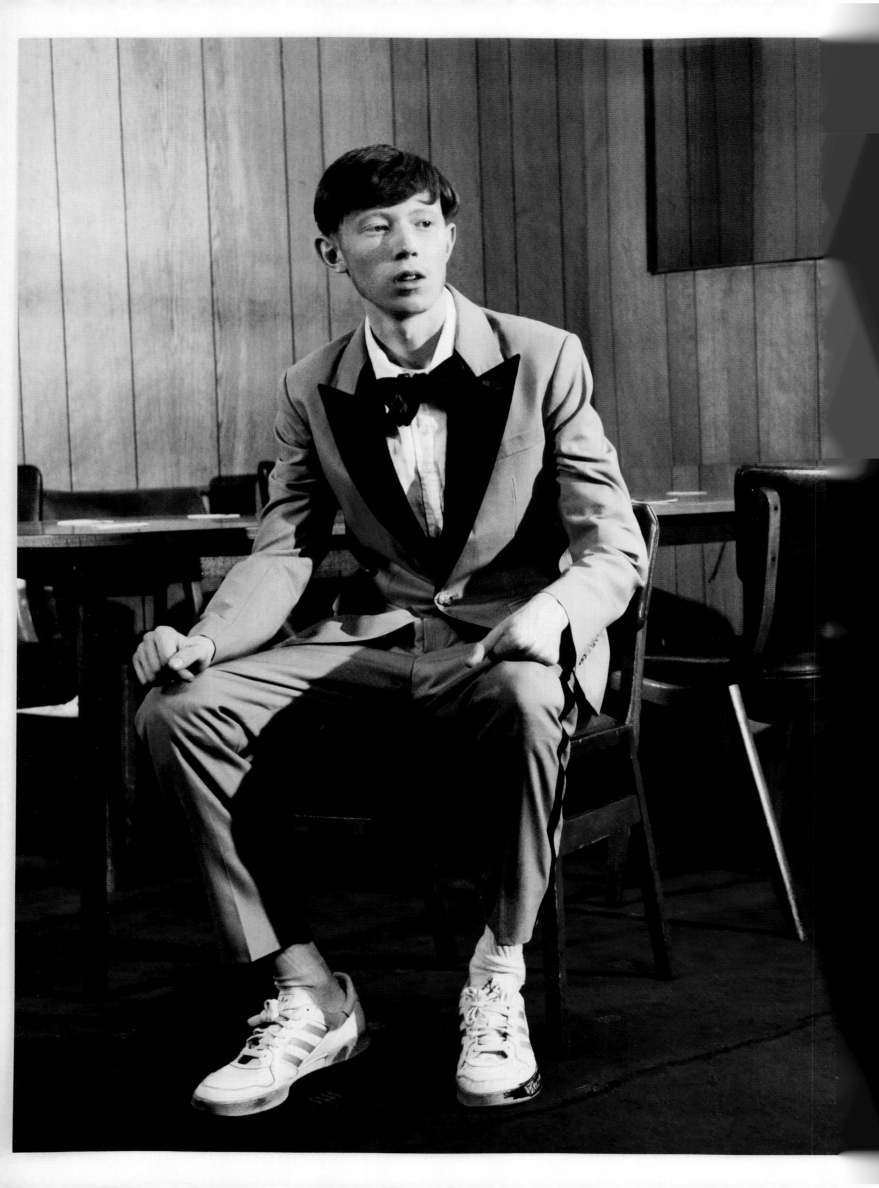

TUXEDO SUIT BY MARC BY MARC JACOBS,
DRESS SHIRT VINTAGE ALEXANDER MCQUEEN
FROM MAY THE CIRCLE REMAIN UNBROKEN,
SILK BOW TIE BY LANVIN, ADIDAS TRAINERS
(WORN THROUGHOUT) ARCHY'S OWN.

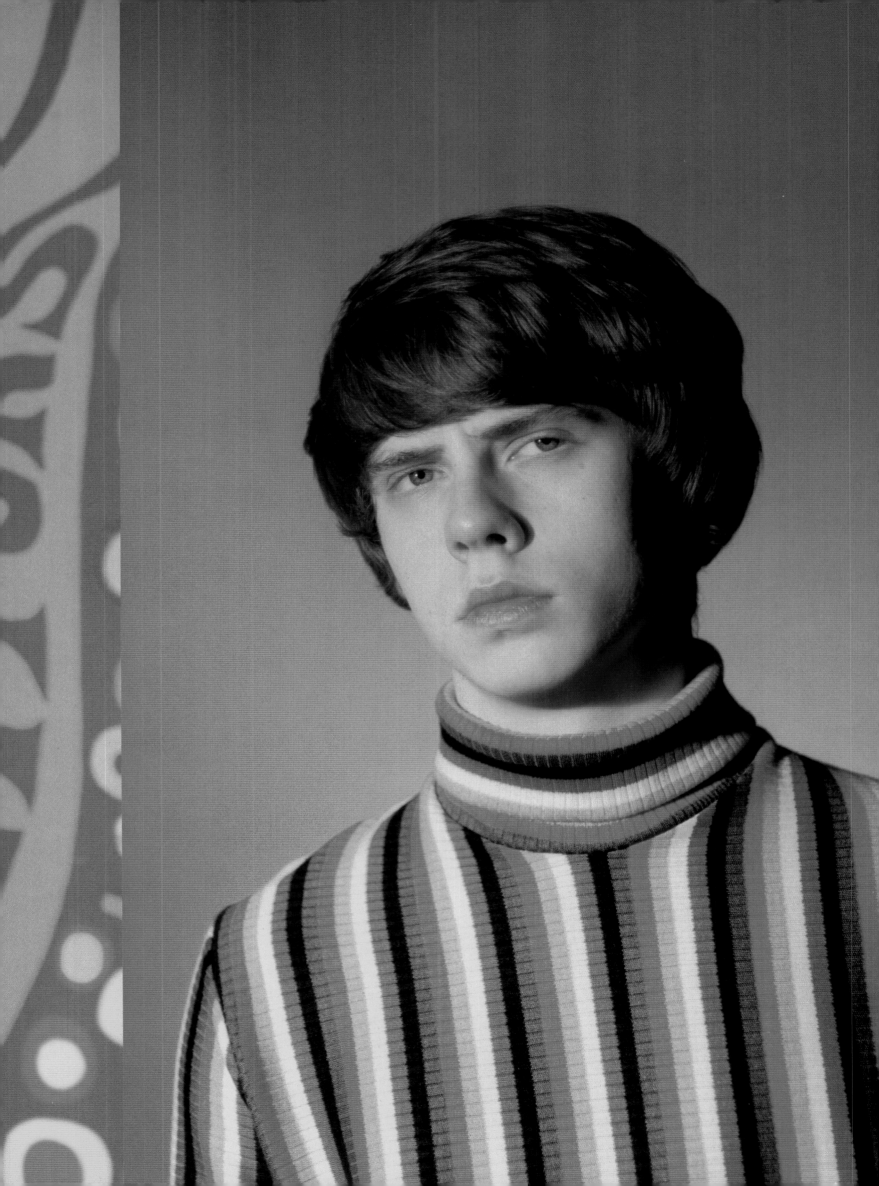

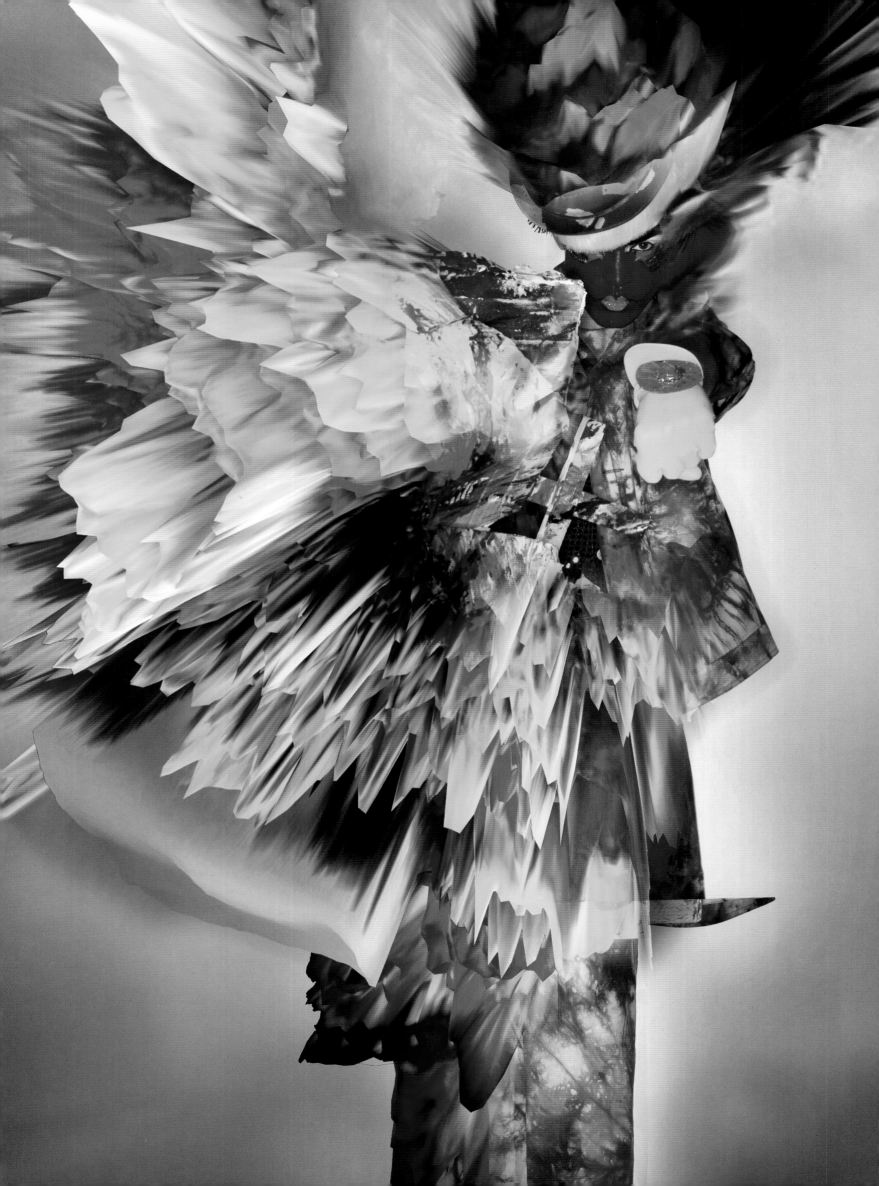

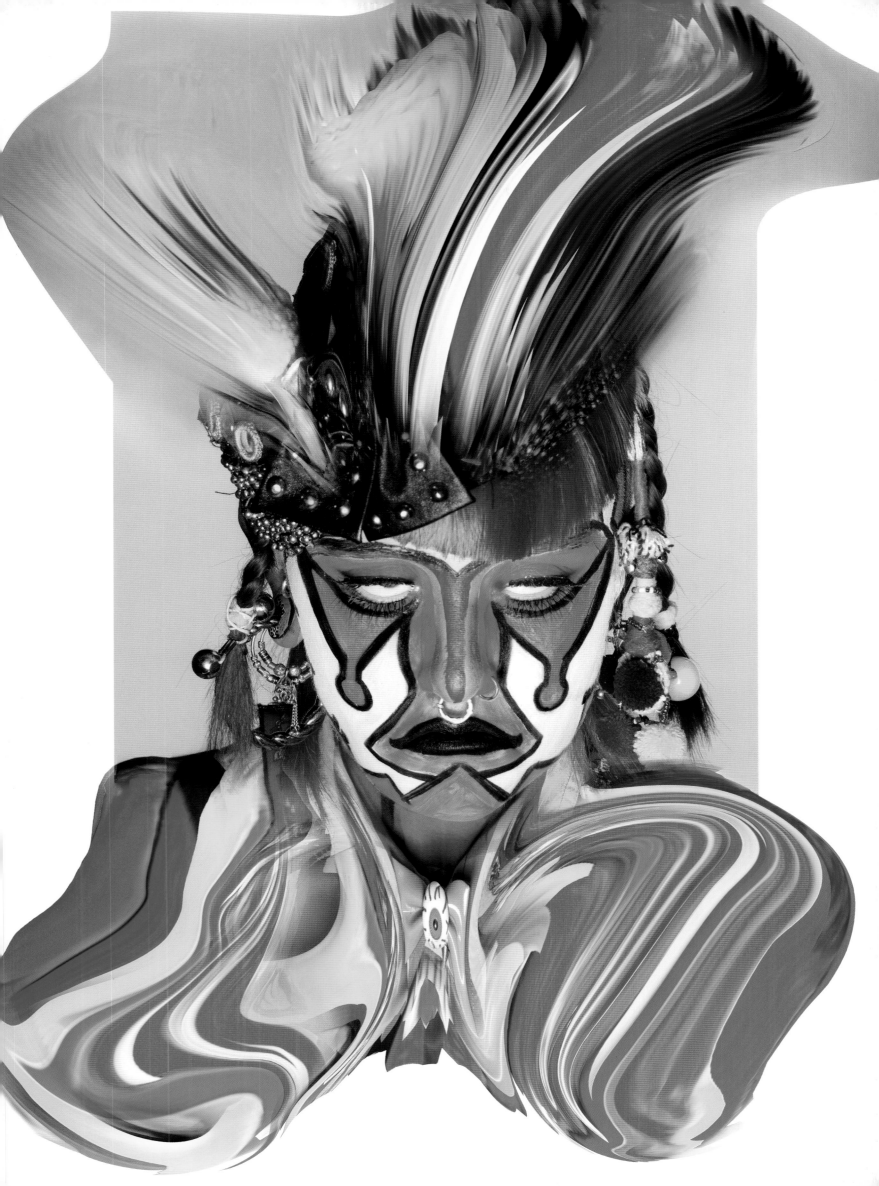

BECAUSE THE NIGHT

*"When the sun goes down, you're in the dark
and a blanket of a new feeling comes over you…
and that new feeling is magical."*
—David Lynch

NOCTURNAL INQUISITION
by
JARVIS COCKER
(with apologies to Padgett Powell)

"The night-time – that's the right time"
from In The Nighttime by The Strangeloves

Why is that?
Why is what?
Why is it easier to be yourself in the dark?
Dunno
Are you afraid of the dark?

Does that mean that you're afraid of yourself?
& what you might get up to?
Shall I go on?
Ok...

What time do you get up in the morning?
What time do you open your eyes?
& what do you think when you open them?
"Awesome—can't wait to get started"?
or
"Not this dump again"?
or
"Where am I & who are you?"?
None of the above?
Awkward sod, aren't you?
I guess what I'm trying to ask is: have you ever uttered
the phrase "Seize the day"?
& meant it?

Do you leave the light on?
At night, I mean?
Would you say that you were perverse?
Just a question

Am I trying to chat you up?
That would be telling, wouldn't it?
Where were we?
Ah yes—we were in bed weren't we?
What time do you call this?
Do you think the sun is rude?
Do you think that the sun has no manners?
I mean creeping in here & spoiling our fun like that—who does he think he is?
Couldn't it wait?
Couldn't he see that we were having a good time?
Couldn't we have had a couple more hours?
What's the rush?
Does the lighting really have to be so harsh?
So bright?
Would a couple of shadows be too much to ask?
I mean, really—it's hardly flattering is it?
Is reality absolutely necessary?
At this time of day?
Why do they call it "Natural Light" anyway?
Does it feel natural to you?
No?
You know what?
I think you're more of a "Night-Person"—am I right?

What exactly is a Night-Person?
The same as a Nice Person?
Or the opposite?
I guess you'll just have to find out, won't you?
Did you get dressed in the dark?
Looks like it
Funny, aren't I?
(But seriously—did you?)

263

Would you like to hear a story?

What if there was a person who—a long time ago—lived in a flat above an old factory & this person thought it very romantic to live in such an unusual locale. & it would have been except there was no heating or anything & the person didn't have much money (sob, sob) & it was Thatcher's Britain & all that & so the days were pretty difficult. Difficult because maybe this person was trying to convince himself that he was living in a movie or something. Or another time. Or another country. But the daylight & the evidence of his own eyes etc. kind of put the old kibosh on that there fantasising. Yes, the days were pretty tricky... But the nights! Now we're talking... There was a nightclub that was free to get into before 10pm. Halcyon days! (Or should that be Halcyon nights?) & you'd get a buzzy eardrum from someone trying to tell you something really earnest & dead interesting—philosophical even—but maybe a bit inappropriate because "Human Fly" is playing in the background & you're into it & everything but they're shouting so loud to try & make their point that it actually hurts. So you take in the scenery for a while & then split & in a way that walk home is your favourite bit because nobody else lives in that industrial area & the buildings are tall & massive against the brownish sky, like a film set they forgot to strike & now you are the main character & now you call the shots & conjure whatever you want out of the darkness. The darkness all around & the darkness within you. The dark corners of yourself that you haven't had time to explore yet & in the day it's very hard to feel like the master of anything but here in the night it's your time in the lime-light. Or the lamp-light. No difference really—you own this town. You are the city & you feel life—the Night-Life—move through you & in Your City night goes on as long as you want it to because you're in control & unauthorised daybreak is illegal & there's plenty more where that came from...
What if there was a person like that?
Eh?
Have you fallen asleep?

✳✳✳✳✳

264

What is my point?
Well...
How about contrast?
Contrast?
Don't you see?
Do I make myself clear?
Foreground & background—yes?
(Stay with me)
Are you listening?
How do we show our true colours?
How do we display ourselves to our best advantage?
By standing in front of a dark background—right?
So we show up nice & bright
In full effect
Against the fathomless void
Get me?
& what is darker than the night?
Don't answer that

Isn't it enough that we have found each other—& ourselves—in the dark?
Isn't it?
Hope so

Night night xx

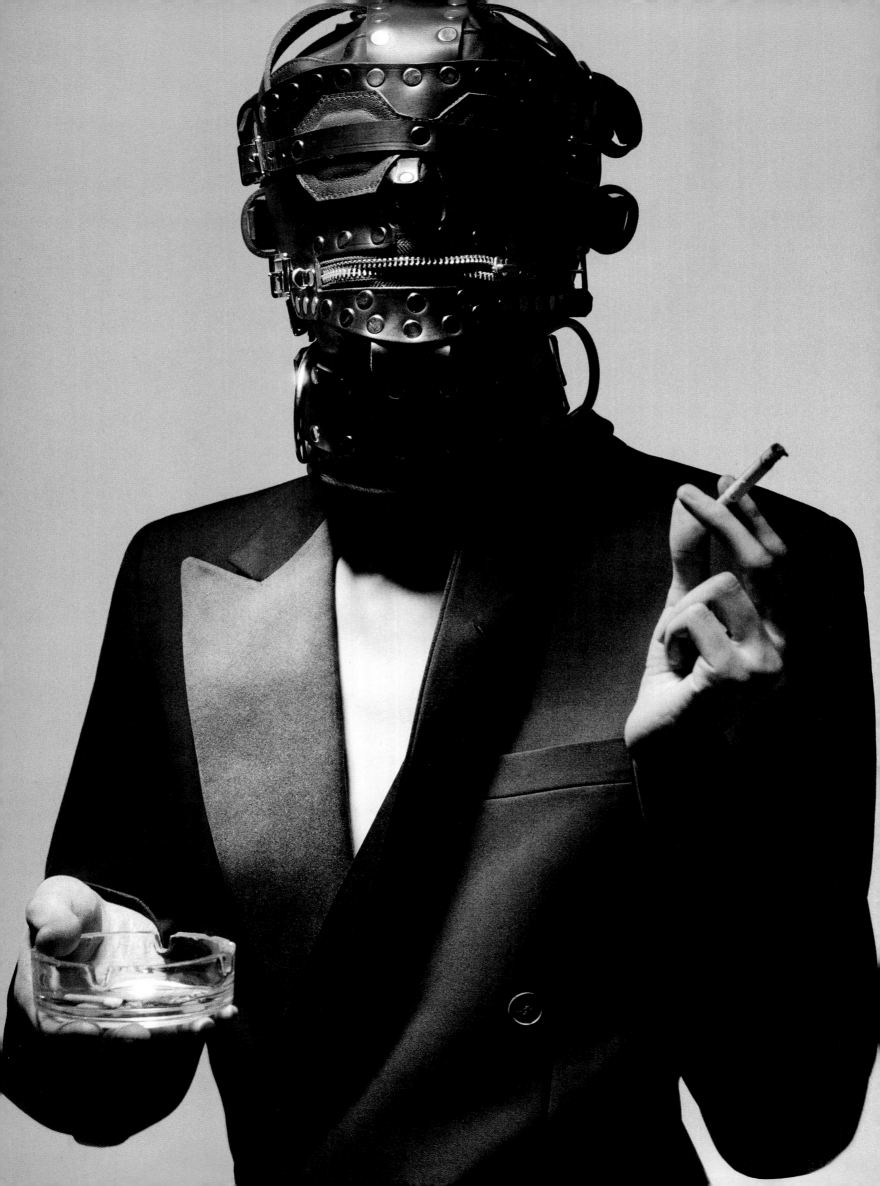

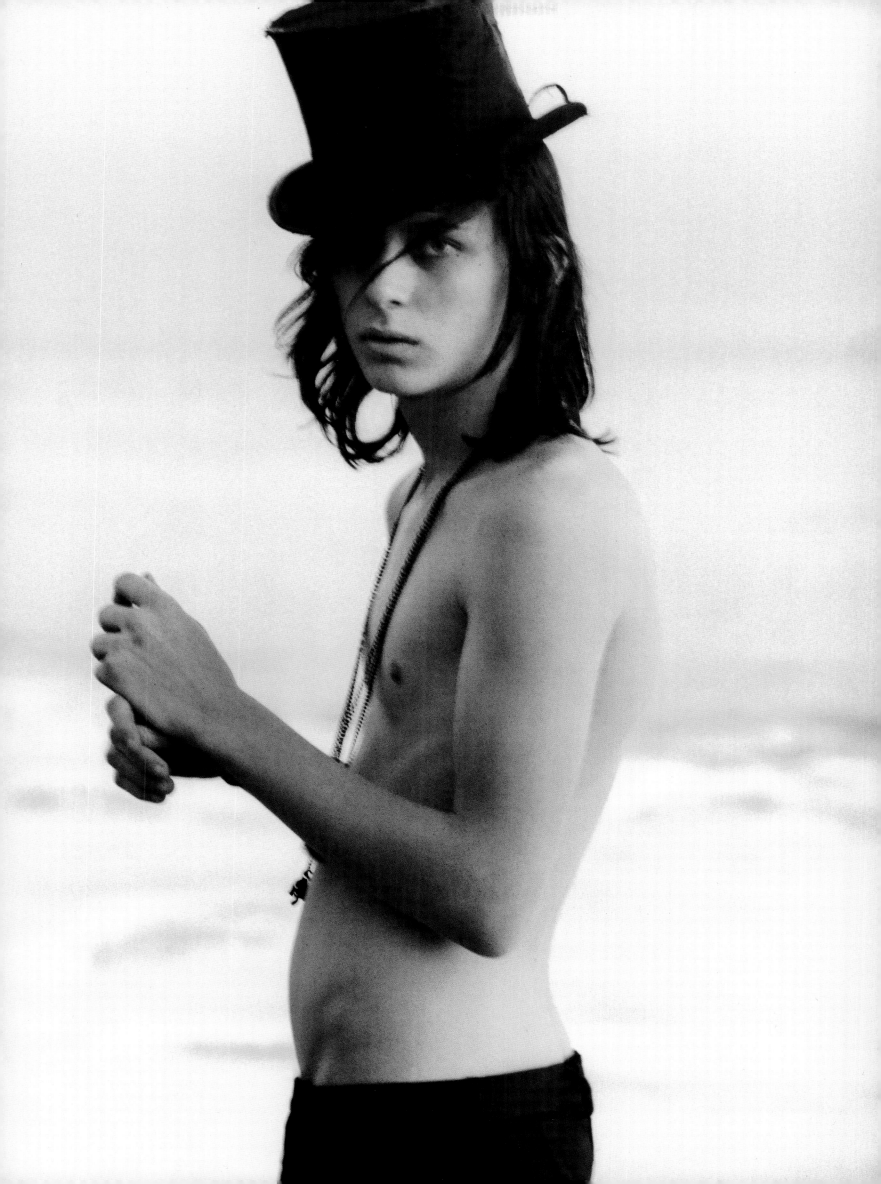

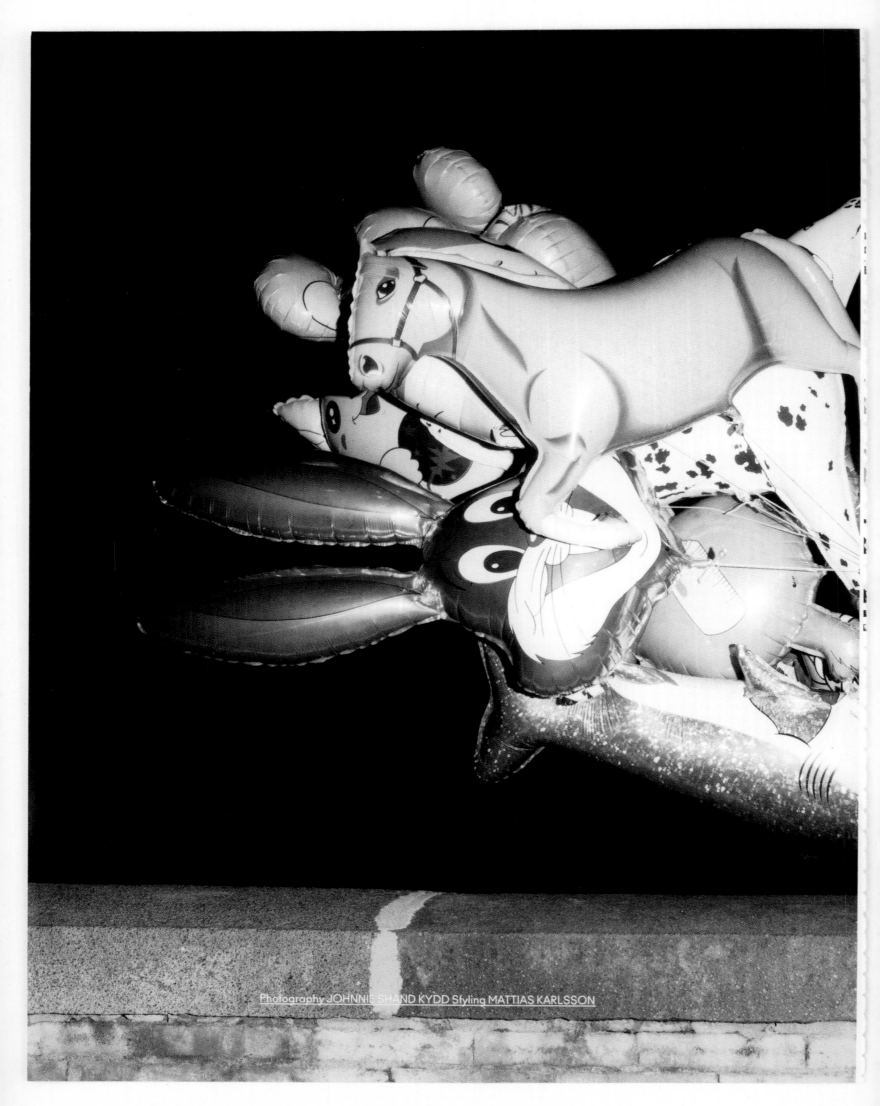

Photography JOHNNIE SHAND KYDD Styling MATTIAS KARLSSON

268

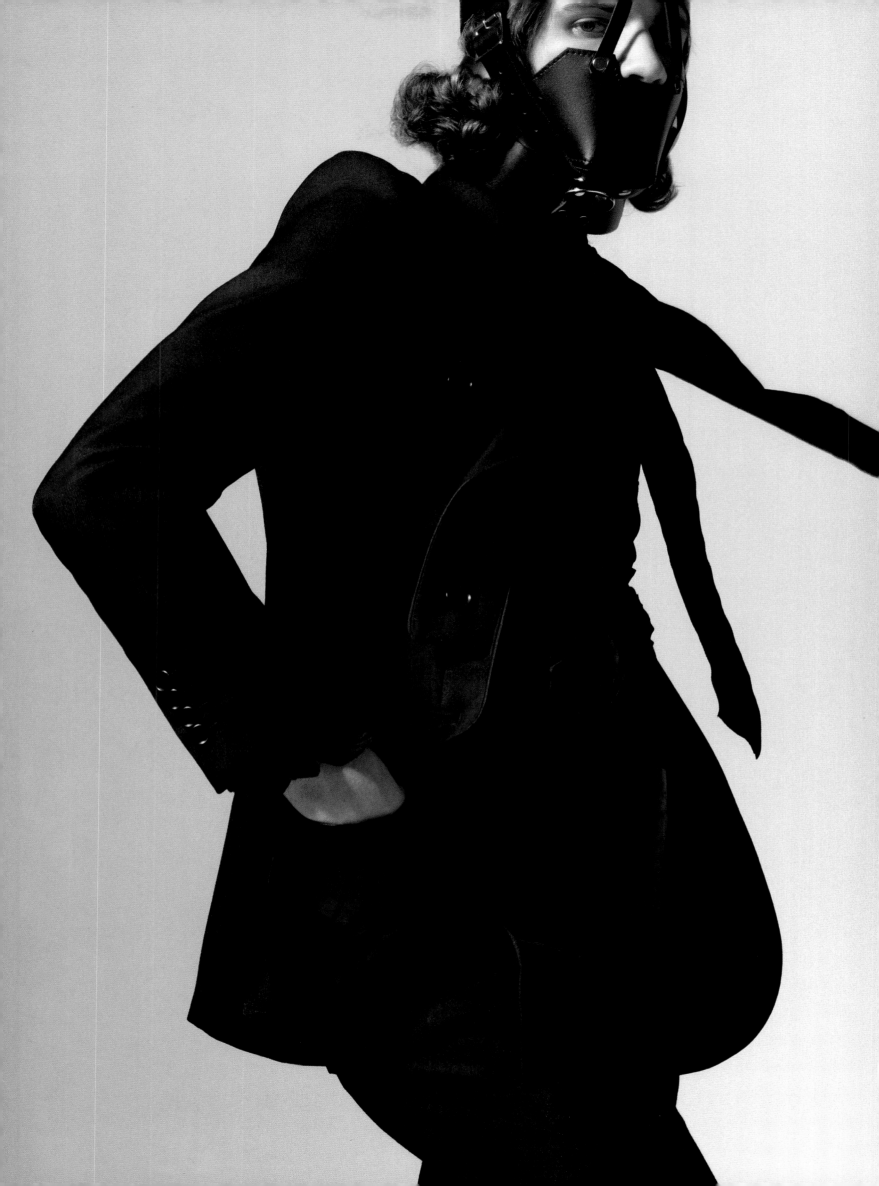

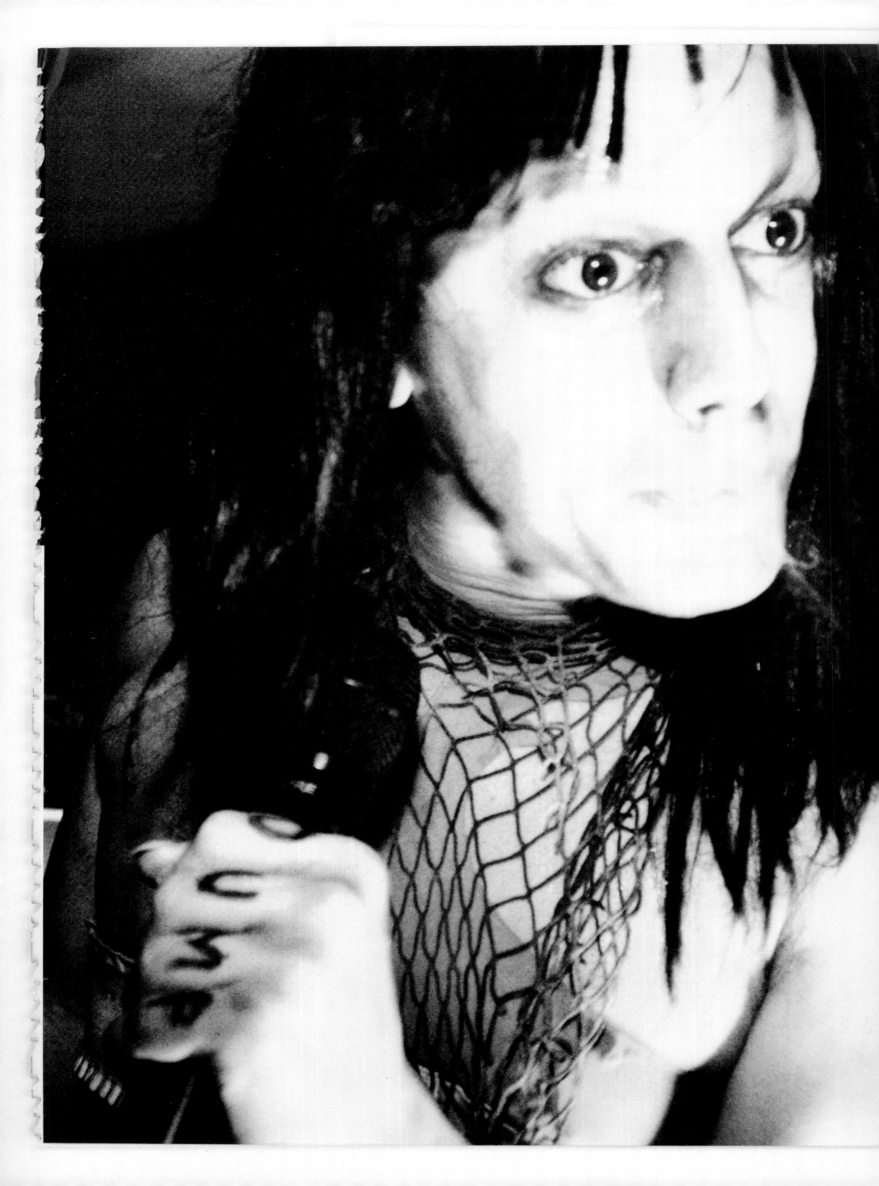

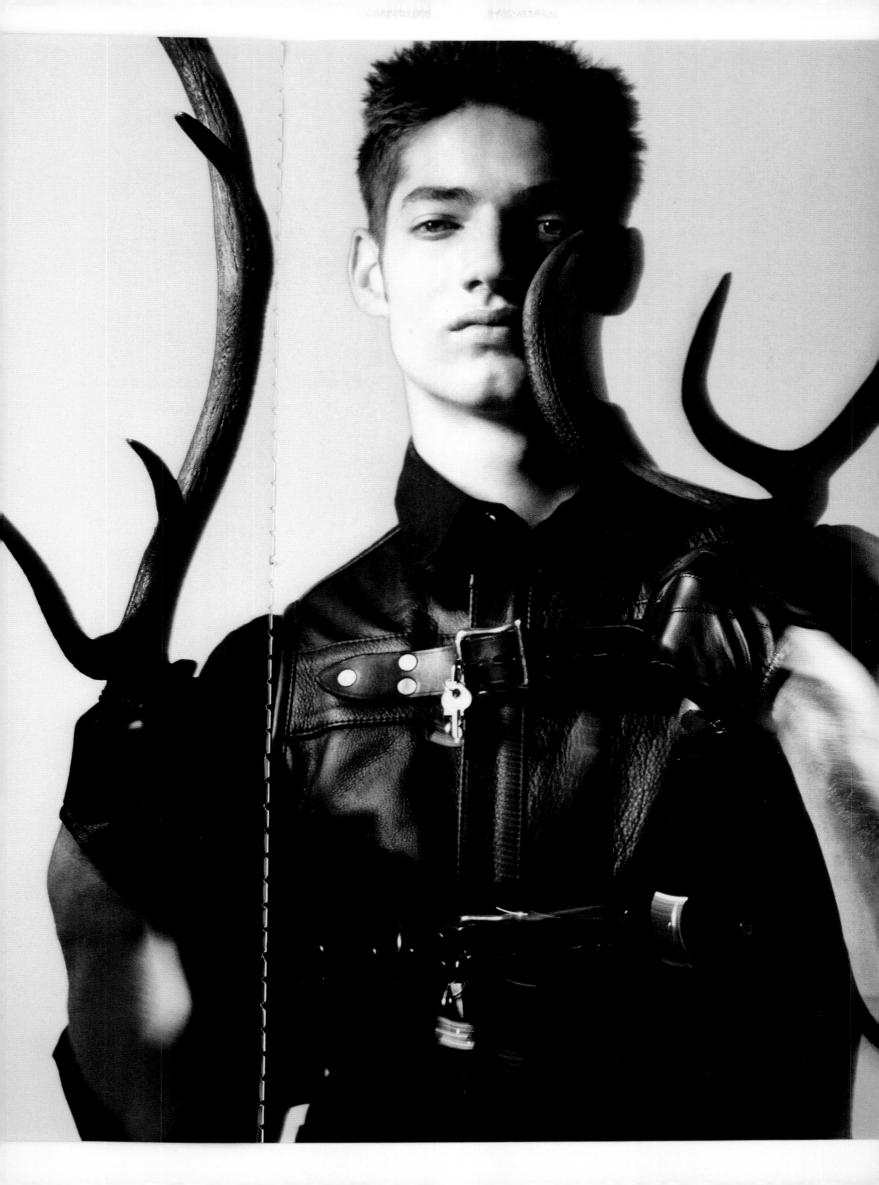

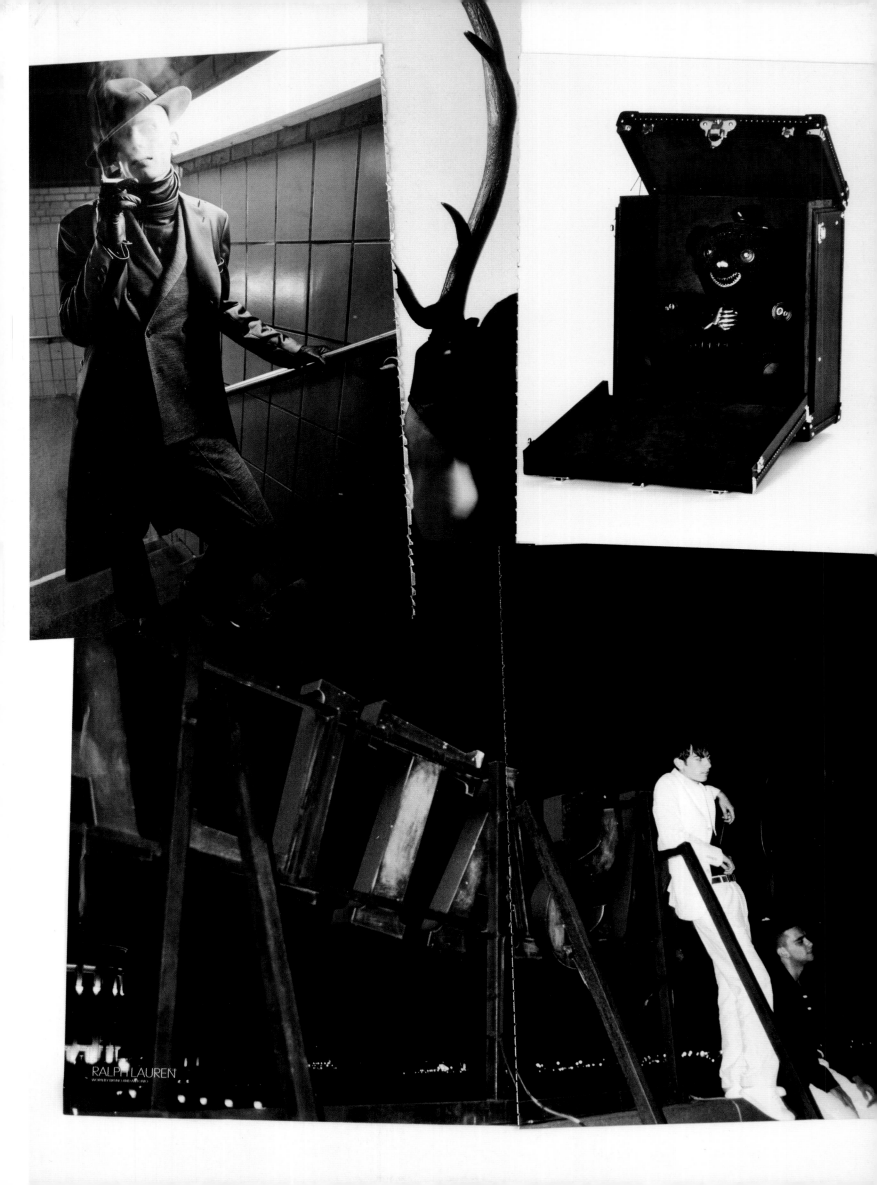

RALPH LAUREN

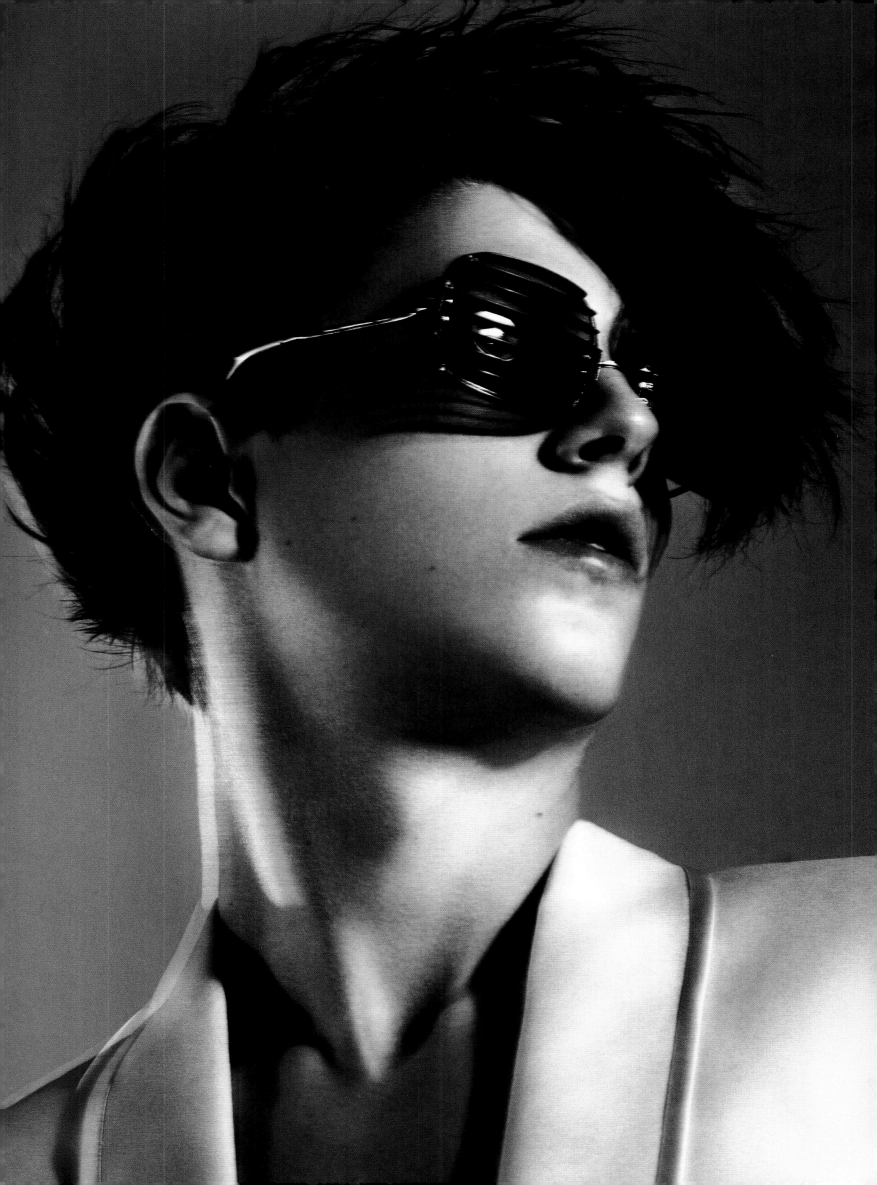

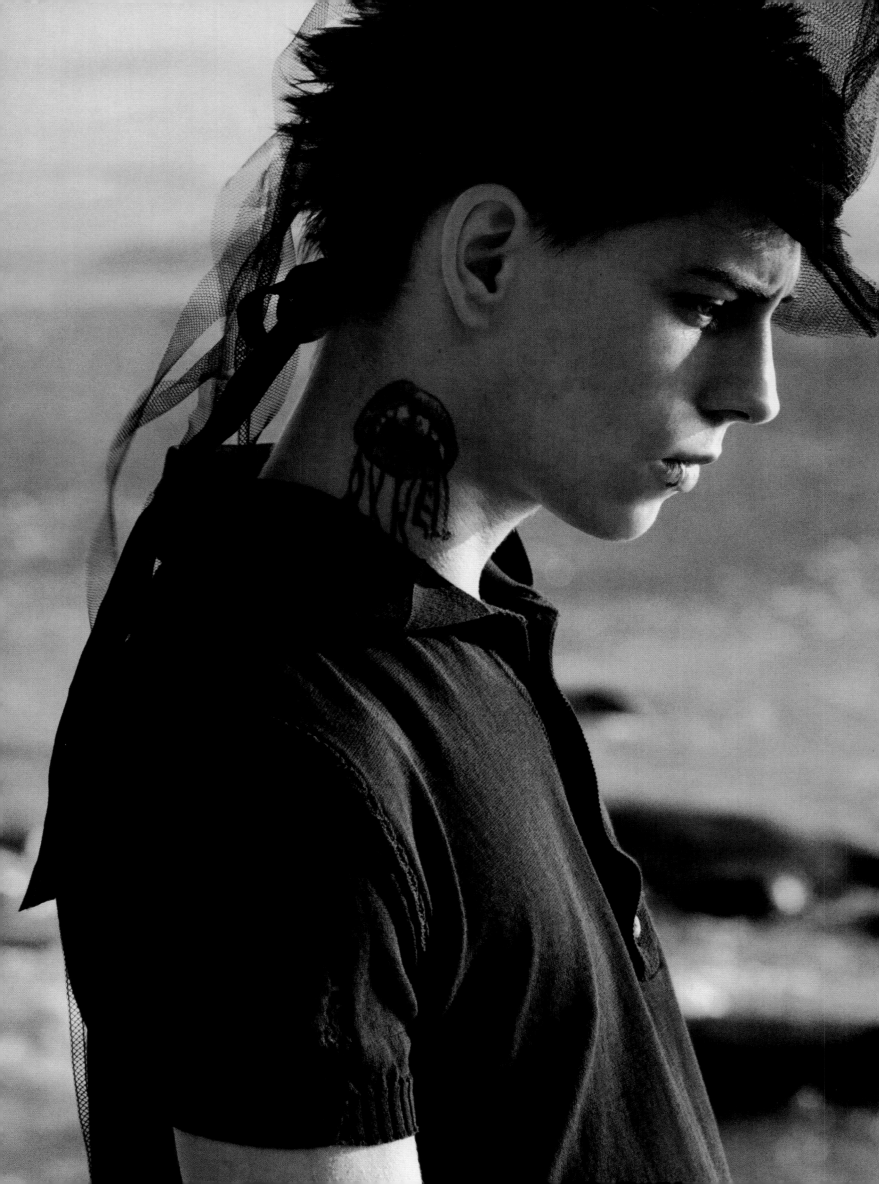

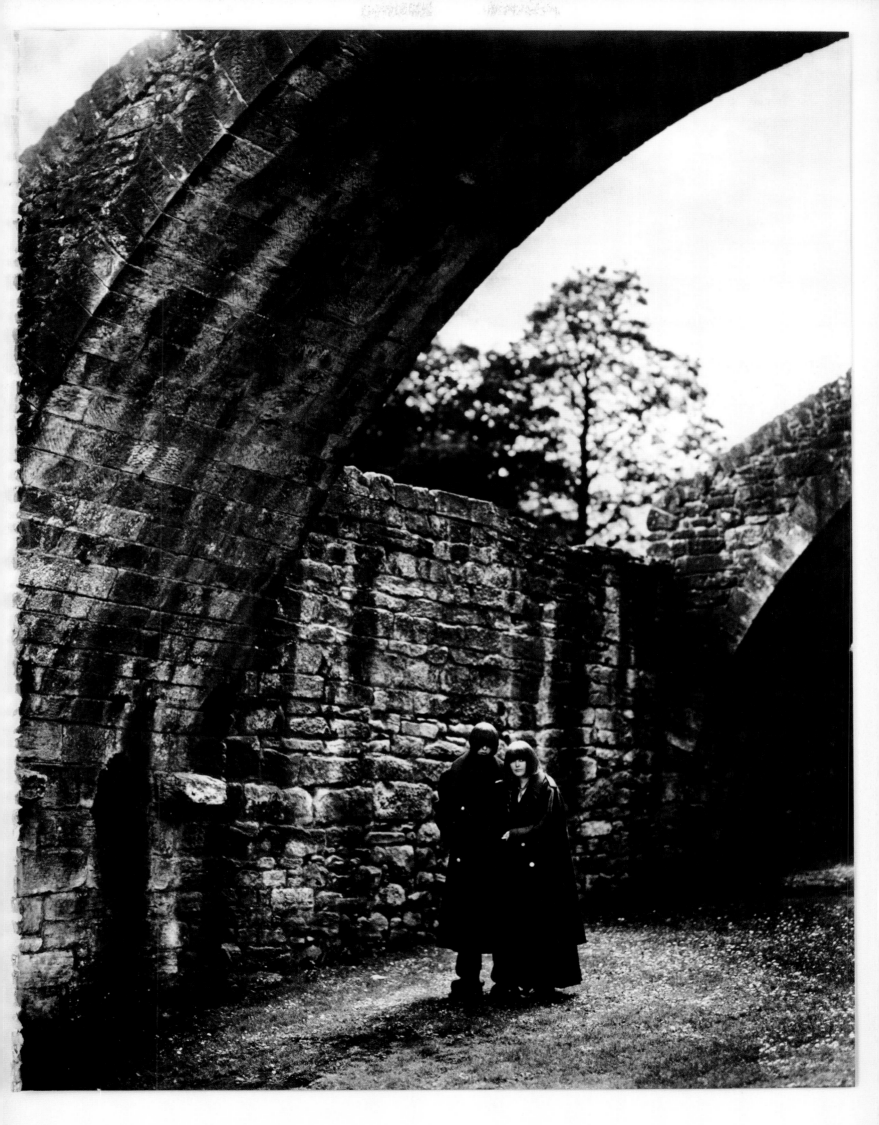

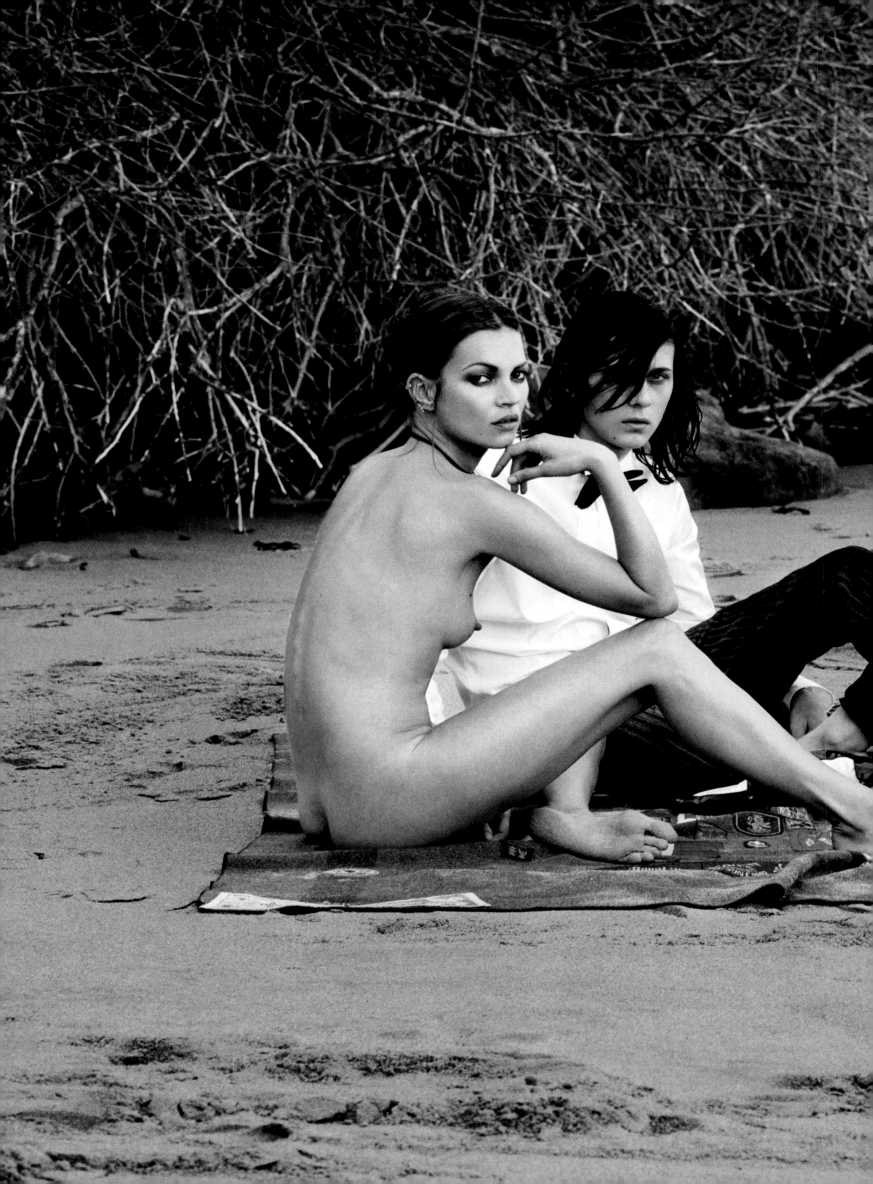

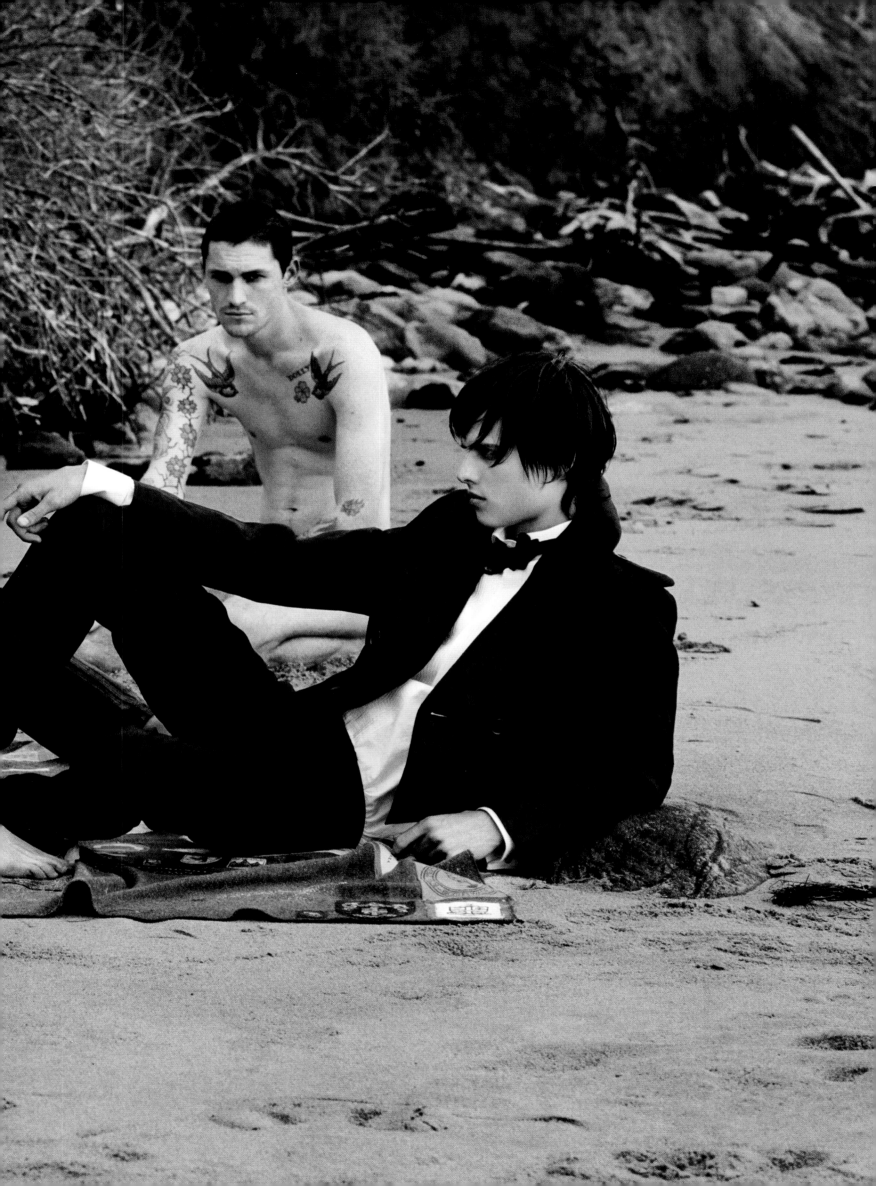

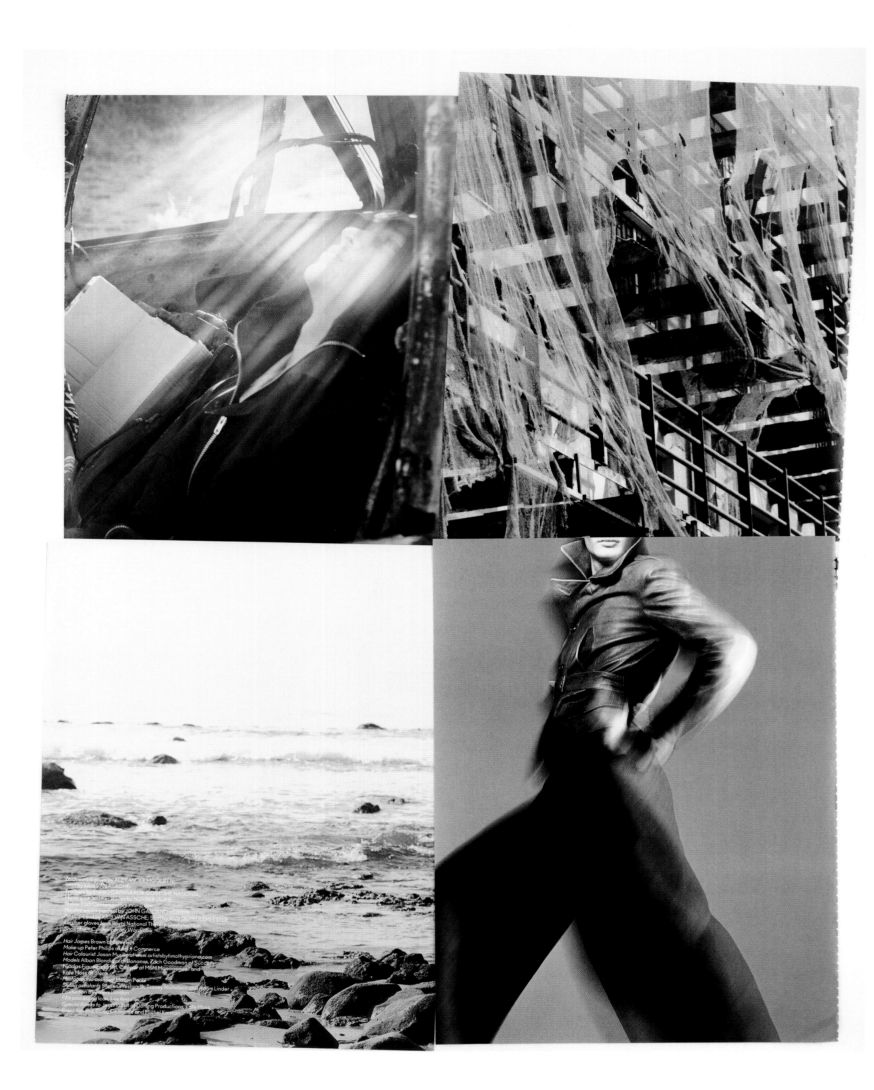

Zach wears trousers by ALEXANDER McQUEEN.
Shirt by KRIS VAN ASSCHE.
Trousers by ENRICO CAPASA FOR COSTUME NATIONAL.
*Shirt and sunglasses by NUMBER (N)NE.
Shoes from Glastonbury by Y WANG.
Necklace (worn throughout) by JOHN GALLIANO HOMME.
Make-up and hat by KRIS VAN ASSCHE; SERGE by DRIES VAN NOTEN.
Leather gloves from Royal National Theatre.
Shoes from Contemporary Wardrobe.

Hair Japes Brown at Streeters
Make-up Peter Philips at Art + Commerce
Hair Colourist Jason Murillo at www.artistsbytimothypriano.com
Models Alban Blondiaux at Bananas, Zach Goodman at Success,
Nicolas Figueiredo at M, Coraline at M6M Management and
Kate Moss at Storm
Photographic assistant Mason Poole
Styling assistants Steven Westgarth, Tracey Nicholson and Adam Linder
Production by Anna Laundy
Fin special thanks to Icon, Los Angeles
Special thanks to Jerry Hall of Darling Productions, Kate Moss,
Xavier Vendrell, Didier Dedoncker and Michel Knüpfe

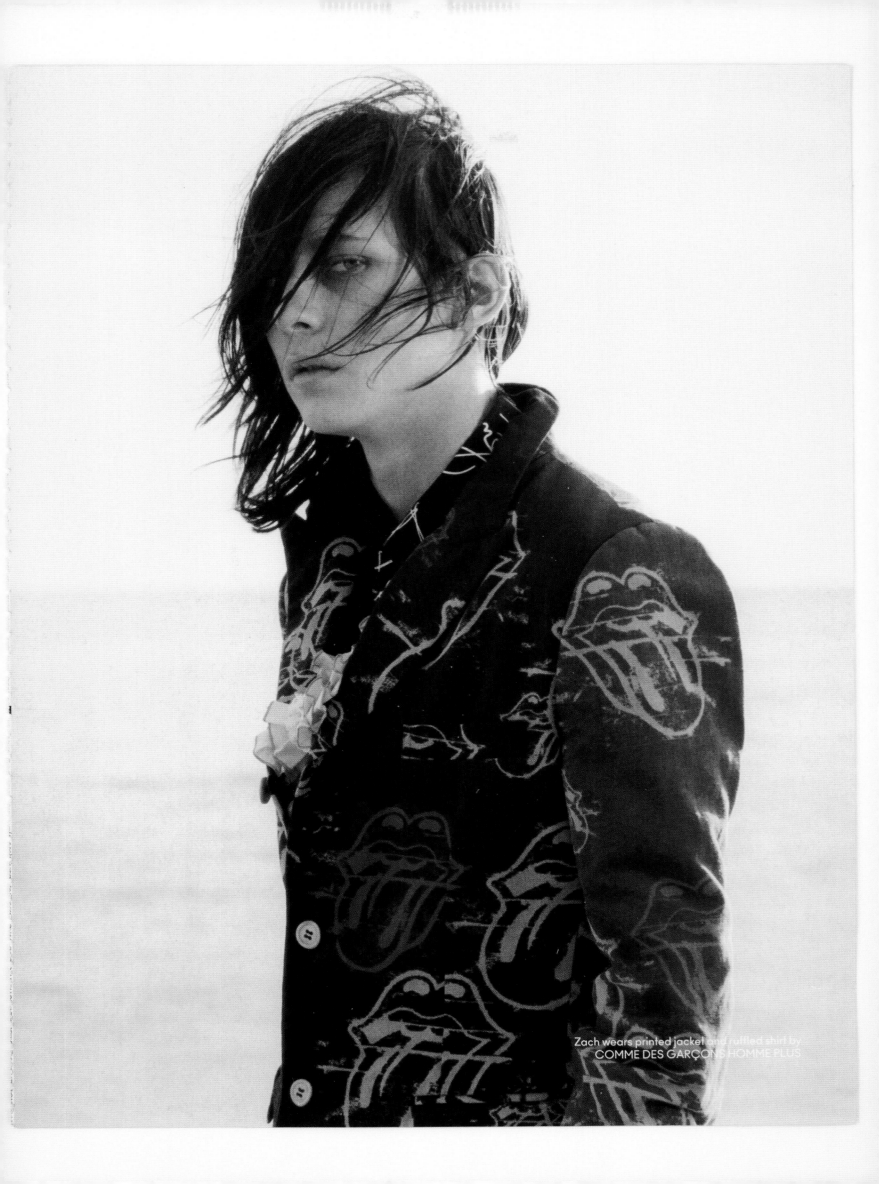

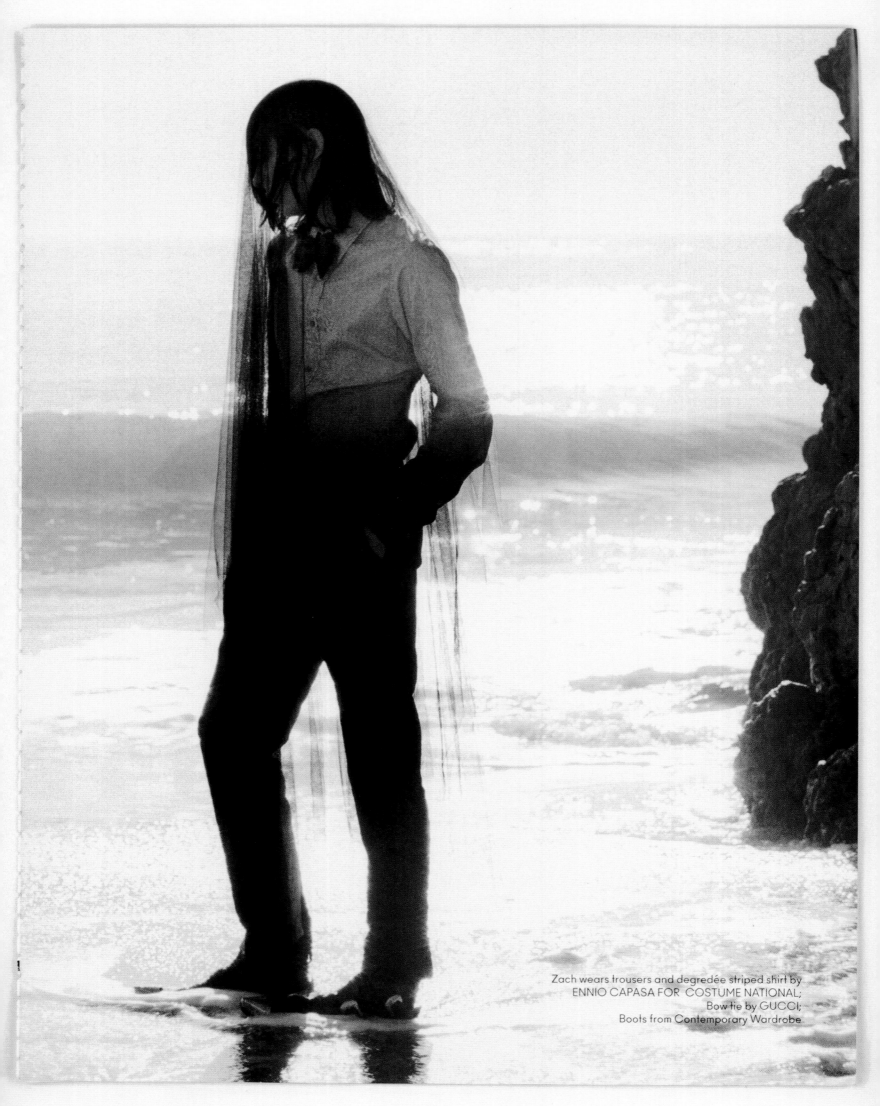

Zach wears trousers and degredée striped shirt by
ENNIO CAPASA FOR COSTUME NATIONAL;
Bow tie by GUCCI;
Boots from Contemporary Wardrobe

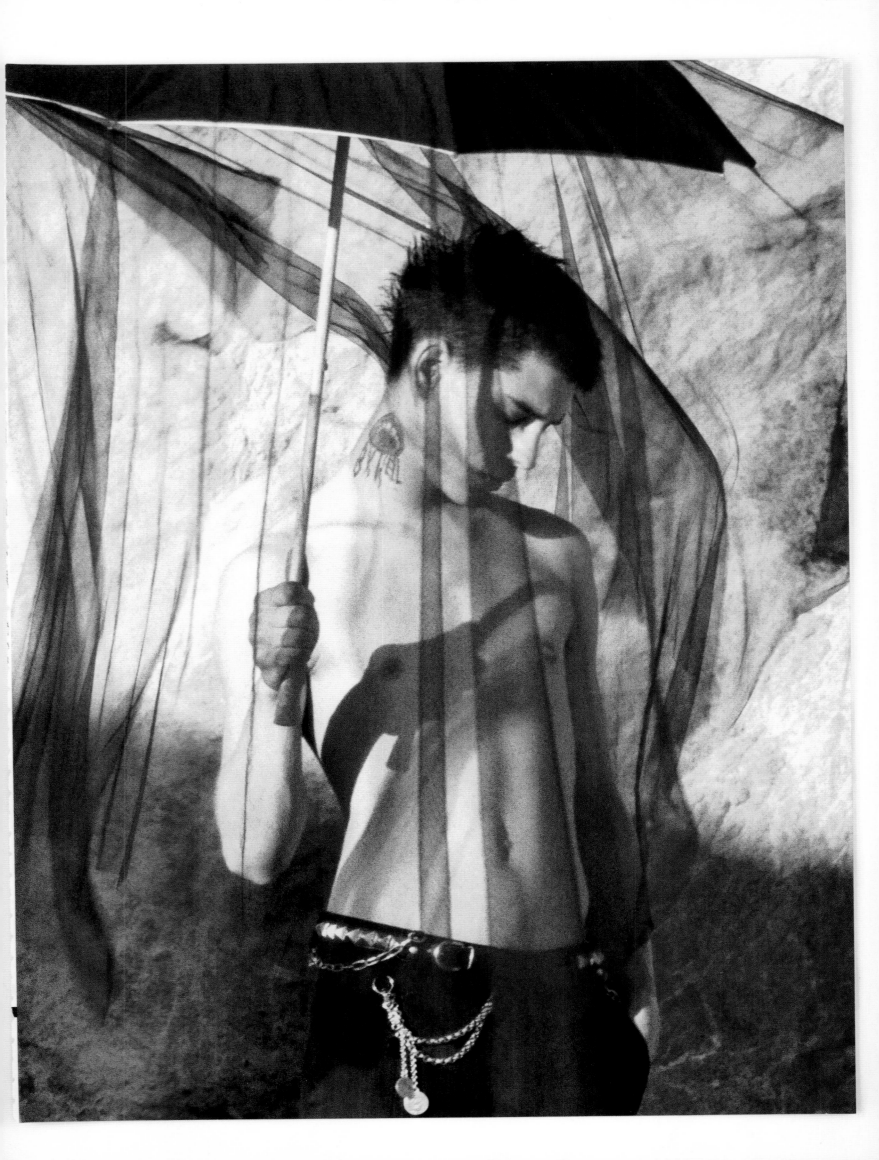

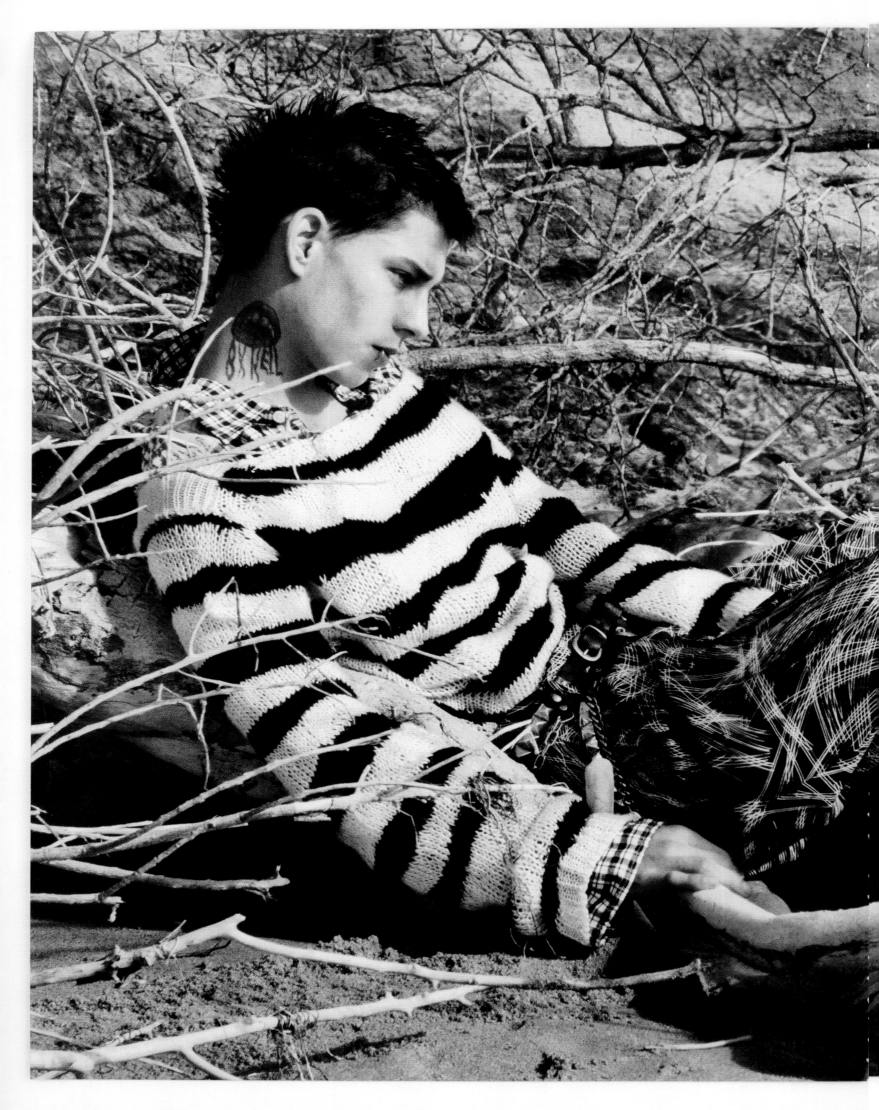

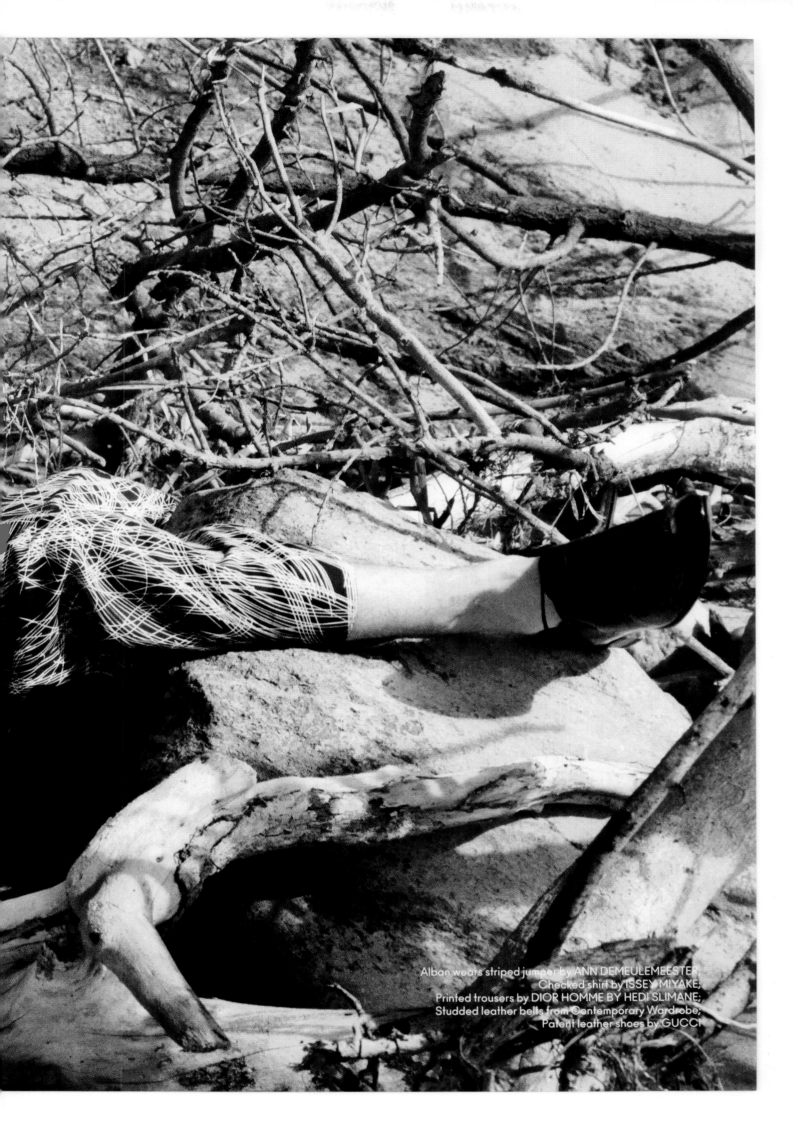

Alban wears striped jumper by ANN DEMEULEMEESTER;
Checked shirt by ISSEY MIYAKE;
Printed trousers by DIOR HOMME BY HEDI SLIMANE;
Studded leather belts from Contemporary Wardrobe;
Patent leather shoes by GUCCI

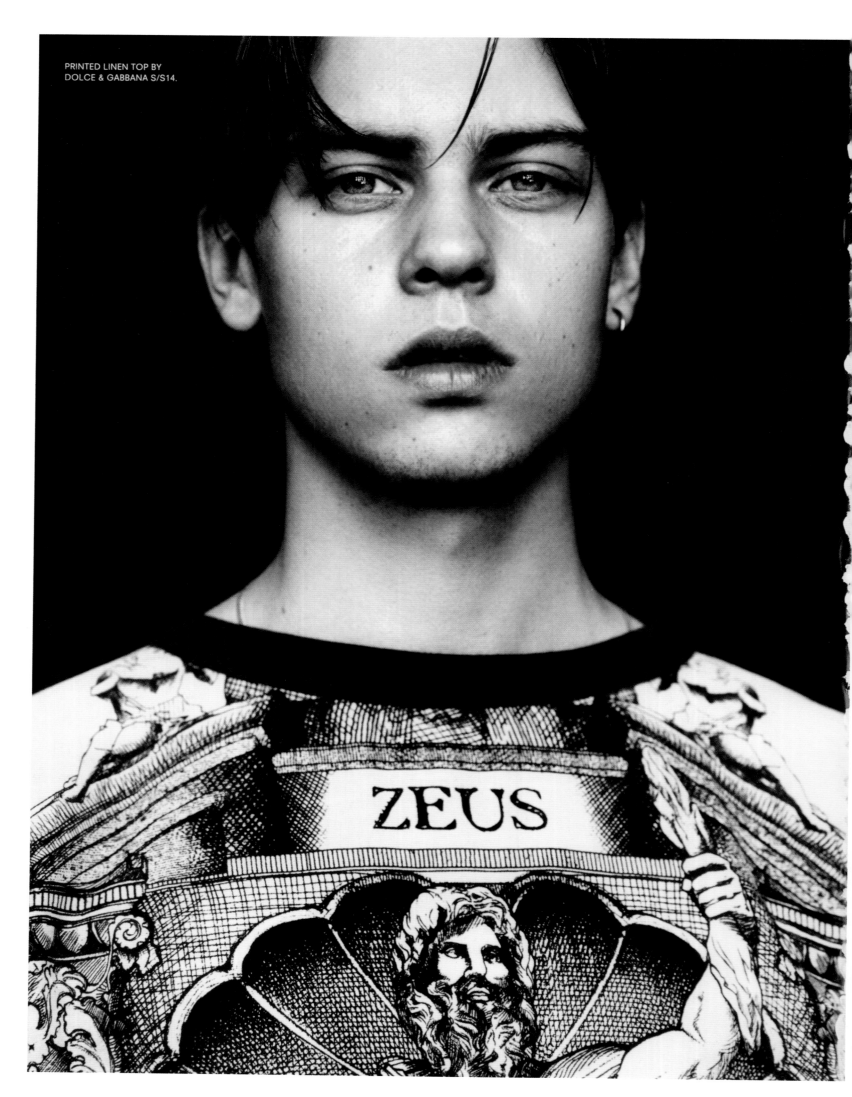

PRINTED LINEN TOP BY
DOLCE & GABBANA S/S14.

ZEUS

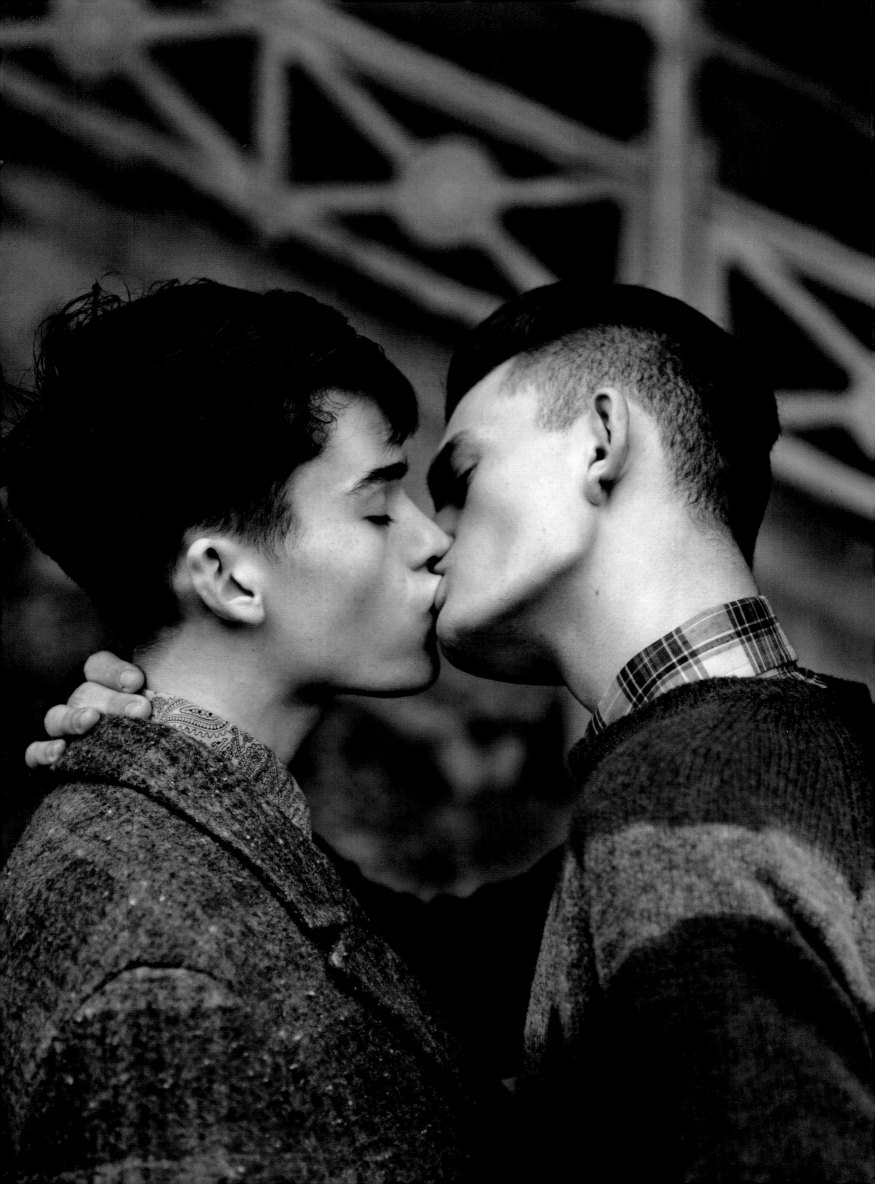

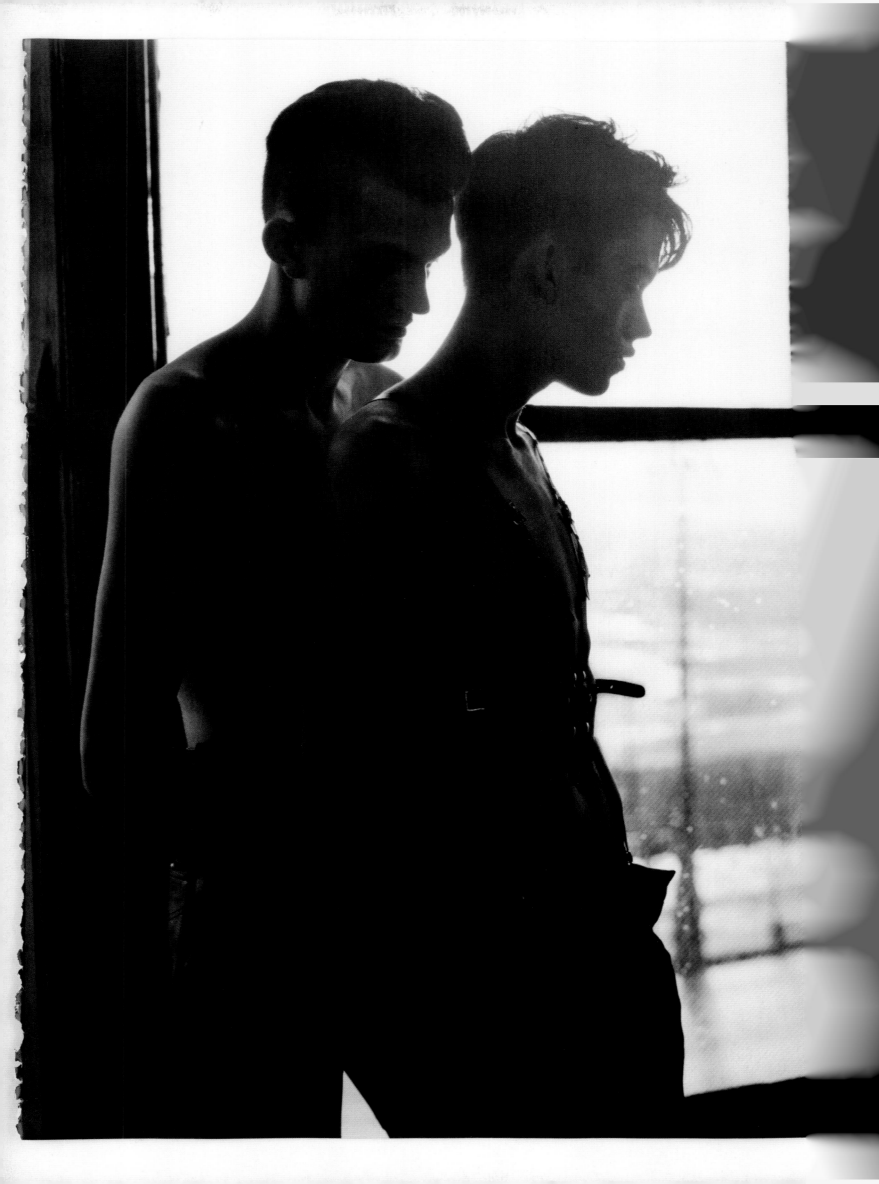

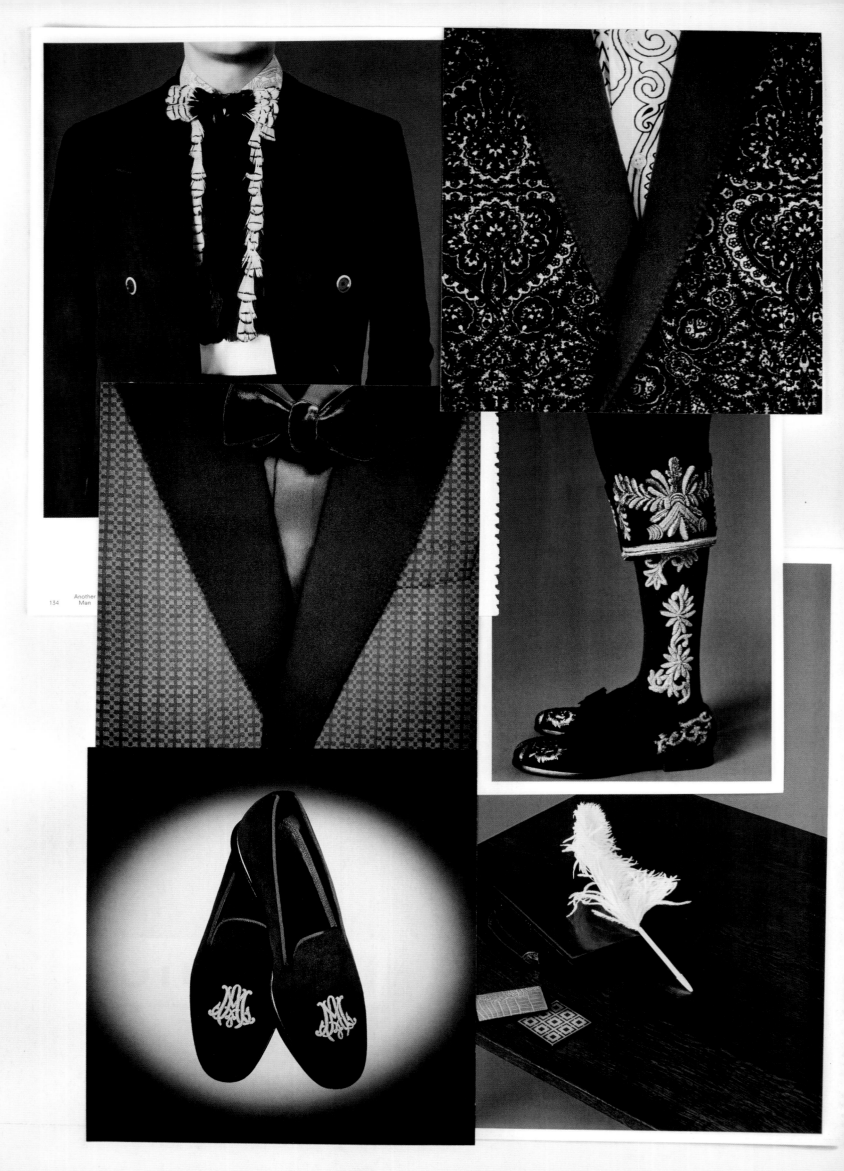

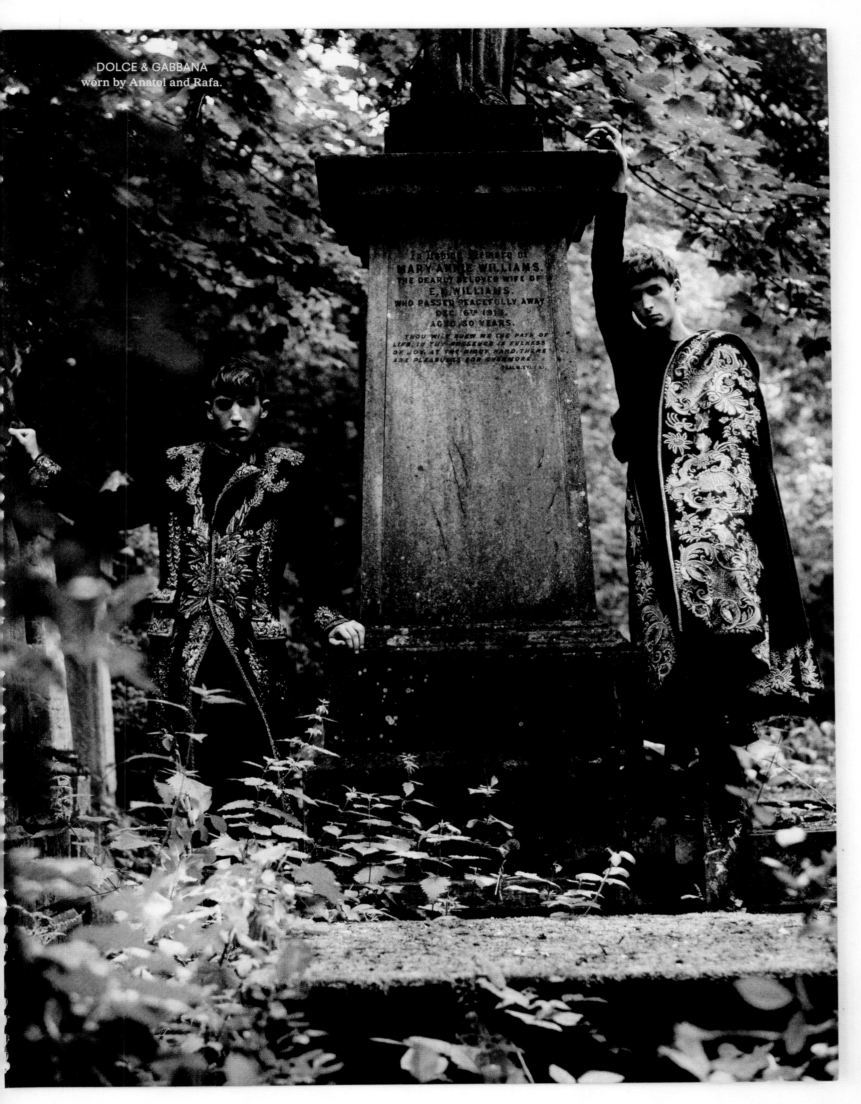

DOLCE & GABBANA
worn by Anatol and Rafa.

289

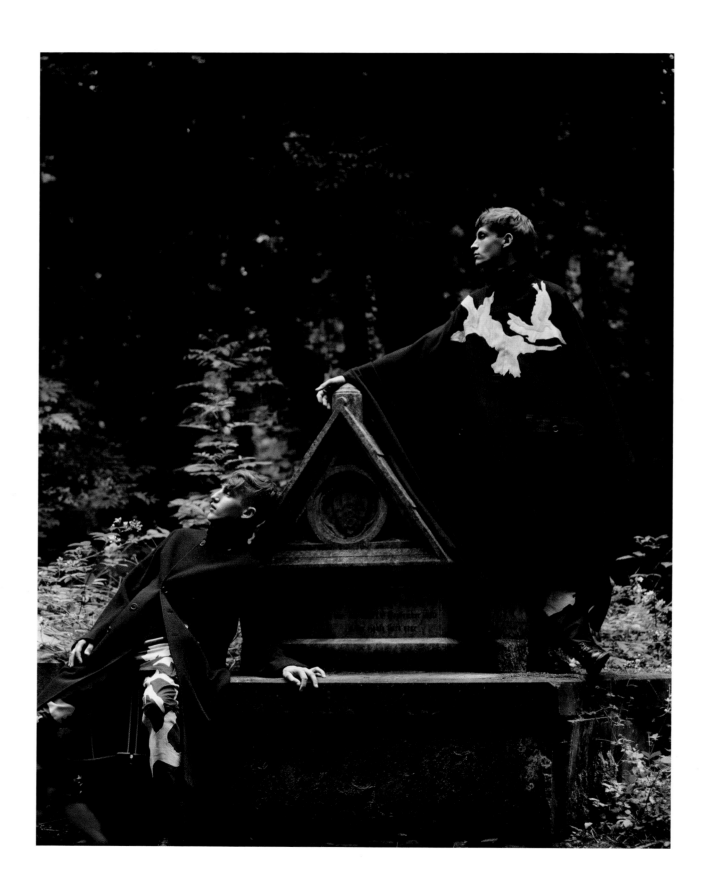

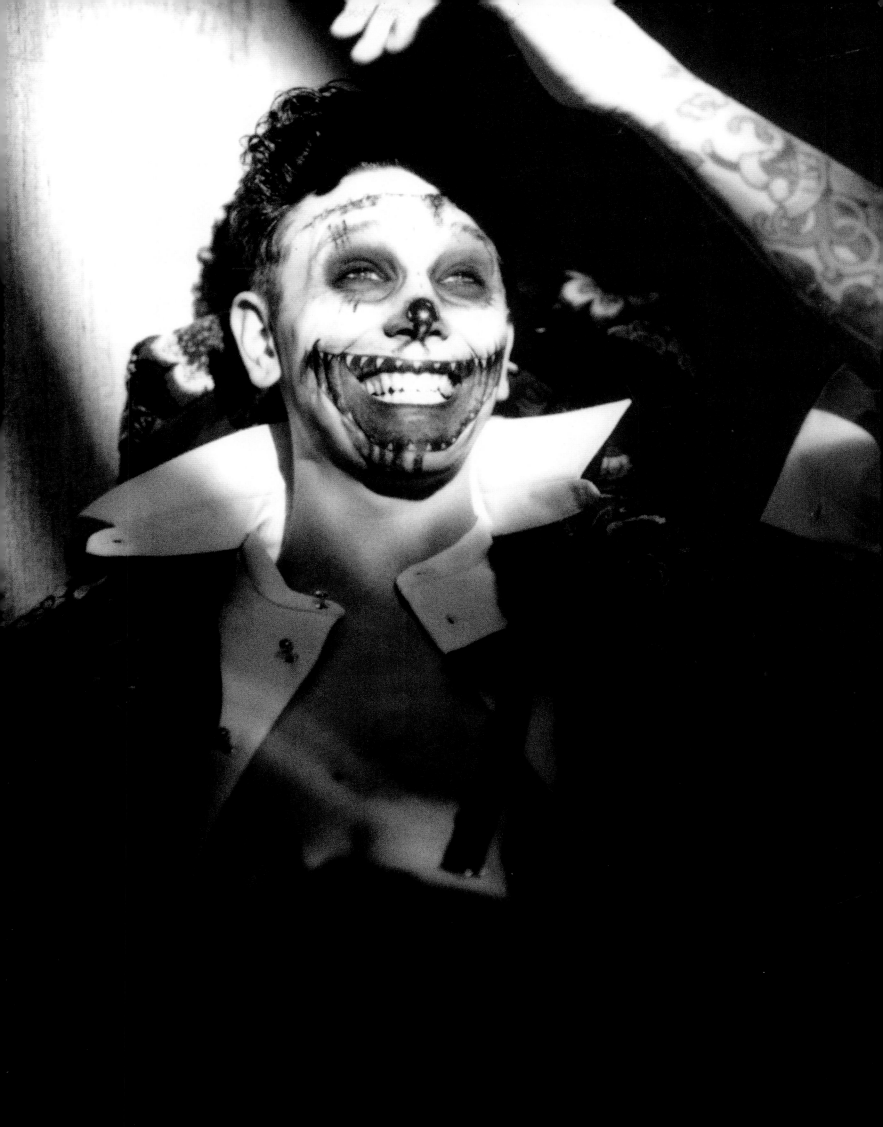

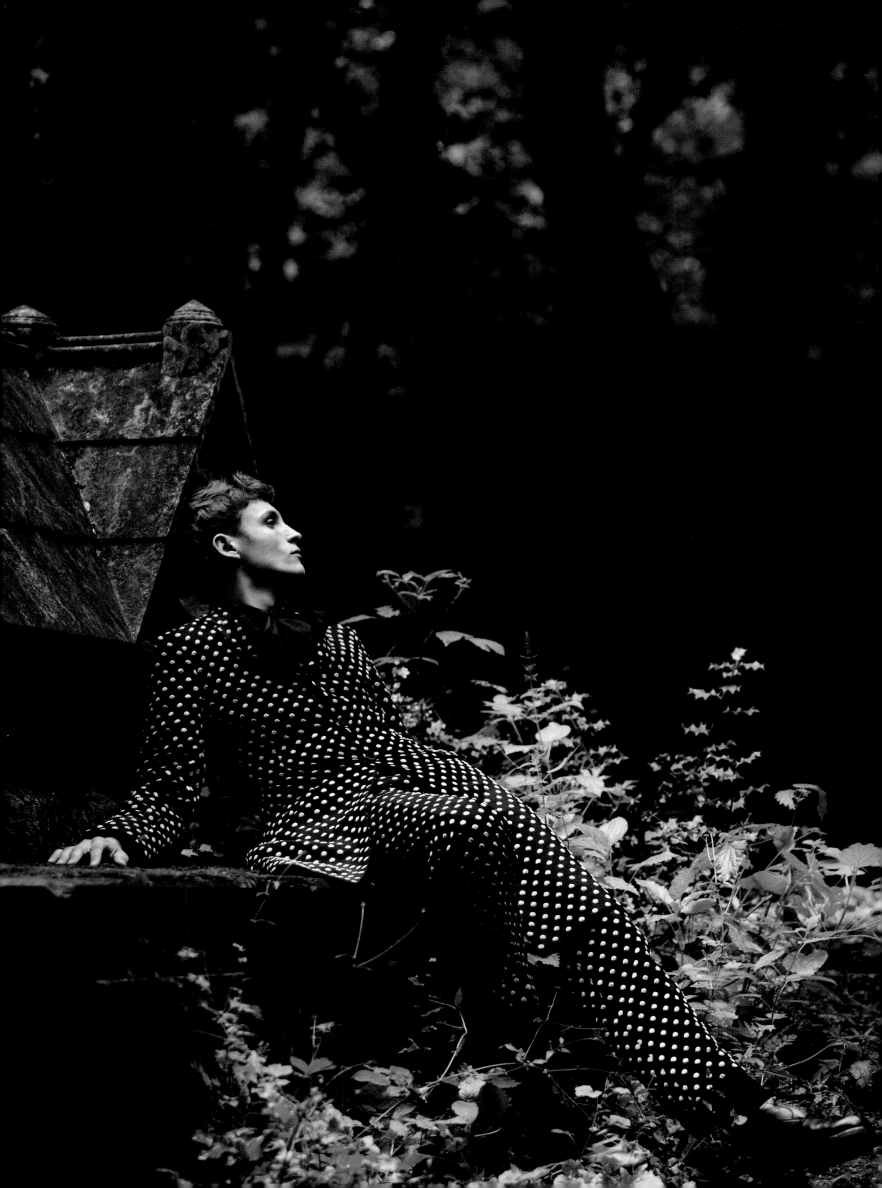

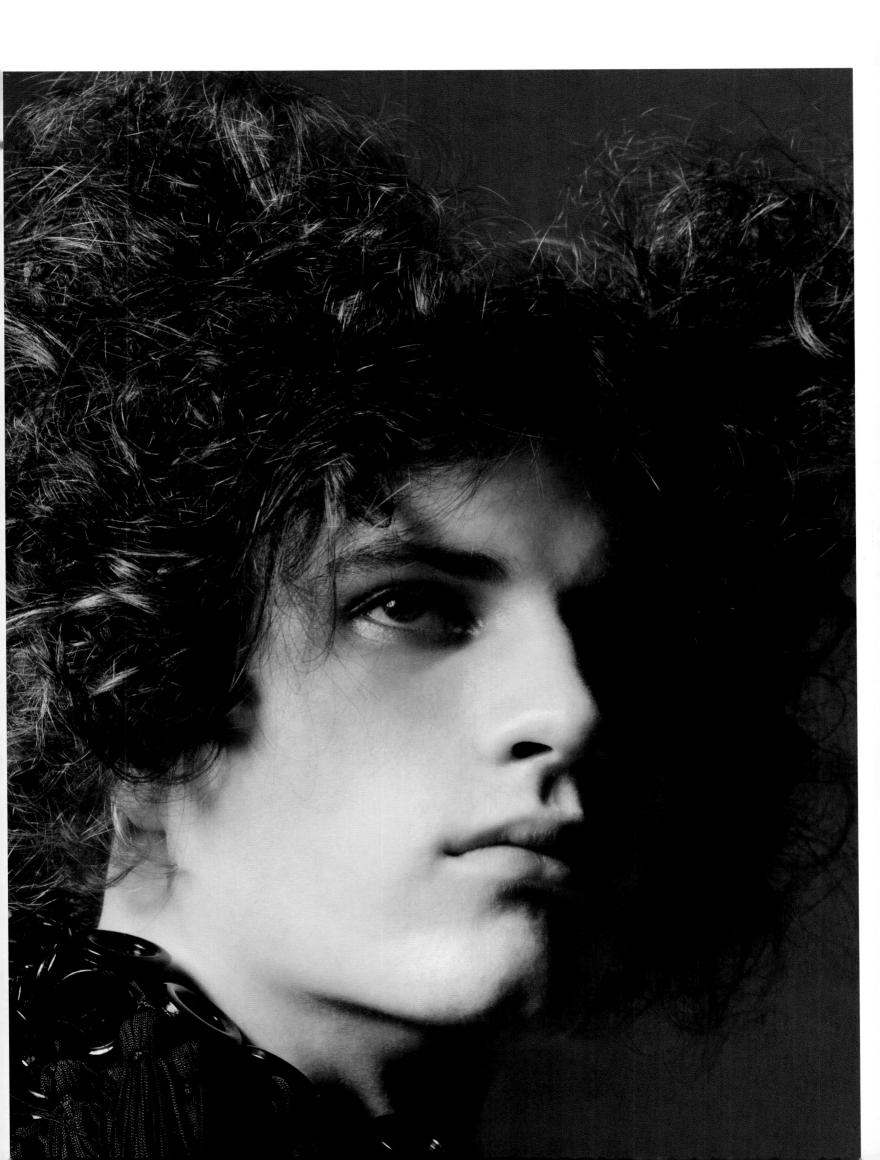

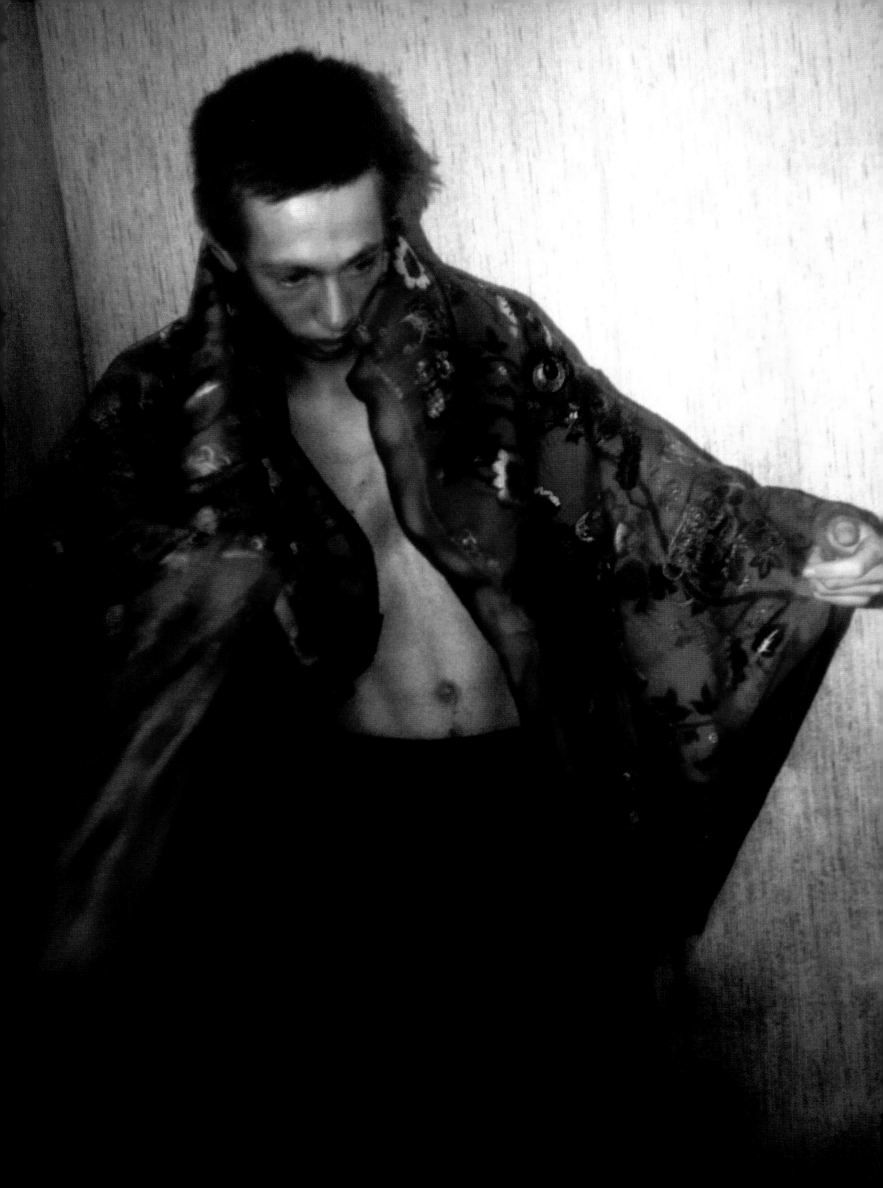

BOBBY GILLESPIE reveals how he came into the possession of punk legend Johnny Thunders' bow tie...

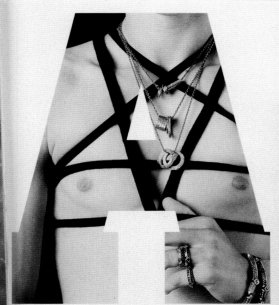

THE NATIONAL MAGAZINE OF ENTERTAINMENT JULY 1976 $1.25

AFTER DARK

RUBY AWARD PARTY
CICELY TYSON
JAN-MICHAEL
VINCENT
OREGON
SHAKESPEAREAN
FESTIVAL
"LOGAN'S RUN"

eather
boy 3

$12

Centaurus
£1
www.centaurus.co.uk

3·50

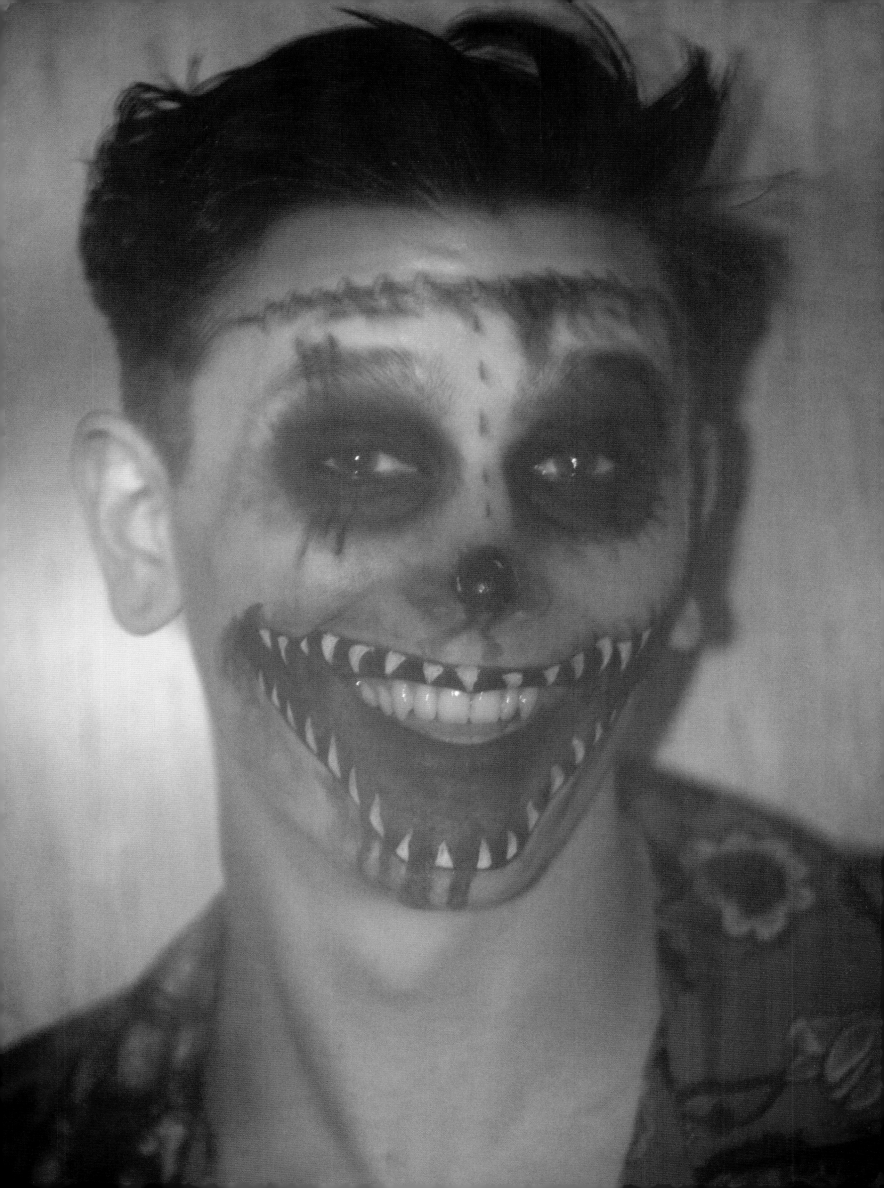

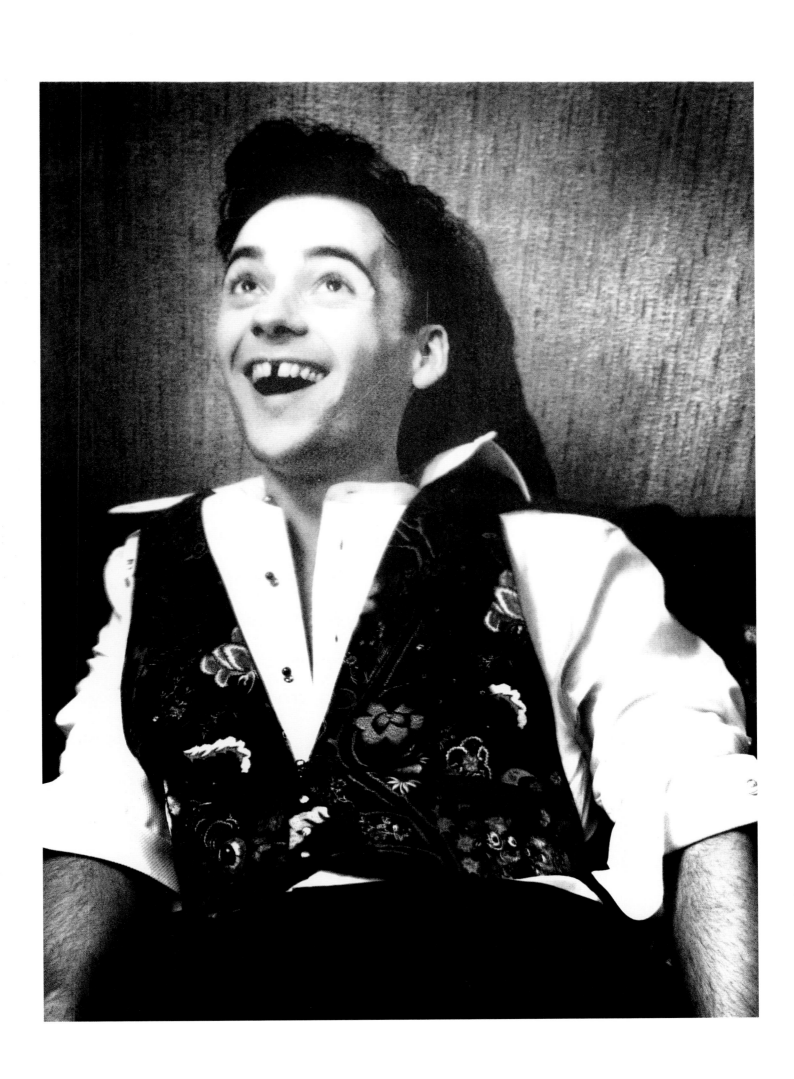

ACKNOWLEDGMENTS

Alister Mackie would like to thank the following people for their dedication and expertise on this project:

Editors: Ben Cobb and Jefferson Hack

Designed at Michael Nash Associates by Anthony Michael and Stephanie Nash with Alister Mackie

Project Director: Felicity Shaw

Image Researcher and Assistant to Alister Mackie: Eddy Martin

Text Contributors: Tim Blanks, Jarvis Cocker, Paul Moody, John-Paul Pryor

And with very special thanks to: Jake & Dinos Chapman, William Gibson, Bobby Gillespie, Kate Moss, Paul Simonon

Alister would also especially like to thank all the photographers, stylists, artists, art directors, assistants
and individuals who have collaborated on *Another Man* magazine throughout the years and on this book,
including the following people:

Beat Bolliger, Polly Borland, Joel Bough, Cedric Buchet, Richard Burbridge, Jeff Burton, Jeff Busby, Thea Charlesworth,
Ellie Grace Cumming, Horst Diekgerdes, Katy England, Nicola Formichetti, Richard Foster, Laura Genninger, Jim Goldberg,
Tom Guinness, Phil Hale, Desiree Heiss, Bart Hess, Julia Hetta, Martina Hoogland Ivanow, David Hughes, Benjamin Alexander
Huseby, Daniel Jackson, David James, Jacob K, Nadav Kander, Mattias Karlsson, Andy Keate, Nick Knight, Serge Leblon,
Brett Lloyd, Glen Luchford, Maryam Malakpour, Zoe Maughan, Gareth McConnell, Craig McDean, Alasdair McLellan,
Bryan McMahon, Lucy McRae, Dennis Morris, Thom Murphy, Niall O'Brien, Laurence Passera, Elizabeth Peyton, Walter
Pfeiffer, Jack Pierson, Richard Prince, Terry Richardson, Derek Ridgers, Pierrick Rocher, Nancy Rohde, Sofia de Romarate,
Alex Rose, Gosha Rubchinskiy, Laura Rule, Viviane Sassen, Christian Schoeler, Norbert Schoerner, Collier Schorr,
Mark Segal, William Selden, Johnnie Shand Kydd, David Sims, Kim Sion, Pennie Smith, Mario Sorrenti, Robbie Spencer,
Andrea Spotorno, Sølve Sundsbø, Jacob Sutton, Juergen Teller, Birgitta Toyoda, Scott Treleaven, Tyler Udall, Willy
Vanderperre, Jake Walters, Vincent van de Wijngaard, Paul Wetherell, Panos Yiapanis

We would also like to thank the following studios and agents:
Oren Silverstein at Alamy; Jessica Daly, Kimberly La Porte and Becky Lewis at Art+Commerce New York; Silvia Sini at
Art+Commerce Paris; Gregory Spencer at Art Partner; Frank Verkade at Bart Hess; Philippe Bustarret at Bird Production;
Cally at Bryter Music; Nye Jones at Corbis Images; Gracey Connelly at Craig McDean Studio; Natalie Doran at D+V
Management; Sakiko Yamagata at Studio Jackson; Sarah Dawes and Anna Francis at David Sims studio; Nina Weissman at
Elizabeth Peyton Studio; Tim Goossens at Envoy Enterprises; Todd M. Lander at Freeman, Freeman & Smiley, Max Teicher at
Gagosian New York; Irène Cramm at Galerie Urs Meile Lucerne and Beijing; Lucy Kelly at Getty Images; Trysha Le and Peter
London at HarperCollins Publishers; Linda Lee Bukowski, Richard Hell; Josh at Ignition; Anika Jamieson-Cook at Jake &
Dinos Chapman studio; Yunice Kang at Jeff Burton studio; Nathalie Burgun, Georg Ruffles and Jenny Slattery at Juergen Teller
Ltd; Kate Constable at Lucy McRae; Julie Brown and Stewart Searle at M.A.P Inc; Martha Millard at Martha Millard Literary
Agency; Jonathan Carmichael, Neal Mistry and Isaac Murai-Rolfe at Michael Nash Associates; Todd Ifft at Photofest Inc; Kristie
Cannings at Photoshot; Samira Agamasu at Polydor Records; Ben Thornborough at Regen Projects; Stephen Atkinson at Rex
Features; Kelly Kiley at Rough Trade Records; Charlotte Knight at SHOWStudio; Cliff Dane at Snapper Music; Joanna Ling
and Katherine Marshall at Sotheby's Picture Library / Cecil Beaton Studio Archive; Victoria Sullivan at Streeters; Mark Dowd
at Topfoto; Robert Rosenberg at Trinifold Management Ltd; Billy Vong at Trunk Archive; Shane O'Neill at UMusic; Stephanie
Cannizzo and Chip Lord at University of California, Berkeley Art Museum and Pacific Film Archive (BAM/PFA) on behalf
of Ant Farm; Matt Nicholson at Visual Artists UK; Peter-Frank Heuseveldt at Viviane Sassen; Sophie Greig at White Cube;
Floriane Desperier at Willy Vanderperre; Fiona Young

12 13 14 15 16 17 18 19 20 21 22 23

24 25 26 27 28 29 30 31 36 37 38 39

40 41 42 43 44 45 46 47 48 49 50 51

52 53 54 55 56 57 58 59 60 61 62 63

64 65 66 67 72 73 74 75 76 77 78 79

80 81 82 83 84 85 86 87 88 89 90 91

92 93 94 95 96 97 98 99 100 101 102 103

104 105 110 111 112 113 114 115 116 117 118 119

120 121 122 123 124 125 126 127 128 129 130 131

132 133 134 135 136 137 140 141 142 143 144 145

146 147 148 149 150 151 152 153 154 155 156 157

012 Alex Turner, photography by Willy Vanderperre, styling by Alister Mackie, *Another Man* issue 16, 2013
013 Joaquin Phoenix, photography by Craig McDean, styling by Beat Bolliger, *Another Man* issue 1, 2005
014 Viggo Mortensen, photography by Richard Burbridge, styling by Panos Yiapanis, *Another Man* issue 7, 2008
016 Willem Dafoe, photography by Willy Vanderperre, styling by Alister Mackie, *Another Man* issue 15, 2012
017 Joseph Gordon-Levitt, photography by Terry Richardson, styling by Alister Mackie, *Another Man* issue 1, 2005
018 Alex Turner, photography by Willy Vanderperre, styling by Alister Mackie, *Another Man* issue 16, 2013
019 Gael García Bernal, photography by Craig McDean, styling by Panos Yiapanis, *Another Man* issue 2, 2006
020 Alex Turner, photography by Willy Vanderperre, styling by Alister Mackie, *Another Man* issue 16, 2013
021 Keith Richards, photography by Mario Sorrenti, styling by Maryam Malakpour, *Another Man* issue 11, 2010
022 Nick Cave, photography by Polly Borland, *Another Man* issue 6, 2008
023 Ben Whishaw, photography by Nick Knight, styling by Alister Mackie, *Another Man* issue 4, 2007
024 Jack White, photography by Mark Segal, styling by Robbie Spencer, *Another Man* issue 10, 2010
025 Ezra Miller, photography by Willy Vanderperre, styling by Alister Mackie, *Another Man* issue 17, 2013
026 Michael Clark, photography by Jake Walters, *Another Man* issue 9, 2009
027 Casey Affleck, photography by Mark Segal, styling by Alister Mackie, *Another Man* issue 5, 2007
028 Tom Ford, photography by Jeff Burton, *Another Man* issue 12, 2011
029 Joseph Gordon-Levitt, photography by Terry Richardson, styling by Alister Mackie, *Another Man* issue 1, 2005
030 King Krule, photography by Willy Vanderperre, styling by Alister Mackie, *Another Man* issue 18, 2014
031 Garrett Hedlund, photography by Alasdair McLellan, styling by Alister Mackie, *Another Man* issue 14, 2012
036 *Another Man* issue 14, 2012, *Buster Keaton, 1928* © Hulton Archive / Getty Images
037 Photography by Horst Diekgerdes, styling by Nancy Rohde, *Another Man* issue 1, 2005
038 Photography by Johnnie Shand Kydd, styling by Mattias Karlsson, *Another Man* issue 2, 2006
039 *Another Man* issue 14, 2012, *Keith Richards, 1979* © Henry Diltz / Corbis
040 Photography by Andrea Spotorno, styling by Bryan McMahon, *Another Man* issue 17, 2013
041 Photography by Johnnie Shand Kydd, styling by Mattias Karlsson, *Another Man* issue 2, 2006
042 Photography by Daniel Jackson, styling by Mattias Karlsson, *Another Man* issue 12, 2011
043 Photography by Andrea Spotorno, styling by Bryan McMahon, *Another Man* issue 17, 2013
044 (clockwise from top left) Photography by Andrea Spotorno, styling by Bryan McMahon, *Another Man* issue 17, 2013. Alex Turner, photography by Willy Vanderperre, styling by Alister Mackie, *Another Man* issue 16, 2013. Photography by Andrea Spotorno, styling by Bryan McMahon, *Another Man* issue 17, 2013. Ian McKellen, photography by Nadav Kander, *Another Man* issue 4, 2007
045 Photography by Collier Schorr, styling by Tyler Udall, *Another Man* issue 6, 2008
046 Photography by Andrea Spotorno, styling by Bryan McMahon, *Another Man* issue 17, 2013
047 *Another Man* issue 15, 2012, *Ian McCulloch, 1979* © Kevin Cummins / Getty Images
048 Joe Cole, photography by Vincent van de Wijngaard, styling by Mattias Karlsson, *Another Man* issue 18, 2014
049 Photography by Alasdair McLellan, styling by Alister Mackie, *Another Man* issue 18, 2014 *Another Man* issue 18, 2014, *Leigh Bowery, 1989* © Derek Ridgers Archive. Joe Cole, photography by Vincent van de Wijngaard, styling by Mattias Karlsson, *Another Man* issue 18, 2014. King Krule, photography by Willy Vanderperre, styling by Alister Mackie, *Another Man* issue 18, 2014
050 John Byrne, photography by Glen Luchford, *Another Man* issue 2, 2006
051 Photography by Horst Diekgerdes, styling by Bryan McMahon, *Another Man* issue 9, 2009
052 Photography by Collier Schorr, styling by Tyler Udall, *Another Man* issue 6, 2008
053 Photography by Benjamin Alexander Huseby, styling by Mattias Karlsson, *Another Man* issue 15, 2012
054 Photography by Alasdair McLellan, styling by Alister Mackie, *Another Man* issue 18, 2014
055 John Lydon, photography by Dennis Morris, *Another Man* issue 14, 2012
056 All photography by Andrea Spotorno, styling by Mattias Karlsson, *Another Man* issue 18, 2014
057 Photography by Julia Hetta, styling by Robbie Spencer, *Another Man* issue 18, 2014
058 Artwork by Christian Schoeler, *Another Man* issue 8, 2009
059 Photography by David Sims, styling by Alister Mackie, *Another Man* issue 17, 2013
060 Gary Card, photography by William Selden, styling by Nicola Formichetti, *Another Man* issue 6, 2008
061 Artwork by Christian Schoeler, *Another Man* issue 8, 2009
062 Artwork by Christian Schoeler, *Another Man* issue 8, 2009
063 Photography by Gareth McConnell, styling by Alister Mackie, *Another Man* issue 6, 2008
064 Artwork by Christian Schoeler, *Another Man* issue 8, 2009
065 Photography by Gareth McConnell, styling by Alister Mackie, *Another Man* issue 6, 2008
066 Photography by Gareth McConnell, styling by Alister Mackie, *Another Man* issue 6, 2008
067 Photography by Niall O'Brien, styling by Katy England, *Another Man* issue 17, 2013
072 *Another Man* issue 8, 2009, *Ant Farm: Space Cowboy Meets Plastic Businessman, 1969; performance, Alley Theater, Houston, Texas. Photo: Ant Farm, courtesy University of California, Berkeley Art Museum and Pacific Film Archive*
073 Ethan Hawke, photography by Craig McDean, styling by Alister Mackie, *Another Man* issue 3, 2006
074 Photography by Sølve Sundsbø, styling by Nicola Formichetti, *Another Man* issue 5, 2007
075 Photography by Jacob Sutton, styling by Thom Murphy, *Another Man* issue 3, 2006
076 Photography by Gosha Rubchinskiy, styling Robbie Spencer, *Another Man* issue 16, 2013
077 Photography by Willy Vanderperre, styling by Alister Mackie, *Another Man* issue 3, 2006
078 Photography by Willy Vanderperre, styling by Alister Mackie, *Another Man* issue 3, 2006
080 Artwork by Phil Hale, styling by Alister Mackie, *Another Man* issue 10, 2010
081 Photography by Laurence Passera, styling by Nicola Formichetti, *Another Man* issue 5, 2007
082 Artwork by Phil Hale, styling by Alister Mackie, *Another Man* issue 10, 2010
083 Photography by Jacob Sutton, styling by Thom Murphy, *Another Man* issue 3, 2006
084 Artwork by Phil Hale, styling by Alister Mackie, *Another Man* issue 10, 2010
085 Photography by Willy Vanderperre, styling by Alister Mackie, *Another Man* issue 3, 2006
086 Photography by Alasdair McLellan, styling by Alister Mackie, *Another Man* issue 13, 2011
087 Photography by Willy Vanderperre, styling by Alister Mackie, *Another Man* issue 15, 2012
088 Photography by Martina Hoogland Ivanow, styling by Desiree Heiss, *Another Man* issue 1, 2005
089 Photography by Paul Wetherell, styling by Bryan McMahon, *Another Man* issue 11, 2010
090 Photography by Andy Keate, *Another Man* issue 15, 2012. *The cover of the December 20, 1919 edition of L'Illustration, featuring Scottish artist Henry Raeburn's eighteenth-century portrait of William Ferguson of Kilrie*
091 Photography by Sølve Sundsbø, styling by Nicola Formichetti, *Another Man* issue 8, 2009
092 Photography by Martina Hoogland Ivanow, styling by Desiree Heiss, *Another Man* issue 1, 2005
093 *Another Man* issue 1, 2005. *Henry, Duke of Gloucester, c. 1653, by Adriaen Hanneman. Courtesy of National Gallery of Art, Washington, DC*
094 Photography by Nick Knight, styling by Katy England and Alister Mackie, *Another Man* issue 18, 2014
095 Photography by Nick Knight, styling by Katy England and Alister Mackie, *Another Man* issue 18, 2014
096 Photography by Alasdair McLellan, styling by Alister Mackie, *Another Man* issue 15, 2012
097 Photography by Serge Leblon, styling by Bryan McMahon, *Another Man* issue 7, 2008
098 Photography by Serge Leblon, styling by Bryan McMahon, *Another Man* issue 7, 2008
100 Photography by Serge Leblon, styling by Bryan McMahon, *Another Man* issue 7, 2008
101 Photography by Horst Diekgerdes, styling by Nicola Formichetti, *Another Man* issue 3, 2006
102 Photography by Horst Diekgerdes, styling by Nicola Formichetti, *Another Man* issue 3, 2006
104 Photography by Horst Diekgerdes, styling by Nicola Formichetti, *Another Man* issue 3, 2006
105 Photography by Norbert Schoerner, styling by Nicola Formichetti, *Another Man* issue 7, 2008
110 Photography by Jack Pierson, styling by Bryan McMahon, *Another Man* issue 14, 2012 (left). Photography by Richard Prince, *Another Man*, issue 1, 2005 (middle). Photography by Benjamin Alexander Huseby, styling by Nicola Formichetti, *Another Man* issue 1, 2005 (right).

112 Photography by Jeff Busby, *Another Man* issue 4, 2007
113 Photography by Benjamin Alexander Huseby, styling by Nicola Formichetti, *Another Man* issue 1, 2005
114 Photography by Benjamin Alexander Huseby, styling by Nicola Formichetti, *Another Man* issue 1, 2005 (left). Photography by Horst Diekgerdes, styling by Nicola Formichetti, *Another Man* issue 4, 2007 (middle). Photography by Jeff Busby, *Another Man* issue 4, 2007 (right)
116 Photography by Jeff Busby, *Another Man* issue 4, 2007 (left). Photography by Alasdair McLellan, styling by Alister Mackie, *Another Man* issue 17, 2013 (middle). Photography by Alasdair McLellan, styling by Alister Mackie, *Another Man* issue 17, 2013 (right)
118 Photography by Jeff Busby, *Another Man* issue 4, 2007 (left underlay). Photography by Alasdair McLellan, styling by Alister Mackie, *Another Man* issue 17, 2013 (left overlay). Photography by Juergen Teller, styling by Alister Mackie, *Another Man* issue 16, 2013
120 Photography by Juergen Teller, styling by Alister Mackie, *Another Man* issue 16, 2013
121 Photography by Jeff Busby, *Another Man* issue 4, 2007 (right underlay). Photography by Juergen Teller, styling by Alister Mackie, *Another Man* issue 16, 2013 (right overlay)
122 Photography by Juergen Teller, styling by Alister Mackie, *Another Man* issue 16, 2013
123 Photography by Benjamin Alexander Huseby, styling by Nicola Formichetti, *Another Man* issue 1, 2005
124 Photography by Brett Lloyd, styling by Tom Guinness, *Another Man* issue 18, 2014
126 Garrett Hedlund, photography by Alasdair McLellan, styling by Alister Mackie, *Another Man* issue 14, 2012
127 Photography by Benjamin Alexander Huseby, styling by Nicola Formichetti, *Another Man* issue 1, 2005
128 Photography by Jeff Busby, *Another Man* issue 4, 2007
129 Photography by Alasdair McLellan, styling by Alister Mackie, *Another Man* issue 14, 2012
130 Photography by Alasdair McLellan, styling by Alister Mackie, *Another Man* issue 14, 2012
131 Photography by Jeff Busby, *Another Man* issue 4, 2007
132 Photography by Alasdair McLellan, styling by Alister Mackie, *Another Man* issue 14, 2012
133 Photography by Viviane Sassen, styling by Mattias Karlsson, *Another Man* issue 4, 2007
134 Photography by Viviane Sassen, styling by Mattias Karlsson, *Another Man* issue 4, 2007
135 Photography by Alasdair McLellan, styling by Alister Mackie, *Another Man* issue 13, 2011
136 Photography by Viviane Sassen, styling by Mattias Karlsson, *Another Man* issue 4, 2007
137 Photography by Alasdair McLellan, styling by Alister Mackie, *Another Man* issue 13, 2011
141 Artwork by Jake & Dinos Chapman, Ezra Miller, original photography by Willy Vanderperre, styling by Alister Mackie, *Another Man* issue 17, 2013
142 Photography by Nick Knight, styling by Alister Mackie, *Another Man* issue 1, 2005
143 Photography by Nick Knight, styling by Alister Mackie, *Another Man* issue 1, 2005
144 Photography by Nick Knight, styling by Alister Mackie, *Another Man* issue 1, 2005
145 Photography by Nick Knight, styling by Alister Mackie, *Another Man* issue 1, 2005
146 Photography by Nick Knight, styling by Alister Mackie, *Another Man* issue 1, 2005
147 Photography by Nick Knight, styling by Alister Mackie, *Another Man* issue 1, 2005
148 Willem Dafoe, photography by Willy Vanderperre, styling by Alister Mackie, *Another Man* issue 15, 2012
150 Ezra Miller, photography by Willy Vanderperre, styling by Alister Mackie, *Another Man* issue 17, 2013
151 Ezra Miller, photography by Willy Vanderperre, styling by Alister Mackie, *Another Man* issue 17, 2013
152 Photography by Alex Rose, styling by Alister Mackie, *Another Man* issue 11, 2010
154 Photography by Richard Prince, *Another Man* issue 1, 2005
155 LucyandBart, a collaboration between Lucy McRae and Bart Hess, photography by Nick Knight, styling by Alister Mackie, *Another Man* issue 11, 2010
156 LucyandBart, a collaboration between Lucy McRae and Bart Hess, photography by Nick Knight, styling by Alister Mackie, *Another Man* issue 11, 2010 (all images)

158 159 160 161 162 163 164 165 166 167 168 169

170 171 178 179 180 181 182 183 184 185 186 187

188 189 190 191 192 193 194 195 196 197 198 199

200 201 202 203 204 205 212 213 214 215 216 217

218 219 220 221 222 223 224 225 226 227 228 229

230 231 232 233 234 235 236 237 238 239 240 241

242 243 244 245 246 247 248 249 250 251 252 253

254 255 256 257 258 259 266 267 268 269 270 271

272 273 274 275 276 277 278 279 280 281 282 283

284 285 286 287 288 289 290 291 292 293 294 295

296 297

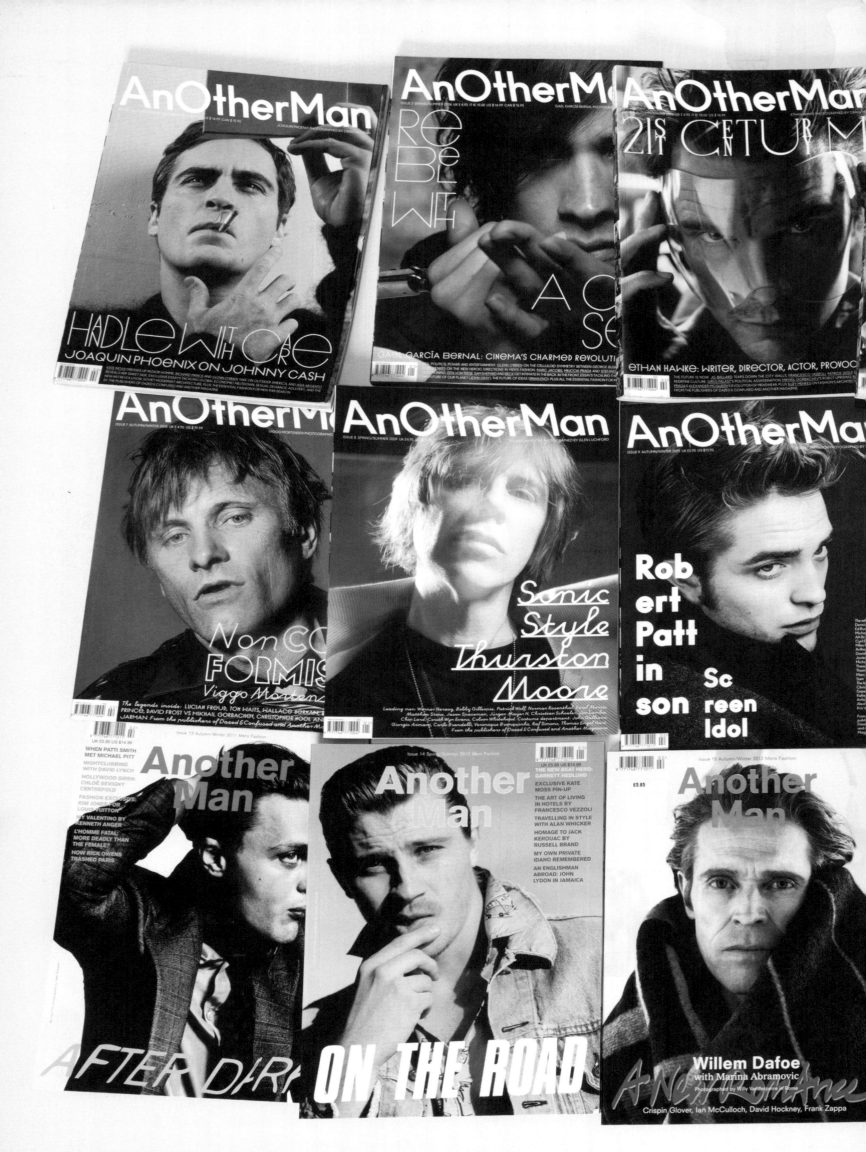